EARTH FROM SPACE

EPIC STORIES OF THE NATURAL WORLD

MICHAEL BRIGHT AND **CHLOË SAROSH**

BBC
BOOKS

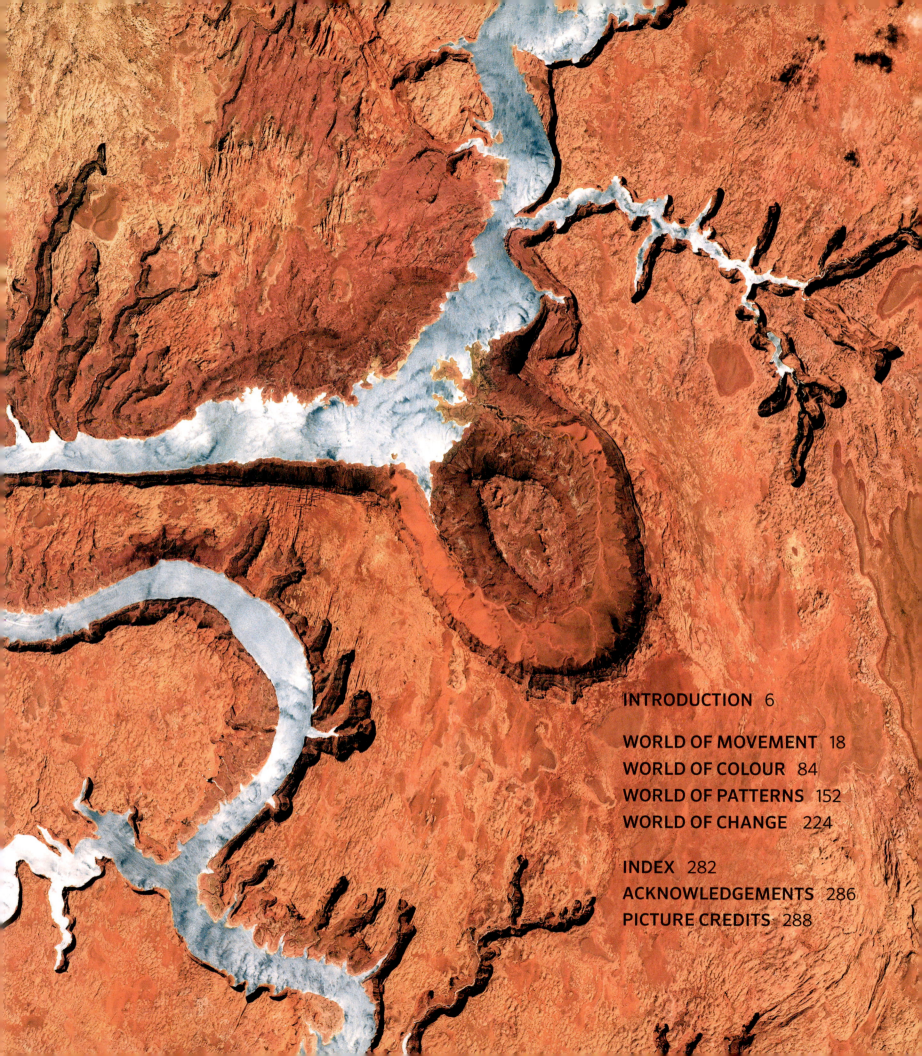

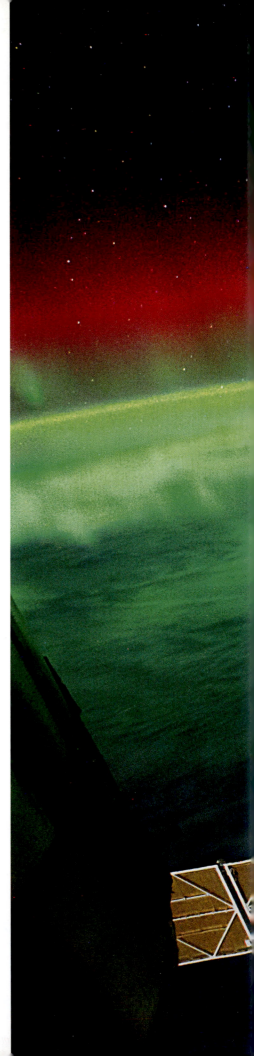

Observing the Earth: a short history

During the Late Stone Age, about 27,000 years ago, a group of hunter-gatherers in the Pavlov Hills, in what is now the Czech Republic, looked around the landscape in which they lived and realised that if they had some means by which they could easily find their favourite hunting grounds and the best places in which to camp, then they would have a better chance to survive. Word of mouth from one generation to the next would have been one way to stoke tribal knowledge, but these people had a new and more permanent solution: they scratched marks onto a mammoth tusk, and this would provide them with a visual representation of where they had been, where they were now, and where they could go ... in other words, they had created a map.

Those early cartographers were limited in their outlook. They had to make their observations from the tops of hills or, like later civilisations, from the masts of ships, but that did not stop them from considering the bigger picture. There was always a desire to view ourselves as the gods might see us, and in the sixth century BCE, the Babylonians had a go at depicting the entire Earth in space with their Map of the World. It is a clay tablet, in size about 12 by 8 centimetres, that shows our planet as a flat disc surrounded by the sea, and, according to the British Museum where the artefact is kept, it is thought to be copied from an earlier depiction made sometime after the ninth century BCE.

Archaeological finds like these show how, since the mists of time, people have had an abiding curiosity about what the world looks like when seen from above. But it was not until Greek philosophers and mathematicians came along that we realised the Earth was not a flat disc, but a sphere. It was the perfect shape the gods would have preferred.

By the 13th century CE, ancient mariners had drawn up navigational charts, like the portolan charts, which guided ships across the world in pursuit of silk, spices, opium, political influence and the conquest of new lands. They were so valuable that the charts were often closely guarded state secrets, and the outlines of the known continents were remarkably accurate considering the highest a ship's navigator could climb to view the sea and shore was to the crow's nest, about 30 metres above the deck.

Then, during the 18th century, there was a quantum leap in the way the Earth could be observed: the invention of the balloon. In November 1783, the Montgolfier brothers flew a manned balloon in France, but it was not until 75 years later that balloons were used to take photographs of the Earth below.

RIGHT **It has taken less than 25,000 years to get from a simple map scratched on a mammoth's tusk to an International Space Station from which pictures can be taken of an aurora from above. Our ancient forebears were eager to see our world as the gods saw it, and now we can do just that. Astronauts dreamed of travelling to other worlds, but it wasn't until they looked back and saw our delicate planet hanging in the void of space that we came to have a new kind of self-awareness, something that an International Space Station crewman described as 'orbital awareness' – a new and holistic view of the world.** © Image courtesy of NASA Johnson Space Center.

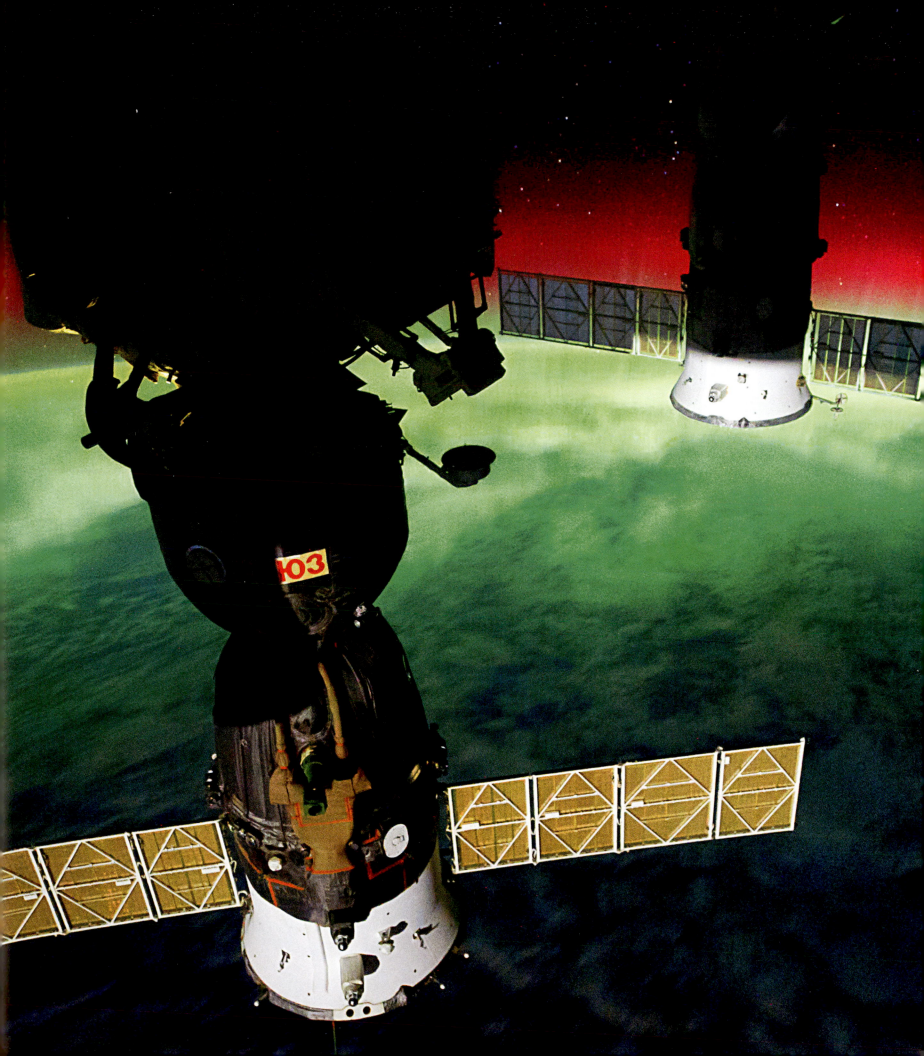

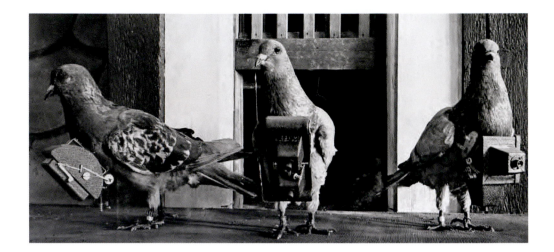

LEFT Pigeons were in the vanguard of the first Earth photographers. Julius Neubronner's pigeons carried cameras into international expositions in several European cities in the early 1910s. Pictures they had taken on their flight were developed, printed and sold as postcards.

The pioneer was French photographer Gaspard-Félix Tournachon, known professionally as 'Nadar'. In 1858, he took the first known aerial photograph from a tethered balloon about 80 metres above the valley of the Bièvre. It was not easy. The wet colloidal photographic process in those days involved him taking not only a bulky camera and tripod, but also an entire darkroom in the balloon's basket. These early balloonists took enormous risks and very often put their lives in danger.

In the USA in 1860, American photographer James Wallace Black and his fellow balloonist Samuel Archer King tried to photograph the countryside around Boston, but their balloon broke free and they were dumped unceremoniously but safely in high bushes about 50 kilometres from their starting point. Two years later, British scientist James Glaisher and balloonist Henry Tracey Coxwell attempted to go considerably higher in order to photograph above the clouds. They reached an altitude of about 10,900 metres, but Glaisher passed out due to a lack of oxygen. Coxwell lost all sensation in his hands, but could pull the relevant valve cord with his teeth, and they returned gently to the ground but failed to photograph anything at all. And, in the early 1900s, George R. Lawrence was photographing from a cage strung beneath a balloon above Chicago when the cage detached itself and both Lawrence and camera fell towards the ground, only to be caught by telephone wires. Miraculously, he walked away unharmed.

During the years that followed, the desire to photograph the Earth from above gave rise to techniques that became increasingly bizarre. In 1903, German apothecary Julius Neubronner designed and patented a small camera mounted on the breast of a pigeon. The pigeon did not always fly the intended track, but creating a camera this small was an achievement nonetheless. The pigeons were probably less impressed, flying as they did with a wooden box attached to their breast. It was a wonder that they were able to take off at all, let alone fly!

The next major innovation was humankind's copy of the bird – the airplane, and taking pictures from an aircraft had immediate appeal for the military. During World War I, aerial photographs replaced hand-drawn sketch maps in pinpointing enemy positions, establishing troop movements and mapping battlefields, and, in World War II, aerial photography developed to such an extent that General Werner von Fritsch, chief of the German General Staff, remarked that, 'the nation with the best photoreconnaissance will win the war'. Aerial reconnaissance became vital in the planning stages of almost every military operation, and one of the most critical ops for the Allies was the destruction of V-1 and V-2 rocket sites.

Towards the end of World War II, Adolf Hitler saw rockets as a way to win, and he had the scientists and engineers to make it happen. It was at Peenemünde in Nazi Germany that Wernher von Braun and his colleagues developed the V-2 rocket, the world's first guided ballistic missile. It was designed to flatten London, but on 20th June 1944, test rocket MW 18014 went straight up into the stratosphere and beyond, reaching an altitude of

BELOW LEFT The earliest known picture from a balloon was of Paris, taken by Nadar in 1858. 'Montmartre' is conveniently labelled top right corner, as is the 'Avenue du Bois de Boulogne' at the bottom.

BELOW RIGHT James Wallace Black photographed 'Boston as the Eagle and Wild Goose See It' from a tethered balloon at an altitude of 2,000 ft on 13th October 1860.

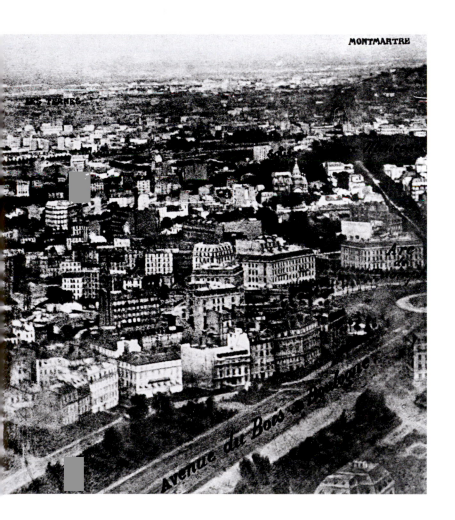

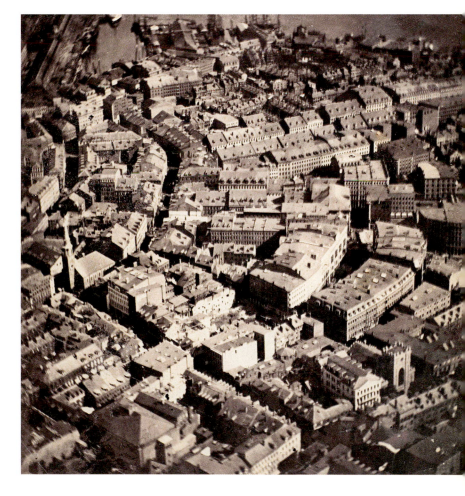

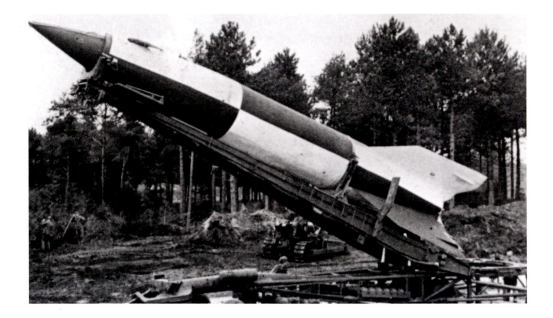

176 kilometres to become the first manmade object to cross the Kármán Line, the notional 100-kilometre boundary between the Earth's atmosphere and outer space. It was the first 'space rocket', and, by association, von Braun became the 'father of space exploration'.

At the end of the war, Operation Paperclip spirited von Braun and 1,600 other German scientists and engineers out of Europe, and they were secretly moved to the USA, along with 300 goods wagons filled with V-2 rocket parts. There, the assembled team began new experiments with V-2s. American-born NASA pioneer John T. Mengel, for example, replaced V-2 warheads with cameras. It enabled scientists to look at our planet in a very different way.

On 24th October 1946, sub-orbital V-2 rocket number 13 took off from White Sands Missile Range in New Mexico and rose to an altitude of 105 kilometres to obtain the first photographs of the Earth from space. The rocket fell back to Earth and ploughed into the ground, smashing the camera, but the film was safe inside its steel cassette. When the footage was processed, it led the camera's designer, Clyde Holliday of John Hopkins University Applied Physics Laboratory, to remark in a 1950s edition of *National Geographic* magazine that the photo showed for the first time 'how our Earth would look to visitors from another planet.'

Until then, the only pictures taken of our planet from the edge of space were from Explorer II, a manned, helium-filled, high-altitude balloon that reached a record 22 kilometres above the Earth's surface. It took off from South Dakota on 11th November 1935, with the crew – Captain Albert W. Stevens and Captain Orvil A. Anderson of the US Army Air Corps – ensconced inside its spherical, 2.8-metre-diameter cabin. Until then, the programme had been fraught with difficulties, and, like their 19th-century forebears,

the two balloonists found themselves in mortal danger. The previous attempt – the hydrogen-filled Explorer I (not to be confused with the USA's first satellite Explorer 1) – suffered a rip in the fabric of the balloon and its hydrogen canisters exploded. As the cabin plummeted towards the Earth, the crew had just enough time to bale out and drift down the last 150 metres to the ground on parachutes, their cabin having been totally destroyed on impact with the ground. When they returned to Earth on the Explorer II mission, and touched down softly and safely, the two captains were hailed as national heroes, but far more exciting was a very significant scientific accomplishment: they took the first picture showing the curvature of the Earth. They had seen that the Earth was not flat.

The V-2 rockets went five times higher than those balloons, and, on 7th March 1947, a rocket obtained the first pictures above an altitude of 160 kilometres. They were black and white and grainy, but they showed the Earth with patches of white cloud against the blackness of space, and, when the mosaic of pictures was stitched together, each panorama covered thousands of square kilometres of the Earth's surface. The USA, however, did not have space to itself.

BELOW **The first images from space were taken from the sub-orbital V-2 rocket launched from the US Army's White Sands Missile Range on 24th October 1946. Flight 13 reached an altitude of 105 kilometres, which was five times higher than any picture taken before. Pictures were taken every second-and-a-half.**

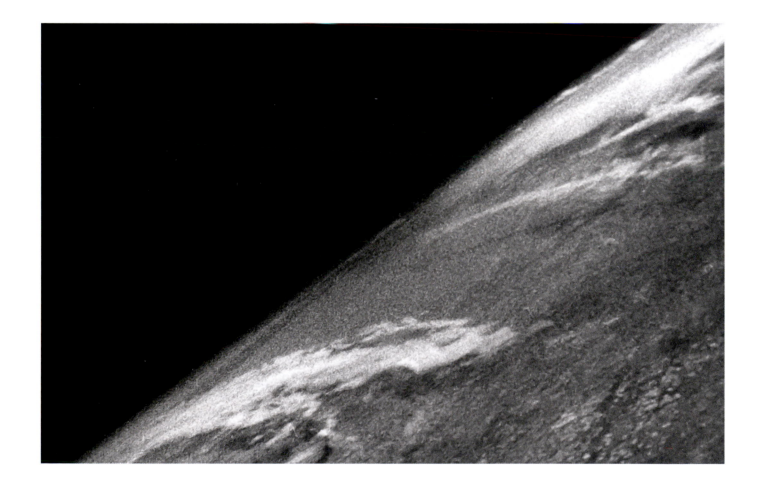

In 1957, the USSR's Sputnik, the world's first satellite, ushered in the 'space age' and accelerated the 'space race'. The first satellite photographs followed a couple of years later. On 14th August 1959, America's Explorer 6 satellite was at a distance of 27,000 kilometres when it beamed back the first pictures of the Earth from a satellite in orbit. The pictures were not too good. Landscapes and seascapes were virtually unrecognisable, a far cry from the images we see today.

One of the game-changers was ATS-3, a small, tin-can-shaped NASA weather and communications satellite. On board was a camera designed by Finnish-American Verner Suomi, the 'father of satellite meteorology'. On 10th November 1967, at a distance of

BELOW LEFT **Explorer II took off from the Stratobowl, South Dakota, and ascended to 22 kilometres over South Dakota. It was so cold the pilots' sandwiches froze.**

BELOW RIGHT **The flight lasted 8 hours and 13 minutes, and it had flown about 360 kilometres, landing near White Lake, South Dakota.**

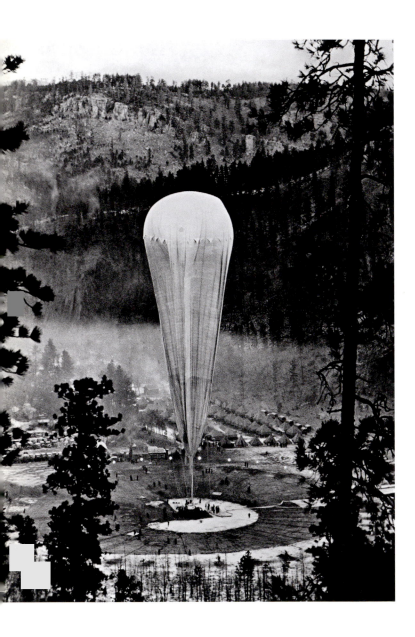

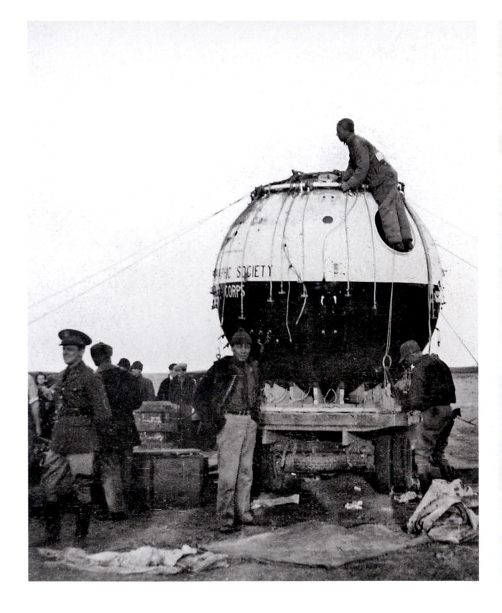

35,800 kilometres from the Earth's surface, it captured an image of the whole planet. It was grainier than the famous Blue Marble picture of the Earth taken in 1972 by the *Apollo 17* astronauts, but it showed the whole of our small and fragile planet set in the darkness of space for the very first time. Since then, many other satellites have presented us with whole Earth images, but the most poignant, perhaps, was the Earth as a very tiny pale blue dot, when photographed on St Valentine's Day 1990 by Voyager 1. The spacecraft was beyond the orbit of Neptune, close to the edge of the Solar System, a distance of about 6 billion kilometres from home, and, as Voyager scientist and astronomer Carl Sagan pointed out, it showed just how small our planet is and how insignificant we are in the Universe.

BELOW **These were the first pictures of the Earth from an altitude greater than 160 kilometres. When the movie frames were stitched together, you could see over 2.5 million square kilometres in a single glance.** © Johns Hopkins Applied Physics Laboratory.

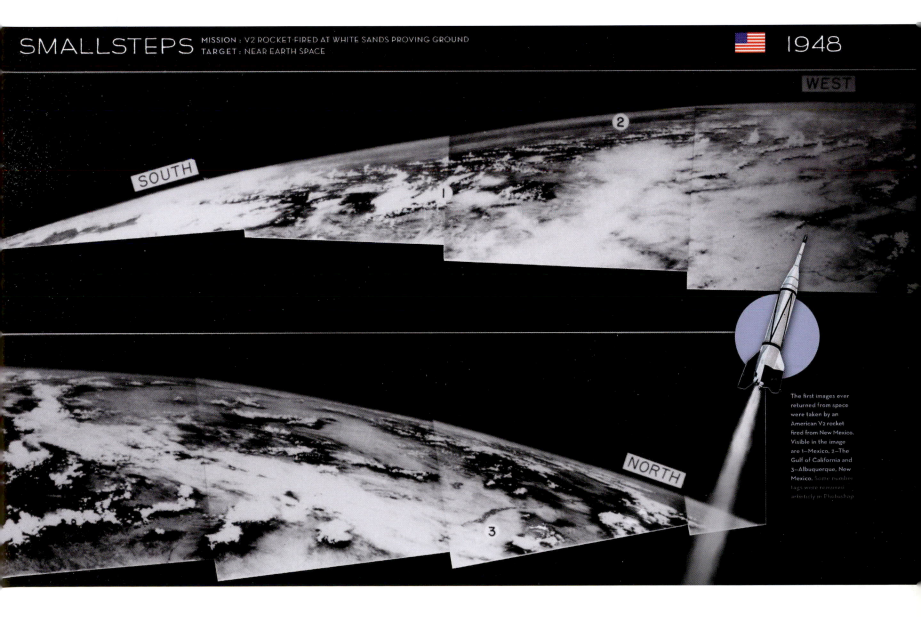

SMALLSTEPS
MISSION : V2 ROCKET FIRED AT WHITE SANDS PROVING GROUND
TARGET : NEAR EARTH SPACE
1948

WEST

SOUTH

2

1

NORTH

3

The first images ever returned from space were taken by an American V2 rocket fired from New Mexico. Visible in the image are 1—Mexico, 2—The Gulf of California and 3—Albuquerque, New Mexico. Some number tags were removed artisticly in Photoshop.

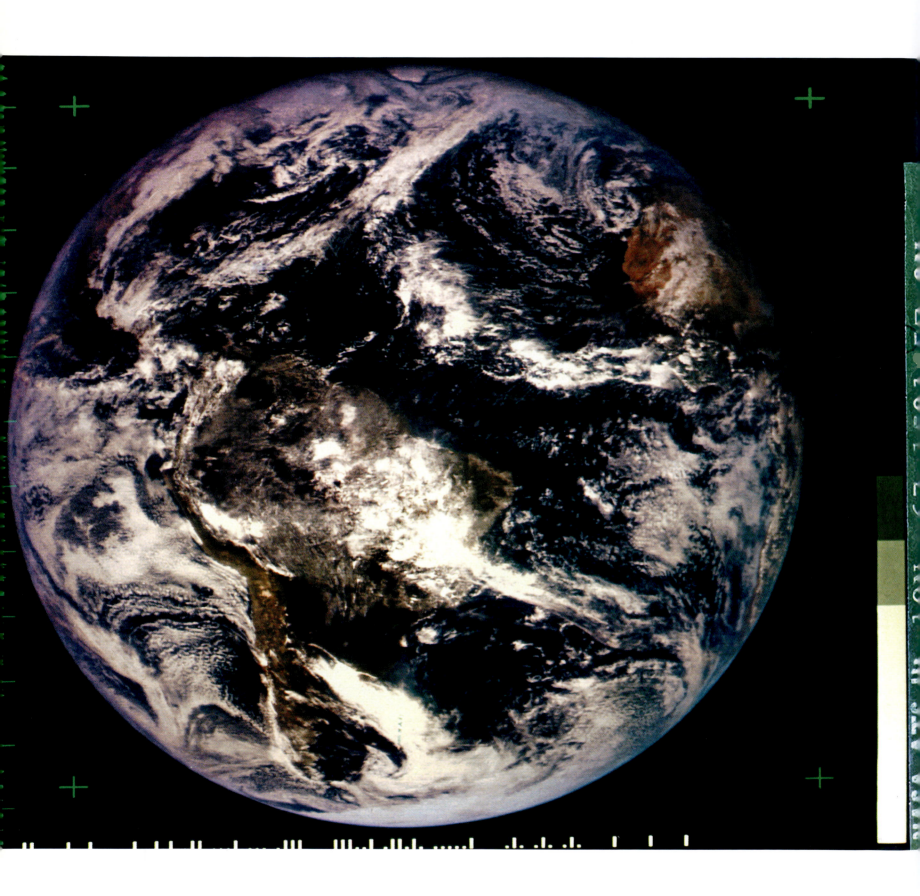

INTRODUCTION

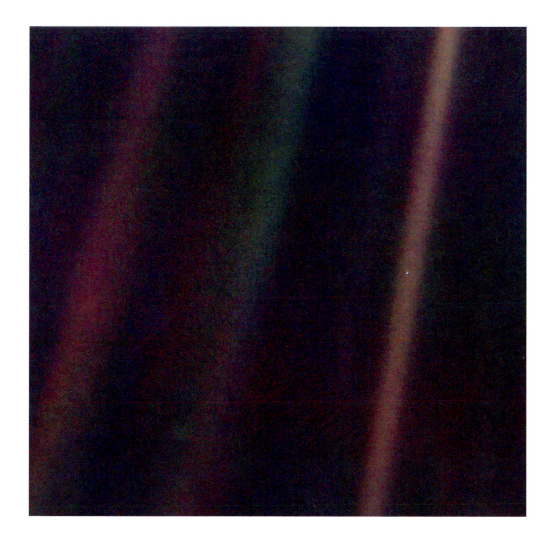

Today, satellites closer to home are doing quite the opposite. They show just how significant people are in looking after that pale blue dot. Satellite imagery is now so refined that changes in the fabric of our planet can be seen with unbelievable clarity, and that's from hundreds of kilometres above the Earth's surface – the equivalent of a person standing in London and seeing a football in Amsterdam. This powerful tool is part of an ongoing revolution in space technology that has not only enabled us to look at our world in a new way, but has also changed our lives in many different ways.

In this book, we dip a toe in the water of satellite imagery, and explore the movements, colours, patterns and changes we can see when we look down at the Earth from space. From dust clouds crossing the Atlantic to bring nutrients from the Sahara to the Amazon rainforest, to melting ice creating vivid turquoise lakes in Greenland, we reveal our planet as you've never seen it before.

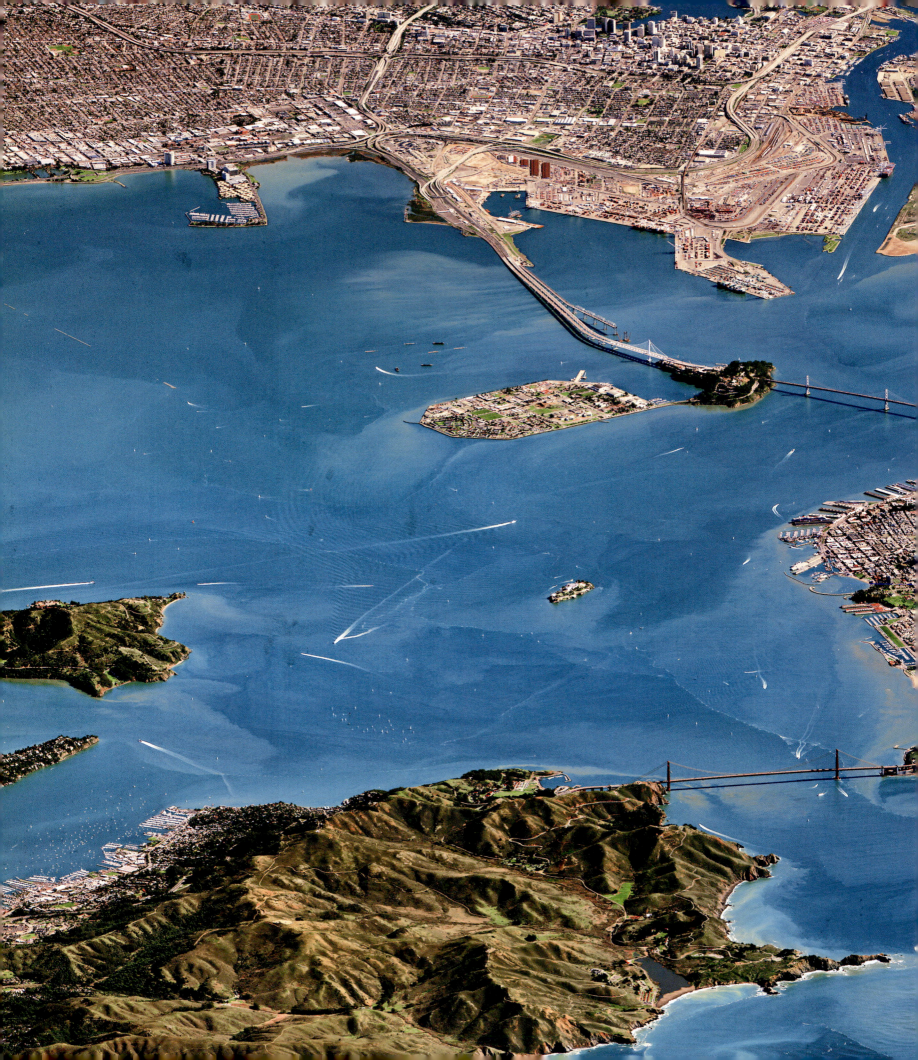

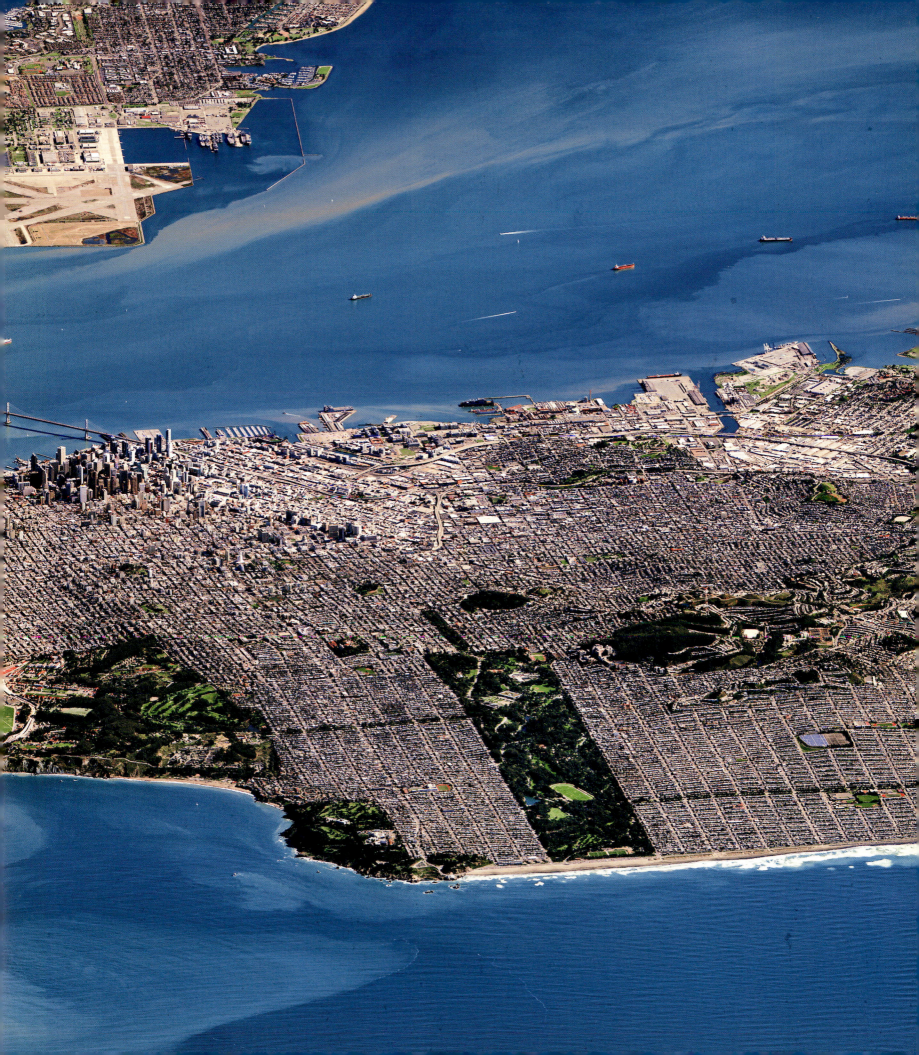

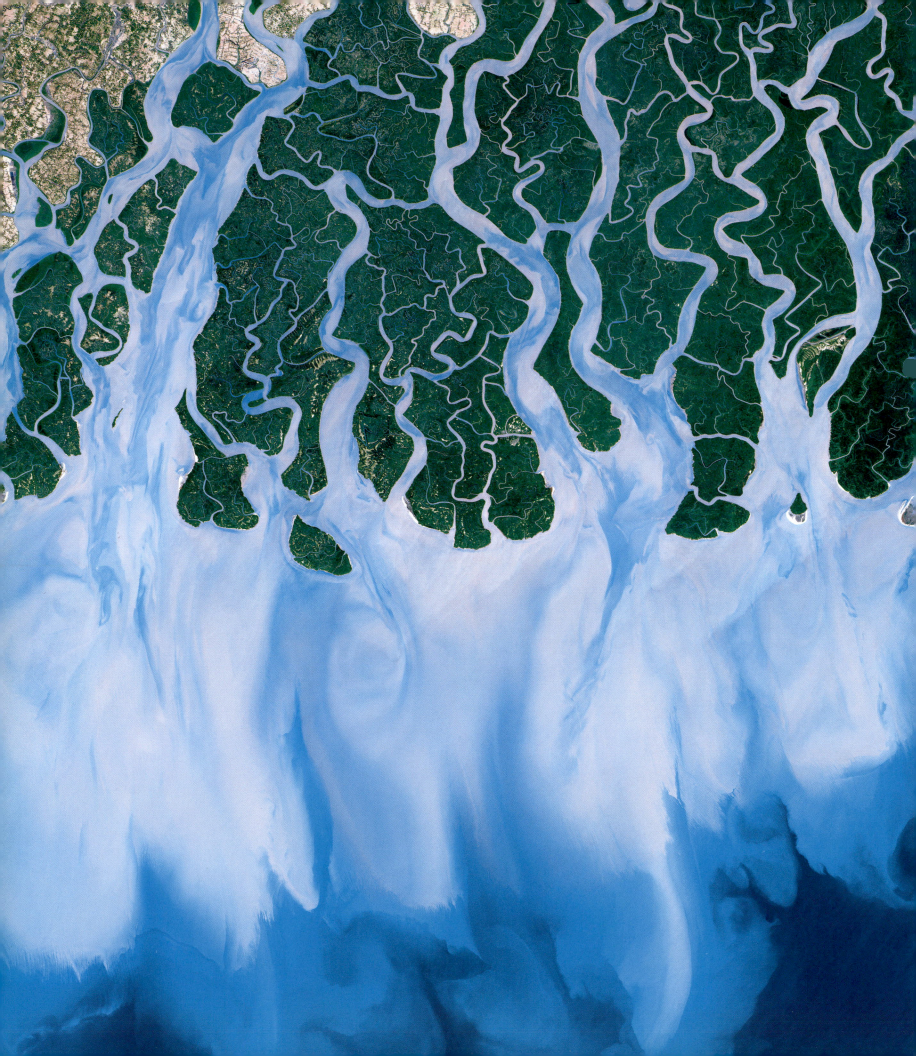

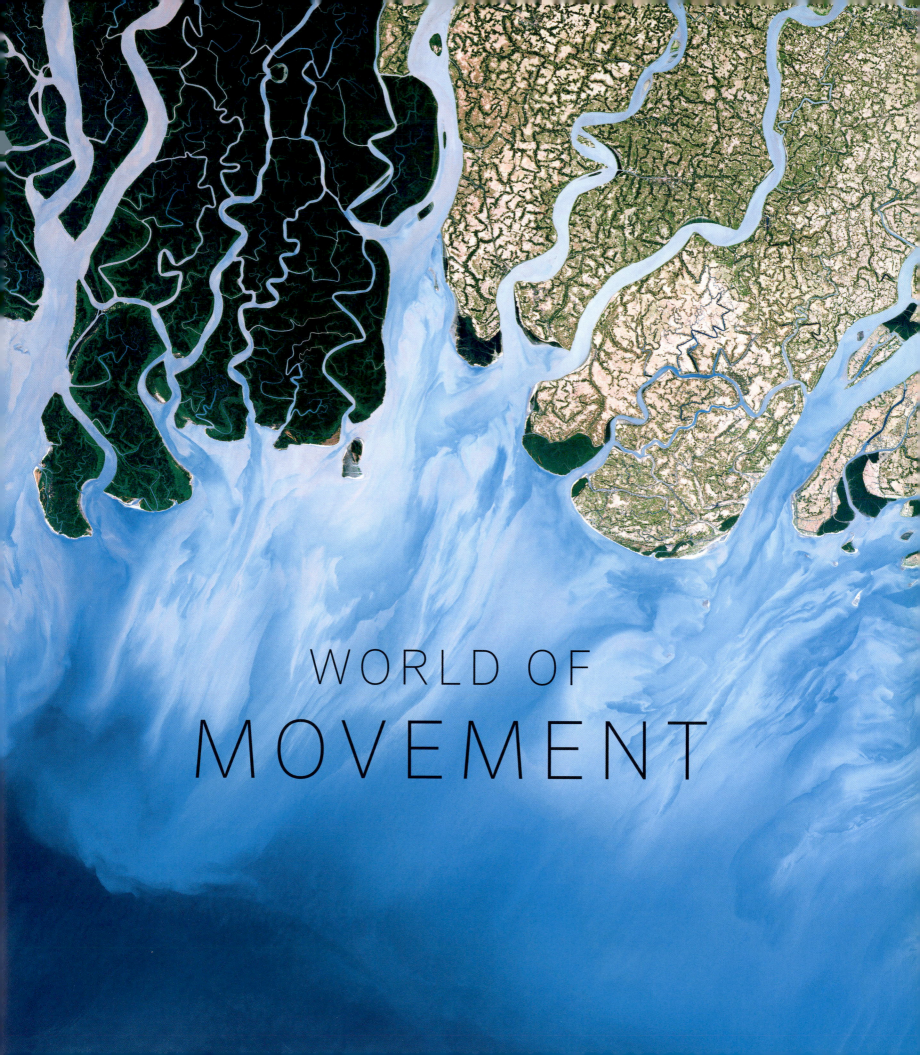

WORLD OF
MOVEMENT

In the beginning, the dream was to explore space and everything that was 'out there in the great unknown', but the first astronauts found that the truly remarkable view was looking back at the Earth; and, with the latest satellite camera technology, our view is better than it ever was. From space we can track the drama of powerful weather systems, trace the relentless flow of ocean currents, witness the epic daily rhythms of time and tide, follow the mass migration of people and wildlife across the globe, and even chase specks of dust as they're swept through the atmosphere. Viewed from space these movements span oceans and continents, paying no heed to boundaries, both natural and manmade. Everything on our planet is linked, in more ways than you might imagine. The Earth is a living, breathing, moving entity in the black void of space, and we are just a tiny part of it.

RIGHT NASA's Aqua satellite photographs plumes of dust from Senegal, the Gambia and Mauritania that are being blown out into the Atlantic Ocean. Heavy particles drop into the sea just offshore, while the finer dust clouds carry on to Latin America. © NASA

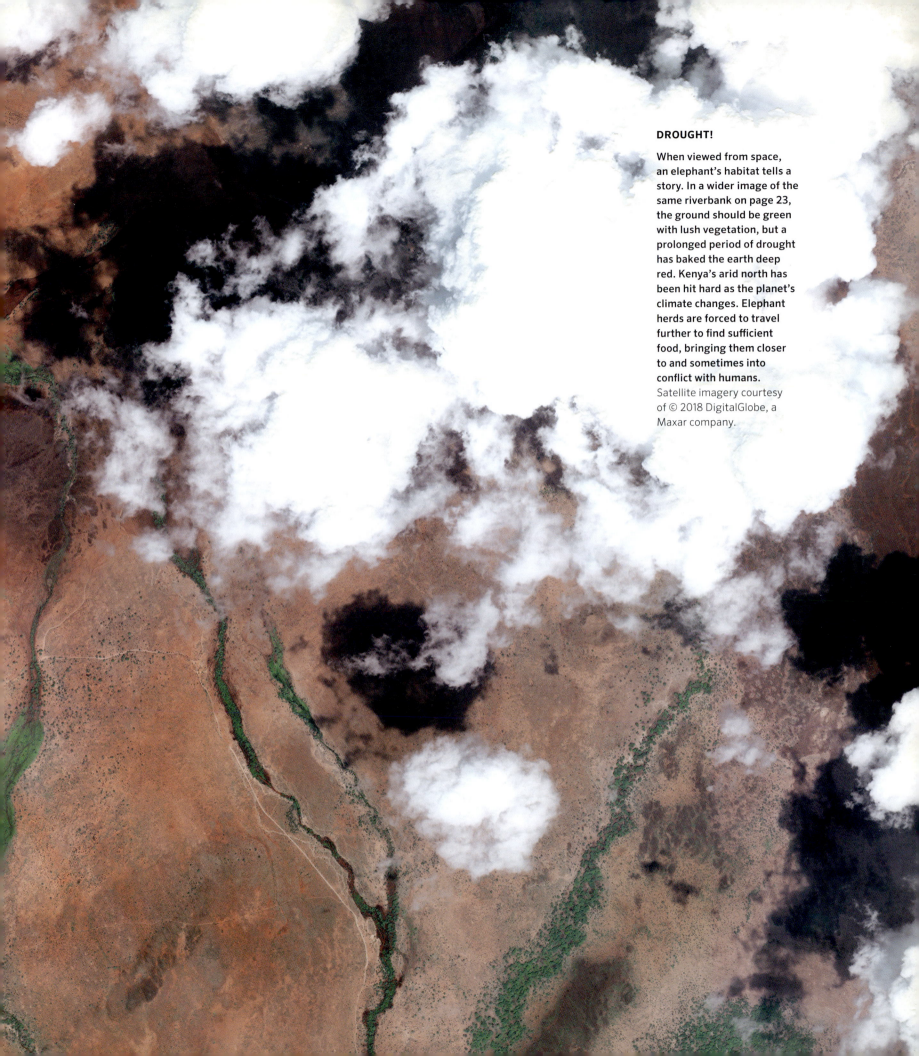

DROUGHT!

When viewed from space, an elephant's habitat tells a story. In a wider image of the same riverbank on page 23, the ground should be green with lush vegetation, but a prolonged period of drought has baked the earth deep red. Kenya's arid north has been hit hard as the planet's climate changes. Elephant herds are forced to travel further to find sufficient food, bringing them closer to and sometimes into conflict with humans. Satellite imagery courtesy of © 2018 DigitalGlobe, a Maxar company.

four months. The wet season should have arrived, but Raine and her herd had not felt a drop. With rivers dry and vegetation dying, the elephants were forced to move out of their protected area in search of food and water. This left them vulnerable to illegal hunters, and could have brought them into conflict with farmers if the animals had tried to feed on their crops.

Fortunately for Raine, the matriarch of her herd is Cyclone; an experienced and resourceful grandmother. She led the herd to the Nakuprat Goto Conservancy on high ground where a little rain had fallen. Here, farmers are tolerant of elephants, so herds use the area more freely. Cyclone had been in that area before. She knew it would be a safe place to lead her herd, but then the weather changed.

Weather satellites showed clouds gathering, swirling and darkening. Rain fell, and everyone was expecting Cyclone to head back home, but she did not: she stayed put. It turned out this was no ordinary rainstorm, and the film crew on the ground found out just what was about to be unleashed.

BELOW AND OPPOSITE
The elephants of Buffalo Springs and neighbouring Samburu rely heavily on areas outside the reserves where they sometimes come into conflict with people. Even so, the population has been increasing at a rate of 4.6 percent per year.

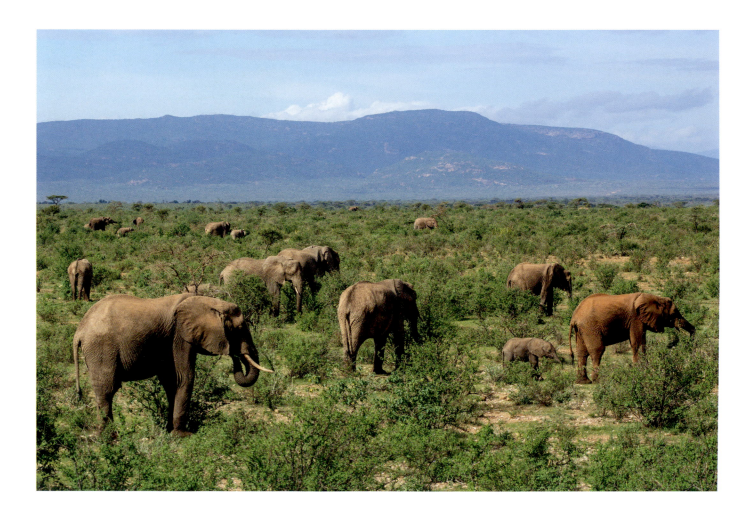

Torrential rain fell continuously for many hours – not in Buffalo Springs itself but in the hills some distance away. Water raced down watercourses, causing flash floods on the dry, concrete-hard ground. Suddenly, many parts of Buffalo Springs and Samburu were flooded, including the film crew's quarters. However, Cyclone's herd was safe in the hills. Had she sensed what was about to happen from past experience, and knew just what to do? We'll probably never know, of course, but we can make an educated guess.

Elephants have impressive memories enabling them to create mental maps that indicate the whereabouts of the best waterholes and worst hazards. They may not have the benefit of weather satellites like we do, but they are incredible weather forecasters. Elephants have a keen sense of smell. It is thought they can sense water several kilometres away. Without Cyclone's memory and super senses her herd and its precious baby may not have survived the drought or flooding. Only she could keep one step ahead and her knowledge, which she passes to the adopted Raine and her new baby, should keep future generations of this herd safe in the difficult times that will inevitably come.

OVERLEAF **Crescent-shaped sand dunes creep across the desert in Chad. They form when the wind blows from one direction, and they move across the landscape faster than any other type of dune.**

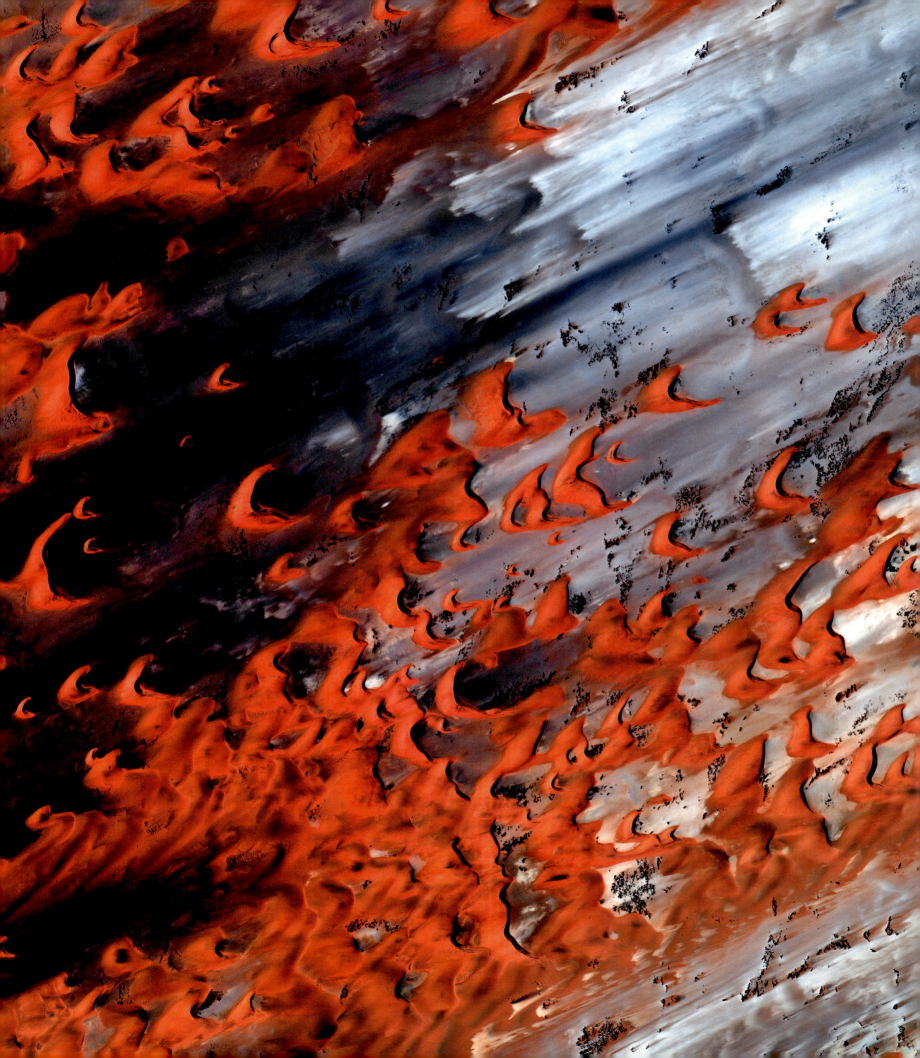

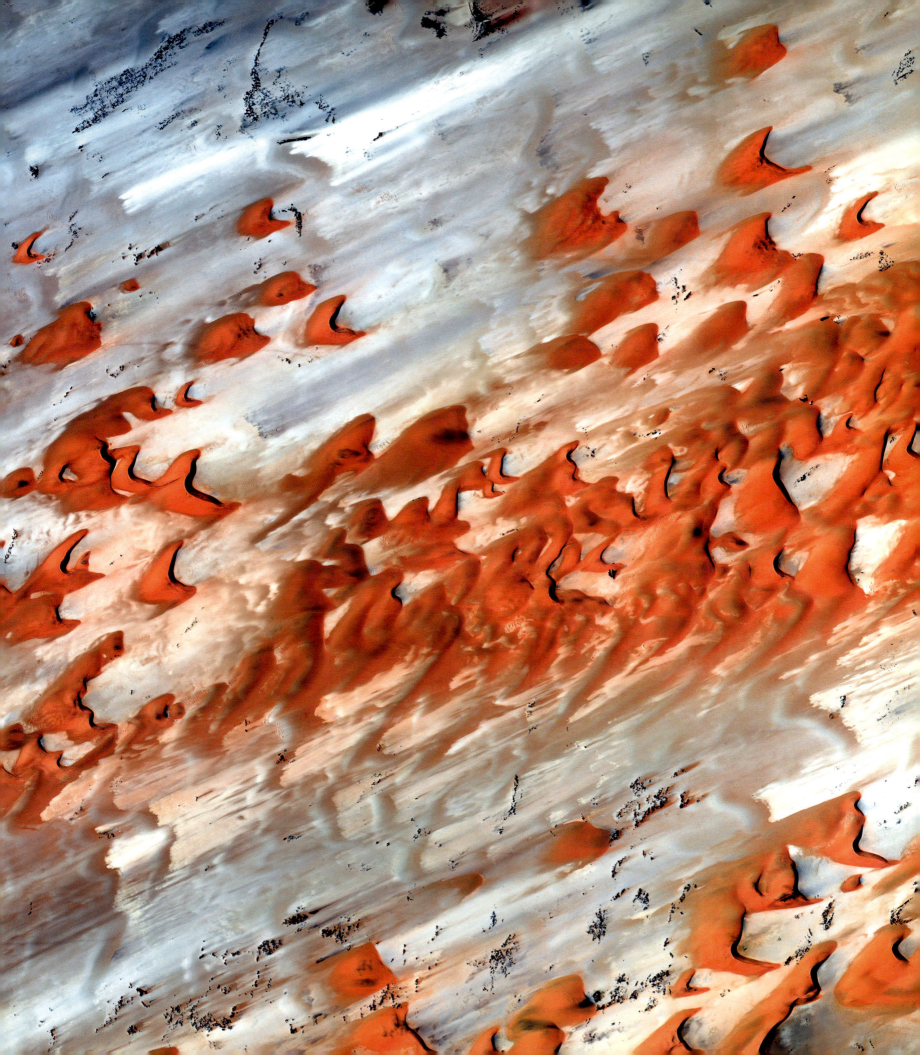

Desert elephants

Buffalo Springs, while hot and dry for much of the year, is a relatively benign place to live compared to the conditions that elephants experience in the Sahel on the southern edge of the Sahara. In the landlocked state of Mali, just to the southeast of Timbuktu, they live in such harsh conditions that they must trek enormous distances and, like Cyclone in East Africa, use their incredible memory and keen senses to find sufficient food and water.

During the past few years, scientists have been following this migration, using all the methods available to them, including satellite surveillance. They track the elephants and plot the locations of permanent and temporary water sources that the herds visit regularly. These elephants, however, are skittish, and for good reason. In recent years, they have not only lived in a war zone, but, like their East African relatives, they are being killed for their ivory, with more than 163 slaughtered since 2012, so they are not easy to follow. They hide from people in acacia scrub by day, resuming their migration at night, but, despite the difficulties, the details of their journeys are slowly being unravelled.

BELOW AND OPPOSITE
An area of green in the otherwise brown African Sahel is the desert elephants' Lake Banzena. The lake contracts in the dry season and expands in the wet; that is, as long as a wet season occurs.
© NASA

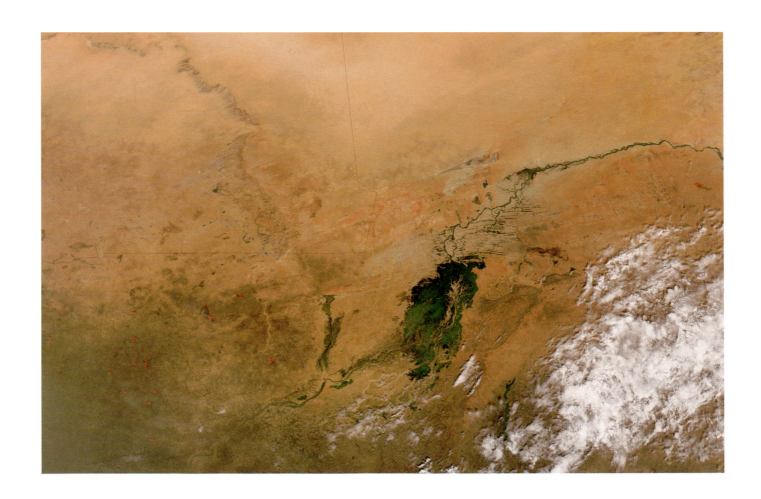

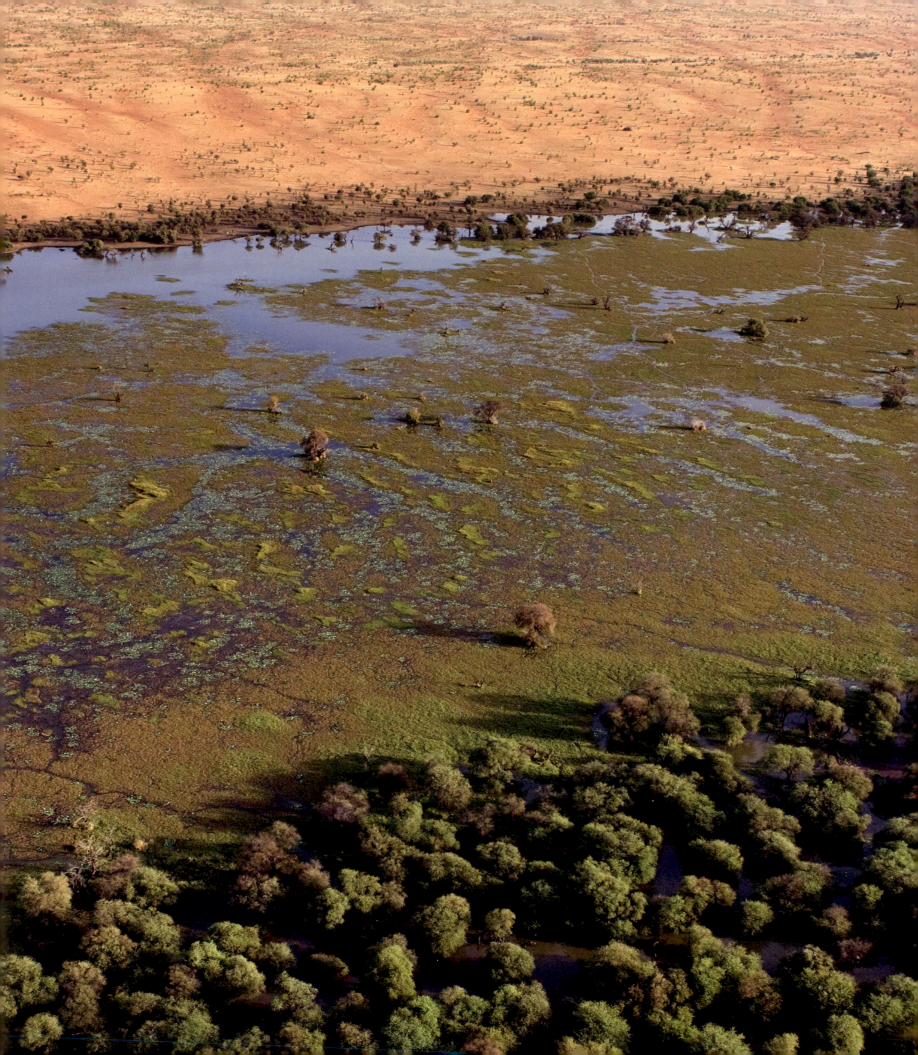

North Africa's elephants, the sub-species that gave rise to the war elephants of Carthage, are extinct, so the Mali elephants are now the most northerly population in Africa, and they travel a vast counterclockwise path covering 32,000 square kilometres of Mali's Gourma. It is the largest known elephant migration circuit, one-and-a-half times greater than the area trekked by Namibia's desert elephants. At the height of the dry season they can travel as many as 56 kilometres in a day.

Bulls follow different routes from cows and calves – probably because males are more tolerant of people and take more risks – and they all travel so far and so often because

BELOW **The Mali desert elephants have small tusks and a thick hide. Their herds roam over an area as large as the Netherlands.**

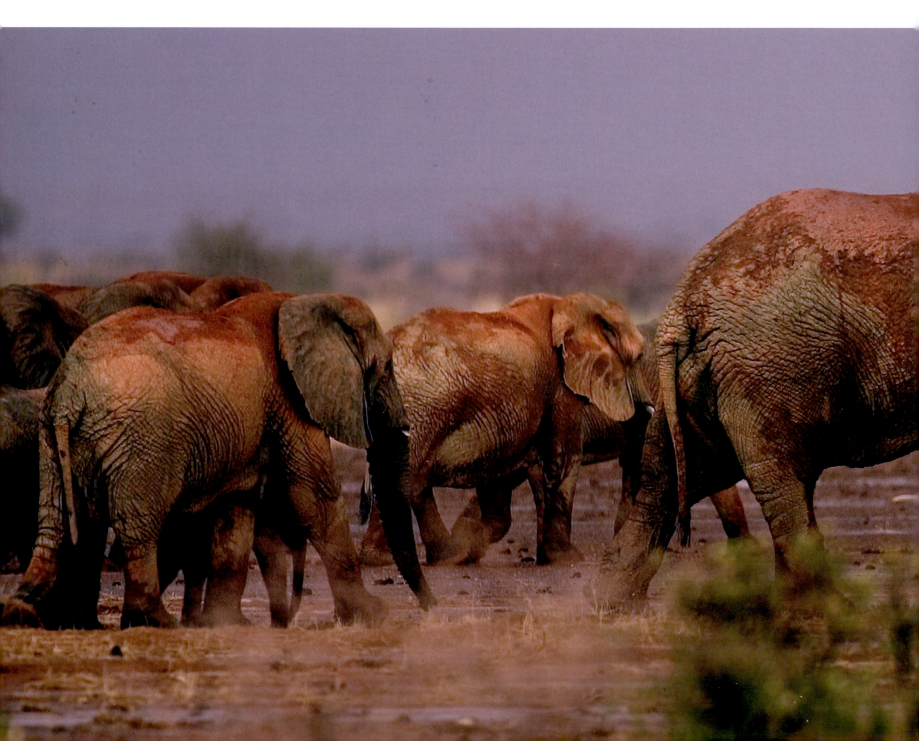

conditions are so hostile. The midday air temperature often rises to 50°C, and there is no guarantee that their next waterhole will actually have water. They linger regularly at Lake Banzena in the northeastern part of their range to take advantage of the rains in June, but in 2009 there were no rains and the lake dried out completely. It is a wonder that any survived, but survive they have, about 350 of them; the remnants of a population of many hundreds of elephants that once roamed right across the Sahel. Their land is like a dustbowl, where the dust is whipped up by gusts of wind that transport it high into the atmosphere and out of Africa.

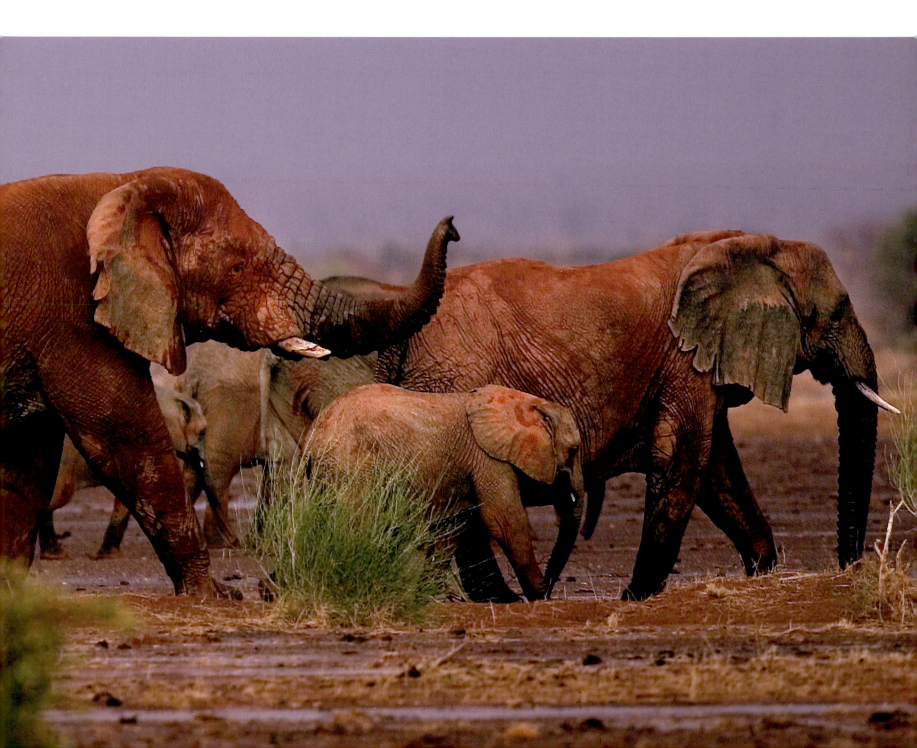

The desert and the rainforest

NASA's Terra and Aqua satellites have tracked dust from the Sahel and Sahara and found that one of the main sources is in Chad's Bodélé Depression. It was once part of a greatly enlarged Lake Chad – the paleolake Megachad, the largest lake on the planet 7,000 years ago – but natural climate change, lack of rain and an increased demand for irrigation water shrank shorelines to the point that the lake is little more than 1 percent of its former size. The dried bottom sediments, where the tiny skeletons of long-dead freshwater organisms, such as diatoms, have accumulated in huge quantities, are rich in phosphorus and iron. It is a deep layer of ancient dust covering an area of 10,800 square kilometres, about half the size of Wales, but it is not staying.

Surface winds, which are squeezed and accelerated through the narrow gap between the Tibesti Mountains and the Ennedi Massif, can be so powerful that they scoop up the dust into gigantic dust storms. During the winter months, they can shift up to 700,000 tonnes per day on average, leaving a huge scar on the ground that can be seen from space. From satellites we can watch this huge mass as it is lifted and carried thousands of kilometres across the Atlantic Ocean, an extraordinary journey with an even more surprising destination. Over South America the dust particles latch onto water droplets in the clouds, so every year 40 million tonnes of desert dust falls with the rain over the Amazon rainforest.

Amazon rainforest soils are poor in nutrients. Most are locked up in the plants themselves or washed into rivers by heavy rains, so the desert dust supplies essential minerals needed to maintain the forest, which, despite extensive logging, is still the largest and richest tropical rainforest in the world. It is a biodiversity hotspot, home to 10 percent of known plant and animal species and probably a whole lot more that have still to be discovered. On average, a new species is recorded here every couple of days. It is said that there are more species of ant in a single tree in the Amazon than there are in an entire country elsewhere. Without this long-standing, long-distance movement of mineral-rich dust from the southern Sahara, one of the greatest natural habitats on our planet might not exist.

It has been estimated that the top four metres of dust has been removed from the lakebed during the past 1,000 years; much of it blown to South America, the rest dumped on the Caribbean and southeast United States. It is likely to last for another 1,000 years, part of an essential cycle of dust that is whizzing around the world … and not only rainforests benefit.

About 75 percent of global dust is deposited on land, while the other 25 percent drops into the ocean, where organisms that make up the phytoplankton utilise the minerals. So, just as we have the large-scale movement of air and water around our planet, we also have the wholesale movement of dust, and, like the Sahara dust, landfall can be a considerable distance from the source. Dust originating in Central Asia, for example, is carried over the Pacific Ocean as far as the west coast of North America, and, from North Africa, red Sahara dust sometimes reaches the British Isles. The winds blowing these dust clouds across the world, however, can be so powerful that, instead of seeding new life, they bring devastation and death.

OPPOSITE **The elephant herds and local people alike frequently endure sand storms, temperatures of 50°C and water shortages.**

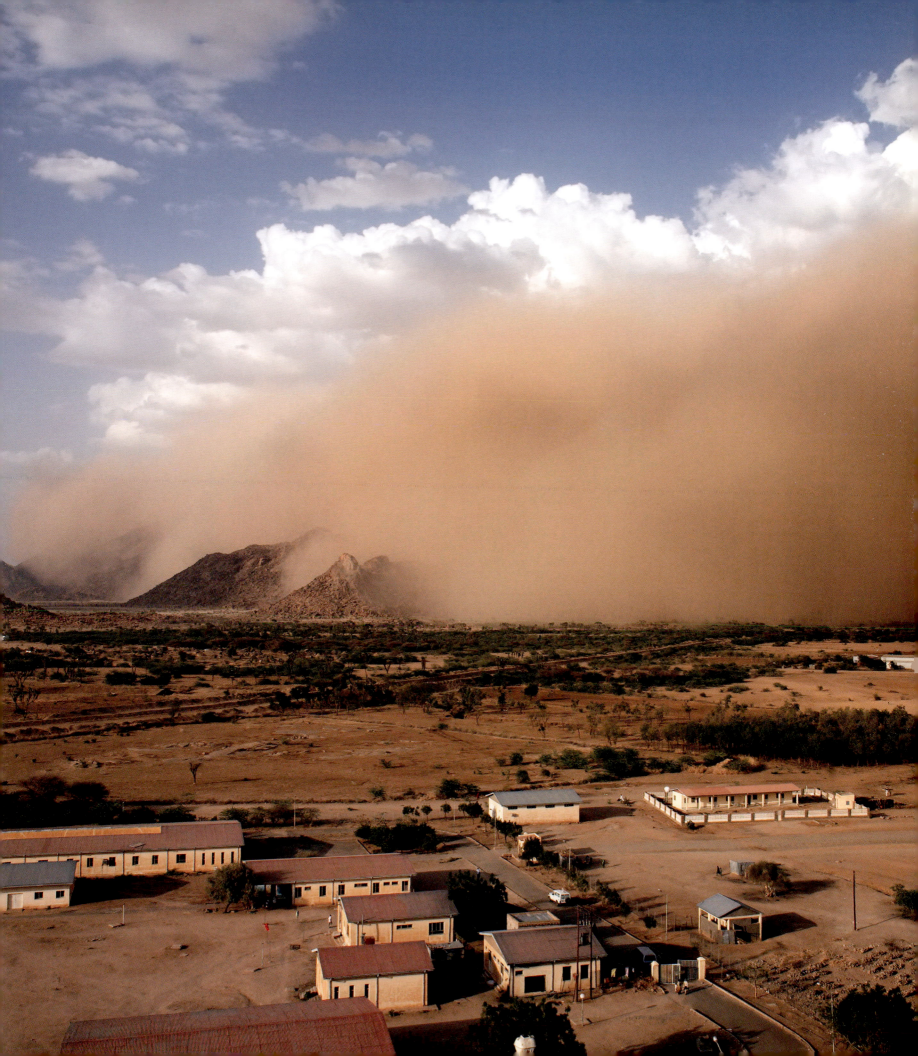

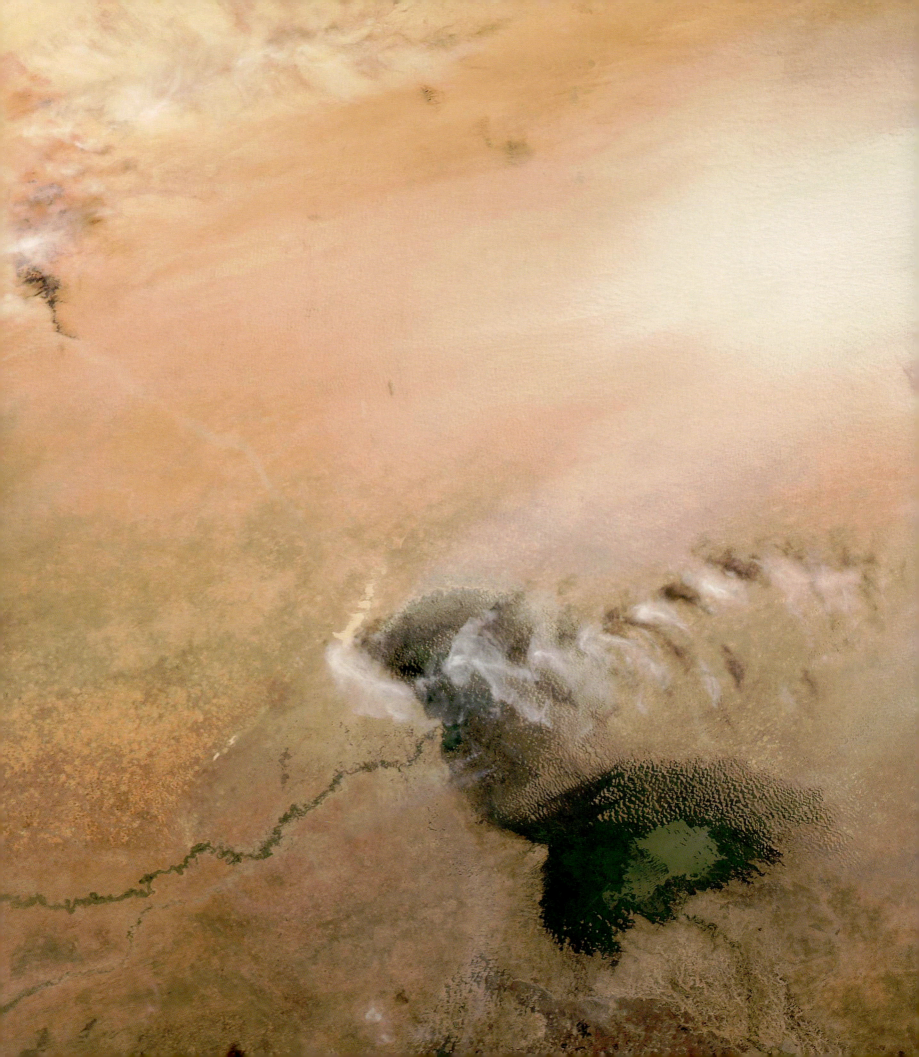

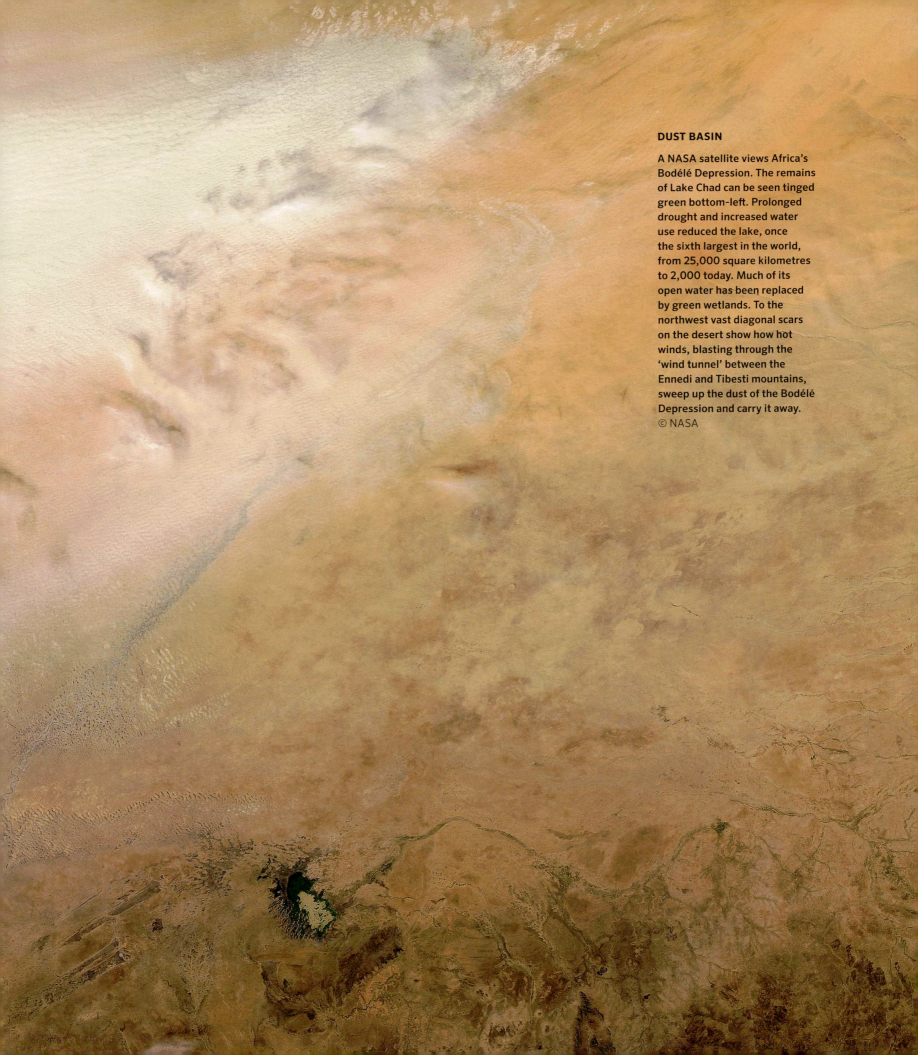

DUST BASIN

A NASA satellite views Africa's Bodélé Depression. The remains of Lake Chad can be seen tinged green bottom-left. Prolonged drought and increased water use reduced the lake, once the sixth largest in the world, from 25,000 square kilometres to 2,000 today. Much of its open water has been replaced by green wetlands. To the northwest vast diagonal scars on the desert show how hot winds, blasting through the 'wind tunnel' between the Ennedi and Tibesti mountains, sweep up the dust of the Bodélé Depression and carry it away.
© NASA

Hurricane Hunters

Highly destructive North Atlantic hurricanes begin *their* life as far to the east as the Cape Verde Islands, off the northwest coast of Africa. Between 1st June and 30th November, on average, a dozen hurricanes push in towards the islands of the Caribbean and the southern coasts of North America. Watching their every move are not only weather satellites, but also the storm chasers: United States Air Force 53rd Weather Reconnaissance Squadron, nicknamed the 'Hurricane Hunters'. Major Kendall Dunn is one of its intrepid pilots.

'It is psychologically a bit of a strange feeling, flying deliberately toward one of the most destructive forces seen on our planet, but without us, those on the ground would have no idea what's about to hit them.'

At first, the strength and composition of an approaching storm has still to be determined. It is up to Major Dunn and his crews to fly in and check out what they are dealing with.

'If you're the first plane in, you're basically the pioneer. The satellites got a good picture, but until you get into that storm, no one really knows. Once you fly through it, and you get back, and you look at that radar picture again, you give Mother Nature much respect.'

And, although the storm itself is chaotic, the survey is not. The aircraft follows a well-rehearsed track; but even so, the hunters are going into the unknown.

'When we fly these storms, we fly a huge X-pattern, each leg about 105 nautical miles long, collecting data the entire time. Different parts of the storm are going to be stronger, and we don't necessarily know that until we get in. You don't really know somebody until you give then a big hug – and we're basically out there hugging storms; and, once we get out there and do that, we know them pretty intimately.'

Viewed from a satellite the hurricane is a gigantic, grey spiral of cloud, but from an aircraft actually in the eye of the storm, it can be a place of breathtaking beauty: a circle of blue sky above, surrounded by a vertical wall of menacing blackness. Passing through the eyewall, updrafts and downdrafts can cause the aircraft to gain or lose height dramatically, seeing even the most seasoned storm chaser reaching for the sick bag.

'The airplane itself is just bouncing back and forth,' Major Dunn explains. 'The rain is sheeting off. It basically looks like you're underwater!'

Within the storm itself, winds can reach 200 mph and, on the surface of the ocean below, waves can be more than 10 metres high. Everything in the hurricane's path must either flee or batten down the hatches.

BELOW **Major Kendall Dunn with his Lockheed WC-130 aircraft, which is flown into tropical storms and hurricanes. Satellites cannot record barometric pressure or wind speeds within a storm. The Hurricane Hunters can.**

OPPOSITE **NOAA's GOES-16 weather satellite takes a full image of the Earth every 15 minutes. By combining images it's possible to see weather systems swirl across the planet and watch events as they unfold. Here, category 4 Hurricane Harvey makes landfall on the coast of Texas. The tightly packed spiral of cloud towards the top and centre of the picture is the hurricane.** © NOAA

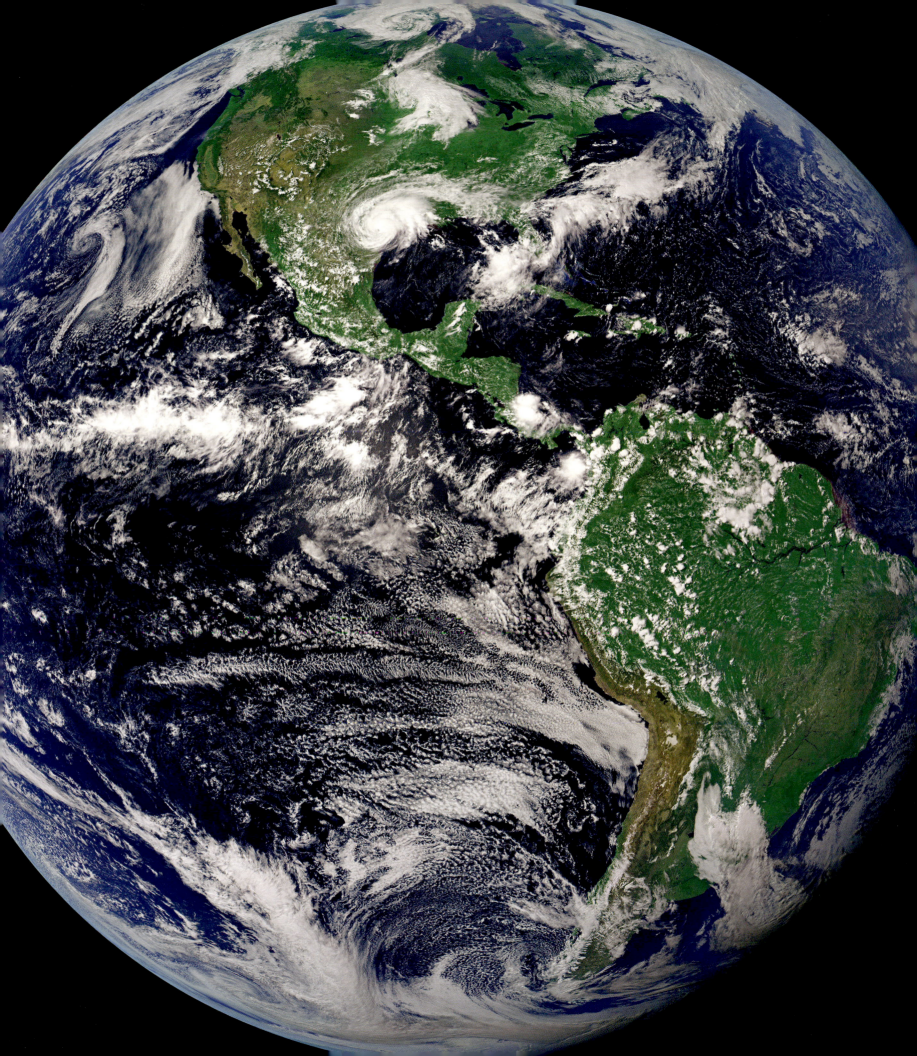

Harvey and the mouse

On Florida's Gulf coast, the extensive bright white sand dunes on Santa Rosa Island sometimes feel the full fury of an incoming storm, not only from the devastating winds, but also from the storm surge – a wall of water that builds up ahead of the hurricane. It pushes in from the Gulf of Mexico, and can be several metres above the normal sea level. The storm surge that accompanied Hurricane Katrina in 2005 put 80 percent of New Orleans underwater. With very little between the ocean and the Florida dunes to buffer the combined impact of wind and waves, wildlife and humans alike can be in mortal danger.

Living here are not only wealthy American retirees with holiday homes beside the sea, but also the mainly nocturnal beach mouse. There are several sub-species and Santa Rosa Island's population is relatively healthy, but others, also confined to the dunes on Florida's low-lying barrier islands, are vulnerable, mainly due to habitat loss and the pressure from tourism. One unfortunately placed hurricane could wipe out a sub-species overnight.

When the *Earth from Space* film crew were in Florida filming the mice, news came in that a storm was brewing in the Gulf. It was the timing that series producer Chloë Sarosh and her teams had hoped for.

'It was our ambition to show the movement of a hurricane through the eyes of a tiny character, but there were so many variables. Would there be a storm at all? Would it travel towards the coast or head off in the wrong direction? With a film crew on the ground, and another in the air, we just had to wait and see what the storm would do.'

BELOW **The dunes on Florida's Santa Rosa Island have been damaged by previous hurricanes, especially overwash from Hurricane Opal in 1995 and Hurricane Ivan in 2004. Planting sea oats helps to stabilise the dunes.**

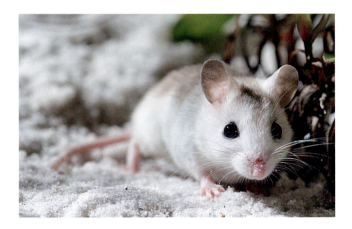

And they didn't have to wait long. A camera team scrambled with the Hurricane Hunters, and, as they flew towards the eye, it became apparent that this wasn't just any storm. It was increasing in intensity. The dunes with their dune mice appeared to be right in its path. It was time for life on the ground to hunker down.

While the winds on the coast were strengthening and the surf was up, Barny Revill's film crew in the air was flying right through the heart of the storm.

'We were filming on the flight that upgraded the hurricane from Category 1 to Category 2. It was becoming a serious storm. In the next 24 hours, it went from Category 3 to Category 4, and, of course, by then it had a name.'

The team watched Hurricane Harvey's progress via satellite, and it became clear that it would not make landfall on the Florida coast. The film crew in the dunes breathed a sigh of relief. Harvey made landfall further along the Gulf coast in Texas, the first major storm to hit the US mainland in 12 years.

'It was shocking to see the news roll in,' recalls Chloë. 'This storm, which we had assumed to be small, just grew and became more powerful as we watched it. We gathered satellite images that showed us the extent of the damage in Texas. We had hoped to be able to tell the story of an animal's life in a precarious habitat, but we never expected to be in the eye of the biggest storm in a decade. It was a sobering reminder of the awesome power of nature.'

On their Florida islands, however, the little beach mice were safe, and, to top it all, they had some new neighbours, but they were not sticking around to enjoy the view.

Emerging from nests below the sand were loggerhead turtle hatchlings. Most appeared during the night, when predators were fewer, and they headed instinctively towards the sea, guided by the intensity of light over the ocean. They were embarking on an epic journey, during which they swim frantically to the open ocean. Here, they hide amongst floating seaweeds and ride the ocean currents for, in the big blue, predators are probably less concentrated than on the coast. The currents then carry these youngsters around the globe. By hitchhiking on the North Atlantic Sub-Tropical Gyre, some loggerhead sea turtles make at least one circuit of the North Atlantic, before returning to the same stretch of coastline where they hatched out ten years before.

ABOVE **As permanent residents of Santa Rosa's dunes, dune mice are in constant danger from storm surges during the hurricane season. Loggerhead turtles are only vulnerable while in their underground nest.**

OVERLEAF **Swirling currents of the Gulf Stream can be seen in the blooms of algae growing in the northwest Atlantic Ocean in spring. Circular patterns, bottom left, are huge eddies spinning off from the main current, and the concentration of colour to the east of Cape Cod is the underwater plateau of Georges Bank, where the Gulf Stream and Labrador Current meet.** © NASA/ NOAA Suomi National Polar-orbiting Partnership.

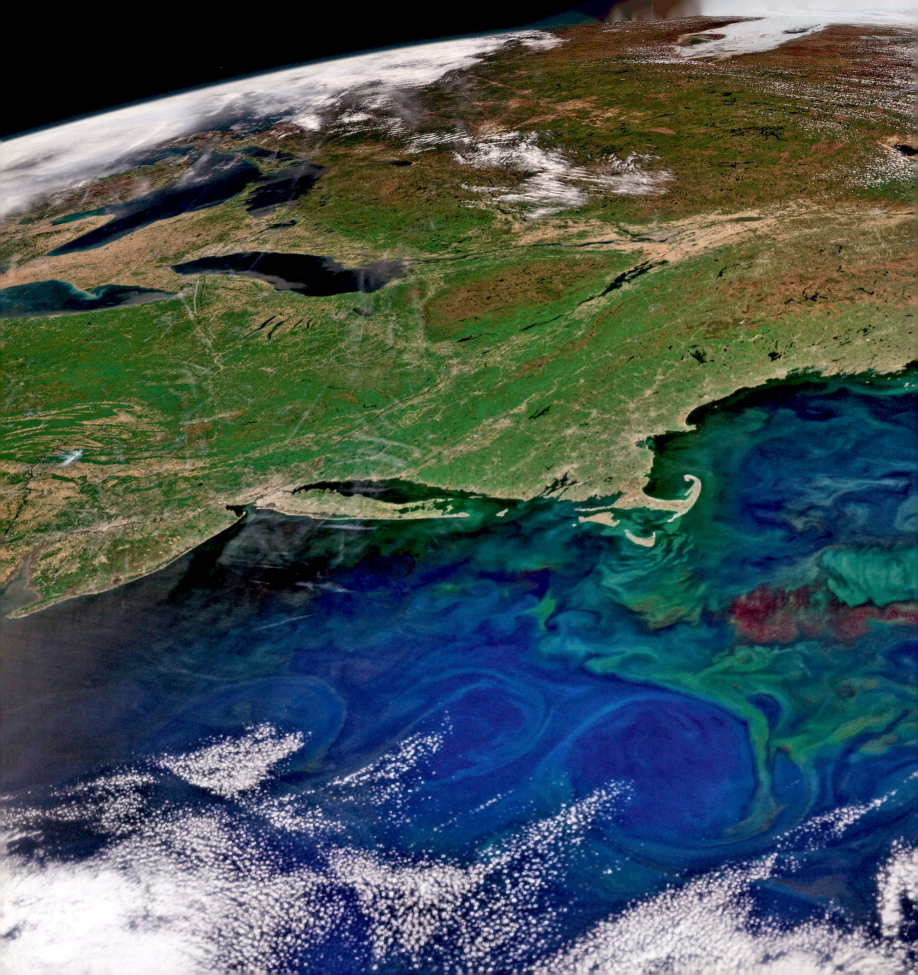

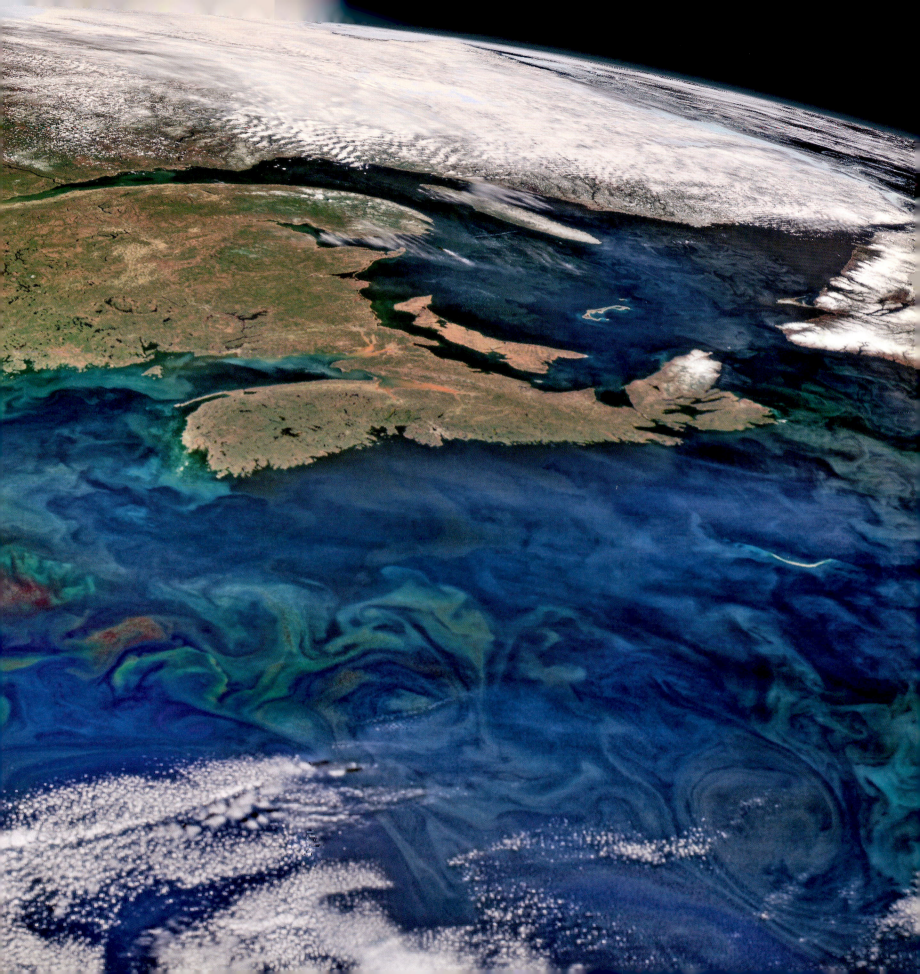

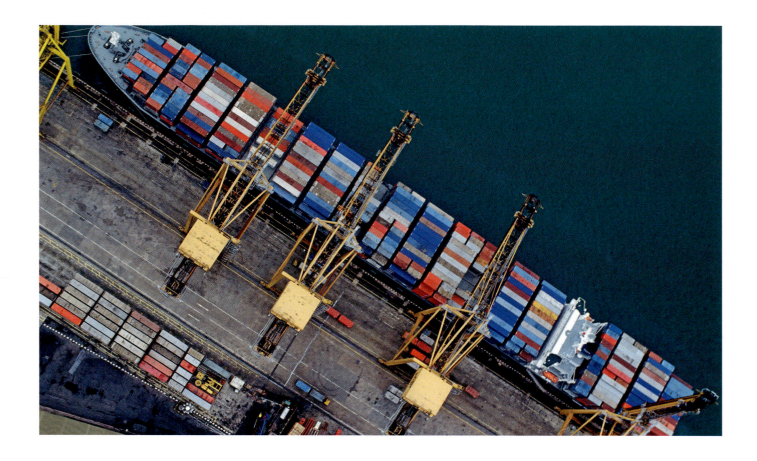

Transoceanic takeaway

Driven by the prevailing winds, the ocean currents on which the baby sea turtles ride are effectively invisible, but they can be tracked from space, using data from drifting buoys and satellites in Earth's orbit. They reveal both the order and the chaos of the world's oceans and seas. At the surface, there are fast-flowing 'rivers', such as the Kuroshio in the Pacific and the Gulf Stream in the Atlantic. They move vast quantities of water, heat, nutrients – and baby sea turtles – for thousands of kilometres across the globe, while hundreds of localised slow-moving pools or eddies, resembling giant whirlpools in the ocean, swirl along the edges of continents and into gulfs and bays. It is all part of the 'global conveyor belt' that connects all the world's oceans and seas, and those currents are not only highways for baby sea turtles and other marine animals on migration: people take advantage of them too.

Ships can increase their speed and save fuel by riding with the current, and, when travelling in the opposite direction, instead of fighting the current, they find a route that circumvents it. As early as 1769, Benjamin Franklin published a chart showing the

ABOVE **Colourful shipping containers are loaded onto a gigantic container ship.**

OPPOSITE **Ships entering and leaving the Port of Singapore.** Satellite imagery courtesy of © 2018 DigitalGlobe, a Maxar company.

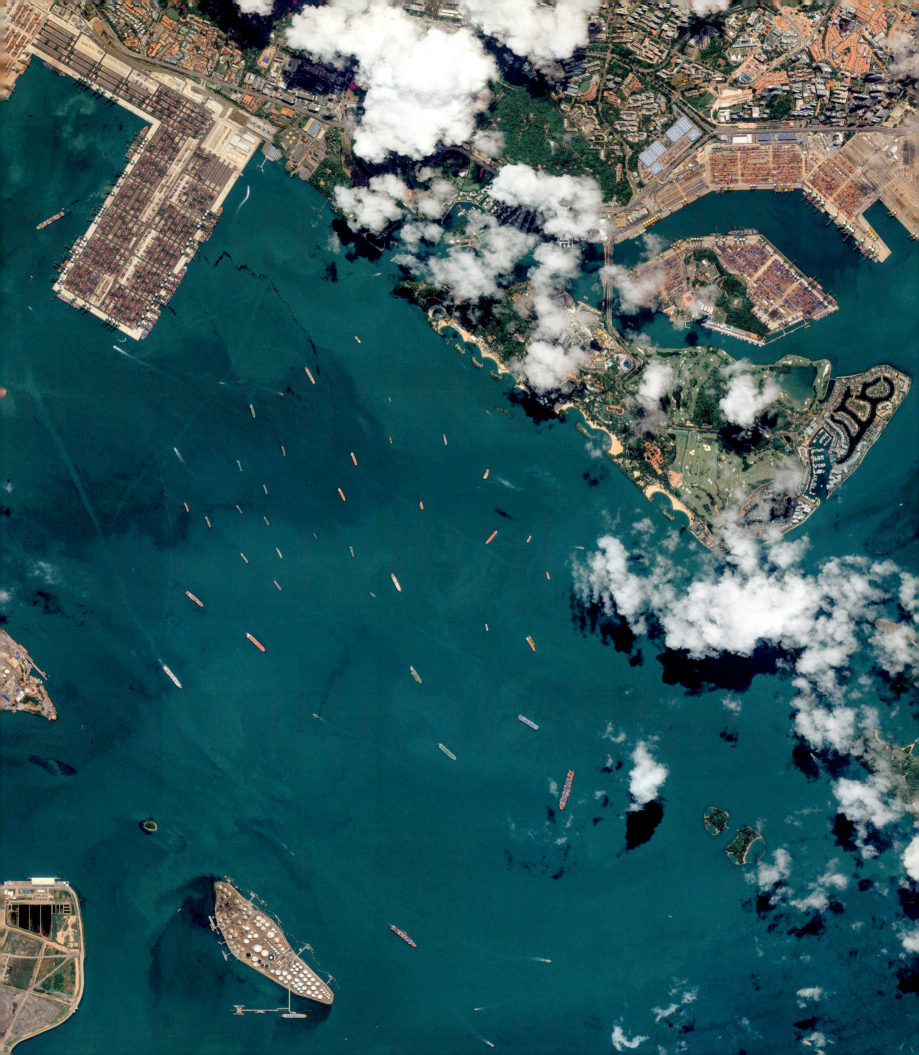

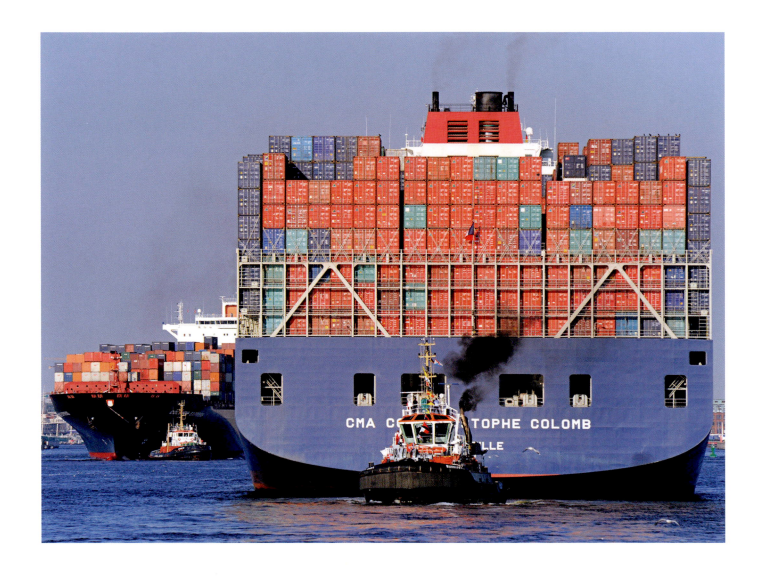

whereabouts of the Gulf Stream, which helped navigators find the best routes between Europe and the USA. More recently, scientists have been able to put some numbers on Franklin's assertions. Travelling at 16 knots, a ship can save 7.5 percent of its fuel when riding with the Gulf Stream, while saving about 4.5 percent when avoiding it in the opposite direction. With 90 percent of world trade carried by about 70,000 ships worldwide, this can make a significant dent in fossil fuel consumption. Oceanographers and shipping companies are now looking at the other ocean currents for energy-saving routes, as well as avoiding adverse winds, high waves, ice and fog, and that's not all. Another fuel-saving initiative is 'super-slow steaming'; with ships pootling along at speeds as slow as 12 knots, which means modern cargo ships take roughly the same time as 19th-century clipper ships to complete long-distance journeys.

ABOVE **The container ship CMA CMG *Christophe Colomb* is one of the biggest in the world. It can carry 13,800 containers.**

From space, these ships appear as tiny spots of colour, the most kaleidoscopic being the giant container ships with their brightly painted shipping containers. The *Earth from Space* team had an interest in one in particular. It was travelling from Shanghai to Southampton, one of its containers carrying a special cargo. After leaving Shanghai and crossing first the East China Sea and then the South China Sea, the ship squeezed through the congested Straits of Malacca, before riding the North Equatorial Current across the Indian Ocean. It joined the queue for the Suez Canal, travelled the length of the Mediterranean, and finally tried to avoid the southward-flowing section of the North Atlantic Gyre to the English Channel – a journey of about 36 days.

At Southampton, the container was loaded onto a truck and taken by road to Nottingham's Wollaton Hall, home to the city's natural history collection. Carefully packed away in the shipping container were the skeletons of dinosaurs. One was *Gigantoraptor*, discovered in what is now Inner Mongolia. At eight metres long, it was one of the world's largest feathered theropod dinosaurs. Another skeleton was even bigger, a monstrous sauropod dinosaur with the tongue-twisting name *Mamenchisaurus*. It is instantly recognisable by its exceptionally long neck, even for sauropods – nearly half of its total body length. The largest specimens are 35 metres long, and, when alive about 150 million years ago, they probably weighed about 45 tonnes. They were part of the 'Dinosaurs of China' exhibition, and they were brought to Nottingham with the help of one of the largest movements on the planet – the ocean currents.

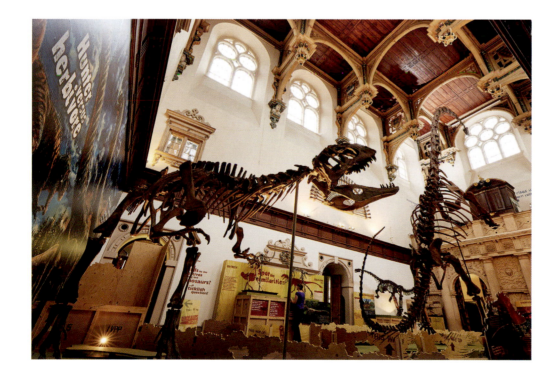

LEFT *Gigantoraptor* (left) and *Mamenchisaurus* (right) at Wollaton Hall for the 'Dinosaurs of China' exhibition.

Highs and lows

The ebb and flow of the tide is another water movement that can be monitored, and, in one way, has its origin in space. Contrary to popular belief, the Moon is not the sole influence on the tides. If it were, there would only be one high tide a day as the Earth rotated and the Moon's gravitational pull caused a bulge of the ocean to travel around the world; but many places experience two tides a day. This is due to the Earth also moving in a circle, producing a centrifugal force that causes another bulge to form on the opposite side of the Earth to the Moon. The result generally is two high and two low tides every 24 hours and 50 minutes, the 50 minutes representing the distance the Moon progresses each day whilst orbiting the Earth.

The Sun is also part of the picture, but because it is so far away its influence is considerably less than that of the Moon. Even so, its presence can be noticed at the spring and autumn equinoxes, when the two space bodies line up, causing unusually high or low tides, known as 'spring tides'. To complicate matters even more, some places, such as the Gulf of Mexico, experience only one high and low tide a day, whilst others, such as parts of the Baltic and Mediterranean, have little tidal movement at all. These variations are due to the unique shape of the land bordering or surrounding the sea, but, whatever the pattern, when satellite pictures of the tidal rise and fall are sped up, it looks as if the Earth is actually breathing.

BELOW AND OPPOSITE **Airbus SPOT 5 satellite captures high and low tides around Le Mont-Saint-Michel, about one kilometre off France's northwest coast. The tidal range can be up to 15 metres between high and low tides. At low tide (opposite) mud and silt is exposed all around, while at high tide (below) the mount is an island linked to the mainland by a causeway.** © CNES 2012 – Distribution Airbus DS.

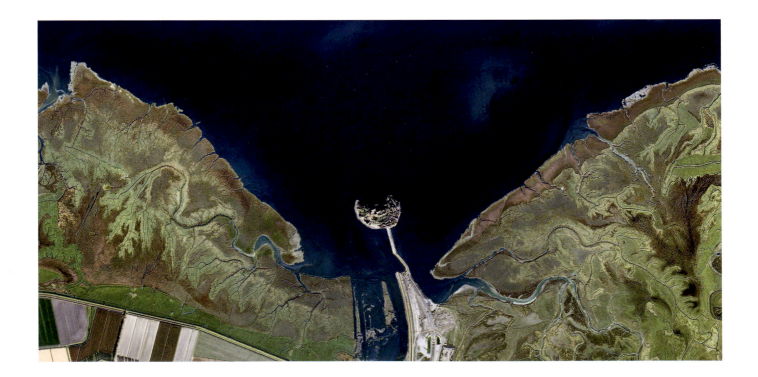

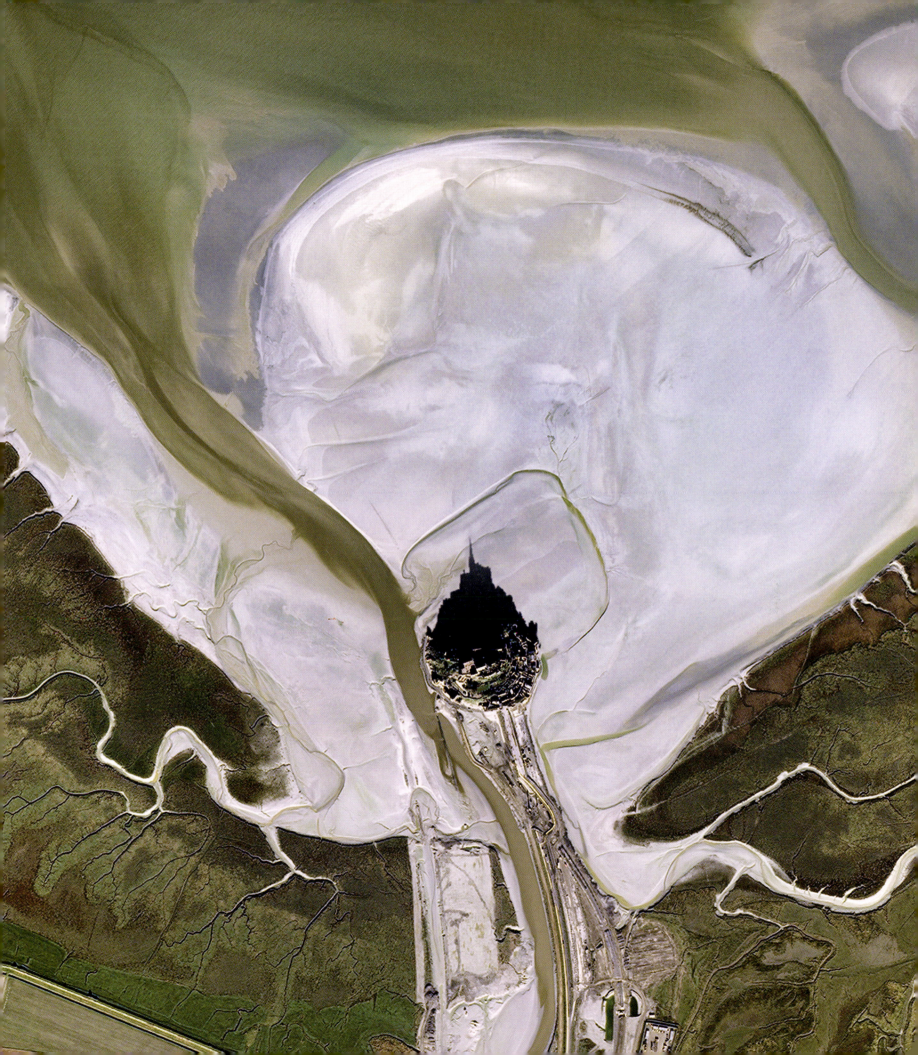

Age-old otter fishing

One of the places on Earth where the daily lives of people and wildlife are greatly influenced by the movement of the tides is the Sundarbans of Bangladesh and India's West Bengal. The name means 'beautiful forest' and it is aptly named. Bordering the Bay of Bengal, where the land meets the sea and freshwater meets salt, it is one of the largest tracts of mangrove forest in the world. Most of the land consists of low-lying islands, each little more than a few metres above sea level, with a complex network of waterways bordered by muddy shores in between. It is home to the smooth-coated otter.

Learning to fish is an important life skill for a wild baby otter, but here, in the tidal channels of the Sundarbans, Bangladeshi fisherman Bhoben Biswash and his son Rhidoy carefully supervise these lessons. They and the rest of their family train an eager team of boisterous otters to help them catch fish. Their village is in the northern Sundarbans, where the coming and going of the sea determines the pace of life and supports this

BELOW **The young otters, without harnesses and peering from the water, watch the trained adult otters and copy what they do.**

OPPOSITE **The Deimos-2 satellite captures an image of the Sundarbans, the world's largest delta. The Ganges, Brahmaputra and several other rivers flow through India and Bangladesh, converging in the Bay of Bengal. Mangrove roots trap silt in the water, creating the largest mangrove forest on Earth. The dark green is the area protected as a national park, while farms and shrimp farms are on its borders.** © 2018, Deimos Imaging SLU, an UrtheCast Company.

OVERLEAF **The heavy scent of musk fills the air and the cacophony of chirps and squeals indicates contented otters. Each receives a handful of fish each day. It's their reward for helping with the fishing.**

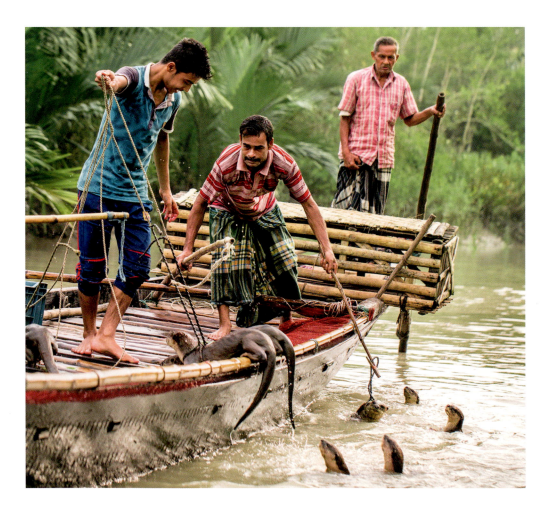

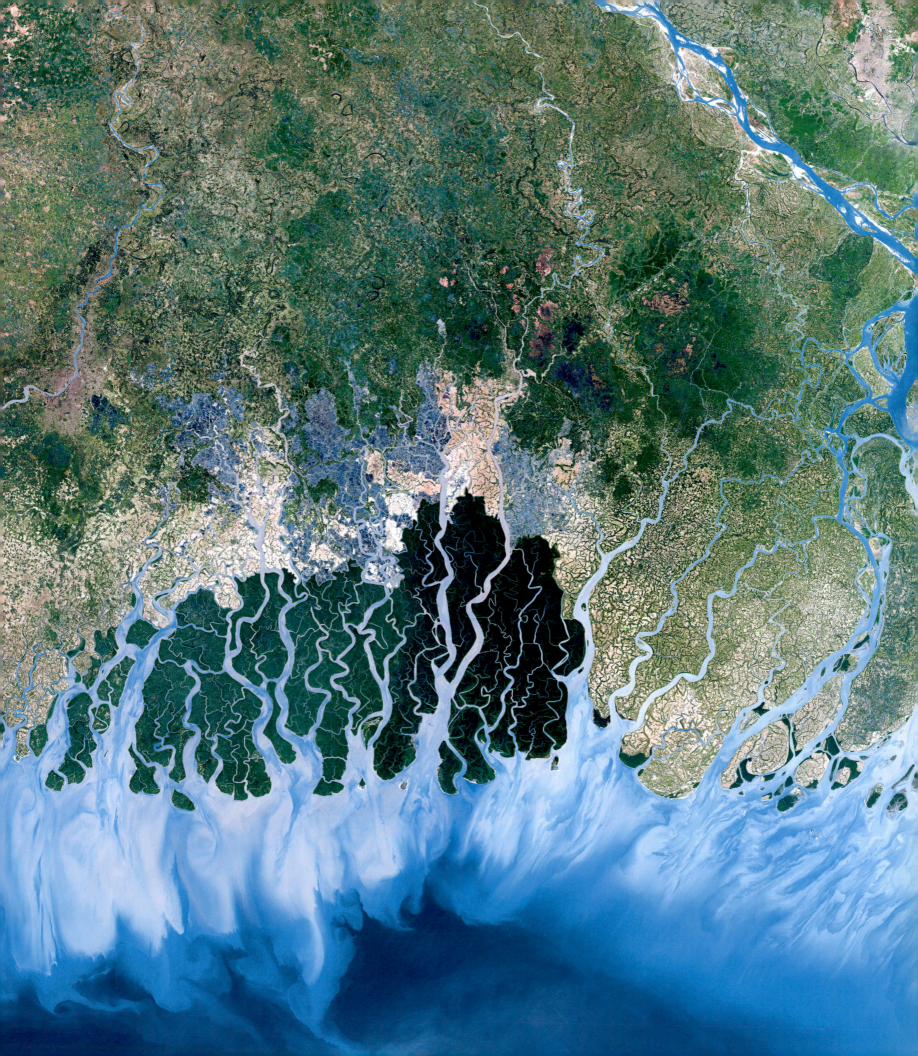

unusual method of fishing. It is a way to catch fish that has been handed down from father to son for centuries.

'I'm a fisherman, my father was a fisherman, and his father before him,' Bhoben points out. 'It's how we've always made a living here. And now I try to teach my son, but he's a teenager … a bit lazy.'

The trained otters are secured to the boat or attached to long bamboo poles by a simple harness and string. Youngsters swim freely with the older animals while learning the ropes. Bhoben uses the otter's natural hunting instincts to find the fish in the muddy river and chase them towards the boat where the fishermen are ready with their net.

The tides are crucial to their success. At high tide, the fish are thinly spread throughout the waterway system, but as the water level falls, they're forced into the main channels where the fishermen are waiting. In go the otters, driving the fish into the net. With the otters' help, far more fish are landed than if the fishermen were fishing alone. And they all receive a reward.

'We have to give them half our catch – that's the deal,' says Bhoben. 'They're like family, but they eat better than I do!'

The question is: for how much longer? Men and otters have been fishing together for hundreds of years – the earliest reference is from the Tang Dynasty of China in the seventh century CE. It was also once common in India and Europe, including the British Isles, but nowadays only Bangladeshis fish with otters, although even here there are only a handful of otter fishing boats remaining across the entire Sundarbans. Bhoben's family and the other fishermen are slowly being pushed out. Large-scale fisheries are mopping up the fish and driving down prices at market and widespread pollution in the delta means that fish are harder to come by. Nevertheless, Bhoben continues to look after his otters, and, by doing so, he has become an inadvertent conservationist, nurturing a mammal species threatened by the loss of its wetland habitat.

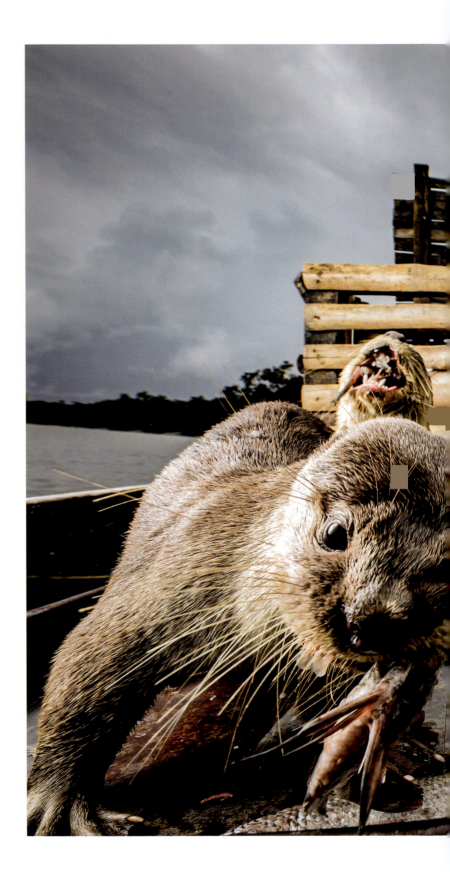

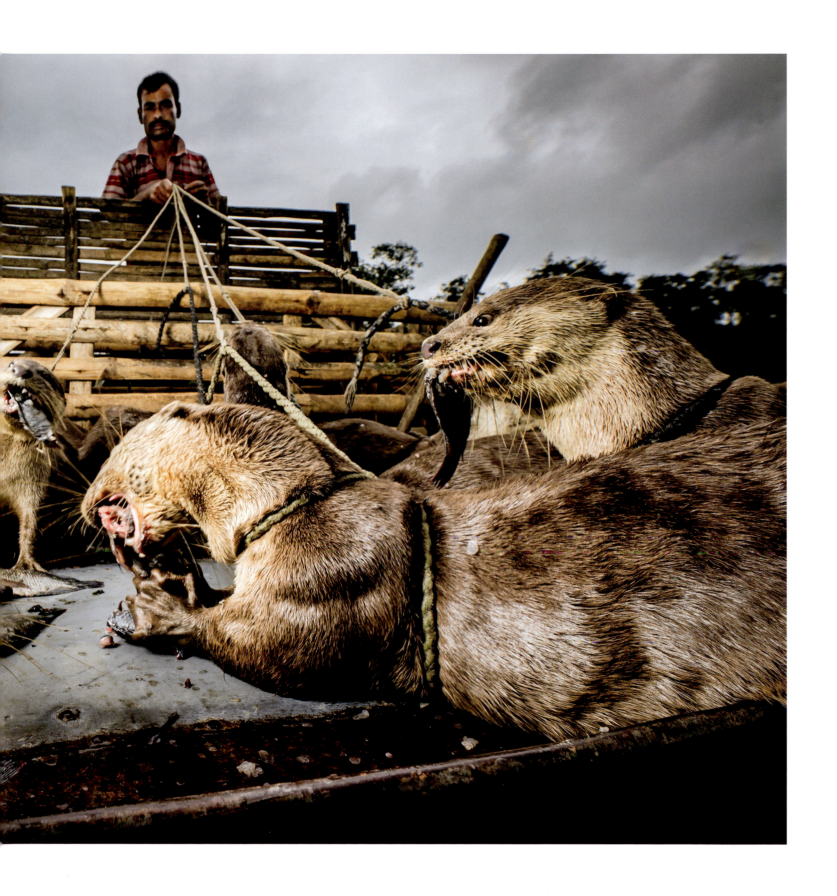

Monsoon lands

Although life in the Sundarbans revolves around the tides, the land and waterways were created with the help of a powerful seasonal force – the monsoon. The wet part of the monsoon cycle occurs because the land and sea absorb heat in different ways. In the warmer months, land temperature rises more quickly than that of the sea. Hot air rises, so low pressure exists over the land, while high pressure sits over the sea. The result is that rain-laden winds blow from the sea to the land, similar to sea breezes on British coasts except they are much greater in intensity, and they dump enormous quantities of water. Indeed, the wettest place on Earth is to the northeast of the Sundarbans, a cluster of hamlets in India called Mawsynram. They sit on a plateau overlooking the plains of Bangladesh. Moisture is swept in from the Bay of Bengal, producing an average annual rainfall of 11,871 millimetres (compared to an average of 3,784 millimetres in Snowdonia, the wettest region in the British Isles).

From space we can see rivers change from silver to brown, as 'bursts' of the monsoon unload the rain, and the floodwaters carry silts and sediments from the Himalayas in the north down towards the sea in Bangladesh. Much of it settles in a huge delta that fans out into the bay, part of which constitutes the Sundarbans. Much of the silt is trapped by the tangle of mangrove roots. They also prevent it from being washed away again. This 'bio-shield' protects the Sundarbans, its people and its wildlife from the powerful tropical storms that frequent the region many times each year.

BELOW AND OPPOSITE **Plant growth on the Indian sub-continent is dependent on the rain delivered by the monsoon. The two satellite photographs show how the land changes colour from shades of brown before the monsoon (below) to green afterwards (opposite). The clouds in this image show up as blue.** © NASA

OVERLEAF **While oppressive heat roasts northern parts of India, browning the landscape and triggering dust storms, thick rainclouds of the southwest monsoon cause floods in the south.** © NASA/NOAA Suomi National Polar-orbiting Partnership.

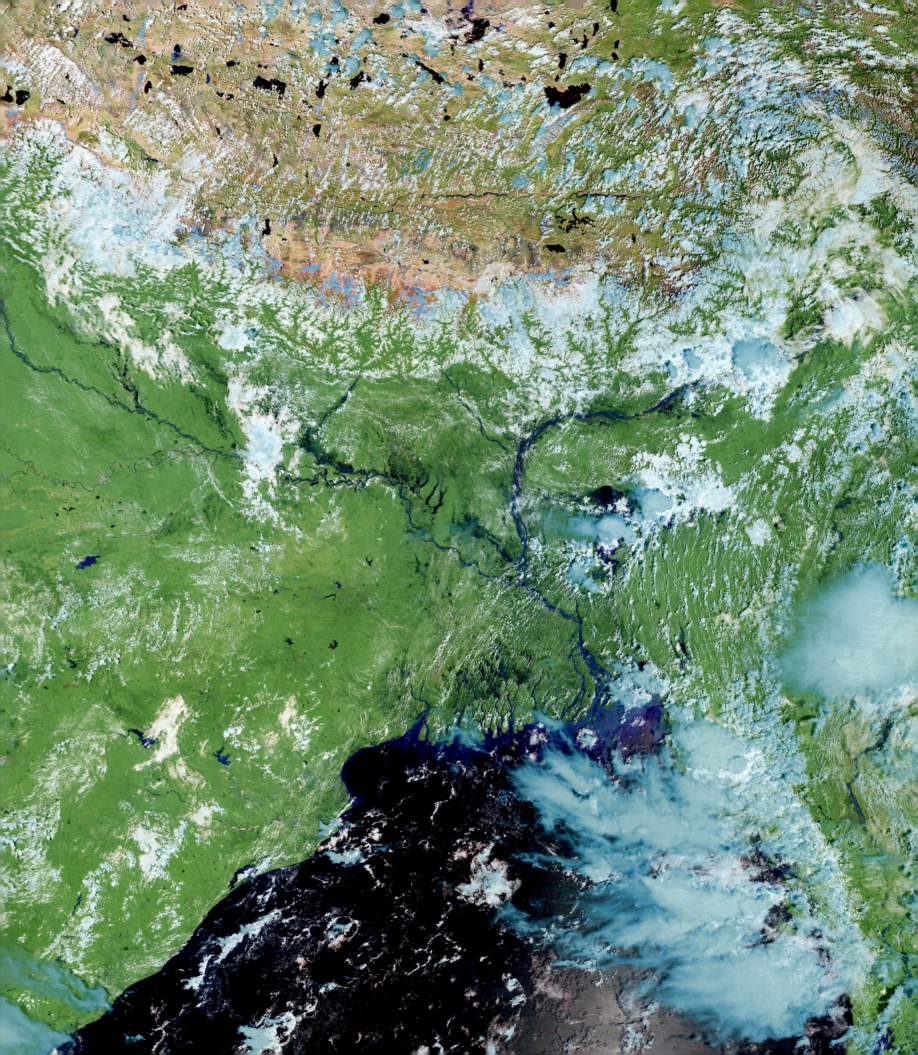

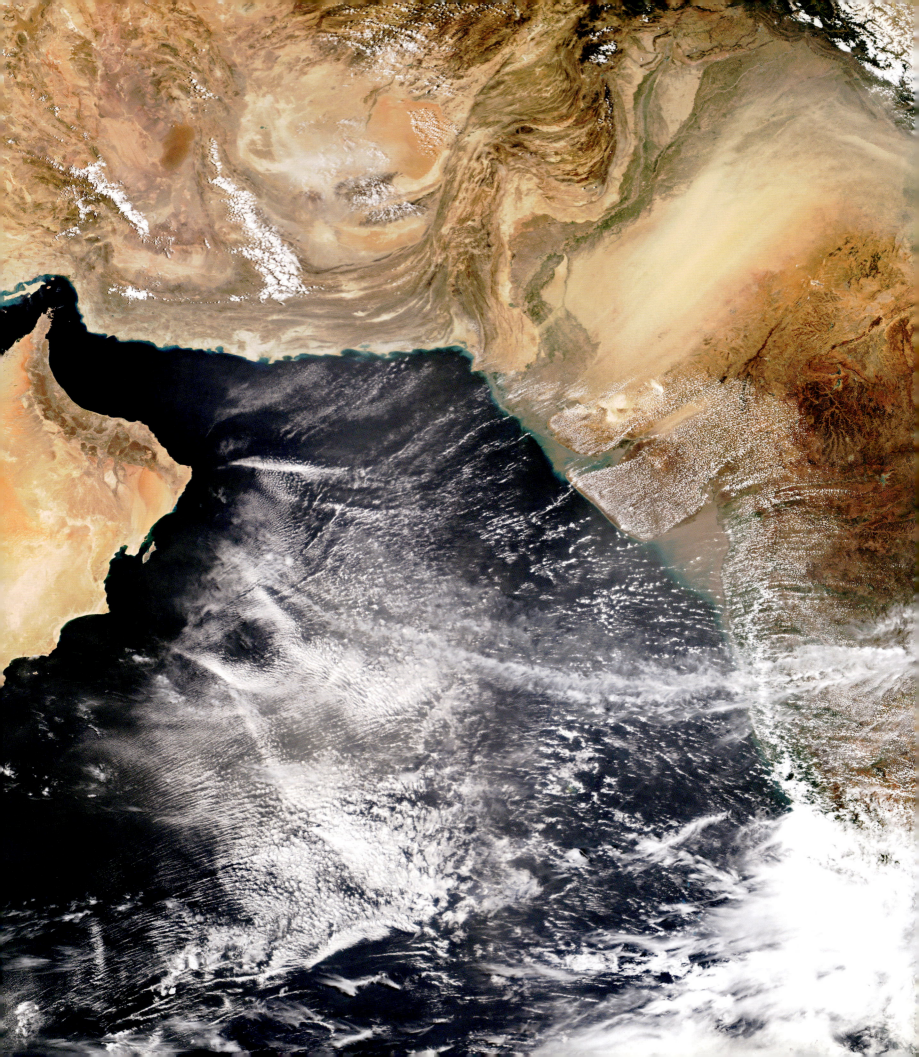

Hippo engineers

A very different kind of delta is found in Botswana, in southern Africa. Here, rainfall occurs in two distinct seasons – wet and dry – and both seasons have a profound effect on the country's wildlife.

Like the elephants of Mali and Buffalo Springs, both floods and droughts pose a serious challenge to life in Botswana. An exceptional dry season, for example, can see hippopotamuses crammed together in rapidly disappearing lakes and pools, causing epic fights to break out between neighbours. Salvation arrives from some distance away.

When rain falls in the Angolan highlands 16,000 kilometres to the north, the water eventually tumbles down rivers that do not flow into the sea, but onto the vast plain in Botswana known as the Okavango Delta. From space the progression of the water can be followed as the delta is transformed from a scorching desert into an inland wetland area and wildlife paradise. The hippos take full advantage of the water, following familiar routes through the swamp and creating distinct pathways.

BELOW **Hippos trample pathways through the lush vegetation. These channels modify the flow of water through the delta.**

OPPOSITE **Seen from space at sunrise, the vast Okavango Delta takes on the colour and shape of a silver tree root. Astronauts on the International Space Station use this 'sunglint technique' to capture the fine detail of water bodies. The rivers from the north flow southwards into a tectonic trough in the Kalahari, creating an inland delta that is flooded seasonally. Most of the incoming water will flow no further. Only a little reaches the Boteti River at the bottom of frame. Most of it evaporates or is lost by transpiration from plants.** © Image courtesy of the Earth Science and Remote Sensing Unit, NASA Johnson Space Center.

OVERLEAF **The pathways made by hippos and other large mammals crisscross the flooded and green Okavango.** © CNES 2016 – Distribution Airbus DS.

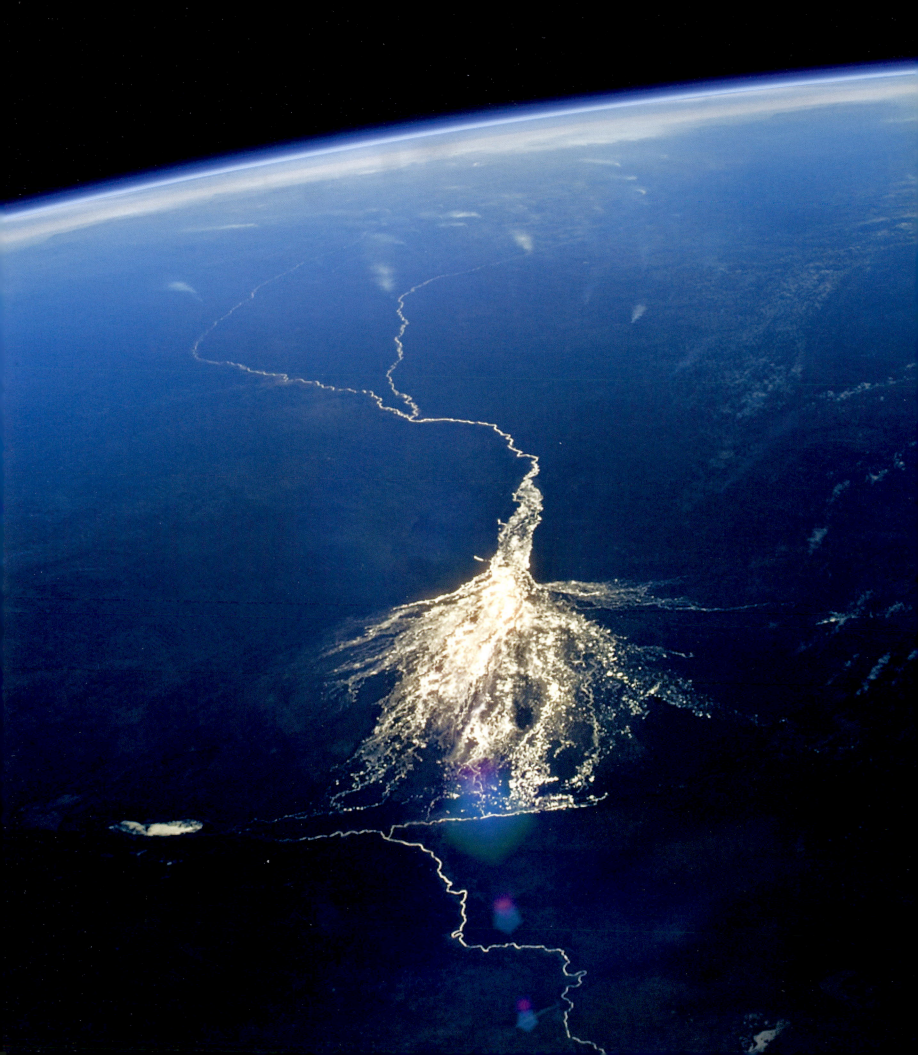

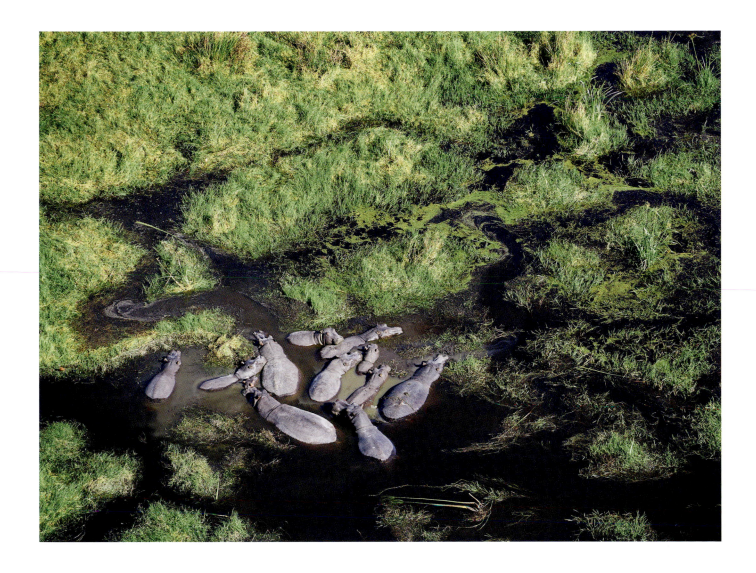

Other large mammals, including buffalo and savannah elephants, also plough through the swamp, but their routes are different from those of hippos. Viewed from space, the direction of the route tells us which animal has made it. Elephants walk directly between islands, so their paths tend to be perpendicular to the gradient, while hippos follow the flow of water and so walk parallel to the slope. This makes them useful bio-engineers. Their pathways are thought to alter patterns of water flow, so water reaches parts of the delta that may not have been penetrated before, which is important to the huge numbers of animals that pour in from all points of the compass when the whole area floods.

OPPOSITE **Hippo trails are not confined to the Okavango. Here, hippos have created a labyrinth of pathways at Lake Kenyatta in northeast Kenya.**

ABOVE **Hippos cool off before heading out to feed during the night. As the water levels fall at the start of the dry season, hippo herds are concentrated in shrinking lagoons.**

Whale-watching from space

Animals are on the move across our planet for a variety of reasons – to find a mate, rear young or leave a crowded living space – although, often as not, the whereabouts of seasonally abundant food is the main stimulus that triggers everything else. Some travel enormous distance, like the Arctic tern that embarks on an annual round trip of 70,900 kilometres between Greenland in the northern hemisphere and the Weddell Sea in the Antarctic, the longest of any animal. But if there was ever an ideal animal to track across the globe using satellite imagery, it is one as big as a great baleen whale … at least, when it is at or near the surface.

Southern right whales enter shallow bays to mate and give birth at Península Valdés in Argentina. Here they have been counted using the WorldView2 satellite. It was the first successful study of its kind, and since then there have been several others. Gray whales, which give birth in the San Ignacio Lagoon in Mexico's Baja California, have been counted from satellites that are 480 kilometres up, and humpback whales have been scrutinised in a similar way as they gather off Maui in Hawaii. Now satellite imagery is revealing more about the life of the fin whale.

It may come as bit of a surprise to learn that, not far from where they spend their summer holidays on the Italian Riviera, many people share the water with the world's second largest animal. A little way offshore from the holiday beaches is the Pelagos Sanctuary for Mediterranean Marine Mammals. It is where fin whales spend their summers too. Here, a current flowing northwards past Tuscany and Corsica and along

BELOW AND OPPOSITE
Digital Globe's Worldview-3 satellite finds four gray whales and a research boat at the mouth of the San Ignacio Lagoon, Baja California. When zoomed in (below) the whales can be seen, even below the water. The satellite is becoming a powerful tool with which to monitor animal numbers in remote locations. Satellite imagery courtesy of © 2018 DigitalGlobe, a Maxar company.

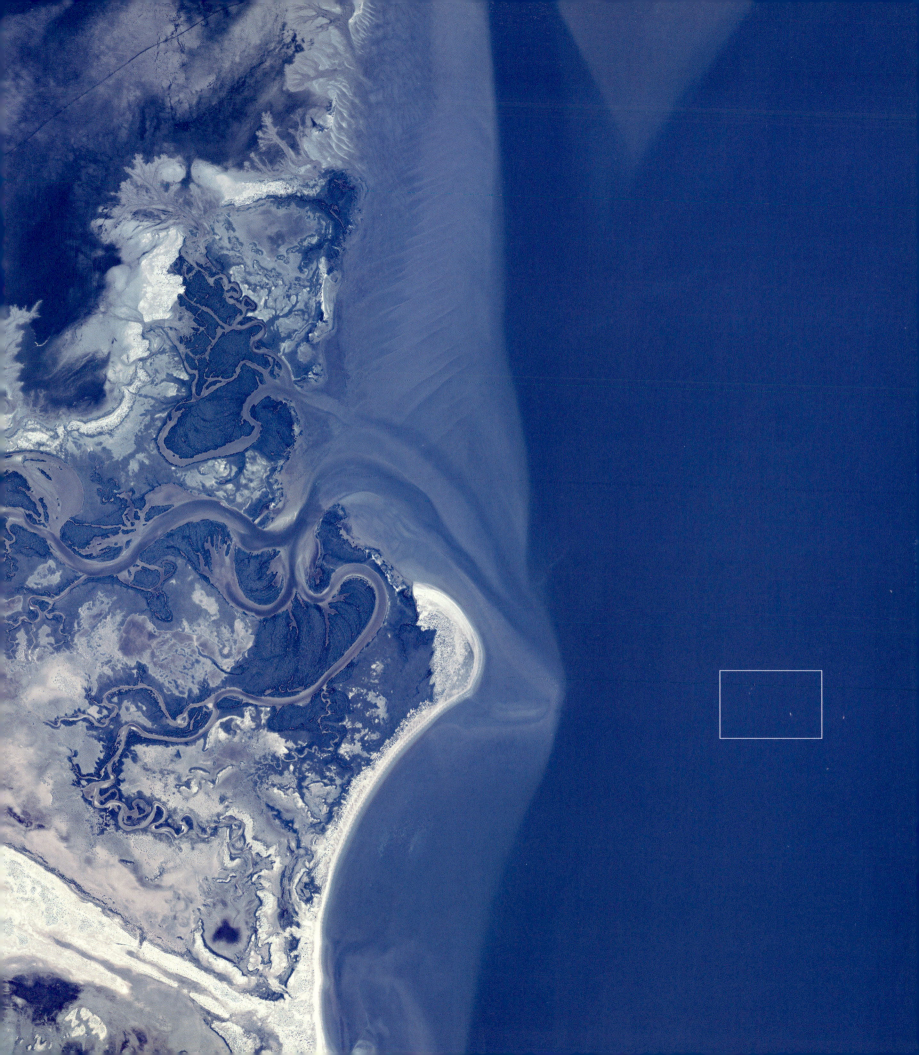

the coast of Liguria and mainland France creates a permanent frontal system between coastal and offshore waters where there is considerable biological activity. Northwesterly winds, known as the 'mistral', drive upwellings that, together with the vertical mixing of waters, bring up nutrients from the deep. Satellite data has revealed that this is where the phytoplankton blooms. These organisms support the zooplankton, such as northern krill, which, in turn, is food for whales, so this sector of the Mediterranean has become one of their primary summer feeding sites.

In winter, food is less concentrated in the sanctuary so the whales move elsewhere. Some of them head for the island of Lampedusa in the Strait of Sicily, where they feed actively both to the north and the south of the island. The problem is that wherever they are, whether it be feeding or migrating, they are crossing busy shipping lanes, such as the high volumes of traffic between the Suez Canal and Straits of Gibraltar that passes to the south of Lampedusa. There is the constant danger of ship strikes, and this population of whales has a higher than average rate of injuries or deaths from collisions. However, knowing where the whales are and where they travel could lead to changes in maritime law, and maybe even the introduction of restrictions on the movements of ships. Fin whales are classified as 'endangered' by IUCN, but this kind of study could be their salvation. Observing the great whales and their food sources from space is a new and exciting development, and it could help to ensure they actually have a future.

BELOW **An aggregation of humpback whales feeding off the coast of South Africa. This species also features in population censuses using satellites.**

OPPOSITE TOP AND BOTTOM **With the success of whale and penguin counts, scientists are finding that other species living in remote areas can be counted from satellites. Migrating wildebeest in East Africa (top) and Cape fur seals hauled out on a Namibian beach (bottom) are two. Pilot studies are already underway.** Satellite imagery courtesy of © 2018 DigitalGlobe, a Maxar company.

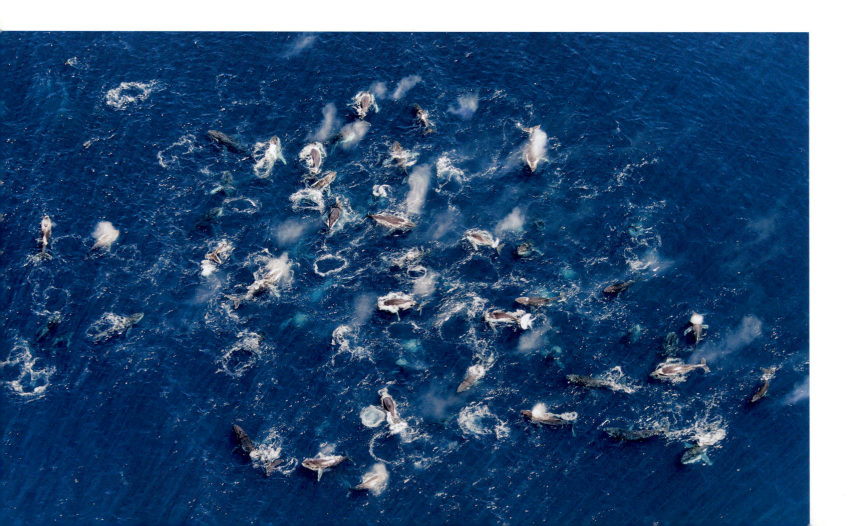

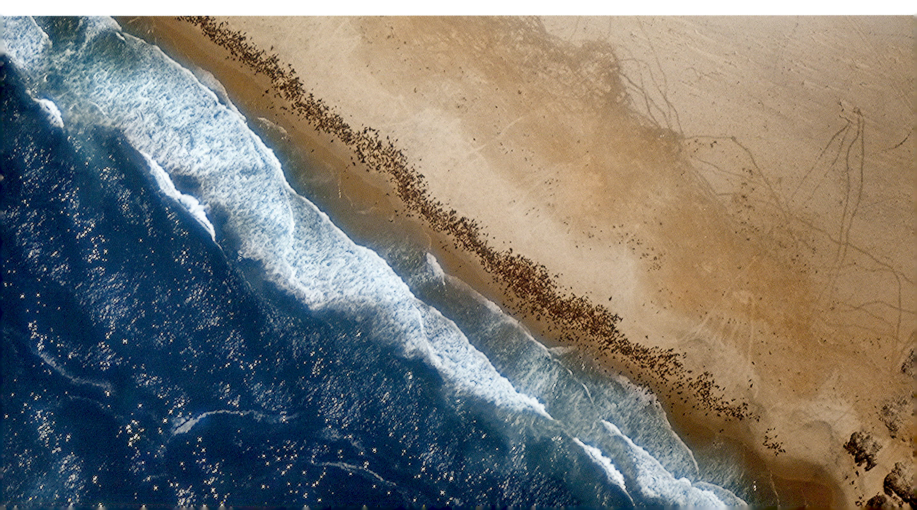

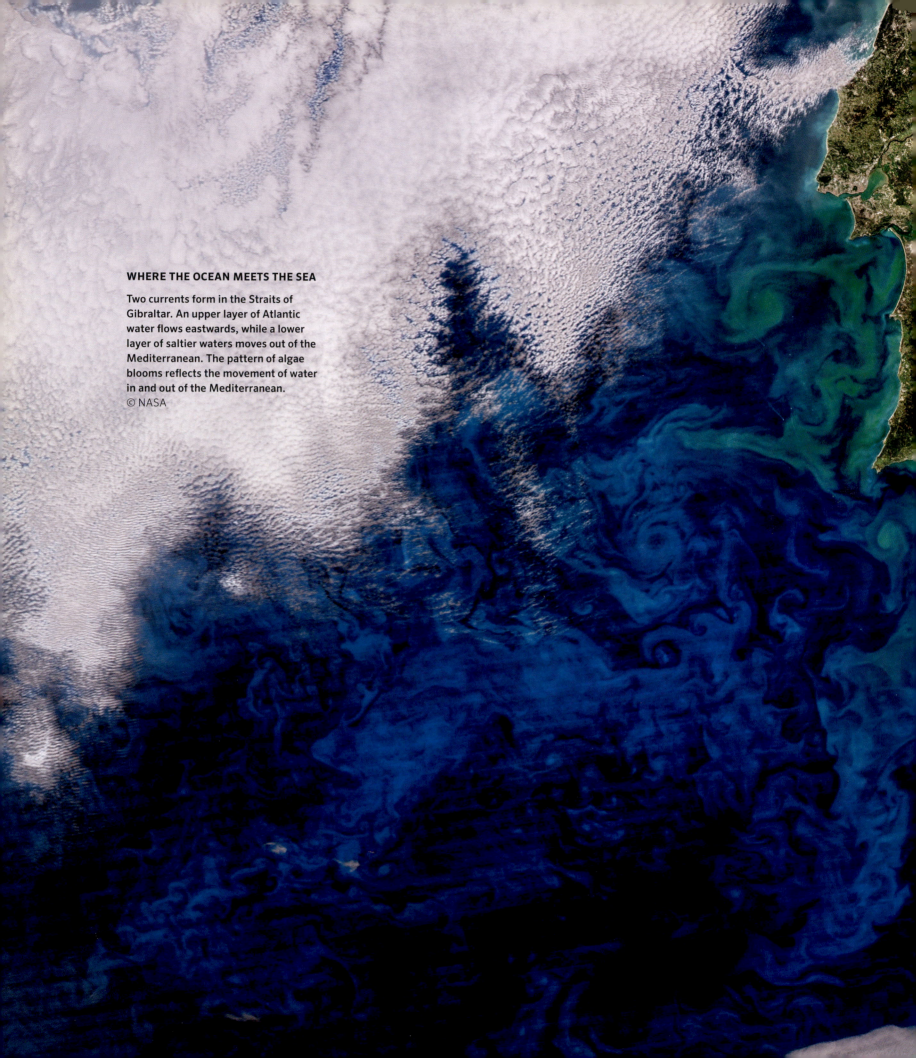

WHERE THE OCEAN MEETS THE SEA

Two currents form in the Straits of Gibraltar. An upper layer of Atlantic water flows eastwards, while a lower layer of saltier waters moves out of the Mediterranean. The pattern of algae blooms reflects the movement of water in and out of the Mediterranean.
© NASA

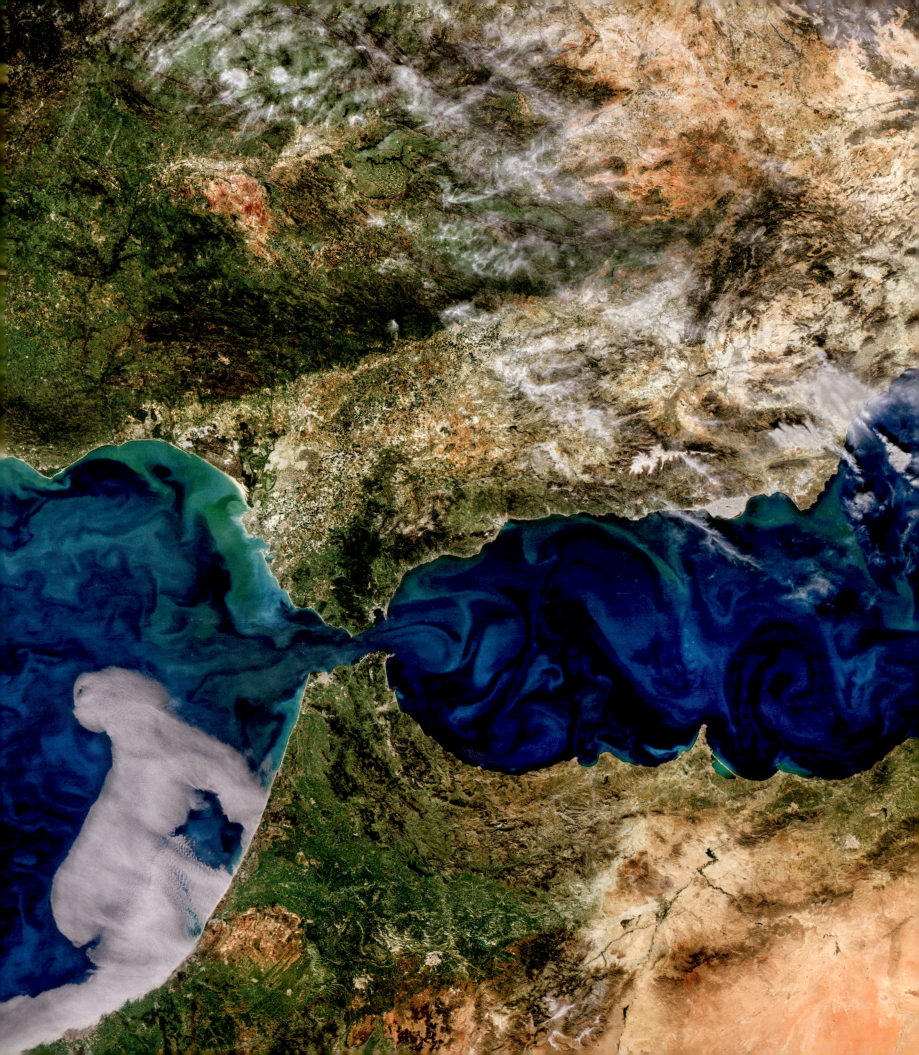

Kung fu and gridlock

Observing individual people from space is not as easy as watching a whale, although military reconnaissance satellites, better known as 'spies in the sky', are thought to be able to resolve something as small as 12–15 centimetres across, and that's from a satellite orbiting more than 300 kilometres above the Earth's surface. It might not be able to read the number on your house, but it can identify the make of car standing outside. Commercial satellites are getting close to this kind of resolution, and the shapes and patterns they can see are attention-grabbing, especially when large numbers of people are all moving together. For this, the *Earth from Space* team went to China.

'Every day, we wake at 5am,' says a bleary-eyed Ching-Yiu, an alarm ringing loudly somewhere nearby. 'When I first arrived, it was really difficult to get up, but now it's not so bad. When the coach calls us, we do as he says.'

Ching-Yiu is just 13 years old and attends a martial arts academy in Dengfeng, in China's central Henan Province. He is one of 35,000 boys who are trying to master Shaolin Wushu, which combines martial arts with Buddhism. Its records can be traced back to 495 CE, and the course today is extremely tough, just as it was over 1,500 years ago.

'In winter, it's so dark. It's doesn't feel like the right time to wake up, but we have to train. It's freezing cold at the beginning, but when we start warming up, it's alright.'

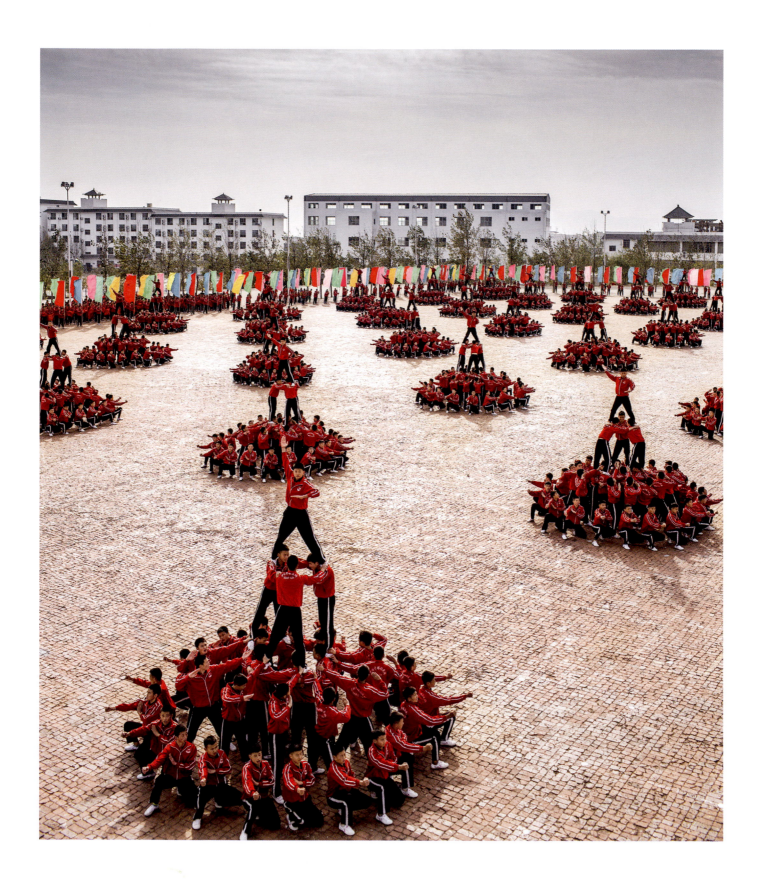

Outside, it was a misty morning, and you could see the breath of each of the young students as they wandered across the yard for breakfast.

'We train for one hour in the early morning and then there are two classes.'

The group came to order and, army style, Ching-Yiu shouted out his number, and the group marched off, chanting as they went.

Kung fu means literally a discipline or skill achieved through hard work and practice, and is not specifically applied to martial arts, but for Ching-Yiu it will take years of dedication, discipline and relentless training to achieve his goals.

'When we're training together, there are sad times and happy times. When someone can't do it, we teach each other, and offer each other encouragement.'

But what does Ching-Yiu want to achieve from all this? What does he want to be when he graduates?

'Some kids say they want to be soldiers when they reach 18 or 19, but most of us want to be kung fu stars. I saw all of these heroes and villains on TV running up walls and doing somersaults, and I wanted to learn that too!'

But it's not all discipline. The students play-fight and mess around like all kids.

'My classmates and I are like brothers,' says Ching-Liu. 'We go out and play together. When I feel sad, I can share it with them, and when I'm happy, I share it with them.'

The children are taught at the school all year round, during which time they perform at special events and competitions right across China, but there is one epic performance for which the school is now famous.

'We only have the performance for special days. Whenever there's a special occasion, or if a leader or VIP comes to visit, we'll put on a big performance so they can see Chinese kung fu. If just one person makes a mistake, the entire team has to do it again.'

And, while the members of the *Earth from Space* film crew were at Dengfeng, they were fortunate enough to be invited to watch and film events as they unfolded. For Ching-Yiu, the pressure was enormous. He had to remember all the moves he had learned, right down to the perfect angle of his arms, the placement of his feet, and the timing of his jumps ... every detail mattered.

'This huge performance is so that we can all train as though we are one spirit. The whole school comes together as one, and we can show our greatness to the school and to our families.'

And, when the big day came, the students performed together at the main event. Their mass movements, in perfect synchrony, created ever-changing shapes and patterns, and, when seen from above, they really did move as one. The display was a huge success, a triumph of coordination and rhythm, a demonstration of how the body can work in harmony with the brain to produce some of the most exquisite patterns and movements on Earth.

With the performance finished, Ching-Yiu was ready to go home for the holidays. 'Spring Festival is when we go home and visit our parents and family to spend the

New Year with them. People from all over the country come back home to have a feast with their parents.'

Faced with a daunting 1,300-kilometre journey, Ching-Yiu said goodbye to his friends and he joined the largest movement of people on the planet.

Every January or February, almost a billion people all across the country, representing about one sixth of the world's population, together with expatriates from around the world, return home to be with family and friends at this special time. During the holiday period, they make more than 2.5 billion excursions by road, 58 million by air, 43 million by sea, and they buy 356 million rail tickets. The travel phenomenon is known as the 'Chunyun' period, and it lasts for as long as 40 days. Many travel by road, the lines of cars and buses on motorways clearly visible from space. It is gridlock. At railway stations and airports people are packed in like sardines, all eager to return home.

The Spring Festival is an important date in the calendar. For many, this is the only chance they get to see their relatives all year, and home for Ching-Yiu is Hong Kong. He has to take a flight, board a ferry and ride a tram, and, when he arrives, the streets of his city were bustling with people buying food, flowers and decorations, everybody in a mad rush to get things done.

'There are so many people around on the streets, and on the buses,' says Ching-Yiu. 'They all like to go shopping to buy new clothes, but I'm not used to so many people. I don't want to go.'

At home, there are traditions to be followed. The family cleans the house thoroughly to sweep away bad luck and make space for good luck, while Ching-Yiu and his sister make a visit to the 'wishing tree'.

This centuries-old tradition began with two special banyan trees near the Tin Hau Temple in Fong Ma Po village, Lam Tsuen. The custom arose when villagers would throw paper josses into the trees to bring good luck. Today, people write their wishes on a piece of colourful paper, tie it to an orange or kumquat, and then throw it up into the wish tree. If the wish hangs on one

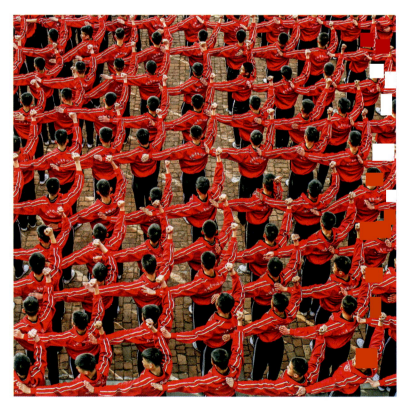

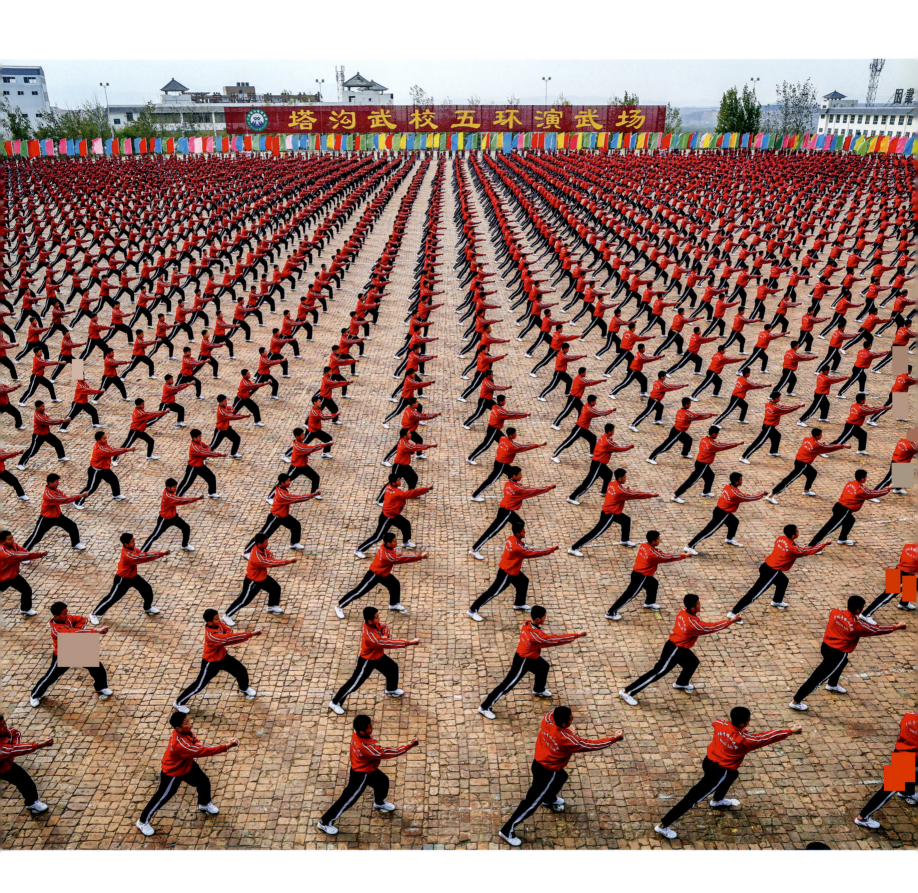

of the branches, it is believed that the wish would come true and, the higher the branch, the more likely the wish would be fulfilled.

For Ching-Yiu, it is an opportunity for him to teach his sister about ancient traditions, although the original wishing trees themselves have been forced into the 21st century. In February 2005, one of the branches gave way and injured two people standing underneath, so now the practice is discouraged, and wooden racks have been set up nearby so that people can still make their wishes, or, if they really want to throw, they can attach a wish to a plastic orange and throw it into the branches of a plastic tree. Ching-Yiu went for the plastic tree.

The next day, there is another important ritual to perform. At the Wong Tai Sin temple, Ching-Yiu and his mother join thousands of people who have been waiting in line for hours.

'We burn incense to wish for good luck and good health for our family. Our family wishes for good health in particular, because we've just had a new baby girl. We hope she'll grow up to be healthy and strong.'

With the tradition performed and prayers offered, it was time in the evening for all the family to gather for a grand dinner. There was a lot to catch up with before Ching-Yiu returned to school, and, like all the other people across China, he and his family were taking full advantage of their time together. It is, after all, the greatest party on Earth.

BELOW **Railway stations are packed tight with travellers heading for their homes to celebrate the New Year with their families. Tickets cannot be purchased before 60 days, so there is usually a last minute rush when up to 1,000 tickets are sold per second.**

OPPOSITE TOP AND BOTTOM **Other large gatherings of people that can be seen from space include religious gatherings, such as the Hajj pilgrimage to Mecca, the holiest city for Muslims (top), and popular music festivals, such as the temporary 'city' in Glastonbury, England (bottom).** Satellite imagery courtesy of © 2018 DigitalGlobe, a Maxar company.

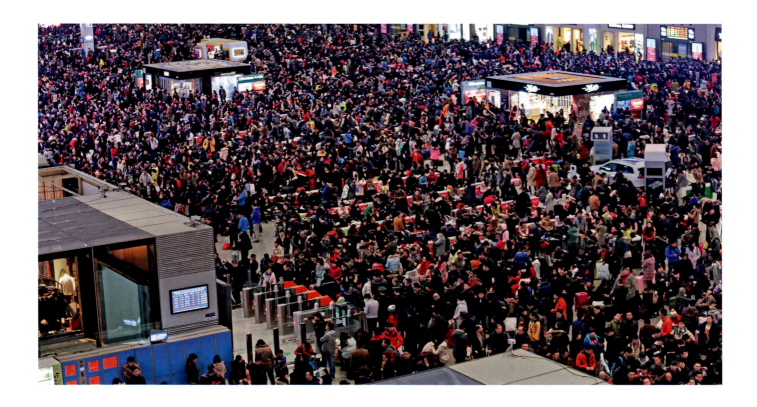

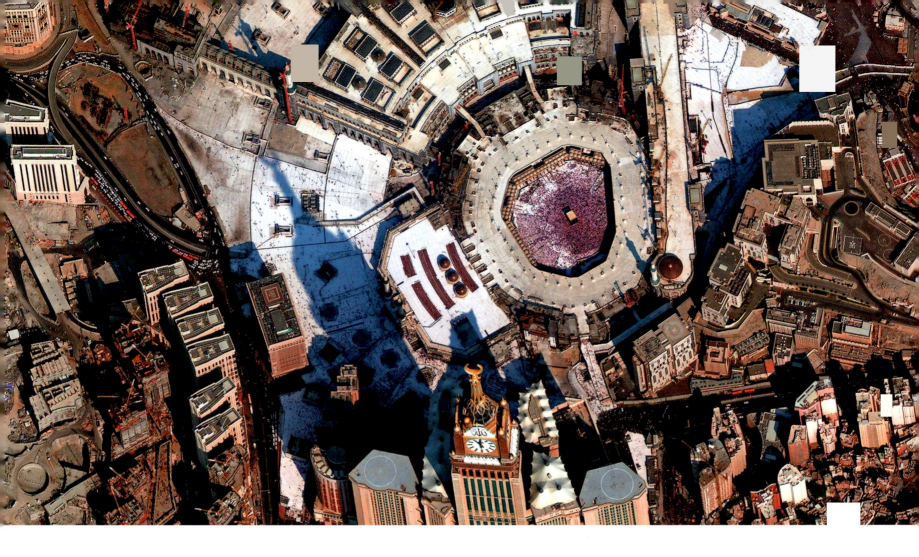

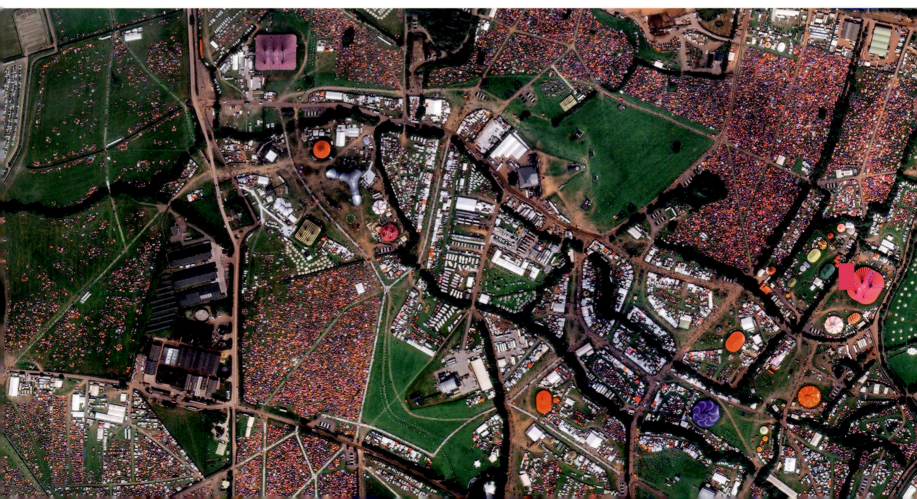

Amelia and the total eclipse

While people and wildlife are on the move, we sometimes forget that the world itself is moving too, and there's no better time to experience it than during a solar eclipse. It is a time when looking back at the Earth from space is a whole new experience, and a very special event for two young scientists in Seattle, USA.

At 12 and 10 years old, Rebecca and Kimberley Yeung were probably the youngest people to have taken part in a space programme, but after successfully launching homemade weather balloons – the first reaching an altitude of 23,774 metres, and the second 30,785 metres – they were ready for the big one: to participate in NASA's Eclipse Ballooning Project in conjunction with the University of Montana.

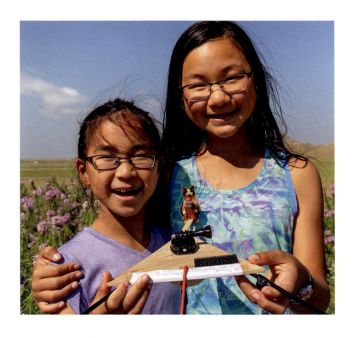

ABOVE **Rebecca and Kimberley Yeung are with their tiny model Amelia Earhart, who will fly to the edge of space.**

OPPOSITE **The shadow of the Moon travelling across North America is seen from a balloon over 50,000 metres above the Earth's surface.**

They had already caught the attention of President Obama, who invited them to his annual science fair at the White House in Washington, DC, and, now, the two young scientists were teaming up with other scientists and enthusiasts from all across the USA to record the solar eclipse. Travelling by road more than 1,760 kilometres east from their hometown, they headed for Casper and the extensive high plains of Wyoming, and they were not alone. There were people pitching tents, parking motor homes and renting every available motel room in the area. Elsewhere in the country, millions of people travelled to areas that would experience totality. They climbed mountains and gathered at stadiums, all ready for the once-in-a-lifetime event.

Rebecca and Kimberley's project was to release another balloon, and this time it was to carry a camera to the edge of space and photograph the shadow of the Moon upon the Earth. As Rebecca pointed out, the balloon would have a passenger, a small Lego® figure. Its identity was the subject of an online poll.

'There were three choices: Hermione Grainger, Amelia Earhart – the first female pilot to fly solo across the Atlantic Ocean – and Merida, from the movie *Brave*, and Amelia Earhart won by a landslide. She was a very strong female. She was very brave, and we think she's a great role model.'

As the girls readied themselves and their balloon, Barny Revill was coordinating film crews along the line of totality.

'We had six separate teams, spread across three states, including one with a super-long lens for close-ups of the Sun. We also had a 360° camera on a balloon of our own, all for just two-and-a-half minutes of totality. We just needed the skies to stay clear.'

So, on 21st August 2017, Amelia was ready for takeoff, and Barny need not have worried: visibility was near perfect. The sisters' balloon climbed to 29,374 metres, more than triple the height of Mount Everest, where the onboard thermometer recorded a temperature of minus 63°C. It was one of 50 balloons rising across the country that would record the first total eclipse across America in 99 years. The live streaming from

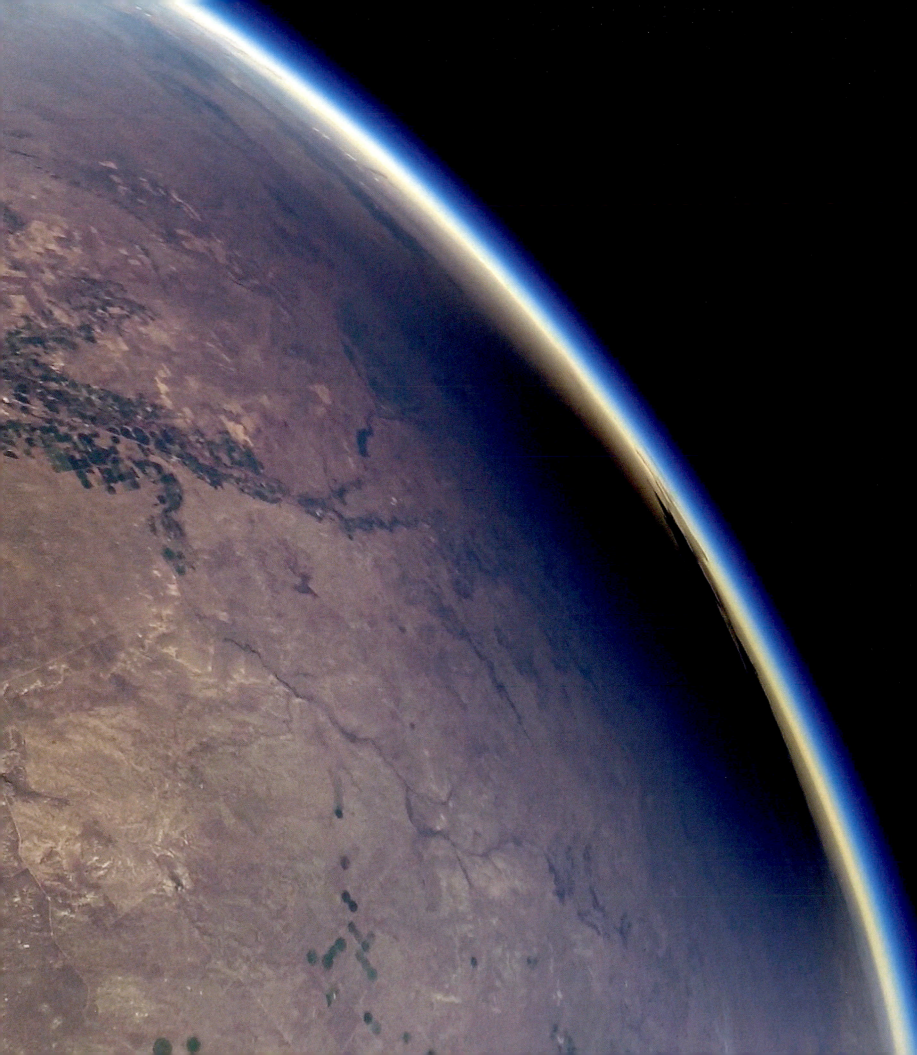

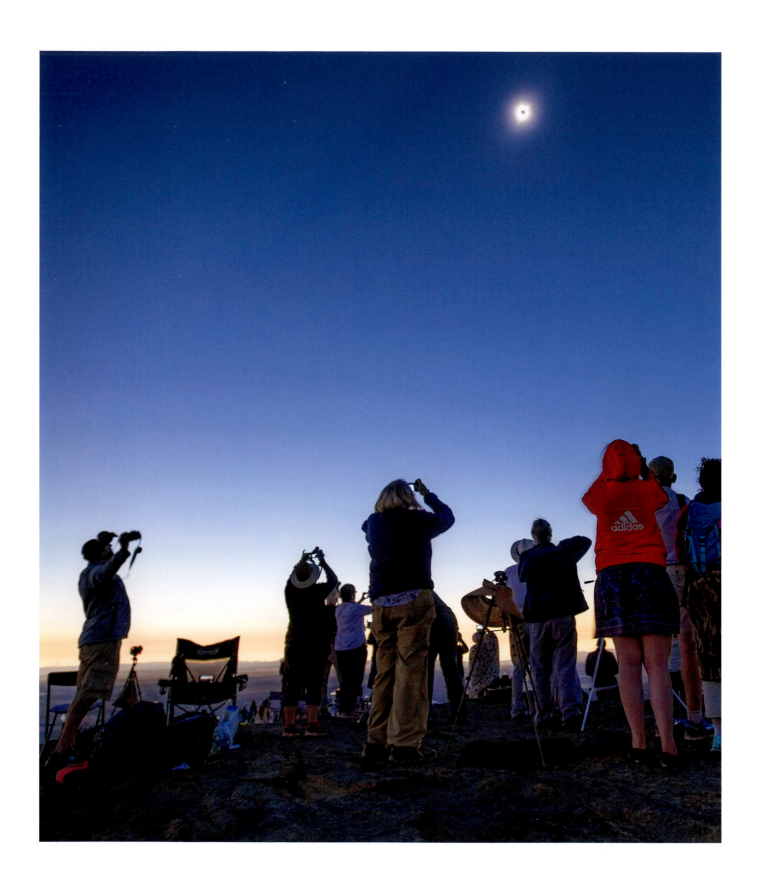

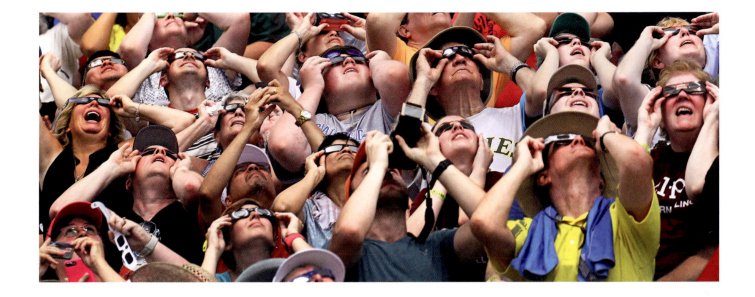

some of the video cameras first revealed the curvature of the Earth, then, at 10.24 precisely in Wyoming, the show began.

Only truly visible from space, a vast shadow swept across the country. All along the route, people felt the temperature drop as they were pitched into darkness. In just one hour and 33 minutes, the shadow passed all the way from the west coast to the east, and out over the Atlantic Ocean. During that time, NASA scientists were not only monitoring the eclipse, but also watching for something that had so far been quite elusive.

Their theory proposes that, as the shadow and the sudden drop in temperature of a total eclipse moves across the planet at supersonic speed, ripples should be produced in the Earth's atmosphere. The ripples are gravity waves (not to be confused with gravitational waves), and they are similar to the bow waves of a ship, which spread out in its wake. They are important because they are responsible for large-scale energy transport in the Earth's atmosphere.

During the 2017 eclipse, they recorded 40 separate gravity wave events, of which a few can be directly associated with the eclipse, and the *Earth from Space* team may have captured one event on video. During the flight, the pictures from the camera can be seen to judder, physical evidence maybe of gravity waves.

Down on the ground, the two sisters were faced with how to get their balloon back. They had to travel some distance over rough terrain to recover it, but when they downloaded the pictures from its onboard camera, they discovered it had all been worth it. Their images showed the Moon's shadow moving across the Earth. They had achieved their main goals, and with their camera at the edge of space, they (and Amelia, of course) had the best seats in the house.

ABOVE AND OPPOSITE **An estimated 215 million adults in the USA watched the 2017 solar eclipse, either directly or electronically. Of those, 21 million travelled to get a better view. It was one of the largest audiences ever recorded for a live event.**

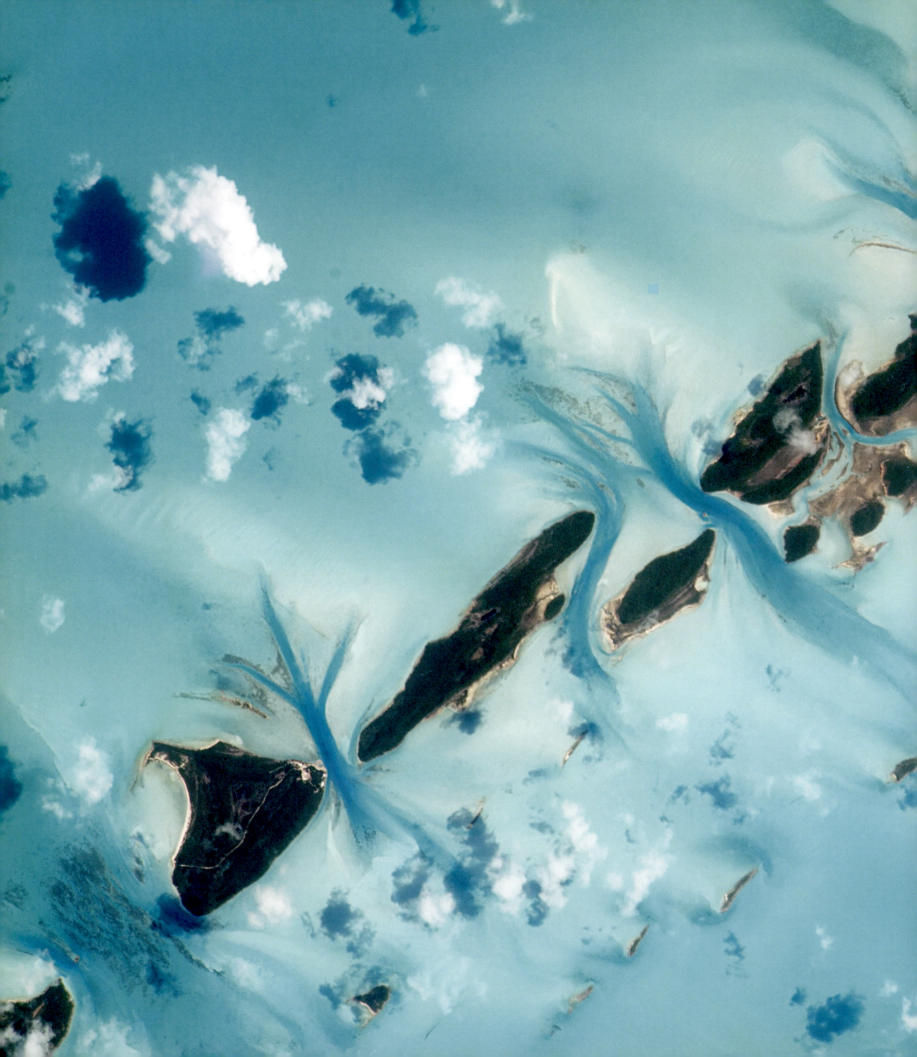

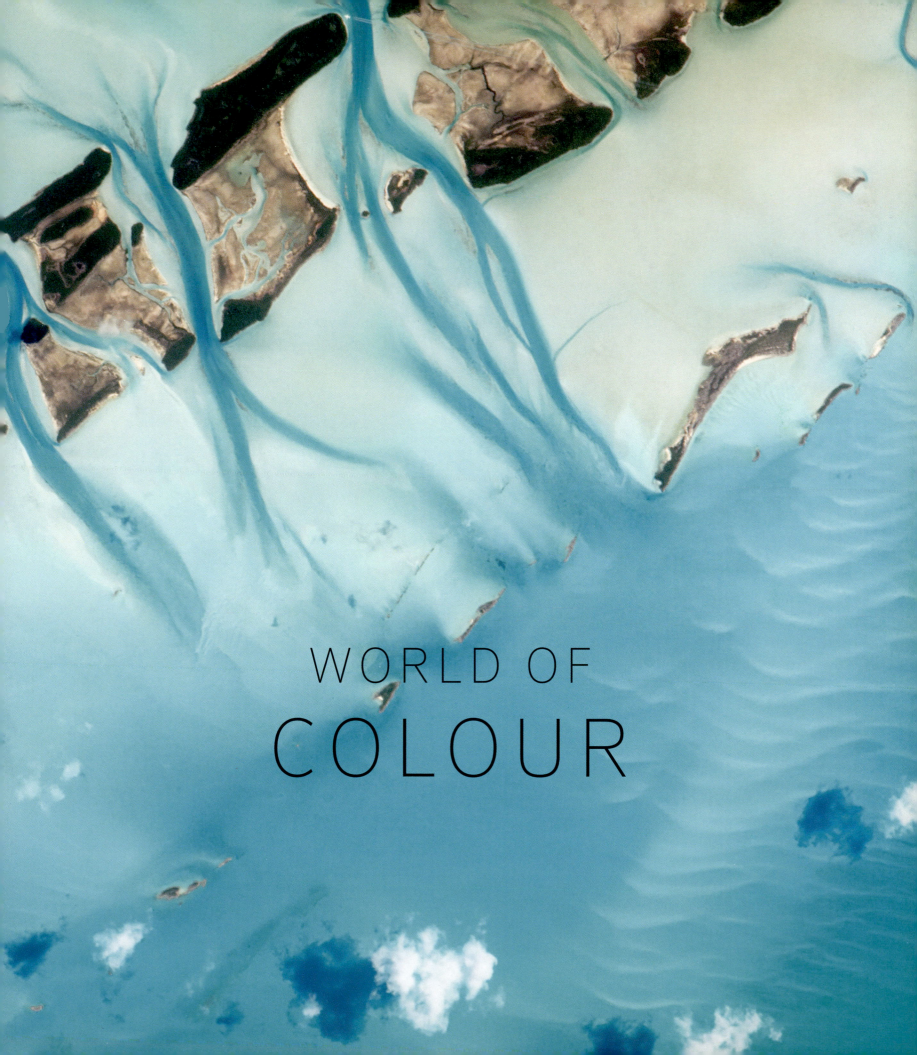

WORLD OF
COLOUR

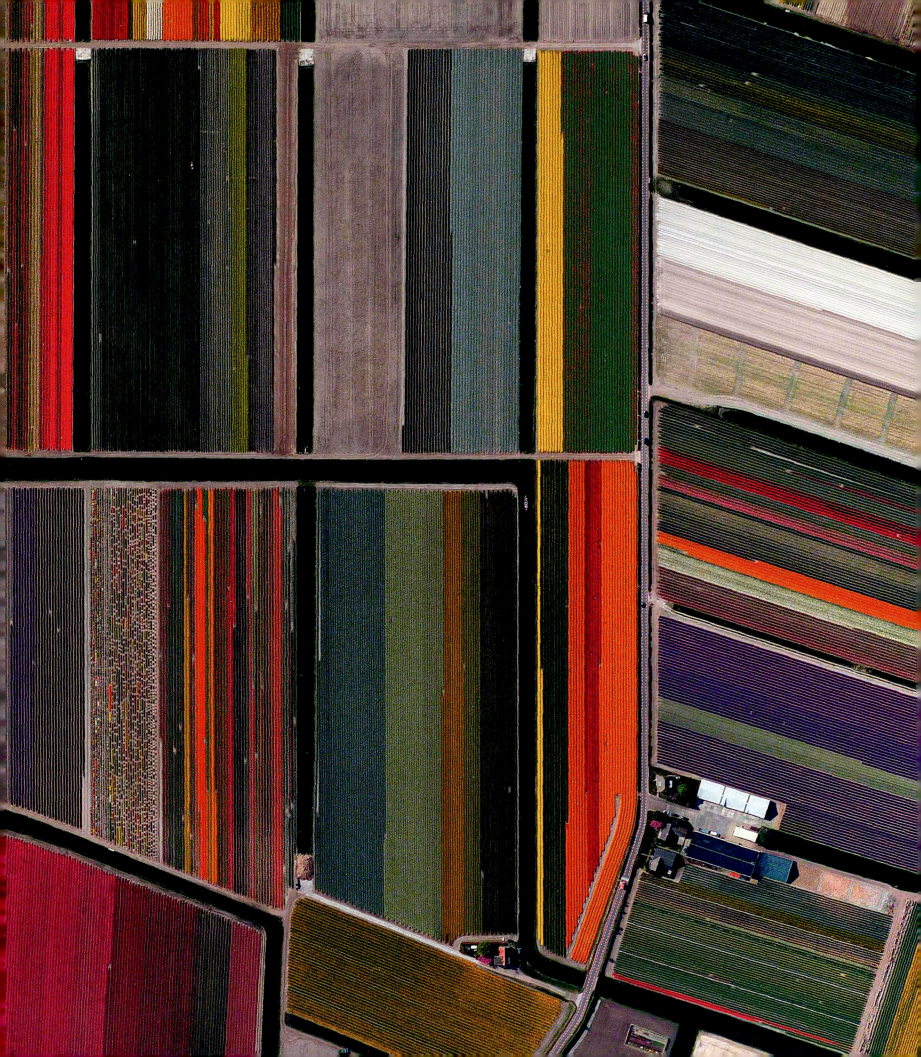

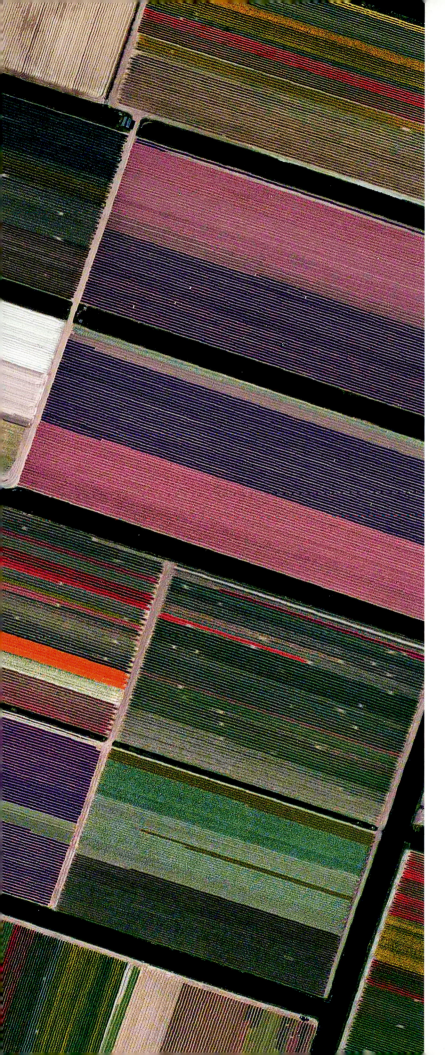

When astronauts first took pictures of the Earth from space, it was generally acknowledged to be the 'blue planet'. Today, satellite imagery reveals a planet that is not just a mosaic of blue, or even of green or brown, but a kaleidoscope of constantly changing vivid colours. Jupiter aside, it is probably the most colourful planet in the Solar System. Plants, animals and even people create and change the colours we see from space – changes that occur from day to night, from season to season, and from one year to the next. Those colours can be a celebration of our planet's health, of its vitality and ever-changing nature, but they can also be the first indication that something is going wrong and that we need to take action. Colour and changes in colour help us to better understand the place in which we live.

LEFT **During late April and early May, the regimented rows of flowers are at their best in the tulip fields of the Netherlands. Crocuses dominated in mid-March, and daffodils and hyacinths during the weeks that followed.**

Dancing lights in the sky

Sofie is an Inuit grandmother who lives in Ilulissat, on the west coast of Greenland. When programme director Justin Anderson and the *Earth from Space* film crew visited her, she was sitting sewing. There were sealskins and paintings of Arctic scenery adorning the walls behind her, but pride of place were the family photographs, including her football-playing son-in-law Peter Frederick. He plays for Nagdlunguaq-48, a club founded in 1948, and which has since won the national football championship on at least ten occasions. Sofie watches all his matches, just like proud relatives all over the world, but, in February, the temperature here can drop to minus 20°C, and the Sun barely nudges above the horizon, so Sofie had to wrap up warm; but, as she set out across the snow, she looked up and gasped. The sky was filled with a brightly coloured and constantly moving hanging curtain of light – the stunningly beautiful Aurora Borealis, or Northern Lights. No matter how many times she has seen it, it still takes her breath away.

'When I was a girl, I was always afraid of the aurora,' she mused, 'I thought it might come close enough to touch me.'

But it was time to go.

The match was especially important for Sofie: her son-in-law Peter is captain. Despite the darkness and cold many people turned out to watch. Greenlanders are passionate about soccer. Local legend tells that its rules were learned not from the British, as history would have it, but from the aurora itself.

BELOW **Sleds pulled by dogs have been the principle form of transportation in the Arctic for centuries, and, even though there are automobiles in Ilulissat, many people, including Sofie, prefer to travel by dog sled.**

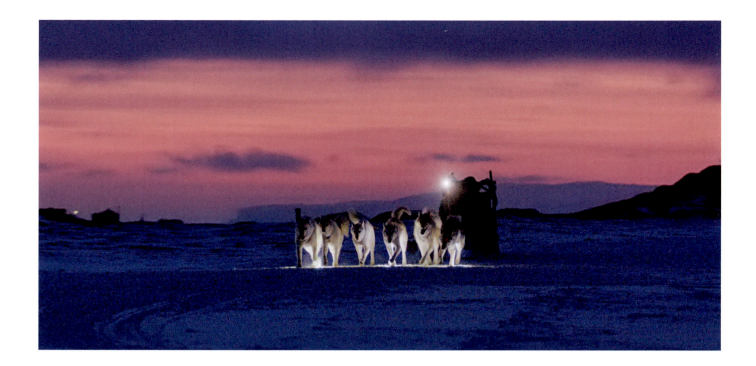

'Our people have always played football. We learned it from the sky above. You call them Northern Lights, but to us they are the footballers. It was always my favourite story when I was a girl. The shapes and swirls of light are the spirits of the dead as they play football.'

Elsewhere in the Arctic, folklore and auroras go hand in hand. The Alaskan Inuit believe that the lights are the spirits of the animals they hunted: seals, whales, salmon and caribou. In Finland, auroras are sparks of fire from the flaming tail of a running fox. In the USA, Native Americans, such as the Menominee Indians of Wisconsin, believes them to be the distant fires of tribes of fearsome giants who were the spirits of great hunters, and the Vikings thought they were the glow from the armour of dead warriors making their way to Valhalla. Science, however, recognises them as something else entirely.

Auroras appear at both ends of the Earth: the *Aurora borealis*, meaning 'dawn of the north' and the *Aurora australis*, meaning 'dawn of the south', and scientists have long known why they form in the high latitudes of these polar regions. Put simply, there is a weakness here in the Earth's magnetic field – its natural defence against dangerous particles from outer space. Think of the force field as a ring-shaped doughnut, so when charged particles from the Sun hit the Earth, they spill into the dimple at each magnetic pole, where they interact with molecules of atmospheric gases. The disturbance gives rise to great moving curtains of light, the colour dependent on the gas: oxygen gives a pale yellowish-green at an altitude of 100–300 kilometres, but bright red at

ABOVE **Sofie's dogs may look alike, but she can tell them apart, even in the dark. They each have their own personality, but they all work together. Most of the dogs like to pull, and the harder the conditions, the better they seem to like it. They move the sled along at an average speed of 10–14 mph.**

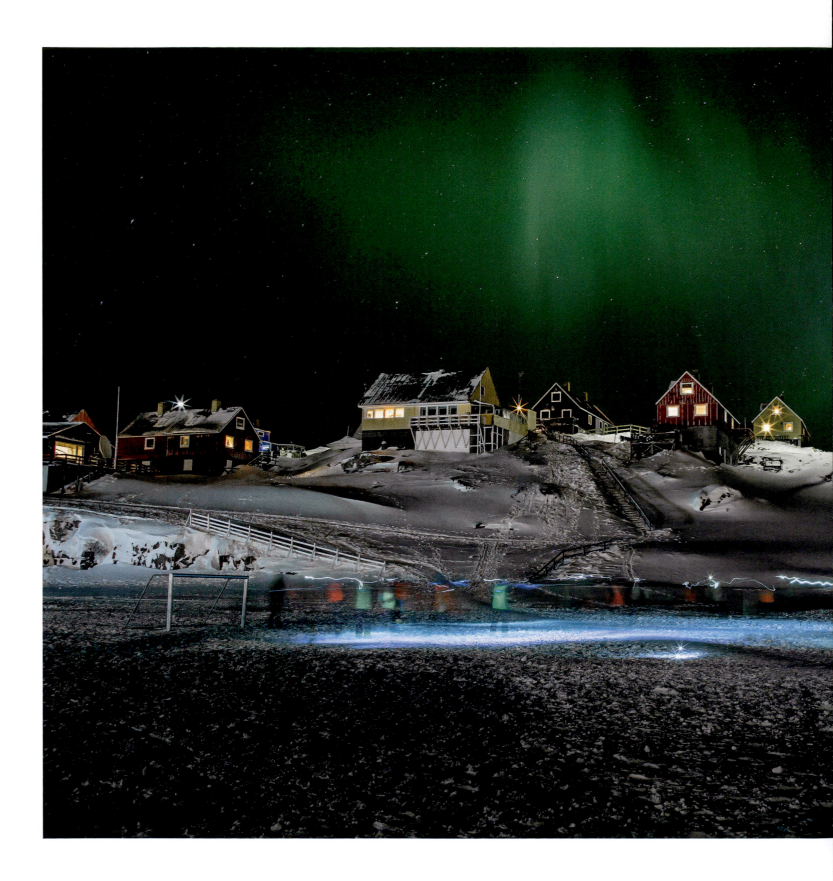

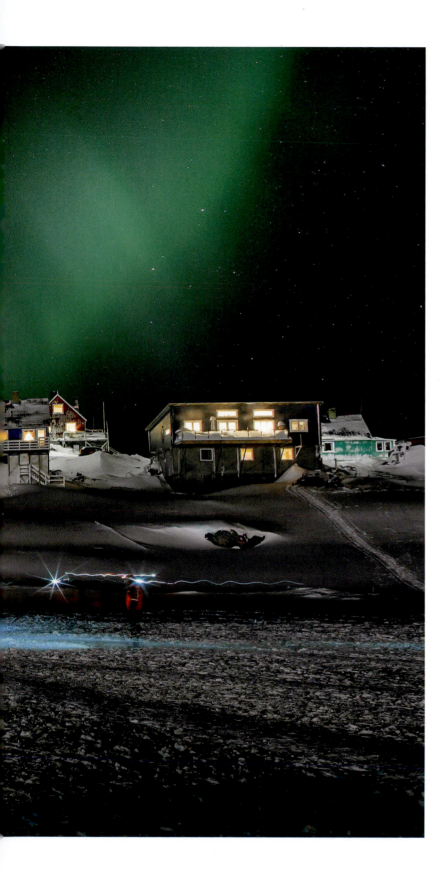

300–400 kilometres, while nitrogen produces blue or purplish-red fringes underneath.

The lights generally occur between 80 and 640 kilometres above the Earth, so from the International Space Station, orbiting at a little over 350 kilometres, scientists can now observe many auroras from above rather than from below. From space, the aurora zone can be seen as two irregular ovals above the magnetic pole at each end of the planet. Those in the north are the mirror image of auroras in the south. Space station cameras have also revealed vertical streaks of brightness. These are the places where the charged particles interact with the lines of force in the Earth's geomagnetic field. From their unique position, the space station scientists can clearly see the high red layer above the green.

Down below, Sofie's team won the game, with Peter Frederick scoring the winning goal. As she made her way home, Sofie paused again and looked up. She could hear the faint crackling and whistling as the green, pink and purple colours of the aurora waved gently across the sky.

Folk here believe that the lights are the spirits of the dead. The crackling is the sound of their feet as they run across the frost-hardened snow of heaven. The whistling is their voices. They are trying to talk to those still living.

'My father taught me to whistle back to the aurora,' Sofie said wistfully, 'to try and bring it closer!'

LEFT **Not many footballers can say they've played under a display of the Northern Lights, but for Greenland teams it is a regular event, and one way to brighten the long Arctic winter.**

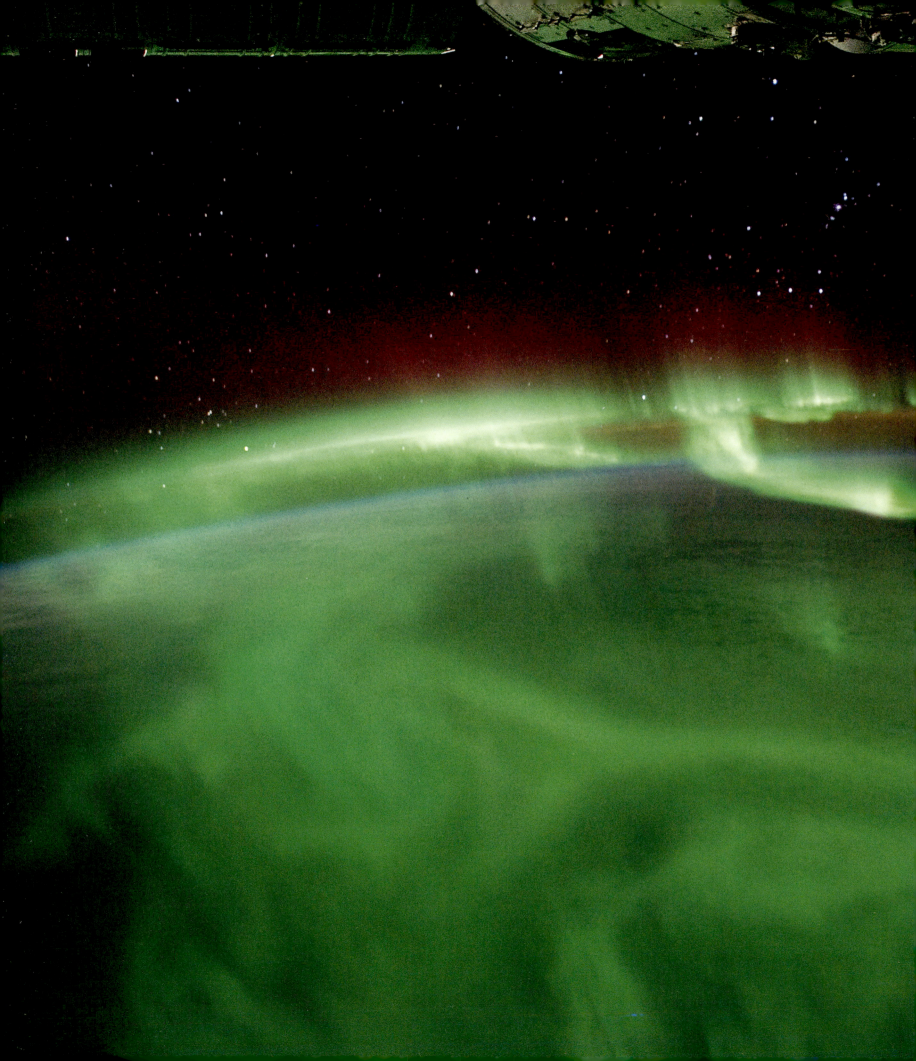

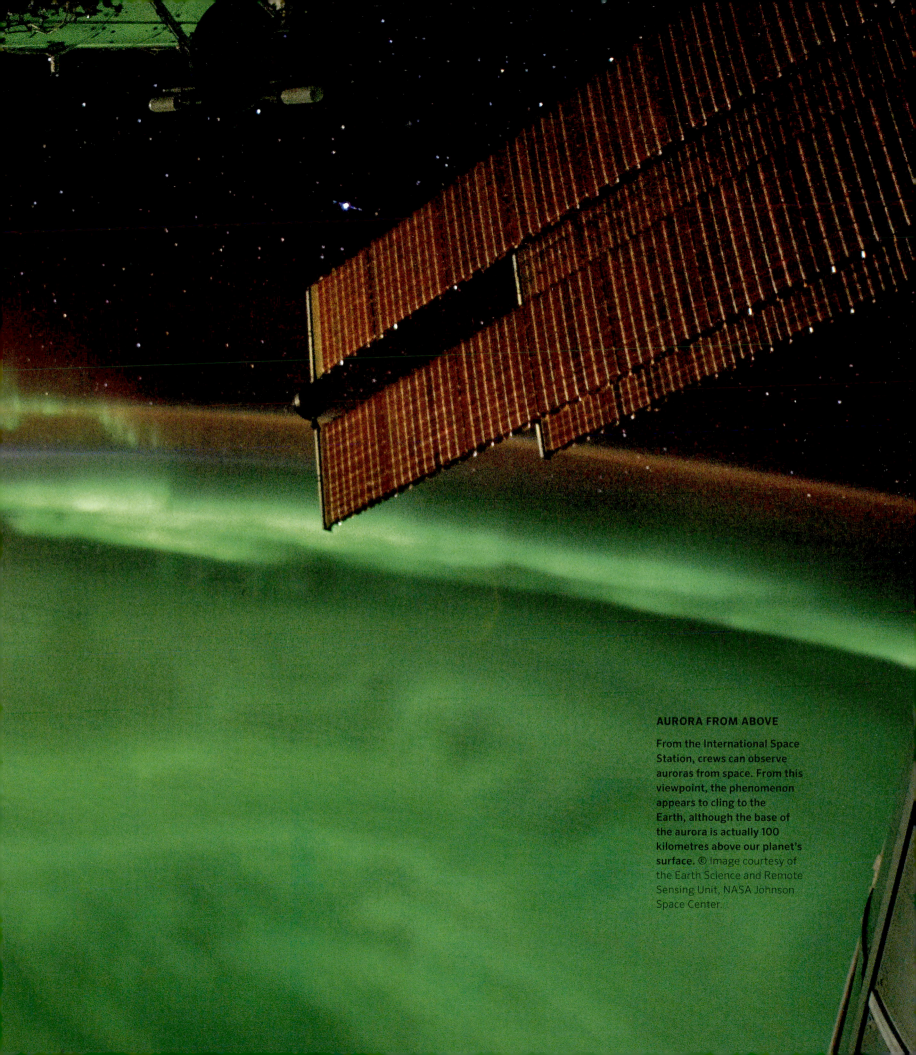

AURORA FROM ABOVE

From the International Space Station, crews can observe auroras from space. From this viewpoint, the phenomenon appears to cling to the Earth, although the base of the aurora is actually 100 kilometres above our planet's surface. © Image courtesy of the Earth Science and Remote Sensing Unit, NASA Johnson Space Center.

Chasing the lights

The *Earth from Space* film crew on the ground had a less romantic first encounter with the aurora. It might be a common occurrence in Greenland, but with a limited window – just ten days – for filming, three things had to coincide: firstly, aurora activity; secondly, a clear sky; and thirdly, hope that the extreme cold did not knock out the specialist camera equipment ... or the crew!

'On the second night,' recalls Justin, 'it looked as if our luck was in. As we climbed the hill wearing snowshoes, and with my pocket stuffed with explosive bangers to scare away inquisitive polar bears, everything looked good. A faint streak of green was glowing overhead, and it was getting stronger as we watched it dancing on the horizon. It lit up the giant icebergs that were grounded in the frozen bay below. Camera operator John Shier began to set up our timelapse cameras, and then the wind started.

'The skies above remained clear and the aurora was rippling away, but the wind became increasingly stronger. It picked up the snow and literally hurled it at us.

'John struggled to operate the cameras. Intricate settings, difficult to set at the best of times, were nigh on impossible in these conditions. He was forced to wear a thin pair of gloves and, very soon, his fingers were numb. The wind in these parts seemed to have a way of piercing any gap in our clothing, and we shivered uncontrollably. The wind chill that night was minus 47°C, but we got a few of the shots we needed.'

For most of the rest of their assignment, the team was teased by the weather. The chances of catching an aurora in full glory were looking grim. On the final night the clouds rolled in. The crew was due to fly out at 05.30 the next morning, and Justin reluctantly made the call to retrieve the cameras. The shoot was effectively over, but as they made a downtrodden and disappointed trudge back up the hill, the sky suddenly cleared. With four hours to go, the team captured a spectacular light show.

'The aurora had left it late,' enthused a grateful director, 'but we got the shots that we needed, albeit by the skin of our teeth.'

RIGHT **The waving green and red curtain of the Aurora Borealis is reflected in the ice and snow on the Greenland coast.**

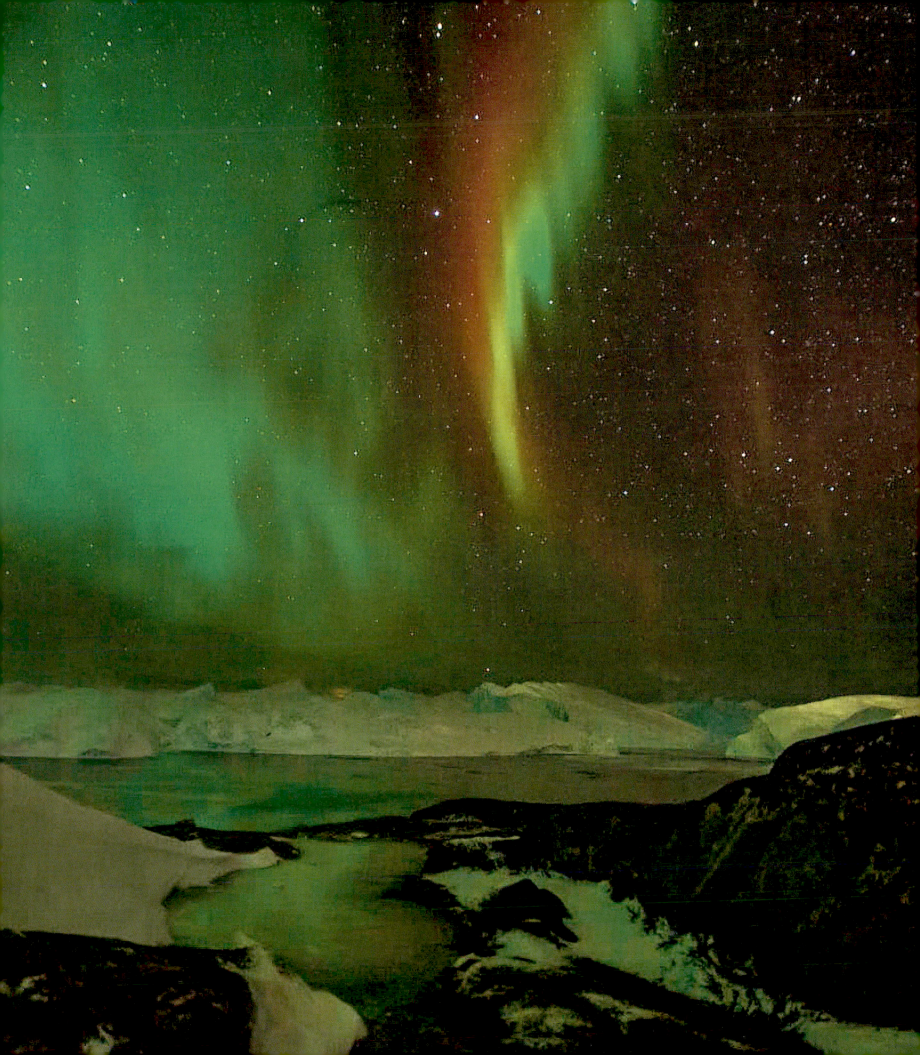

Swirling seas and red tides

Some of the most mesmerising satellite images are obtained when the cameras point down at the sea. In spring and summer, especially at high latitudes, the increase in sunlight causes the phytoplankton to bloom. At sea level, these blooms are unremarkable, but from space they can be seen to create vast swirling patterns of vivid blues and greens.

The planktonic organisms responsible, such as diatoms, are sometimes known as 'the grasses of the sea'. Their single cells contain chlorophyll, the magic chemical that, using energy from sunlight, can change carbon dioxide and water into sugars, with oxygen as a by-product. It makes them among the most important organisms on Earth. They not only help sequester the greenhouse gas carbon dioxide and produce life-giving oxygen, but they are also at the base of most oceanic food chains. The phytoplankton is eaten by zooplankton, such as krill and invertebrate larvae, which is food for small fish, such as anchovies and herring, which, in turn, are prey for bigger fish, and so on up the chain to the top predators, such as sharks and whales. So, when the plankton blooms, everything else goes into overdrive.

Off the coast of Alaska, the spring and summer blooms attract herring, which are food for humpback whales. They travel all the way from Hawaii and Baja California just to be at the feast. They're joined by the locals: immensely agile sea lions and hundreds of swooping seabirds, take advantage of the way the whales concentrate herring into tightly packed shoals. A bloom, however, can be a killer, as well as life-giver.

Dinoflagellates are tiny organisms that are also part of the phytoplankton, but, when the populations of certain types skyrocket, there can be trouble. This kind of bloom often produces a distinctive stain on the sea's surface, a so-called 'red tide', although not all are red. They can be beautiful, but they are deadly. The organisms sometimes

BELOW **The rusty tinge to the sea's surface is a sure sign that a red tide has formed in nearshore waters. Shellfish may filter out and feed on the offending organisms, but the creatures that feed on them, including humans, are in danger of being poisoned.**

OPPOSITE **Blooms of marine algae are common in spring and summer at higher latitudes, such as here in the Barents Sea. Viewed from space, they can be seen to colour the sea's surface with swirls of green, turquoise and blue, the patterns created by the ocean currents.** © ESA.

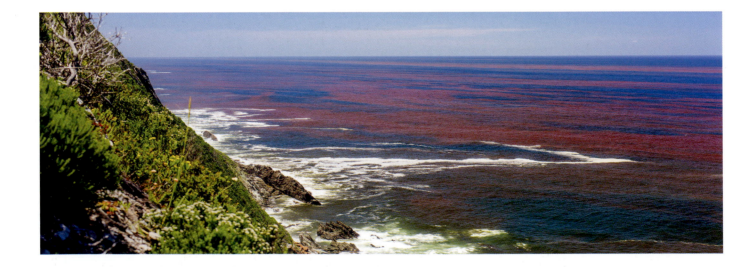

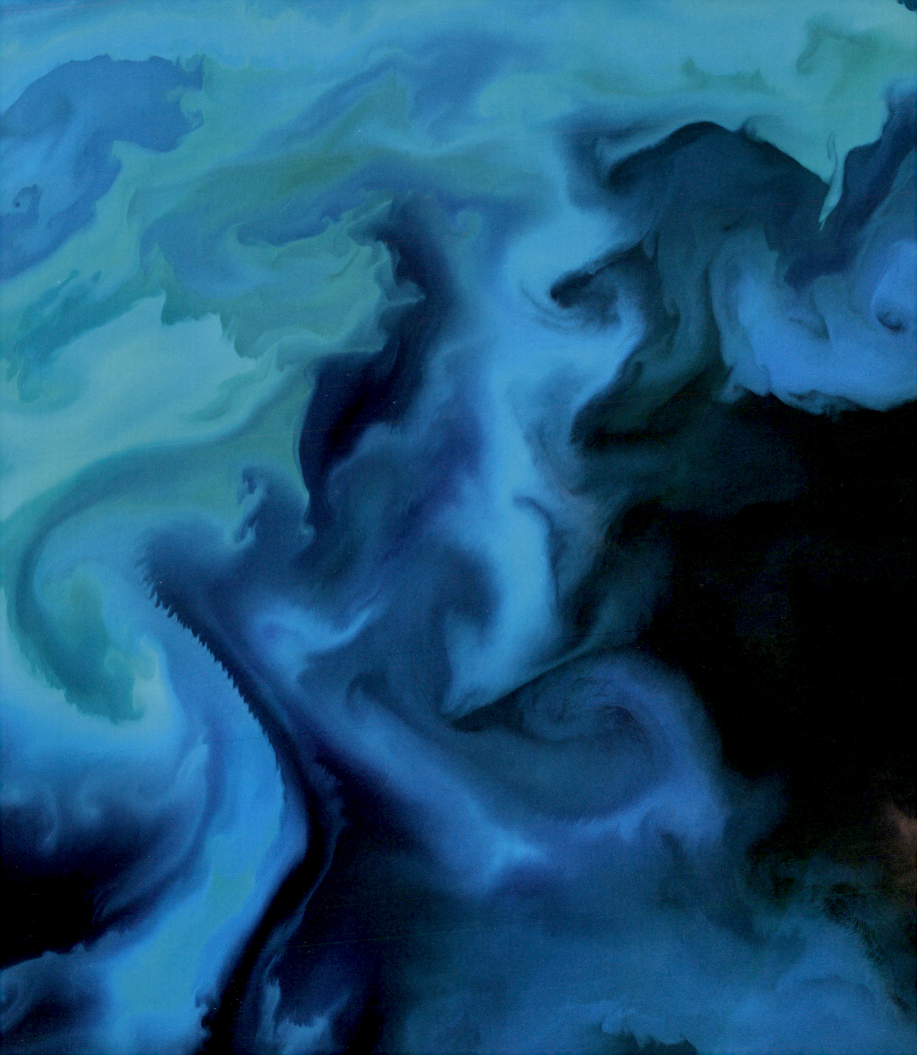

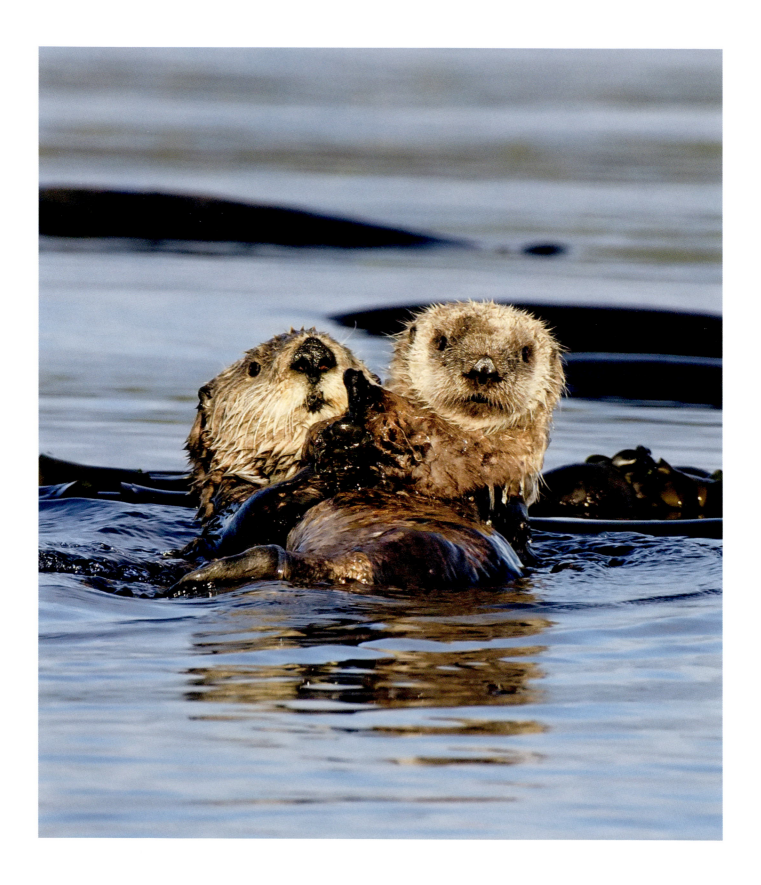

produce a poison that attacks the nervous system, making large fish, birds and mammals vulnerable. Some creatures, such as shellfish, seem immune, but, if they have filtered the poisonous plankton from the water, the neurotoxins are stored in their flesh. Any animals that eat the shellfish, including humans, may become seriously ill because their nervous system has been compromised – a condition known as paralytic shellfish poisoning (PSP).

Off Alaskan shores, the butter clam filters dinoflagellates from the seawater and accumulates their toxins, retaining them in its tissues as a chemical defence. Unfortunately, it is a favoured prey of sea otters. In the past, many sea otters have died because they ate contaminated shellfish, but it seems that some families are learning about the danger. Butter clams living in the inner passages of the Alaskan coast contain toxins throughout the year, but those on the outer shores do not. The otters have learned this pattern. They now confine themselves to the outer shore where the shellfish are safer. It is even thought that mother otters take their youngsters into unsafe areas to teach them what and what not to eat – an invaluable lesson.

Their neighbours, the humpbacks feeding offshore, are not immune either. Mackerel containing neurotoxins that cause PSP in humans have been implicated in the deaths of humpback whales. At Cape Cod, on the east coast of the USA, for example, 14 humpbacks succumbed due to eating toxin-laced mackerel during a five-week period in the summer of 1987. So, a change in the colour of water can bring a bounty and succour life … or it can kill, and it's not confined to the sea.

OPPOSITE **It's sunset off the coast of Vancouver Island, Canada, and a northern sea otter mother and her dependent pup have anchored themselves with bull kelp to prevent them from drifting out to sea on the falling tide.**

BELOW **A group of humpback whales is bubblenet feeding off southern Alaska. One whale blows a circle of bubbles that rise up and trap shoals of herring. The whales then swim up through the column with the mouths agape, bursting through the surface like an untidy flower.**

OVERLEAF **When spring comes to the Gulf of Alaska, and the days get longer, its inshore waters are coloured by the blooms of algae. The algae are food for marine invertebrates, which in turn are food for small fish, such as herring. The huge shoals of herring attract humpback whales from all across the Pacific Ocean.** © NASA

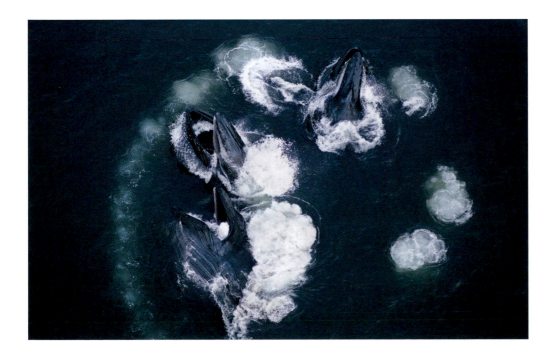

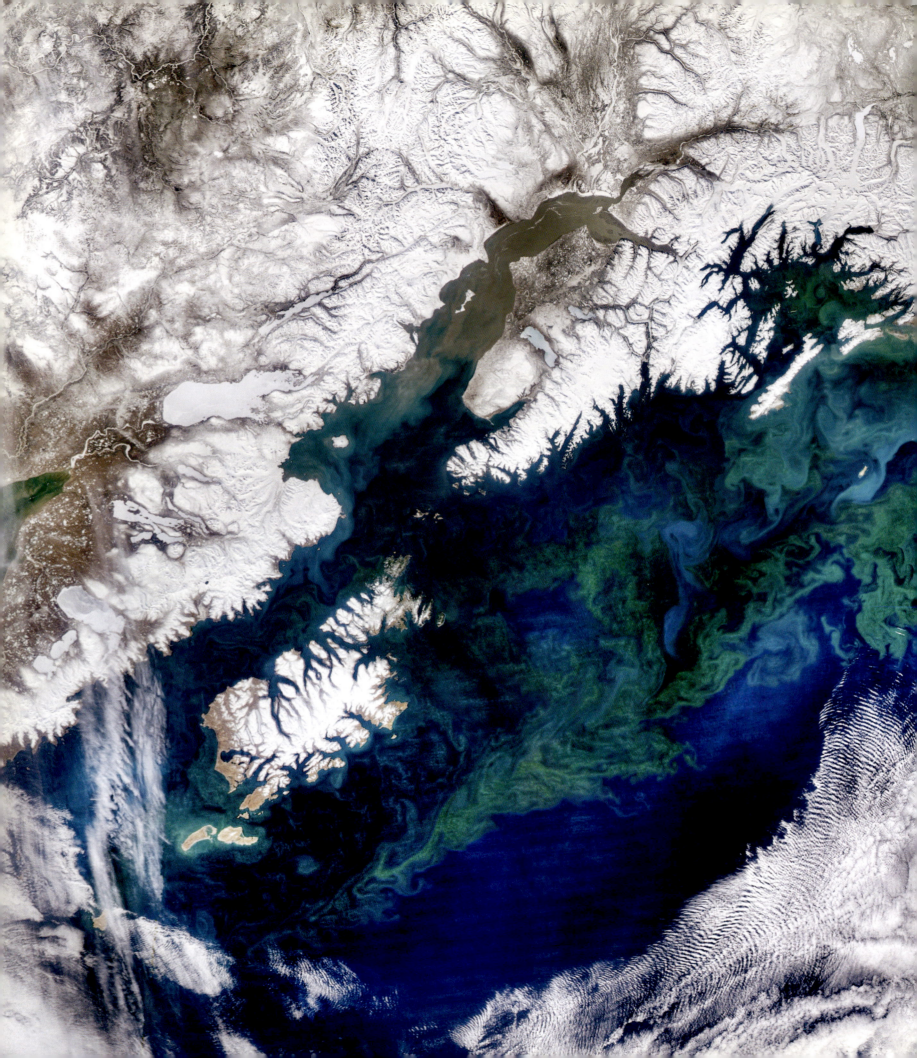

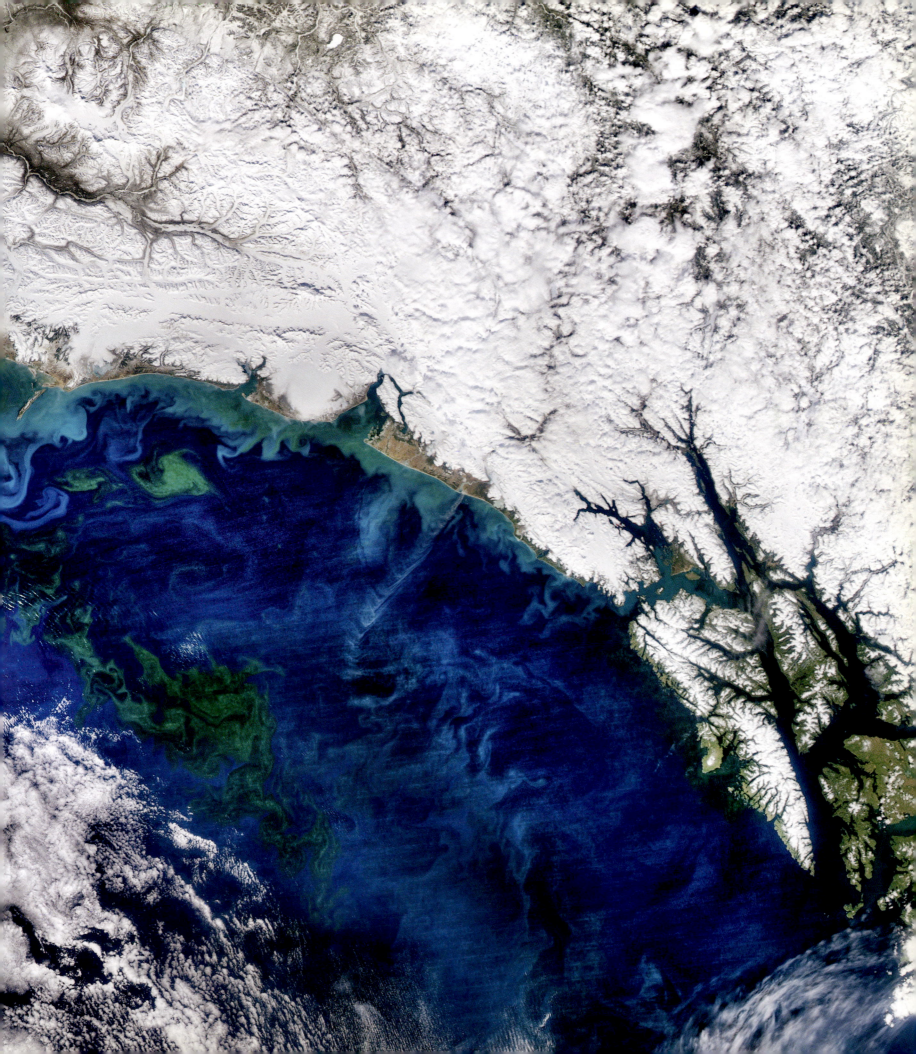

Dance of the Firebirds

Satellite pictures show a clearly visible amorphous pink smudge that changes its shape like a gigantic amoeba against the bright patches of red, orange, blue, white and black of Lake Natron. Natron is a soda lake that sits in the East African Rift in northern Tanzania, and is fed by mineral-rich hot springs and freshwater from the Southern Ewaso Ng'iro River. The lake itself is shallow, little more than three metres in the deepest places, so, as the wet season gives way to the dry, its waters evaporate and the salts and minerals are concentrated to such an extent that the pH can be ten or above. The water that is left is so caustic that it can burn the eyes and skin, but salt-tolerant cyanobacteria thrive, colouring the deeper water red and the shallows orange. Otherwise, it is a difficult place to live.

BELOW AND OPPOSITE
Pink flamingos fly over Lake Natron's highly saline, brown-red waters, the colour due to salt-loving cyanobacteria. Even the salt crust is coloured by them. The smudge of pinks and reds can be seen clearly from space. © 2018, Deimos Imaging SLU, an UrtheCast Company.

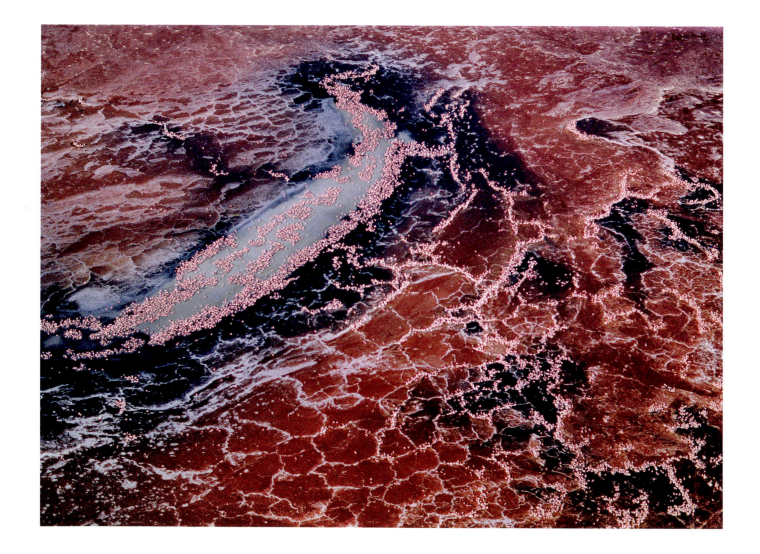

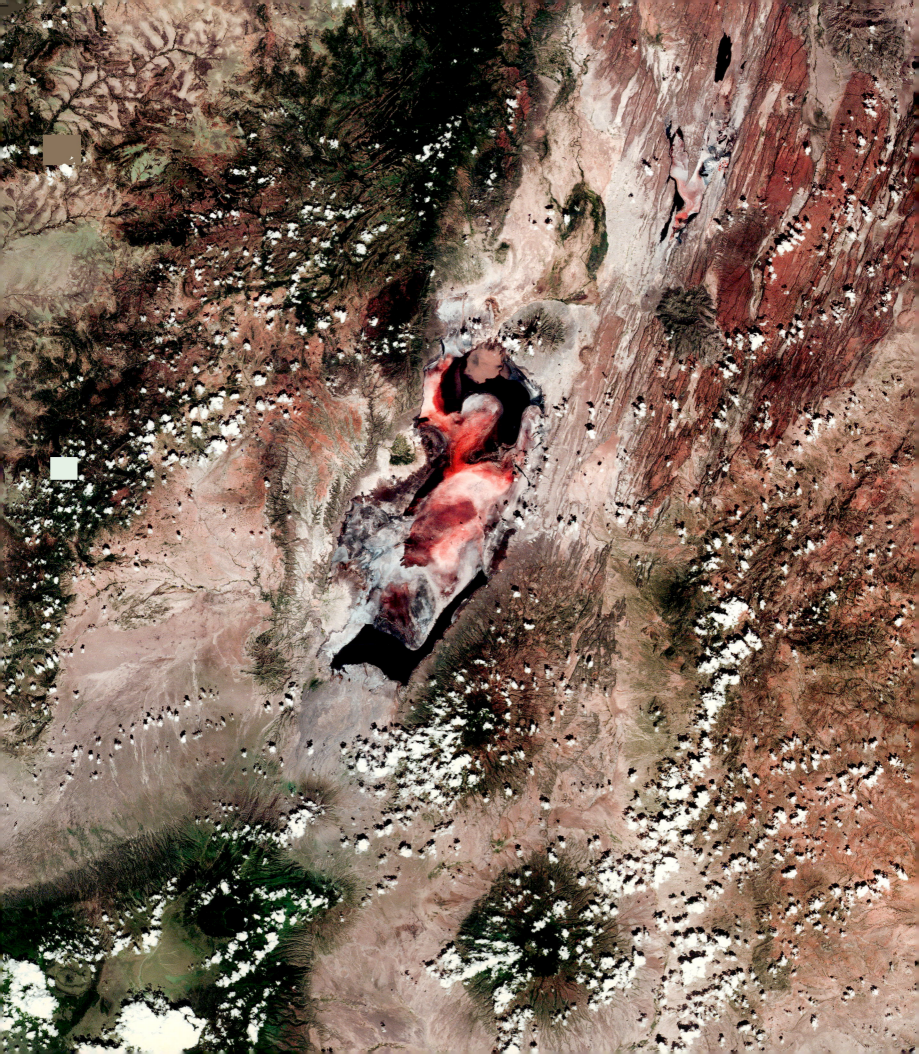

Rainfall is spasmodic, the lake temperature can be up to 60°C and the air temperature can exceed 40°C. Around the lake's edge, birds and bats, confused by its extreme reflectivity, have crashed, died and their bodies turned into grotesque salt-encrusted statues. It is a living hell, that ornithologist Leslie Brown, who almost died walking out on the soda flats, once described as 'the foulest place on Earth'. Despite these extreme conditions, however, 2.5 million bright pink lesser flamingos choose to breed here. They come because the hostile conditions deter many of their potential predators.

At the end of the dry season in September, the moving area of pink represents the largest single population of lesser flamingos on the planet, with 75 percent of the world's lesser flamingo chicks hatching here each breeding season. Their nests are conical-shaped mud mounds set on white, salt-encrusted 'islands' that form from the concentration and crystallisation by evaporation of the soda-rich waters. Before they are occupied, however, the adult birds must find a partner, and to do this, they 'dance'.

Like the performers in a line-dancing routine, large groups of birds strut in synchrony back and forth across the lake, their necks stretched and their heads twisting first one

BELOW **Lake Natron's lesser flamingos crowd together at the start of their communal dance. Birds display up to 136 different moves: it's thought that the more complicated the display, the more successful the bird.**

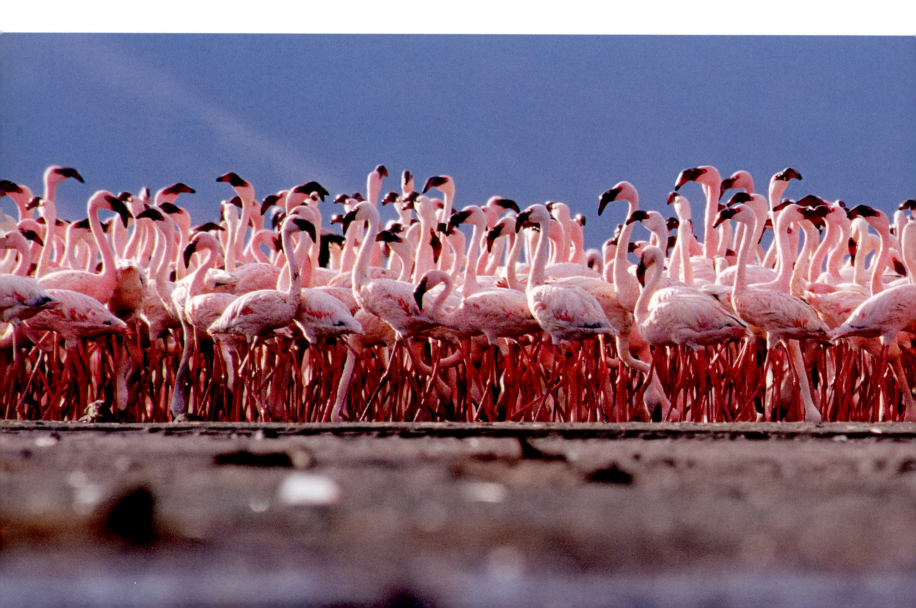

way and then the other. The rules of the dance are not clear, but eventually many pair off and mate. If unseasonal rains do not swamp the nests, chicks appear about 28 days later, usually during the start of the wet season. Both parents feed their chick, flying to neighbouring lakes where they stock up on food, such as the microscopic blue-green alga Spirulina, which they sift from the water. When they return to the vast colony, their youngster must learn to recognise their calls, or it goes hungry.

At six days old, the fluffy grey chicks join enormous crèches, up to 2,000 strong, where, amongst other things, they learn to run, and eventually to fly. Despite the caustic moat around their nests, the chicks are not entirely safe. Eagles, vultures and marabou storks swoop in over the water to grab them, hyenas race in and brave the burning soda to snatch a bird and drag it to the lakeside, and, if that's not enough, surviving chicks can accumulate crystalline soda anklets that gradually increase in size as the bird wades through the soda-rich water. These heavy shackles make running, walking and even the smallest movement impossible. Eventually, they die. It is a serious price to pay for the relative safety the lake otherwise provides.

Our blooming planet

Seen from space, the mottled colours of planet Earth tend to change slowly and continually. White clouds build, billow and break up, the sea washes seamlessly between shades of blue and green, but the land itself can change almost in an instant, suddenly turning into a riot of colour. The architects of such dramatic transformations are the flowering plants.

They first evolved when the dinosaurs were still around, and they have not only outlived them, but, in their own way, they have come to dominate the Earth. From space, mass flowering events create some of our planet's most impressive colour displays.

In spring, savannahs, steppe and prairies turn from empty plains of beige to swathes of verdant green as grasses recover their vigour and freshness. In South Africa's Namaqualand the first rains transform the landscape from arid semi-desert into a vast pageant of wildflowers, enticing fields of orange or yellow Namaqualand daisies. They bloom in such enormous numbers that they create one of the largest natural flower shows on Earth.

It is not only flowers that are the harbingers of change. In the autumn, all across New England leaves bring colour. Woodlands transform dramatically from green to reds, oranges and yellows as chemical changes in their leaves help trees prepare for winter: a colourful reminder for local wildlife to do the same.

A grizzly bear, in the northern parts of North America, is not active all year. It opts out for up to seven months, but, before entering its chosen winter den, it must eat exceptionally large quantities of high-energy food. Some bears stock up on salmon, others graze on berries, or whatever else is seasonally abundant, to pile on the pounds. They can consume an astonishing 100,000 calories a day, the equivalent of eating over 1,200 boiled eggs. Then, generally about two weeks before shuteye, the bear's body gets ready for change. When the amount of fat reaches a critical point, the thyroid gland causes a change in hormone levels, and the bear heads for its den.

During winter, a bear's body does not shut down too dramatically, leading some scientists to declare that it is not true hibernation. Even so, it takes a breath every 45 seconds and its heart beats less than 20 times a minute. It does not eat, drink, defecate or urinate for the entire time. It is part of an animal's annual life cycle that accompanies the changing colours of the seasons.

OPPOSITE **A 'superbloom' of wildflowers colours the Temblor Range on the northeast edge of the Carrizo Plain National Monument in California.**

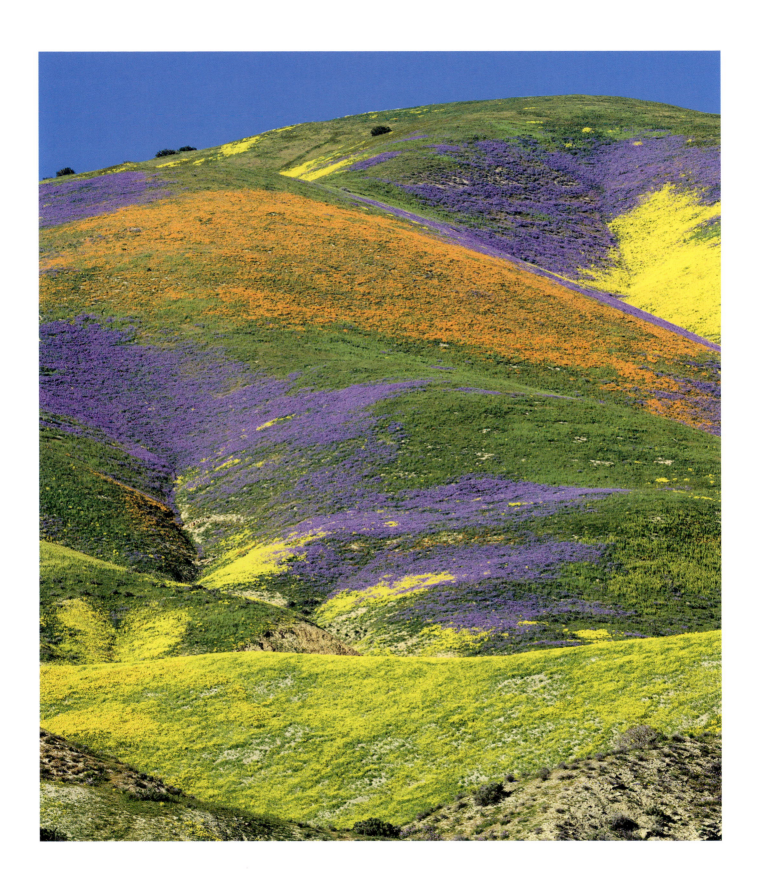

RIGHT Seen from the air, fall in Wrangell–St. Elias National Park, Alaska, results in a mosaic of vibrant colours.

OVERLEAF Satellite view of the Great Lakes area in the fall. The seasonal colour change of leaves turns large areas of the forest reddish-brown. © NASA

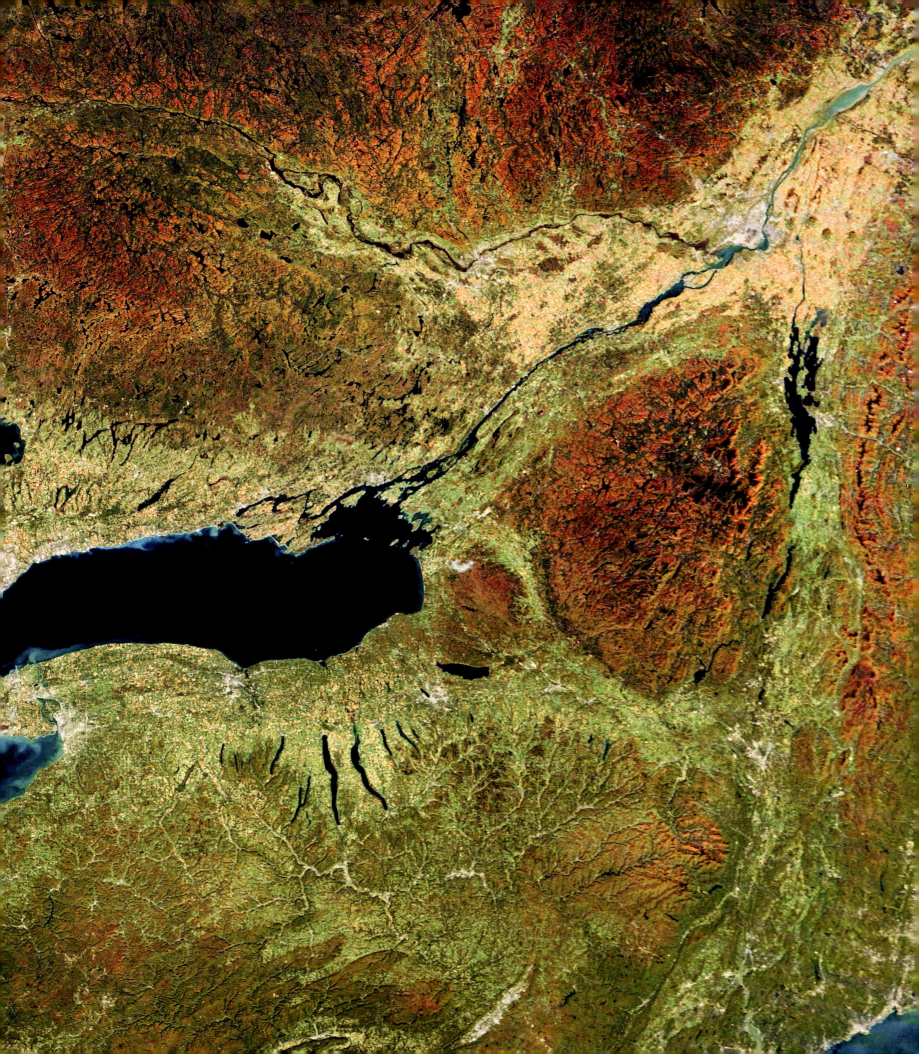

Man-made rainbows

People are directly responsible for extensive colour changes too. Along the shores of San Francisco Bay, ponds of brine for salt extraction are transformed into a kaleidoscope of colours. As the saltwater is moved from one pond to the next, the salinity increases and different kinds of micro-organisms thrive. They cause the water to change colour from blue-green to mustard-yellow to shades of magenta. It is so vibrant that it is not only a landmark for window seat passengers flying in to San Francisco airport, but also for astronauts on the International Space Station.

The red rocks of Utah are splashed with vivid electric blue where coloured dye is added to potash lakes. The darker colour absorbs more sunlight and heat, speeding up the evaporation process and increasing the yield of potash, a key ingredient in fertilisers. Water is pumped underground to dissolve the potash, leaving other minerals undisturbed. The brine, thick with minerals, is then siphoned into the evaporation lakes and the dye added. About 300 days later, the potash crystals are scraped from the bottom of the rubber-lined pools. It's a way of mining potash without miners having to go underground.

The Gobi Desert is brought alive by red shapes that appear on its sandy surface. The bright crimson patches are chillies left out in the Sun to dry. China is now the world's largest chilli farmer, with about 1.6 million hectares of land devoted to producing 31 million tonnes a year. In Massachusetts, USA, the colour red signifies cranberry crops

OPPOSITE AND BELOW **Satellite images show a colourful potash mine near Moab, Utah. Salt-laden water is pumped from the mine and held in evaporation tanks. As darker colours absorb more of the Sun's heat, the liquid is dyed dark blue, accelerating the crystallisation process.** © NASA.

OVERLEAF **Farmers dry red chillies under the Sun near a town in the Gobi Desert.** Satellite imagery courtesy of © 2018 DigitalGlobe, a Maxar company.

that can be seen from space. When the berries are ripe, the boggy fields are flooded, ready for the harvest. The high water level causes millions of cranberries to float to the surface, where they can be skimmed off. It turns the whole landscape red.

In the Philippines, farmed seaweeds, known as *guso*, create a patchwork of dark green, blue and brown in the shallow coastal waters, while in the south of France, Provence turns purple with the colour of lavender. In the Netherlands, almost perfect parallel lines of tulip fields are like vividly coloured bar codes. About 132 square kilometres of farmland is devoted to the production of two million tulips, the largest fields of farmed flowers anywhere in the world. But one of the most spectacular sights must be the flowering of rapeseed in southern China, and the *Earth from Space* team were there to capture farming's most dramatic colour transformation. With Deimos satellites positioned overhead, the images acquired in January showed a vast green landscape, but two months later it was bright yellow.

China produces about 20 percent of the world's rapeseed oil each year, and it is used both for cooking and as bio-fuel. The farms are concentrated in the Luoping region

BELOW **A boom encircles bright red cranberries floating on a flooded cranberry bog. A pump truck or a conveyor belt lifts the cranberries into a truck and they are taken away for processing. 'Wet harvesting' is more efficient than handpicking the fruit.**

OPPOSITE **Bulb fields in the Netherlands as seen from space. The fields are at various stages of growth. About 77 percent of flower bulbs traded worldwide come from the Netherlands, the majority being tulips.** © 2018, Deimos Imaging SLU, an UrtheCast Company.

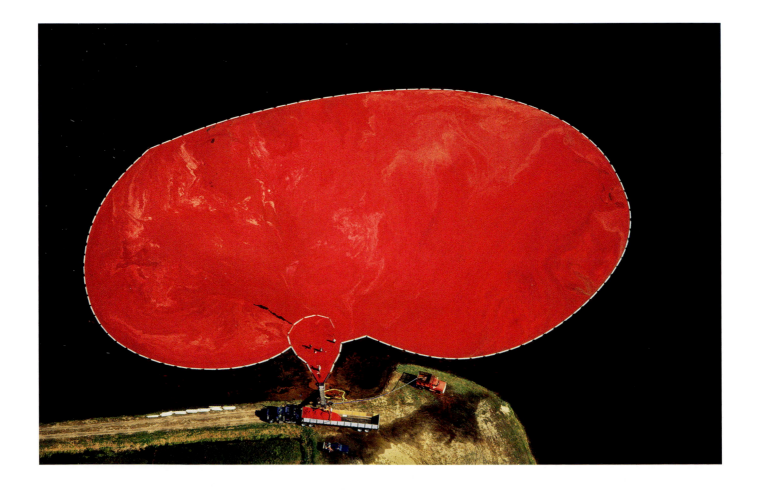

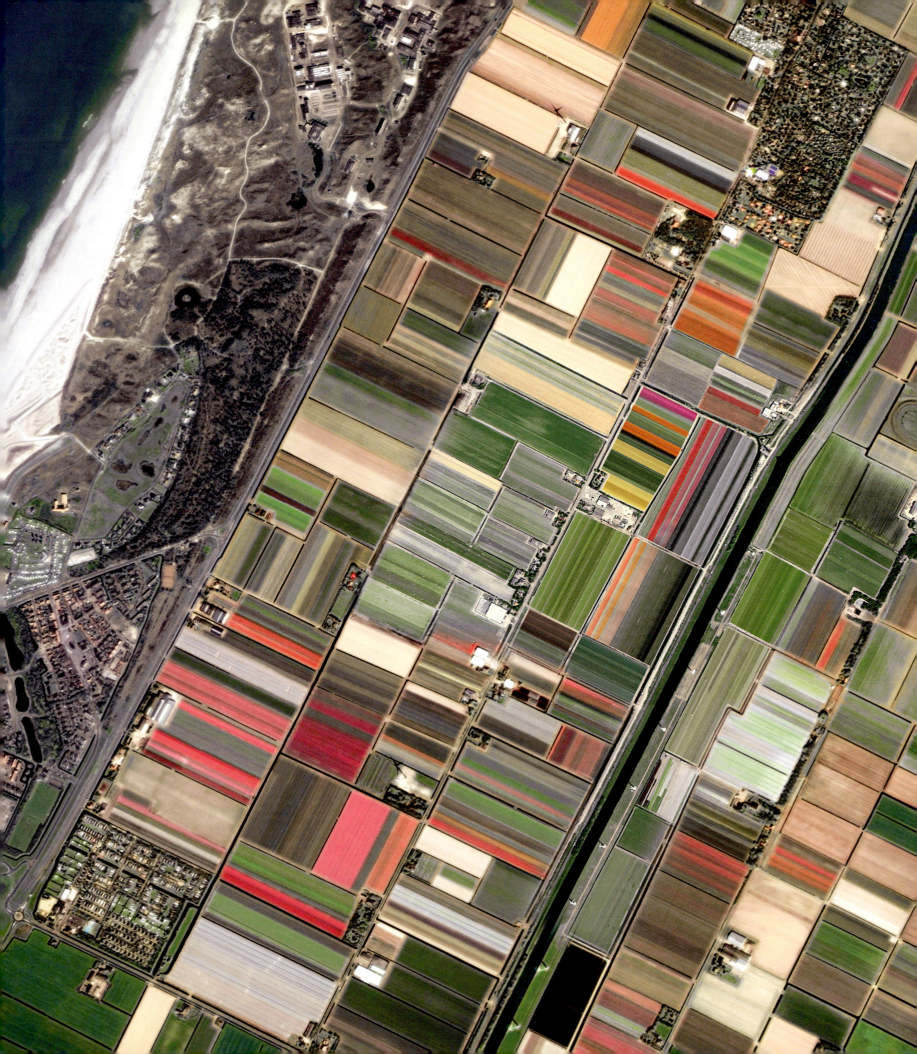

of Yunnan. In the rugged landscape in the north of the region, the crop follows the contours of the ground, much like rice terraces, but in the south the fields stretch from one horizon to the other, the bright yellow sea of rapeseed flowers interrupted only by the brown and green 'islands' of rounded hills. In amongst the fields you will find Mr Dai. He is here for the bumper crop, but not for the oil.

Mr Dai and his son drive throughout Yunnan province, timing their arrival at any one place for when crops are flowering. Their battered truck is stacked with beehives, for Mr Dai is a beekeeper and the profits from the honey his bees will make will feed him and his family for another year. But as he and his son arrive, the weather is not on their side.

'It's cold and grey,' he says, 'so the bees will not fly.'

Timing their arrival is critical. There are only two weeks of full bloom before the rapeseed is sprayed with a pesticide that would kill his bees. Luckily the skies clear and the bees set to work … lots of them! One bee will only produce a twelfth of a teaspoon of honey during its lifetime, so Mr Dai has 1.5 million working for him.

BELOW **Mr Dai must ensure he arrives with his beehives at just the right time, as all the rapeseed flowers bloom simultaneously and only for a couple of weeks.**

OPPOSITE **Rapeseed fields are ripening, while others have just been planted with other subsidiary crops.**

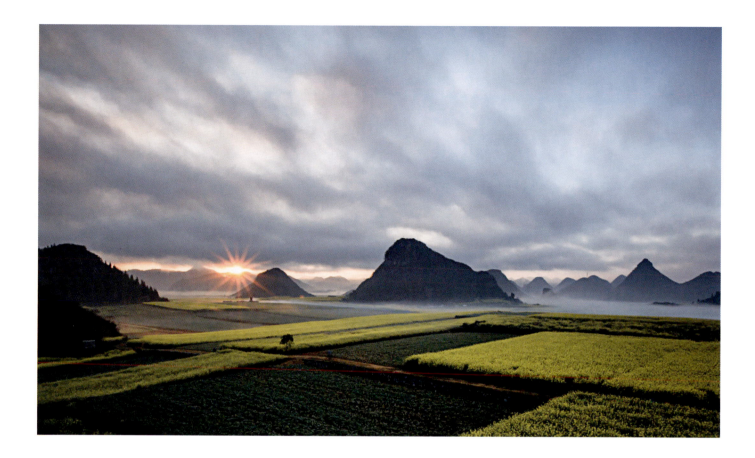

Mr Dai is not the only beekeeper here. Many other nomadic bee farmers arrive from all over China, each competing to make the sweetest honey to sell for the highest price, but Mr Dai is confident.

'My bees make beautiful sweet honey,' he claims, 'the best honey around!'

Colour is not necessarily the best indicator of good honey. It is the way it feels and tastes. Miss Zheng is the local honey taster, and everyone is out to impress her sweet tooth. She supplies all the big shops in China. Mr Dai offers her a spoonful of this year's crop. She is impressed.

'Very nice,' she says enthusiastically, 'yes, very nice.'

With the pesticides due to be sprayed within the next couple of days, it is time for Mr Dai and his son to pack away the hives and move on. The rapeseed is so successful here because of the bees that pollinate it, but with stricter controls being placed on crops, the balance between insect life and chemical farming has never been more delicate. The use of certain types of pesticides has had a devastating effect on bee populations worldwide. In Europe alone, one in ten wild species of bees are facing extinction. Without more positive intervention, the future for these crucial insects looks bleak.

OVERLEAF **China's rapeseed fields are green or brown before the flowers appear, but pictures from space reveal vast areas transformed into yellow when they bloom.** © Satellite imagery courtesy of © 2018 DigitalGlobe, a Maxar company.

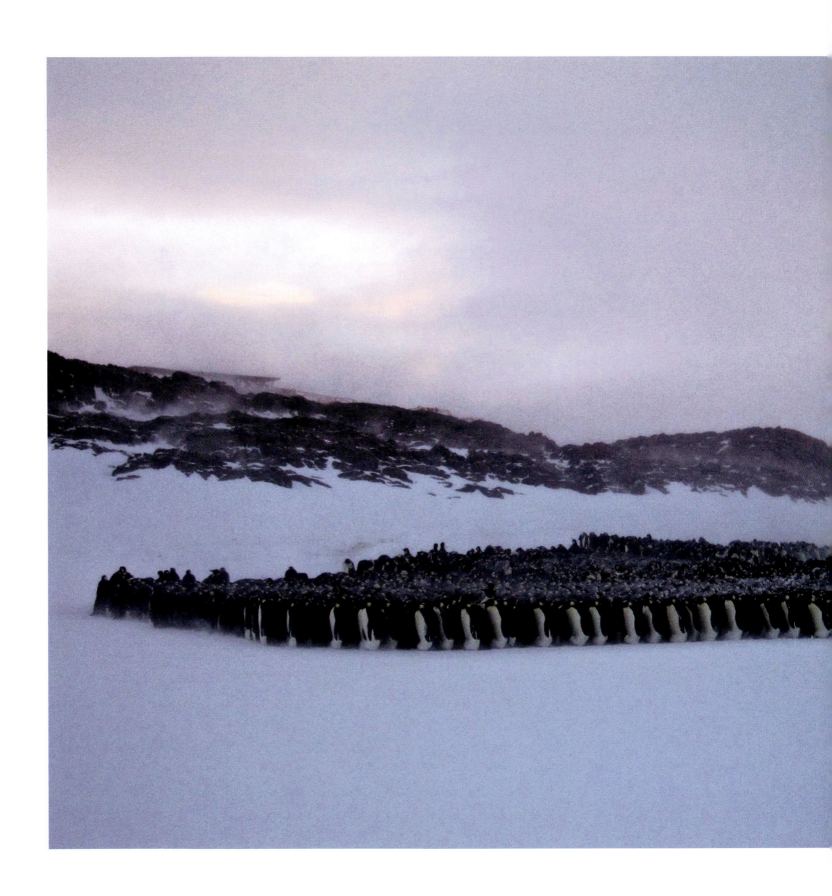

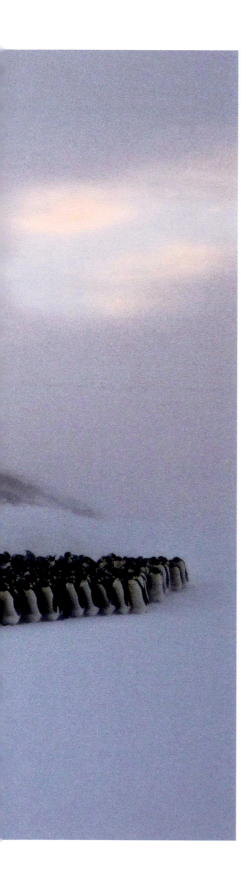

builds up around their feet. As they move en masse in search of fresh snow, the penguins leave a dark trail of guano behind. This telltale stain is what the scientists had first spotted on the satellite pictures. It then led them to pick out the guano trails of individual birds, moving to and from the sea. They also discovered birds in unexpected places.

Generally, breeding colonies form on the sea ice, but with climate change affecting ice formation, the satellite pictures were revealing birds choosing more stable ice further from the sea. It is a decision that has forced the penguins to travel greater distances and to negotiate new and potentially dangerous barriers, such as ice cliffs. Climate change is shaping their behaviour, and has already seen one colony on the Antarctic Peninsula disappear.

This study was the first comprehensive census of an animal species taken from space, and it comes at just the right time. With melting ice becoming a serious concern in the Antarctic, scientists can now closely monitor the birds over time, and assess the affect of climate change on numbers.

Not far away, in the Danger Islands, at the northern tip of the Antarctic Peninsula, scientists using Landsat images spotted the dark guano stains of another species – the Adélie penguin – and have discovered 1.5 million birds that they had no idea were there.

This archipelago lives up to its name. Its islands are notoriously difficult to get to, and its waters perilous. Even in summer, the place is surrounded by thick sea-ice, so nobody had really explored them before, but, prompted by the satellite pictures, an expedition with scientists from several US and UK universities and marine labs made the trip. As the Landsat pictures are not detailed enough, the team also used ground observations and drones in the air to help count the birds.

The results of their census were significant. They showed that these birds had escaped the warming atmosphere and sea surface temperatures that seem to be causing a population decline in the species on the western side of the Antarctic Peninsula. Adélie penguins eat mainly krill, and these shrimp-like creatures proliferate under the ice. With less ice, there are fewer krill. Their location has also protected them from another problem that other colonies face. Ice loss allows more cruise ships to come closer to nesting colonies, spooking the birds. The Danger Islands have plenty of ice and no ships, so the birds there have sufficient krill, they are not disturbed, and the population is robust.

Despite all the modern technological advances in today's world, there are still remote parts of the planet that scientists and explorers cannot reach easily and so we know very little about them. Satellites are changing the way we study these hard-to-get-to places, and the discoveries that have been made to date are nothing short of extraordinary.

LEFT **A group of male emperor penguins, each with an egg carefully balanced on its feet, keeps warm by huddling together. The huddle is continually changing as birds shuffle around to be in the centre and out of the wind. They remain this way for about nine weeks in the depths of winter.**

Sapphire lakes

At the other end of the world, a very different change in the colour of ice is of growing concern. Seen from space, large areas of ice and snow usually appear as brilliant white, but on the Greenland ice cap another colour has started to appear. There are ribbons of turquoise melt water crisscrossing the surface of the ice, and these rivulets flow into depressions forming huge sapphire lakes. The white wilderness is turning blue.

The water has this vivid colour because blue light is the least likely to be scattered, and the water's purity, together with the white reflective background, makes the colour even deeper. This colour change may be attractive, but it has a downside: as the region turns blue more energy from the Sun is absorbed, heating the surface and increasing the warming effect. Looking at the satellite pictures, Justin Anderson is seduced by the colour, but troubled by the scale.

'The imagery is just so beautiful that you have to remind yourself this is not normal, and, whilst the pictures are mesmerising, it's actually a tragedy.'

During the course of the spring and summer, the patchwork of smaller lakes coalesces, creating fewer but larger ones. In places, the water drains away, leaving vast dimples on the ice, while some melt water streams become torrents that slice right through the ice and down to the bedrock far below. Here, it acts as a lubricant, accelerating the movement of glaciers that flow down from the central ice cap. During the past 20 years, it's been estimated that some of Greenland's glaciers have doubled their speed. The result? The ice cap is shrinking and 1.7 million litres of water per second drains into the sea, with an estimated 270 gigatonnes of ice being lost from the Greenland ice cap each year – that's enough melt water to fill 110 million Olympic-size swimming pools. It is a catastrophic loss, which makes Greenland's ice melt one of the main causes of rising sea levels. Beautiful though they are, Greenland's blue lakes are a clear warning that something is seriously wrong on our planet.

BELOW **The water from Greenland's sapphire lakes eventually cascades down cracks and gaping holes to the rocks below the glacier. It then gushes out at the edge of the ice. Less water emerges than expected, so scientists speculate that there are also sub-glacial lakes under the ice as well. Water at the base of glaciers helps lubricate their movements, so they are now looking at how these lakes are going to have an impact on ice melt in a warming world.**

OPPOSITE **Seen from space, the melt water lakes show as flecks of blue on the Greenland ice cap.** © NASA USGS.

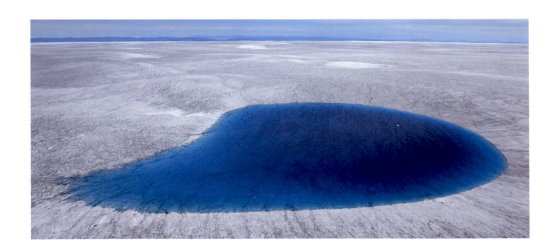

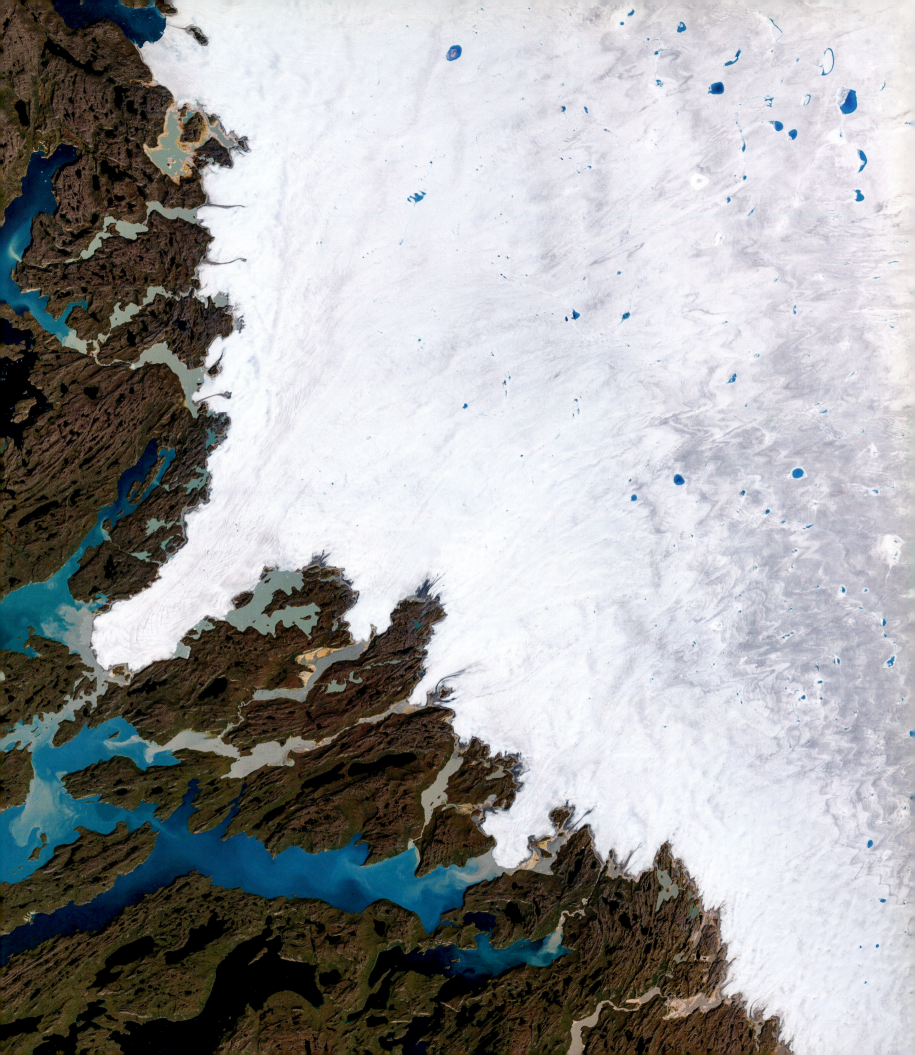

White-out

In the tropics, white is the warning colour, not blue, and one of the key places to see the impact of this colour change is on Australia's Great Barrier Reef. Under normal circumstances, this tropical coral reef and its shallow waters are a multi-coloured world of marine creatures: extravagantly coloured fish, gaudy sea slugs, neon shrimps and prawns, and of course, the varied hues of the corals themselves.

Corals get their colour from dinoflagellates, known as zooxanthellae or 'zooks' for short, which live in the tissues of the coral polyps. Polyps resemble miniature sea anemones, and it is the polyps of stony corals that build coral reefs, helped by their lodgers. These onboard zooks take energy from the Sun, and manufacture food from carbon dioxide and water, in a similar way to green plants and free-living phytoplankton. The coral polyps also trap food with their tentacles, but the tiny photosynthetic zooks are the main driving force behind the growth and productivity of the reef. The relationship, though, is a sensitive one.

Polyps on tropical coral reefs like warm, shallow water: 26–27°C is about right, but if the water temperature rises just a few degrees, the polyps become very sensitive to the change. The zooks living inside them start to create an excess of toxic chemicals that the corals cannot tolerate. They expel them. With the zooks gone, the coral turns white, a process known as bleaching. It can survive for a few weeks like this, but if the warming continues the coral eventually dies. This tragic loss of colour and of life has been occurring along large tracts of the Great Barrier Reef.

During 2015, 2016 and the beginning of 2017, two-thirds of the shallow water reefs bleached. During that time, the average global air temperature rocketed to such an extent that 2016 was declared the warmest year since records began. It was linked to El Niño, the warm phase of a climate cycle in the Pacific Ocean that has an impact on weather systems all over the world. In 2017, the influence of El Niño subsided, but temperatures remained high, with 2017 becoming the hottest year on record without an El Niño event.

The *Earth from Space* team visited Opal Reef, which was previously filmed for the *Blue Planet II* television series in 2015. At that time, the reef was bustling with life, but, as Justin Anderson found, just three years later it was completely bleached.

'The damage to the reef was devastating. As we swam over patches of good reef, the contrast to the bleached reef was stark. Forests of once beautiful electric-blue-coloured staghorn corals were now an eerie jumble of spiky rubble; all the life had gone.'

The reef will be slow to recover, but there is some hope coming from the 100 or so small but healthy reefs, lying down current. Scientists have discovered they are seeding the damaged reefs with fresh coral larvae. Nature is resilient, it seems, but, as the scientists who study the Great Barrier Reef and other tropical reefs in the rest of the world insist, there is no room for complacency. Any change from the multicoloured underwater world to the colour 'white' could still mean the end for a tropical coral reef.

OPPOSITE **A reef of staghorn coral has bleached. The coral polyps have ejected their symbiotic zooxanthellae, and, although they might survive for a short time without them, long-term bleaching will result in the death of the coral.**

OVERLEAF **Pictures from the Deimos-2 satellite show how rising temperatures have caused large sections of the Great Barrier Reef to bleach.** © 2018, Deimos Imaging SLU, an UrtheCast Company.

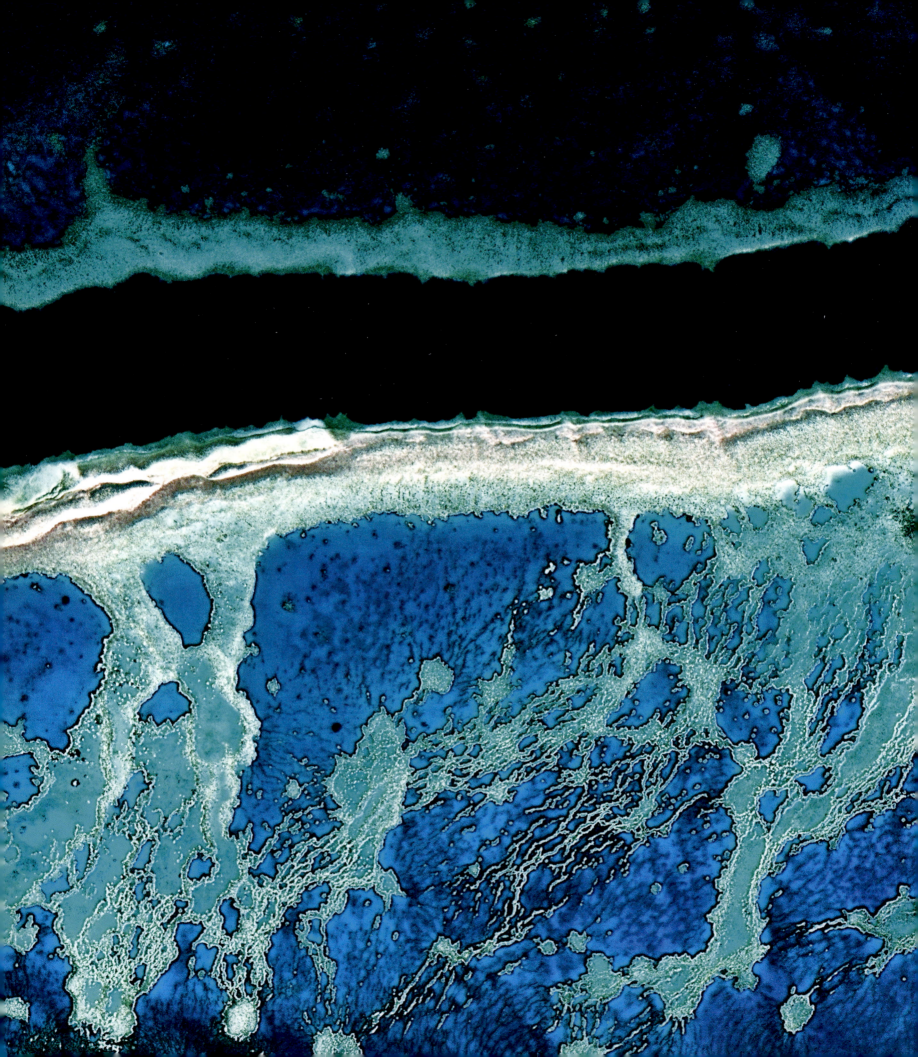

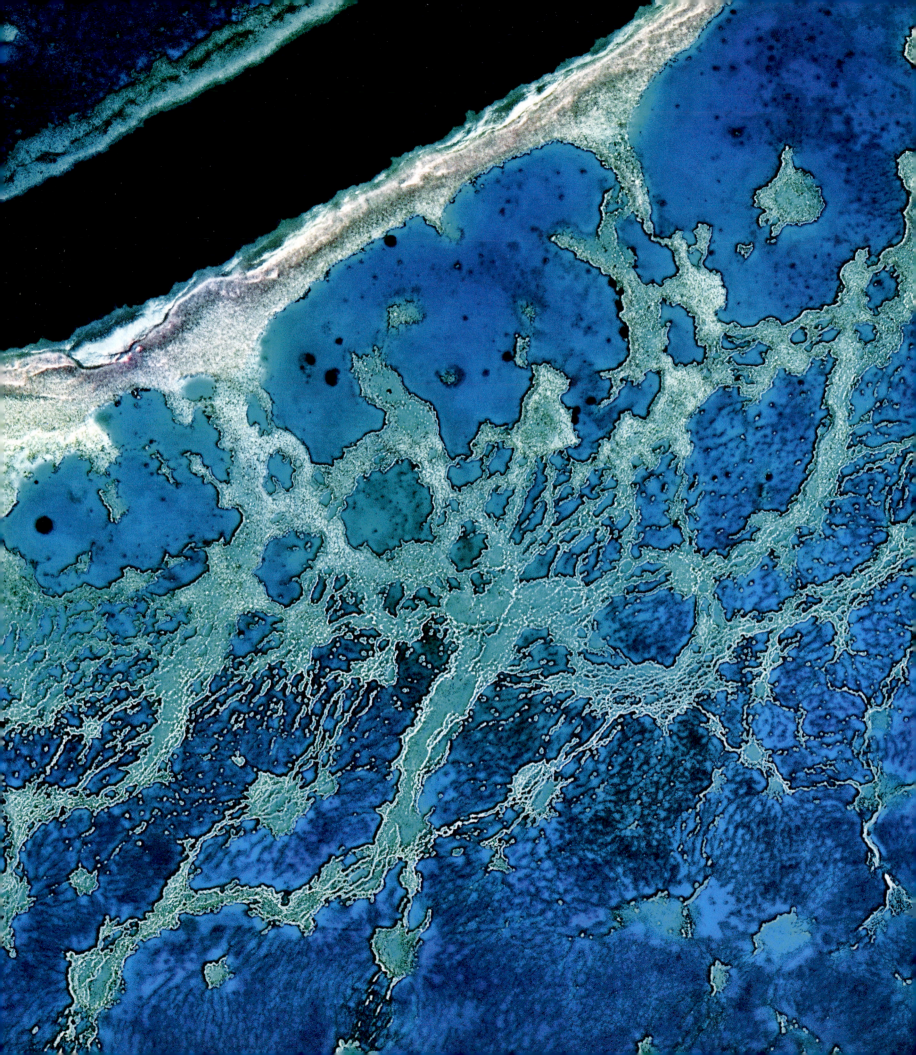

Close encounter

Stretching 2,300 kilometres from end to end, the Great Barrier Reef is the largest living structure on Earth, and clearly visible from space, even without high-resolution cameras. Offshore, in the northern sector, are the Ribbon Reefs, and here people have been getting up close and personal with a marine creature that was only recognised by science in the 1980s – the dwarf minke whale. At no more than eight metres long, it is one of the smaller baleen whales.

They can be seen close to these outer reefs from May to October with a peak during the southern winter months of June and July. They form the only known predictable aggregation of these whales in the world. It is thought they are here to meet others of their own kind, maybe to find a mate or just to socialise, and they do not confine their interest to other whales. They are exceptionally inquisitive, approaching boats and people in the water to within a metre. Justin Anderson was out there with them.

'It came out of nowhere, its torpedo-like shape emerging from the deep blue of the ocean. I could hardly believe it. I was with ten other snorkelers holding on to a long rope floating in the water behind our dive boat. And then I heard it, the unmistakeable sounds of a minke whale. Suddenly there were whales everywhere. It was hard to keep up with where they were coming from. Each whale seemed to have a different personality. A big one would come from behind, heading straight at you, as if looking to surprise you. A smaller whale passed directly below me, and then it turned so we could look each other in the eye. They were in no way threatening, just curious. It did make me wonder who were the tourists. This went on for hours, and it seemed there really was a connection between us. Unable to communicate in any other way, I took to waving hello with every close-up pass. I had made friends with a whale!'

Some of the whales Justin met have been coming to the Ribbon Reefs for 20 years or more, and scientists are beginning to recognise individuals, like the female whale Bento. About six years ago, Bento turned up with her calf, but where she goes for the rest of the year is still a mystery. Tracking studies indicate that the whales head south, hugging the reef as they go. They probably head for cooler waters, maybe even as far as the Antarctic, where the feeding is better. However, what is clear is that, if the colour 'white' should envelope the Great Barrier Reef and were the corals to ever be permanently damaged, we could also lose what is, perhaps, the ultimate wildlife encounter, where you can look a whale in the eye.

RIGHT **A tourist has a face-to-face encounter with a dwarf minke whale. The whale appears to be just as interested in the human as the human is in the whale.**

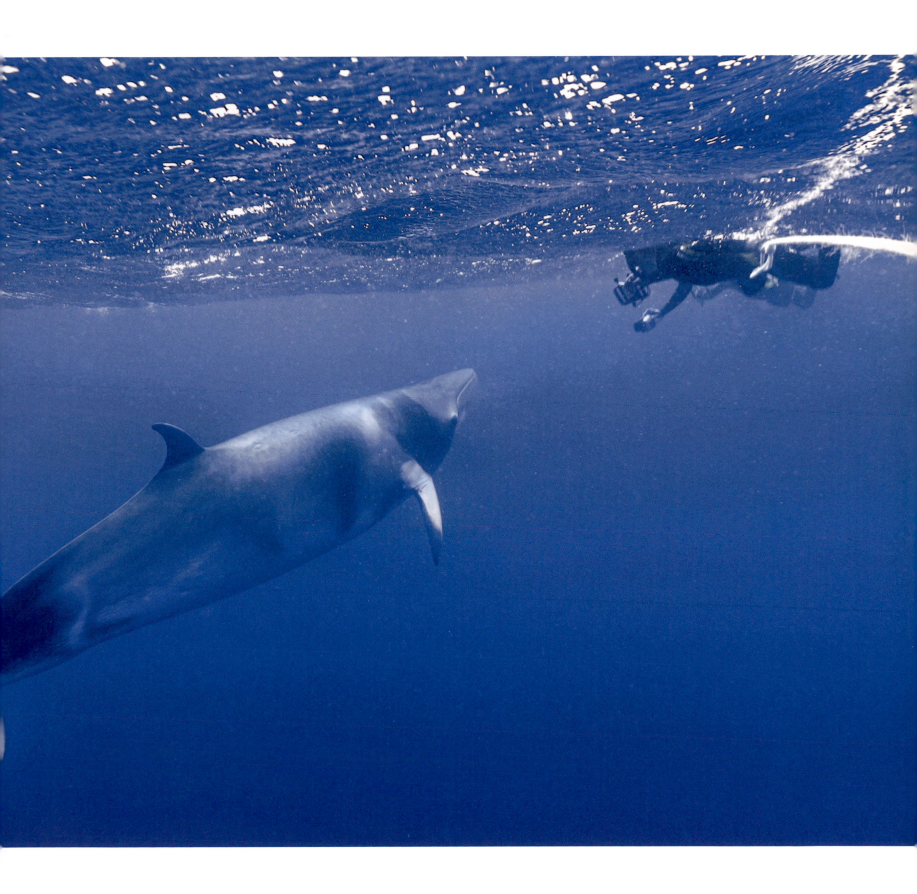

Concrete and clay

From space, one colour is spreading faster than any other. As human populations boom and cities expand, the spread of grey, the colour of concrete, is becoming ever more obvious from space.

In 1960, the only city with a million people in sub-Saharan Africa was Johannesburg. By 2015, there were 46. In China, cities have been expanding at an extraordinary rate. Today, over 50 percent of the country's population is living in urban sprawls, compared to 27 percent in 1990. The city of Shenzhen in southeast China is a classic example. Today it is a modern metropolis on the border with Hong Kong. It has a finance centre, skyscrapers, massive shopping malls and all the trappings of modern life. In 1950, it was a simple fishing village with no more than 3,000 inhabitants, but it is growing so fast that an estimated 12 million people will live there by 2025, almost 40 percent more than are living currently in Greater London. The country where the colour grey is spreading more than anywhere else, however, is India.

In 2008, 340 million people lived in cities in India, but by 2030, that figure is expected to rise to 590 million. With more than half of the world's economic output created in cities, there is a strong incentive for rural people to switch to a life in town. Delhi, for example, welcomes 79 new citizens every hour of every day, and India's streets are some of the busiest in the world. With space at a premium, there is the danger that wildlife will be squeezed out, but in one city lives an individual who is trying to do something about it.

Chennai is India's sixth largest city and it is booming, with jobs in retail, manufacturing and IT industries providing work for the 26,000 people crowded into every square kilometre. In the centre of town is the Pondy Bazaar, and negotiating its bustling streets is camera repair technician Joseph Sekar. The heavy bag of rice he is carrying is slowing him down, so he is worried he will be late getting home. He has some very special guests coming for dinner.

His visitors first started to arrive in 2004, the year of the Boxing Day tsunami. Chennai was flooded, many people drowned, and the surrounding countryside was devastated, including the forests where trees were destroyed.

'The tsunami flooded the whole city,' Joseph remembers, 'but it wasn't just bad for the people. Thousands of birds no longer had a home in the surrounding forests, and they came into the city to look for food. I noticed two parakeets, so I decided to put out some food for them. The next day there were ten more; then, it multiplied to 50, 100 and now 4,000, all of them coming back each and every day.'

BELOW **Twice each day, at sunrise and sunset, Joseph puts out boiled rice for more than 4,000 birds.**

OPPOSITE **The city of Chennai, previously known as Madras, is capital of the state of Tamil Nadu and the fourth most populated city in India. It has been growing rapidly from about 2.5 million people in 1971 to more than 8.6 million in 2011, the date of the most recent census.** Satellite imagery courtesy of © 2018 DigitalGlobe, a Maxar company.

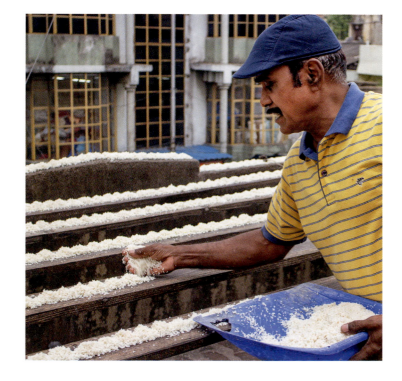

The birds are Alexandrine and ring-necked parakeets. In Chennai, the birds are hungriest at the height of the monsoon, with Joseph feeding two square meals a day to the 4,000 parakeets. He even nurses injured birds back to life, so they can rejoin the flock. His entire day revolves around tending the birds: up at 5am before sunrise for their breakfast feed, and then again at 3.30 before sunset for the dinner break. And it is not just his time that he has sacrificed.

Joseph spends up to half of his earnings on feeding the birds. Does his wife mind? Apparently not. He says she loves the birds as much as he does. His whole family believe in helping others, and join in with his passion; but the years are beginning to take their toll.

'In all these years the birds have never missed a single meal, but it's a tough job, there's no doubt about it. Every day I have to carry sacks of rice up from the ground floor

BELOW Joseph has built a lattice of planks on which he places the food. For 15 years, a growing number of birds have come to eat here twice a day.

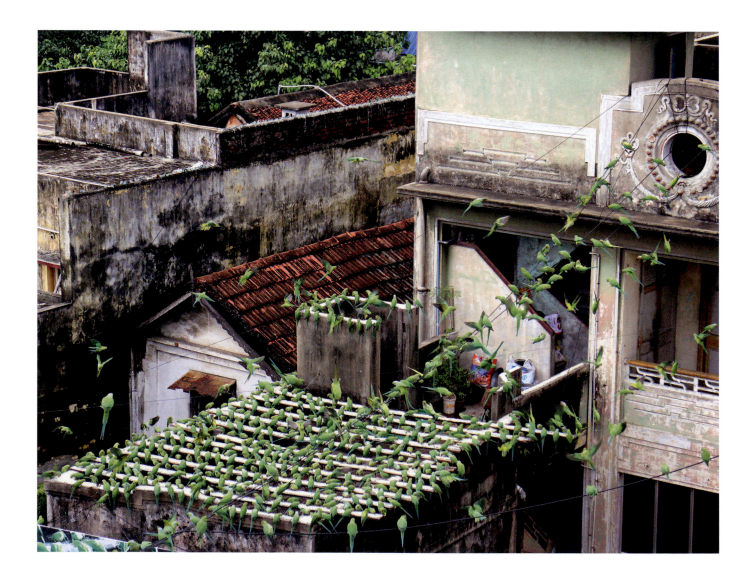

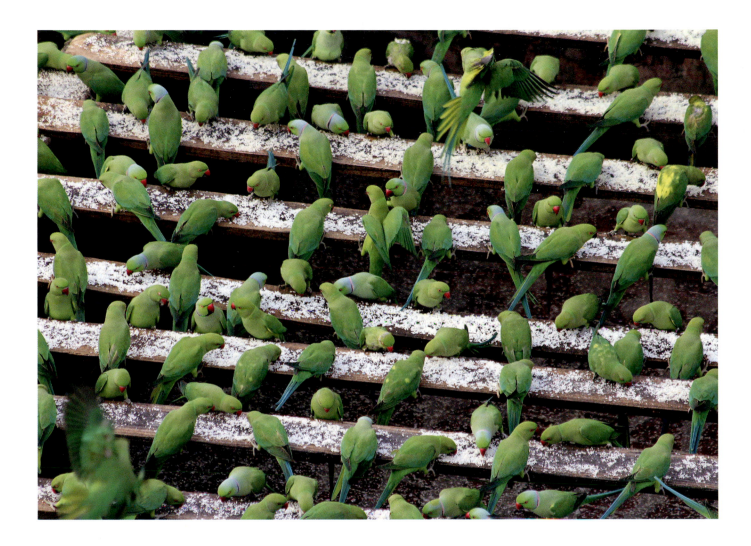

and then buckets of soaked rice, which are even heavier. The wooden planks put out for feeding weigh 20 kilograms ... but God will keep me strong.'

Rest assured, however, that Joseph will not be giving up just yet.

'The colours are fascinating,' he says, 'the green, the red combinations, the ring necks – colour is the most engaging thing about these birds.'

Such is his dedication that high-resolution satellite cameras can pick out Joseph's flock of parakeets: a pinpoint of bright green in a city of grey. It is extraordinary that one man's efforts can make such a difference that it can be seen from space. And, despite the aches and pains, the Birdman of Chennai shows no sign of stopping anytime soon; and he has some advice for us all.

'Love is life. Life is about giving. You should always respect living creatures, no matter what your environment is. The satisfaction in that is immense.'

ABOVE **Ring-necked parakeets dominate Joseph's dining tables. They live for more than 30 years, and are frequently kept as pets. They originate from Sri Lanka.**

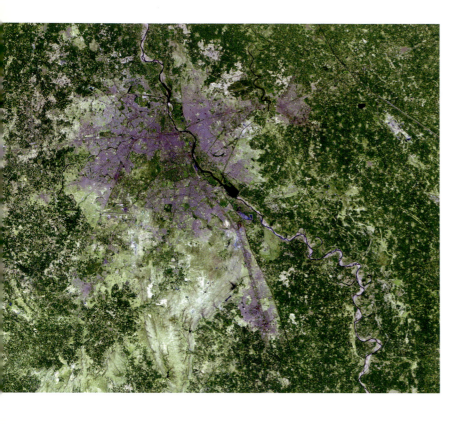

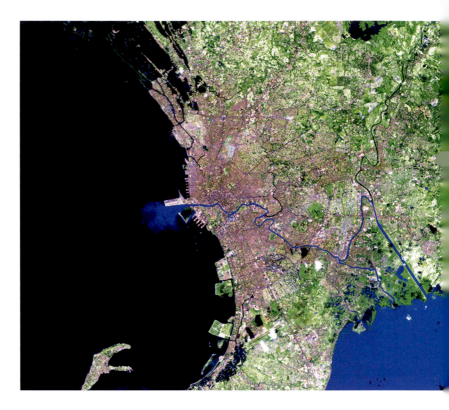

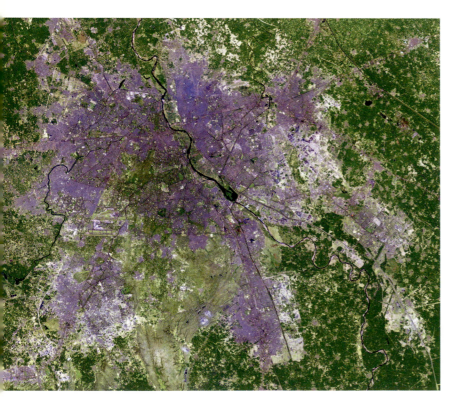

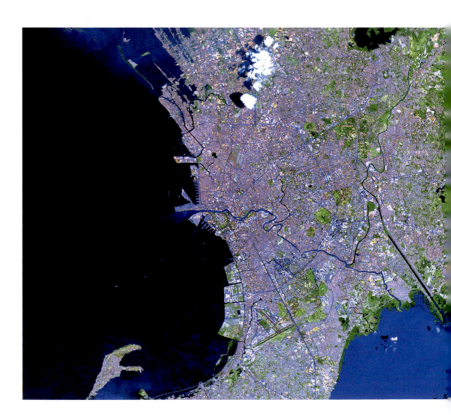

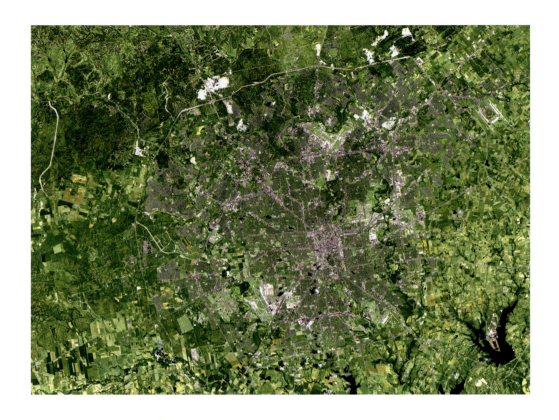

BURGEONING CITIES

Many cities have grown at an astonishing rate in recent years. Pictures from satellites reveal just how dramatic that growth has been. Top far left shows New Delhi in India in 1991, and bottom far left shows how it had grown by 2016. Middle top is Manila in the Philippines in 1989, and middle bottom in 2012. Left is San Antonio, Texas, in 1991, and left bottom in 2010. © NASA

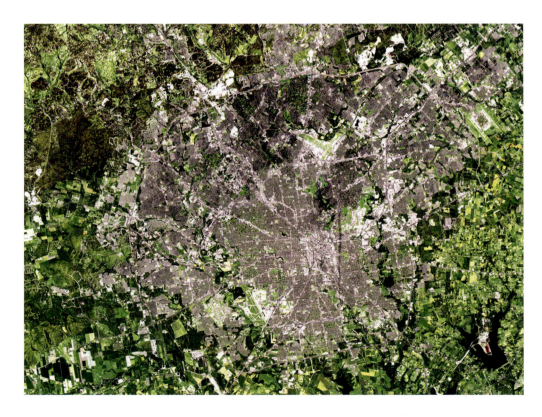

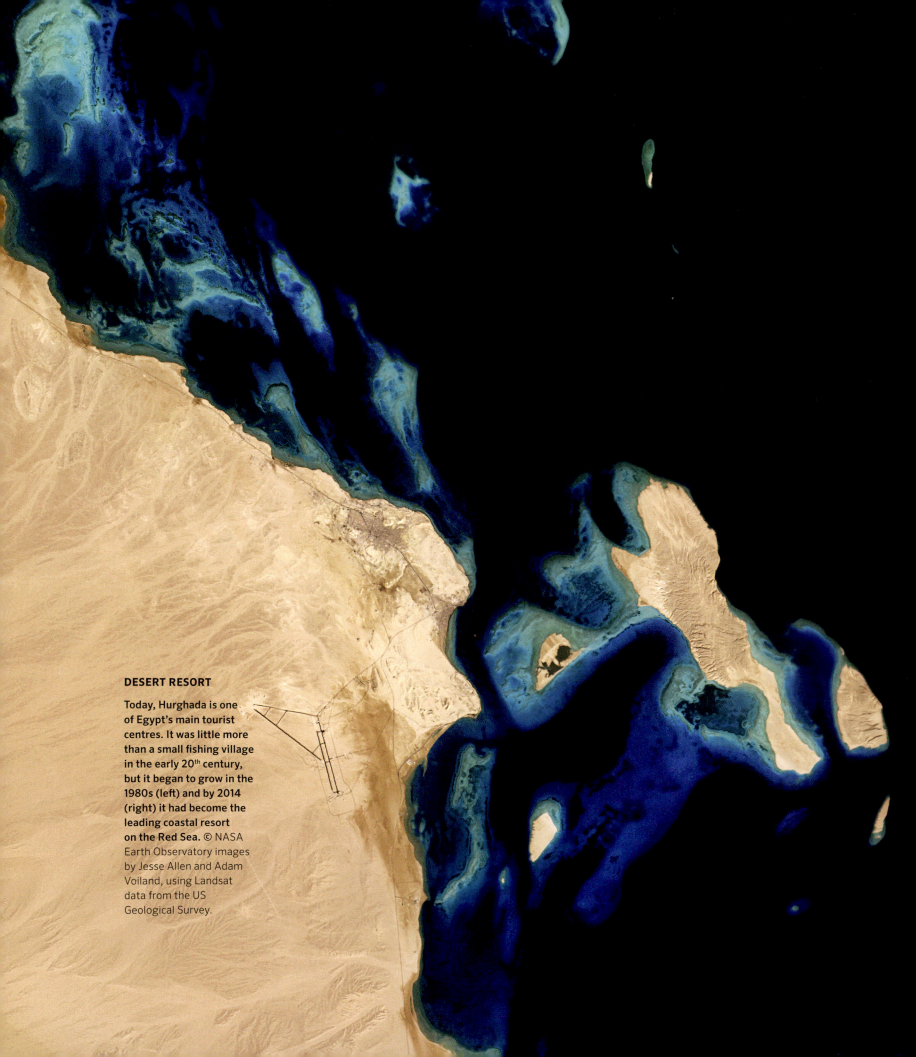

DESERT RESORT

Today, Hurghada is one of Egypt's main tourist centres. It was little more than a small fishing village in the early 20th century, but it began to grow in the 1980s (left) and by 2014 (right) it had become the leading coastal resort on the Red Sea. © NASA Earth Observatory images by Jesse Allen and Adam Voiland, using Landsat data from the US Geological Survey.

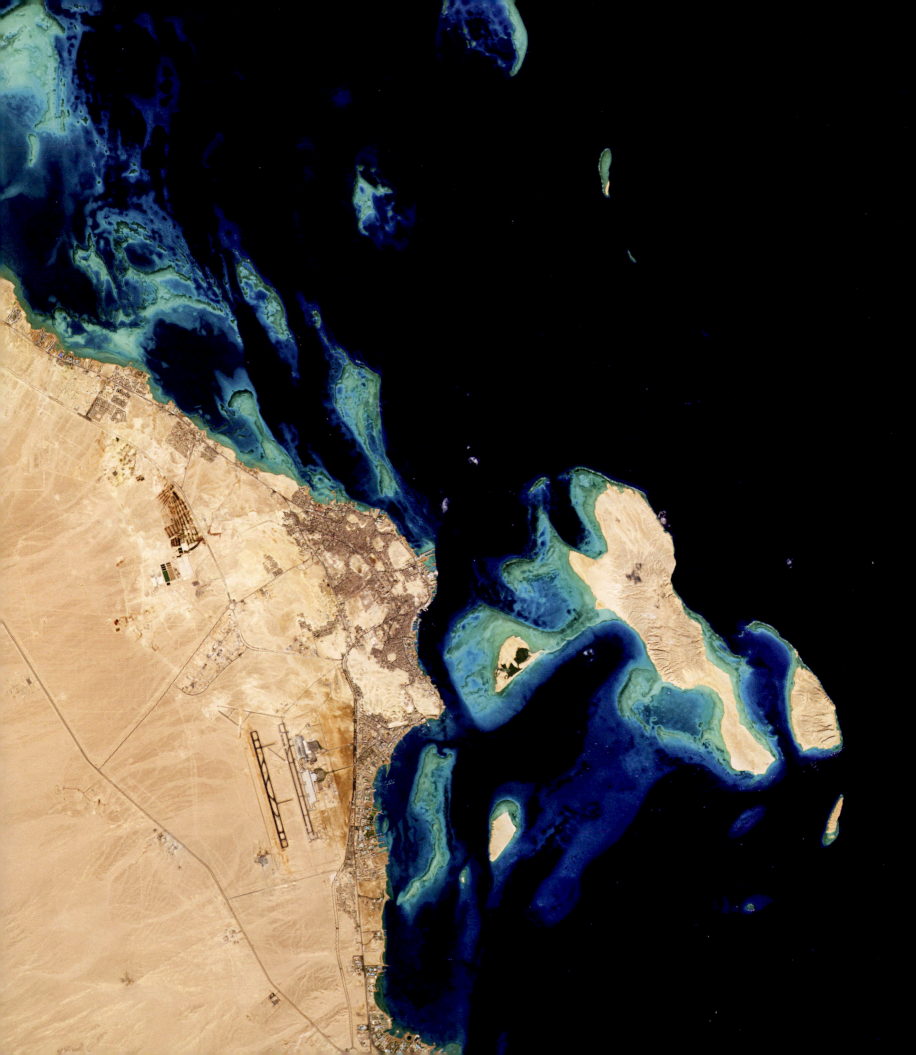

Illuminated cities

While all these changes of colour are visible on the side of the world that is facing the Sun, when the darkness comes they are replaced by the colours of night. For ancient humans, the Earth was bathed in the bright glow of the Moon and the distant sparkle of the planets and stars ... at least, on a clear night. When the clouds obscured the heavens it was pitch black. Then came fire. Campfires and fiery torches illuminated campsites and enabled hunters to operate at night and, if things got a bit hairy, fire deterred predators from approaching too closely. In October 1879, all that changed.

Thomas Edison switched on the lights. He invented an incandescent light bulb and the wherewithal to make it a practical lighting system. The *Columbia*, a cargo and passenger steamship of the Oregon Railroad and Navigation Company, was the first to use it commercially. Now, wherever there are people there is light, and, seen from space, the lights from cities are breathtaking. They appear as white-hot centres of activity, interlinked by illuminated roads that radiate like spiders' webs or grid-like patterns – clear evidence of our existence and distribution on Earth.

While the grey of a city by day may blend gradually with the browns and greens of the surrounding countryside, at night city lights provide sharp boundaries that indicate the densest populations of people and the places where urbanisation is having the greatest effect on Earth's ecosystems. The patterns and colours also show neighbourhoods of different generations.

In many North American cities, older neighbourhoods have irregular street patterns with green mercury vapour lighting, while the newer cities, especially in western USA, have their streets aligned in a north-south and east-west direction and have orange sodium vapour lights. In Brazil's São Paulo, the green lights of the wealthier old town contrast with the surrounding closely packed sodium lights of the favelas. And in Japan, the cities glow a cool blue-green where they have mercury lighting, except in Tokyo Bay, where a new development on the waterfront has a fringe of orange from sodium lamps.

However, these lights, no matter how beguiling, reflect just how much people are changing the surface of our planet. On the one hand they show how human activities interconnect the infrastructure of modern life, but they also draw the eye towards the really dark places, the last wildernesses on Earth.

OPPOSITE TOP LEFT **In Tokyo Bay, areas away from the waterfront have blue-green mercury lighting, but a new development beside the water has orange sodium vapour lighting.** © NASA / ISS Expedition 16 crew.

OPPOSITE TOP RIGHT **São Paulo at night as seen from the International Space Station. It is South America's largest city with 17 million people. The different colours – pink, white and grey – show different generations of streetlights.** © NASA

OPPOSITE BOTTOM **From the International Space Station, London shows up brightly at night, with the dark waters of the River Thames meandering through the city. Dark patches are open spaces, such as parks, and the street lighting changes from orange in the suburbs to white in the West End and City.** © NASA / ISS Expedition 45 crew.

OVERLEAF **This picture of the curvature of the Earth with south of England (left) and the north coast of France (right), separated by the darkness of the English Channel, was taken by British astronaut Tim Peake on board the International Space Station.**

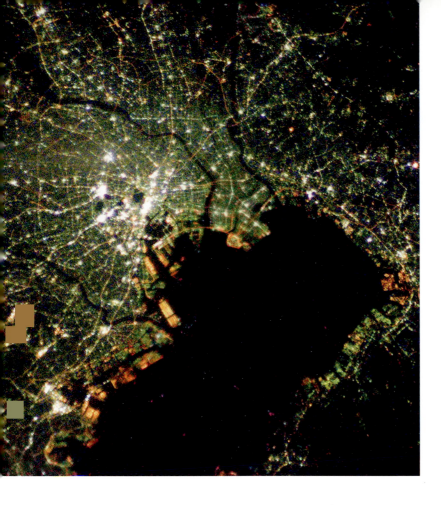
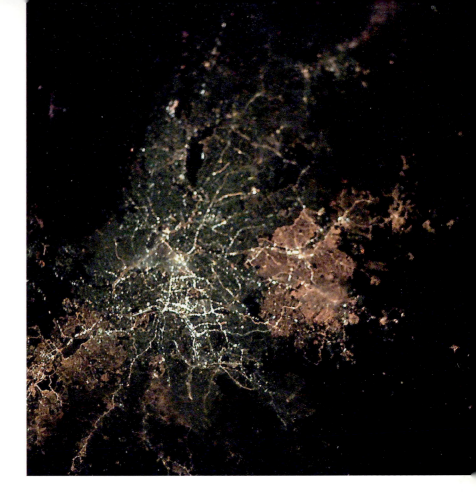
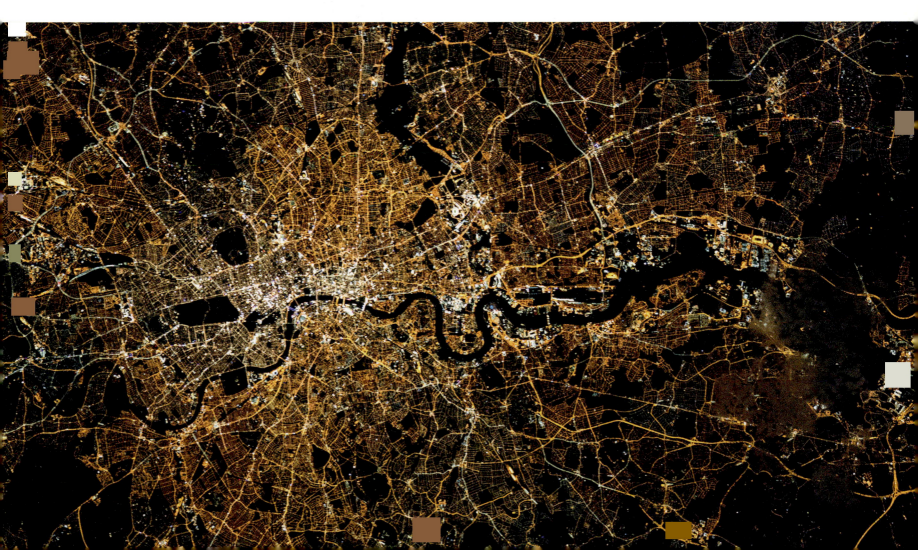

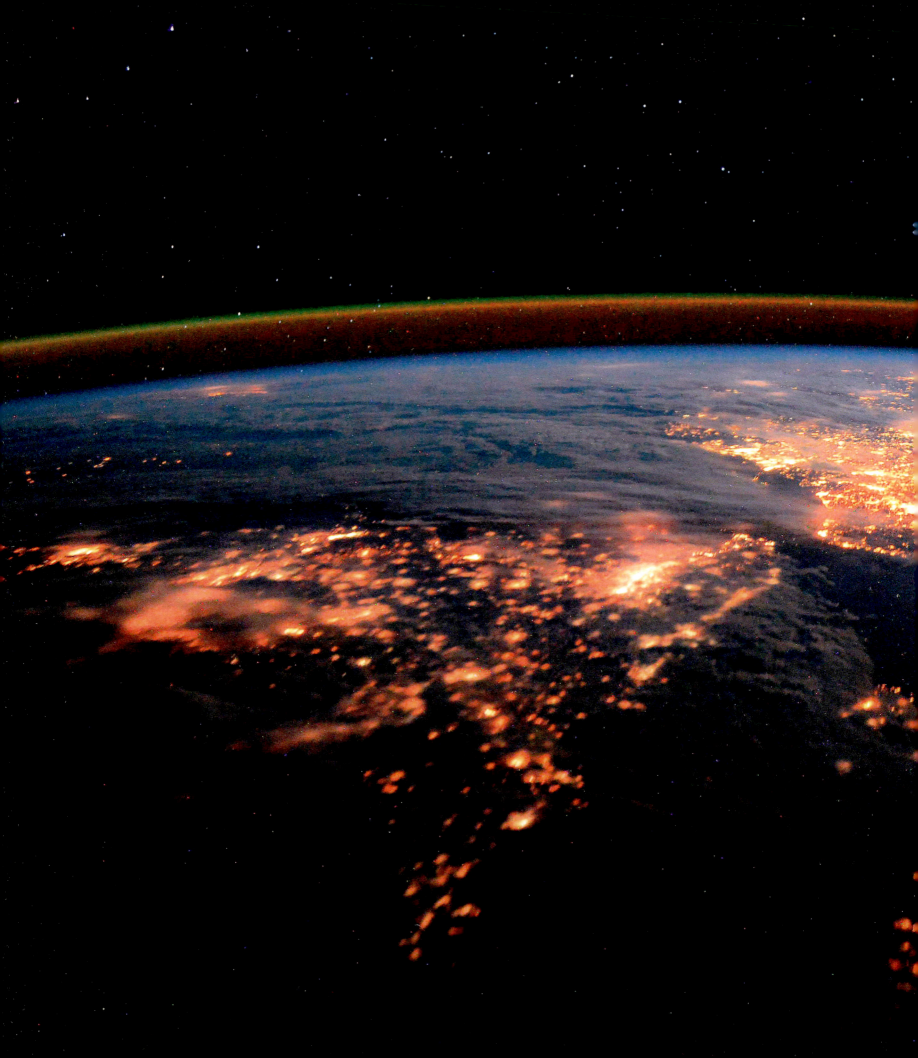

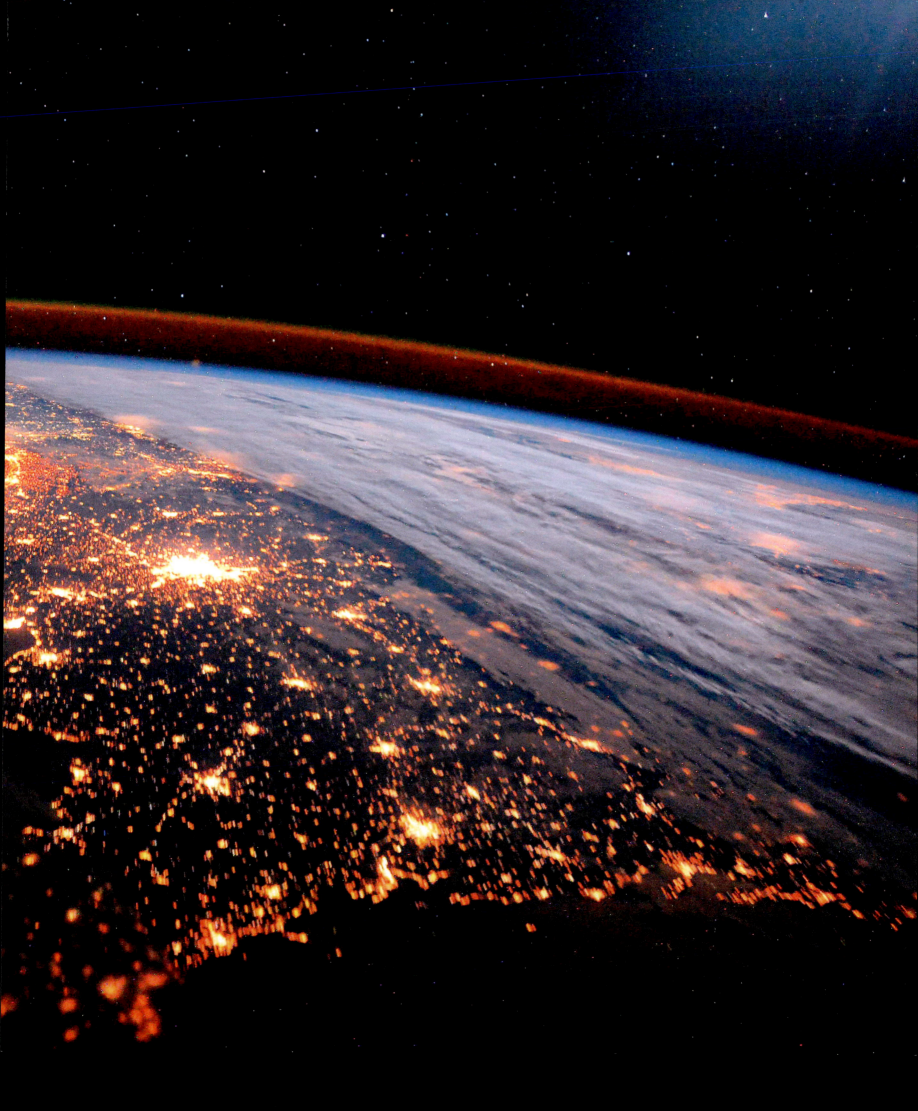

Mystery lights

At night, the oceans (along with most of Antarctica) remain the darkest places on the planet, but in 2012 the Suomi NPP satellite spotted strangely glowing lights in the South Atlantic, 300–500 kilometres off the coast of Argentina. Clusters of bright green lights were appearing hundreds of kilometres from the nearest city, forming what appeared to be a large island where no island exists. It was all very mysterious … but the authorities in Argentina had a hunch and the green colour gave it away.

The lights were on hundreds of fishing boats, many operating illegally within Argentina's territorial waters, and they are drawn here because they are some of the richest fishing grounds in the world. The Malvinas Current, which is enriched by the upwelling of nutrients along the Argentine coast, attracts huge numbers of edible and sought-after marine creatures, such as short-fin squid.

Generally, the squid remain close to the seabed at night, at depths of around 800 metres, making them difficult to catch, but to draw them towards the surface each boat is equipped with more than one hundred high-powered green lights. Plankton and the small fish that feed on it are attracted to the brightness, so the squid rise from the depths in hot pursuit. They become snagged on fishing lines, and are hauled into the boat. The upwellings last for only three months or so, during which time about 1.8 million tonnes of squid will be pulled from these waters. It is a new trend, and it is big business. All across the globe, super-fleets equipped with bright lights are blasting the ocean's darkness and the spread of illegal fishing has become a serious international problem. Countries like Argentina and Peru, the latter a hotspot for giant Humboldt squid, have especially productive seas within their territorial waters, so they are plagued by illegal fishing boats. There is only one answer – send in the coastguard!

Carlos Apablaza is the captain of the Argentine coastguard cutter whose job it is to intercept illegal fishing boats and shut them down. Checking out one or two incursions is one thing, but the super-fleets that Captain Apablaza encounters are something else entirely. He remembers the first time he saw the lights of an extraordinary number of fishing vessels just outside the boundary of Argentine waters.

'For someone who hasn't seen these fishing boats,' he says, 'they have to imagine that it's like seeing a huge, brightly lit, floating city.'

With such an overwhelming flotilla of potentially illegal fishing boats on their doorstep, the authorities have had to take steps to deter them and minimise their impact on Argentine fisheries. To do this, they have embraced the latest surveillance techniques.

While the coastguard cutters are patrolling the high seas, in the sky above are the operation's long-distance eyes. A twin-turboprop King Air Beachcraft maritime patrol flies from a remote air base in Patagonia and keeps a close eye on Argentina's territorial waters. In the driving seat is Commander Carlos Dell Oro, but he is quick to point out that maintaining contact with such a cunning and determined fleet is not easy, even from the air.

OPPOSITE **About 300-500 kilometres from the South American coast a floating city of light appears in the Southern Atlantic Ocean. It's a flotilla of squid-fishing boats close to the boundary of the exclusive economic zone of Argentina.** © NASA/ NOAA Suomi National Polar-orbiting Partnership.

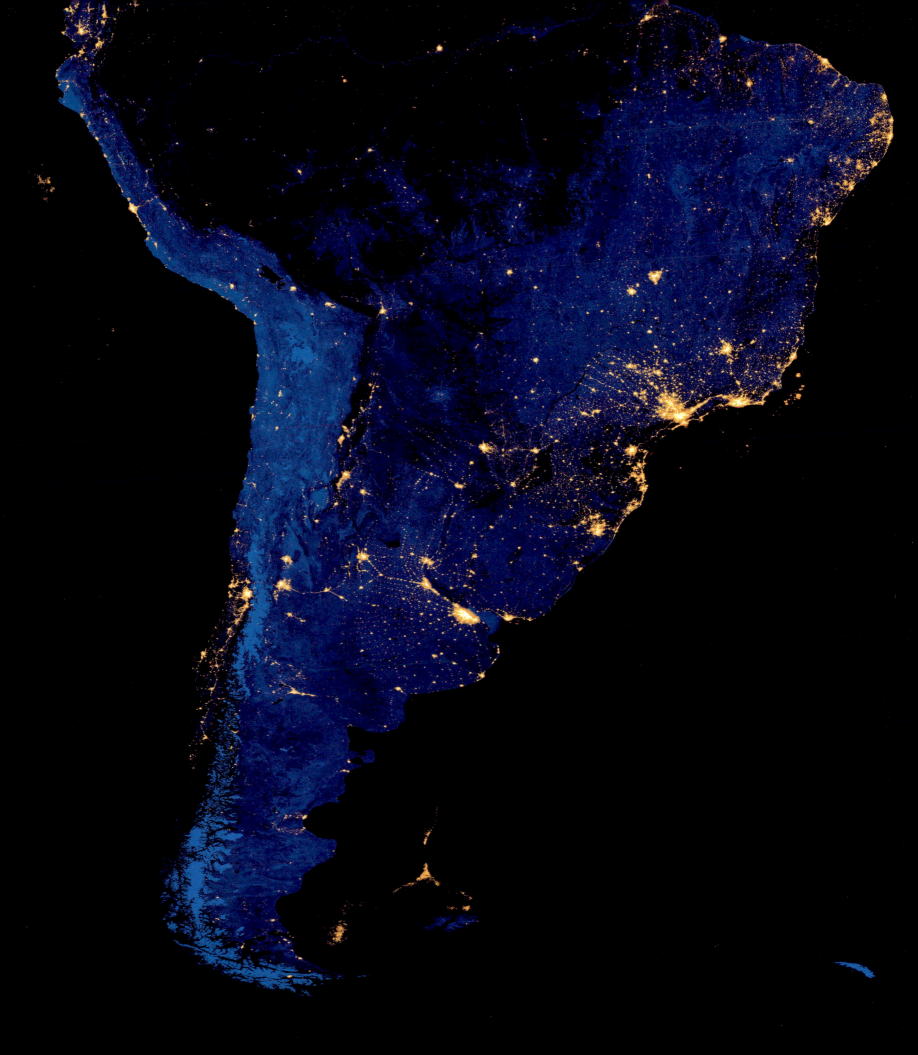

'Depending on the time of year, we usually find between 100 and 400 foreign fishing vessels just outside the exclusive economic zone. It's a big challenge to remain in control of such a massive number of ships, located in such a vast area of sea.'

To confine their surveillance to a manageable area, Captain Apablaza's coastguard cutter sets a course to patrol the outer boundary of the zone. Here, they are more likely to encounter boats that are flouting the law.

'Our main function is to stop foreign boats from coming in to fish in Argentine waters. It's a difficult task, but one we must carry out 365 days of the year with a lot of effort.'

Any boat fishing inside the zone must have the proper papers, but illegal boats appear to know the area well and skirt the line, remaining in international waters until the moment is right. When they think nobody is looking, they make rapid forays into the zone to steal a catch. It is a nautical game of cat and mouse, but now the authorities have a secret weapon to tip the balance in their favour.

At the Argentine navy's satellite observation base in Buenos Aires, satellites are monitoring offshore fishing activity. Every fishing boat is equipped with an Automatic Identification Signal (AIS) transmitter that pings its position to a satellite overhead. It is a way of staying safe on the open sea. A vessel fishing illegally, however, turns off its AIS in an attempt to disappear from view, but the reality is that it has very neatly drawn attention to itself. When a fishing boat behaves in this way, the crew of the *Prefecto Derbes* springs into action, and sets a course to identify and intercept the illegal boat. Overhead, Commander Dell Oro and his crew scan the darkness using the latest thermal-imaging cameras to detect its heat signature.

'The plane is able to navigate faster,' he says, 'so it enables us to cover a larger area than the coastguard ships on the sea's surface. This ability to cover the largest area in the shortest possible time, and keep the coastguard updated with the fishing fleet's location, is vital.'

And, if that doesn't work, they simply wait. Often, fishing vessels simply turn off their lights and try to sneak across the boundary line, but, of course, if they want to fish, they must eventually turn them back on again, which gives the aircraft a chance to find them. Spotting the lights from an aircraft or a coastguard cutter in the vast darkness of the ocean, however, is not guaranteed. This is when satellites come to the rescue again.

The base at Buenos Aires analyses hundreds of square kilometres of satellite imagery and can pinpoint the tiny 'dot' of light of a squid fishing boat. With this capability, it is becoming increasingly more difficult for boats to go undetected. Captain Apablaza sees this as a real game-changer in protecting squid stocks.

'Our technology has advanced, and it has helped hugely to minimise the situation with illegal fishing boats in Argentine waters, and that has made our work much easier.'

However, even though the technology may be making their patrols more efficient, it is still down to good, trusty seamanship that ensures the coastguard is in the right place

at the right time. Captain Apablaza spends much of his life at sea, patrolling the wind-lashed, wave-scoured wilds of the South Atlantic. He knows his job is a vital one, but it's still hard to be away so much from home.

'I'm married, and I'm the father of two daughters. I carry them in my heart. And, although I'm passionate about this job, because it's what I love to do, sometimes it's hard to be away from the family for long periods of time while out on patrol. But you know that your family is always waiting for you when you come back home.'

BELOW **Squid fishing boats are illuminated by row upon row of high-powered green lights. They attract fish to the surface, but they are not the targets of the fishing boats. The squid that follow them are, and boats illegally enter Argentina's territorial waters to catch them.**

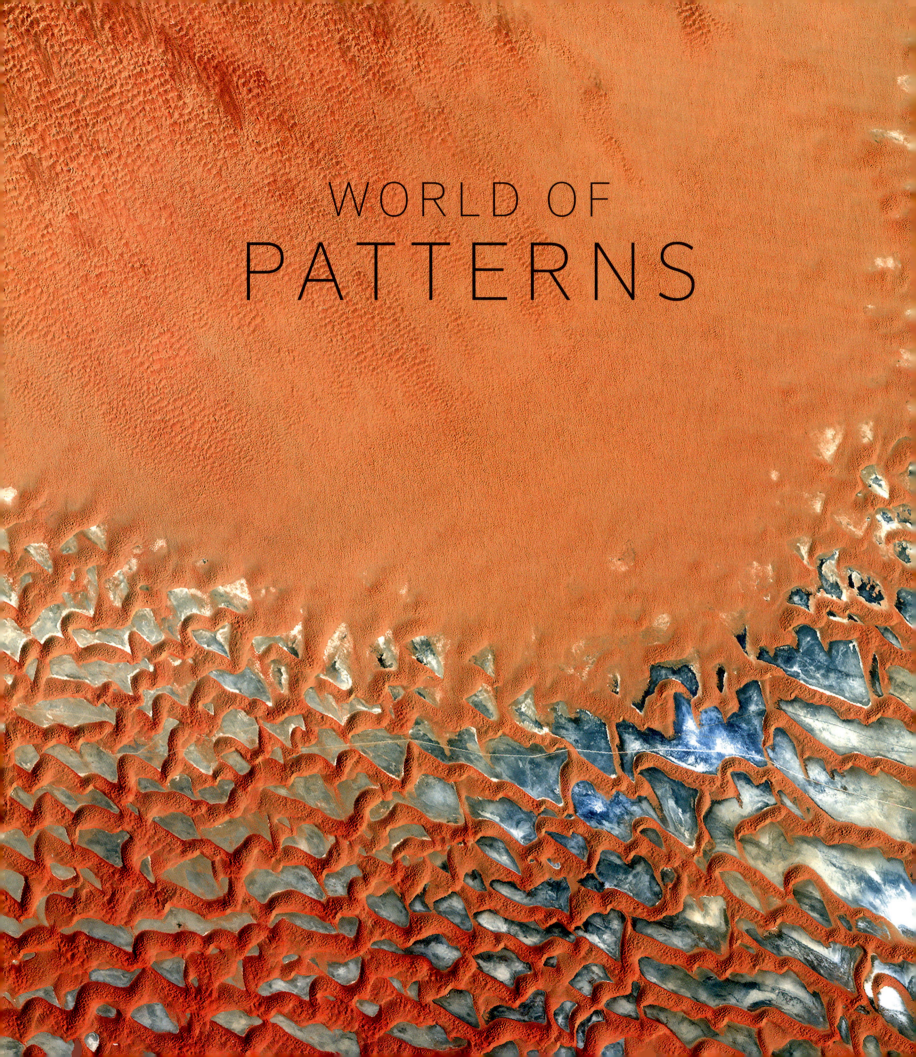

WORLD OF
PATTERNS

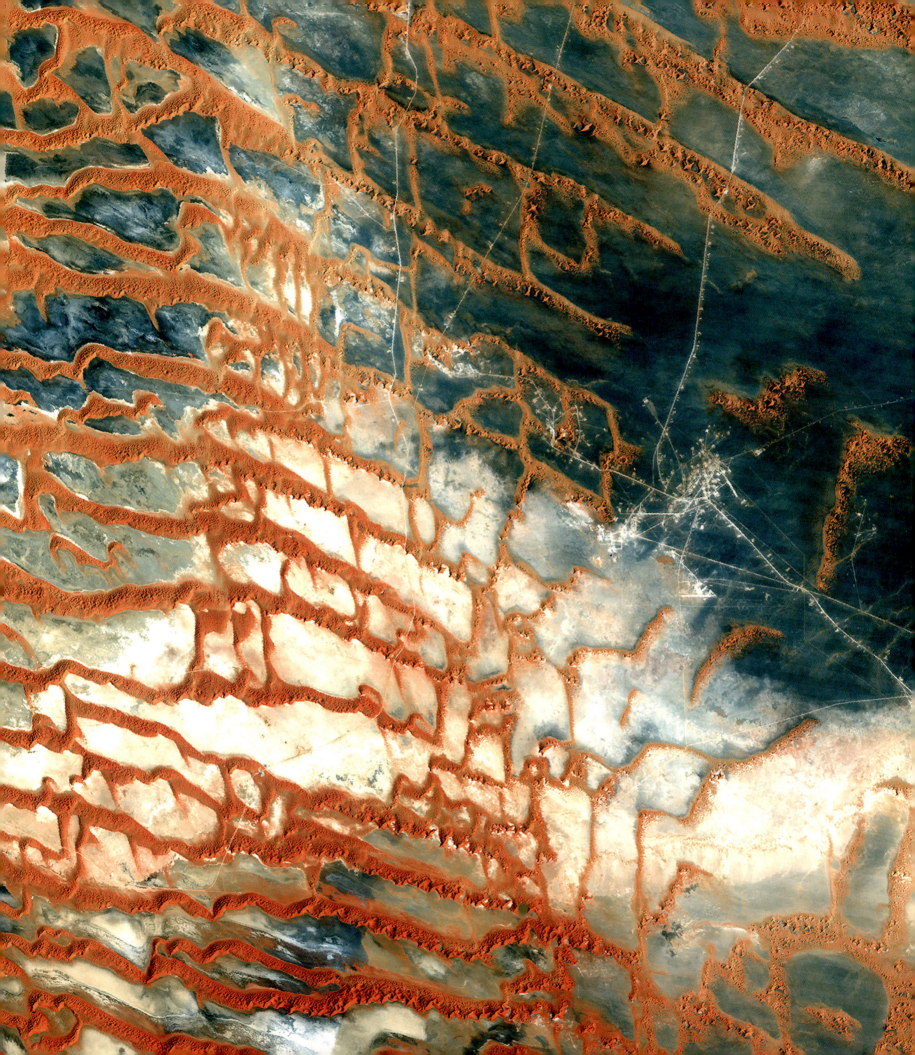

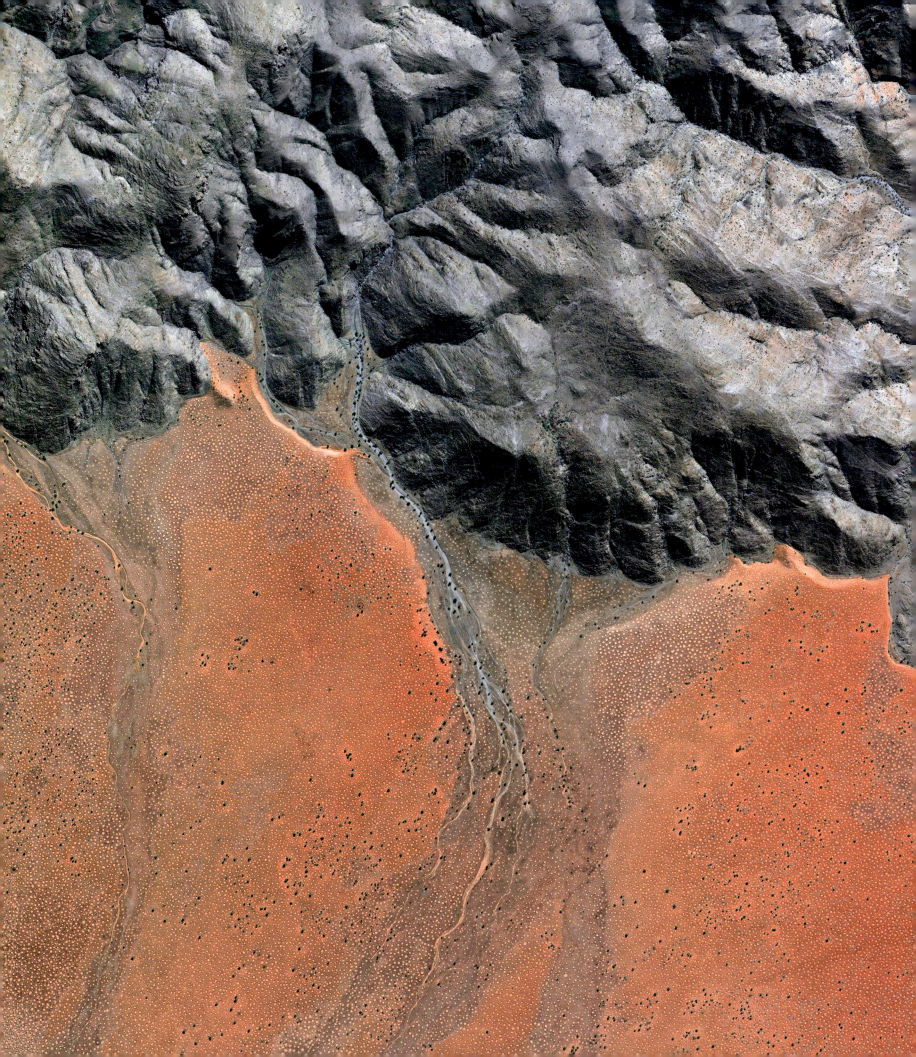

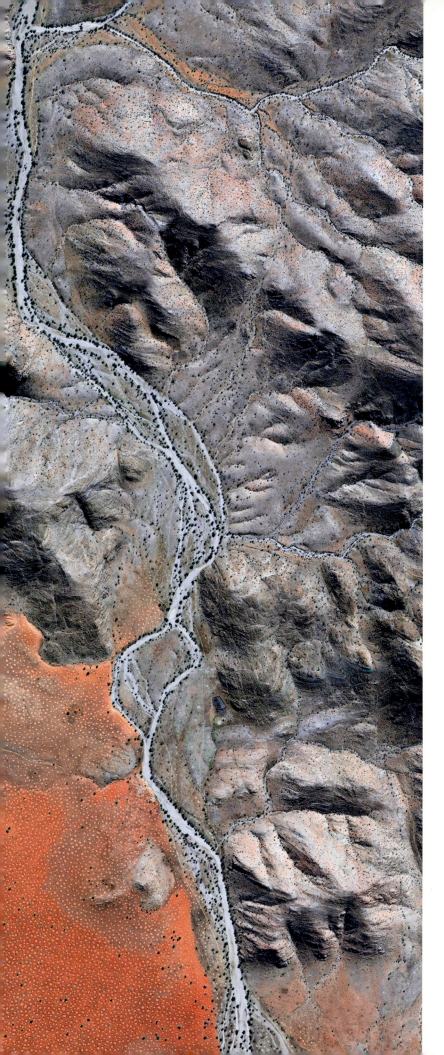

Since Earth's very beginning, about 4.6 billion years ago, natural forces have pummelled and scoured our planet, embellishing its surface with intricate patterns and unique shapes, a patchwork so vast and complex that it can only be truly appreciated from space. Rugged mountain chains are pushed skywards and then worn down again by the many processes of erosion. Ice breaks up rocks, water carves out snaking river valleys, and wind blows shifting sands into vast fields of rippling dunes in an endless cycle of destruction and renewal. Shapes can appear overnight or evolve over millennia, with many created by life itself. It is what makes our planet so unique; and now we humans are leaving our indelible mark, adding our own designs to the infinite variety etched onto the surface of our patterned planet.

LEFT **From space, tiny pale patches can be seen all over the surface of the Nullarbor Plain, South Australia. A landscape created by wombats.** Satellite imagery courtesy of © 2018 DigitalGlobe, a Maxar company.

Siberian seals and ice art

Russia's Lake Baikal is about 25 million years old, the world's oldest lake. It lies in a rift valley, where the Earth's crust is pulling apart at a rate of two centimetres per year. Water fills the gap, creating a lake that is 636 kilometres long, has an average width of 48 kilometres and a maximum depth of 1,642 metres, which makes Baikal also the deepest lake in the world. It holds an astonishing one-fifth of the world's unfrozen surface water … but this *is* Siberia so, in winter, its surface freezes over completely with ice up to two metres thick, strong enough to support a car.

Like any primeval lake, Baikal has its monster legends and natural oddities, but its biggest surprise is its large population of land-locked seals, one of the world's smallest species of seal. Freshwater sub-species of Arctic ringed seals live in Finland's Lake Saimaa and Russia's Lake Ladoga, but it is the Baikal seal, the only separate species of freshwater seal, that has always captured people's imagination.

British naturalist Charles Hose was one of the first to describe it for science in the early 1900s. He was on the Trans-Siberian Railway, when he stopped off at Lake Baikal. Fishermen caught three seals for him and he stored them in the luggage rack of his compartment. Two died, of course, but he dissected them, there and then, throwing soft tissues out of the train window to the consternation of the other passengers. He found them to have relatively large eyes, usually the sign of a deep diver, and larger and more powerful forelimbs and claws than most other seals, an adaptation to keep open breathing holes in the ice and for grasping prey. The biggest question, though, was how on earth did they get to Baikal in the first place?

There are several theories. Most popular is that thousands of years ago the seals came from the Arctic in the north and were cut off, but nobody really knows. What we *do* know is that every February their white, silky-furred offspring are born on the ice, often in dens under snowdrifts, like ringed seals. The pups emerge in spring, and wait on the ice for their mothers to return from fishing. They have to fatten up and wait until their white baby fur is shed and their grey adult coat has grown before they can hunt for themselves in the cold water. Some do not have the luxury of time.

As spring warms the lake and the ice begins to thin, a strange phenomenon occurs on Lake Baikal. Huge, perfectly shaped dark rings of thin ice form on the thawing lake. First spotted in 1999, the rings are up to 7 kilometres across and 1.3 kilometres wide, but, because of their size, they cannot be seen when standing on the ice or even from the top of nearby

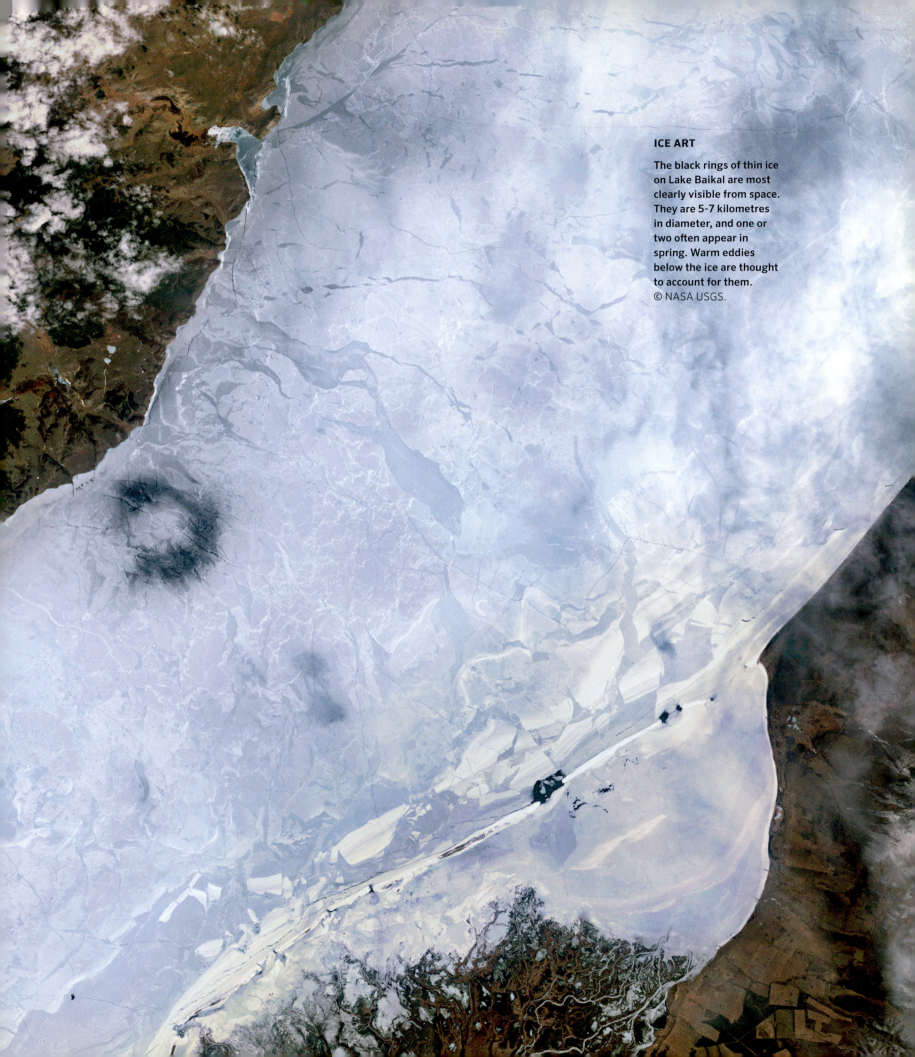

ICE ART

The black rings of thin ice on Lake Baikal are most clearly visible from space. They are 5-7 kilometres in diameter, and one or two often appear in spring. Warm eddies below the ice are thought to account for them. © NASA USGS.

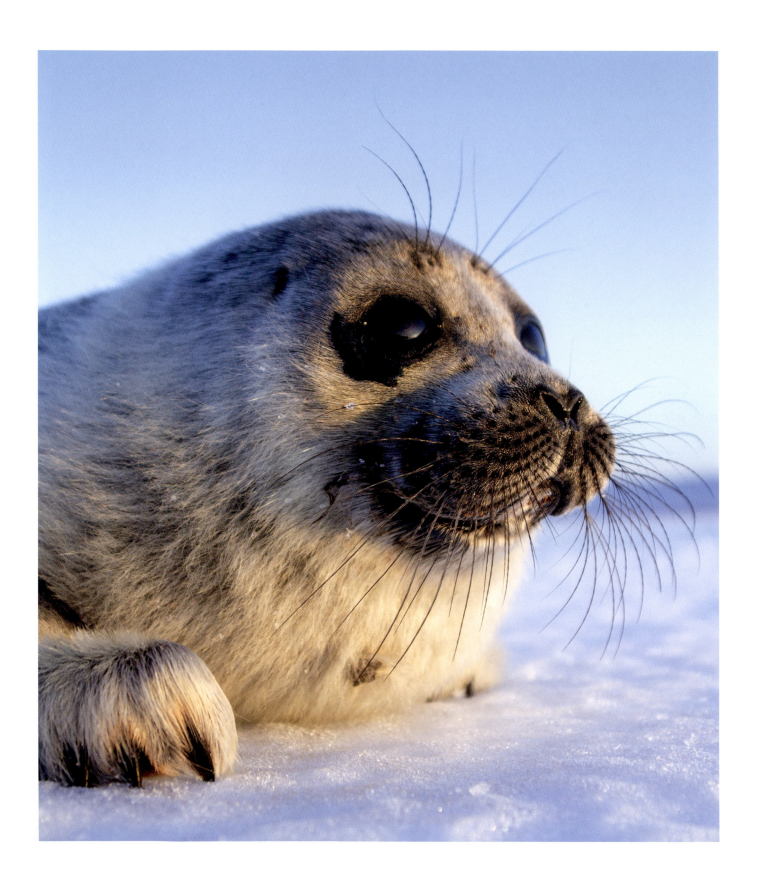

mountains. They are only visible from space. Using historical images from NASA and recent pictures from Urthecast's Deimos-2 satellite, the *Earth from Space* team was able to examine these enormous rings and talk to scientists studying them to discover a possible explanation.

The rings have spawned their fair share of strange theories, from UFOs to shamanic ritual, and even giant bubbles of methane, but the real explanation may be more down to earth. Ice scientists believe they are created by clockwise-flowing eddies with warm water at their centre. Each year, they seem to appear at roughly the same spot in the lake, so the eddies are probably influenced by the underwater topography and water circulation. When the vortex of swirling warm water rises, it melts the ice, which thins and becomes saturated with water. It then sags and cracks, and is seen from space as a very obvious dark ring.

On the ice, it poses a serious threat to baby seals. Any in its vicinity could be in real danger of being forced into the icy water too soon, which could prove fatal. Even so, at the best of times, the lake's youngsters have to learn to be self-sufficient very quickly. The rest of the ice breaks up by late spring, and their mothers leave them. Then they must fend for themselves. Three years on, the survivors will have pups of their own, and with 32,000 square kilometres of frozen lake to choose from, hopefully, they will find safer spots to rear them.

OPPOSITE Baby Baikal seals have thick, white natal hair. They wait on the ice for their mothers to return from hunting. The adults can dive to 400 metres in pursuit of fish, and stay down for 40 minutes, although most dives last for less than 10 minutes.

BELOW Filming on the surface of the ice in winter meant that the film crew had to experience biting winds and a temperature of minus 20°C, although the Baikal area is relatively mild when compared to nearby Irkutsk, where the temperature drops to minus 30°C.

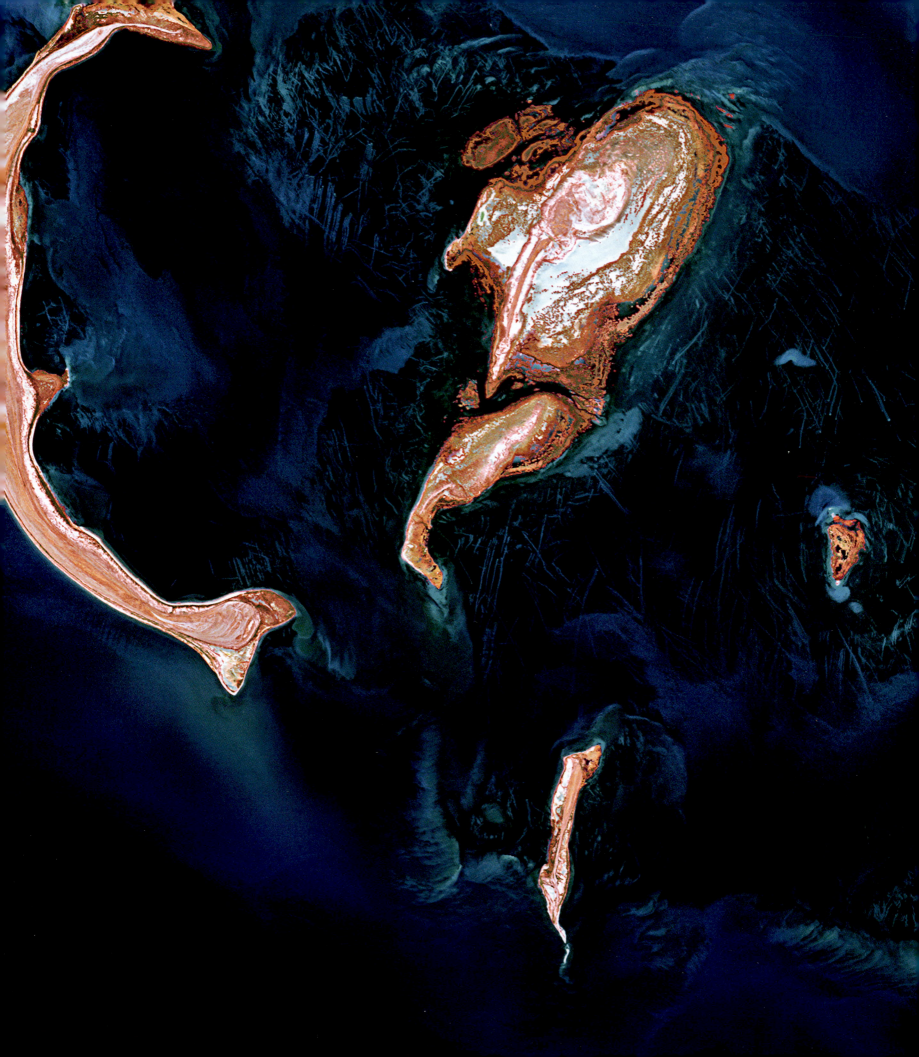

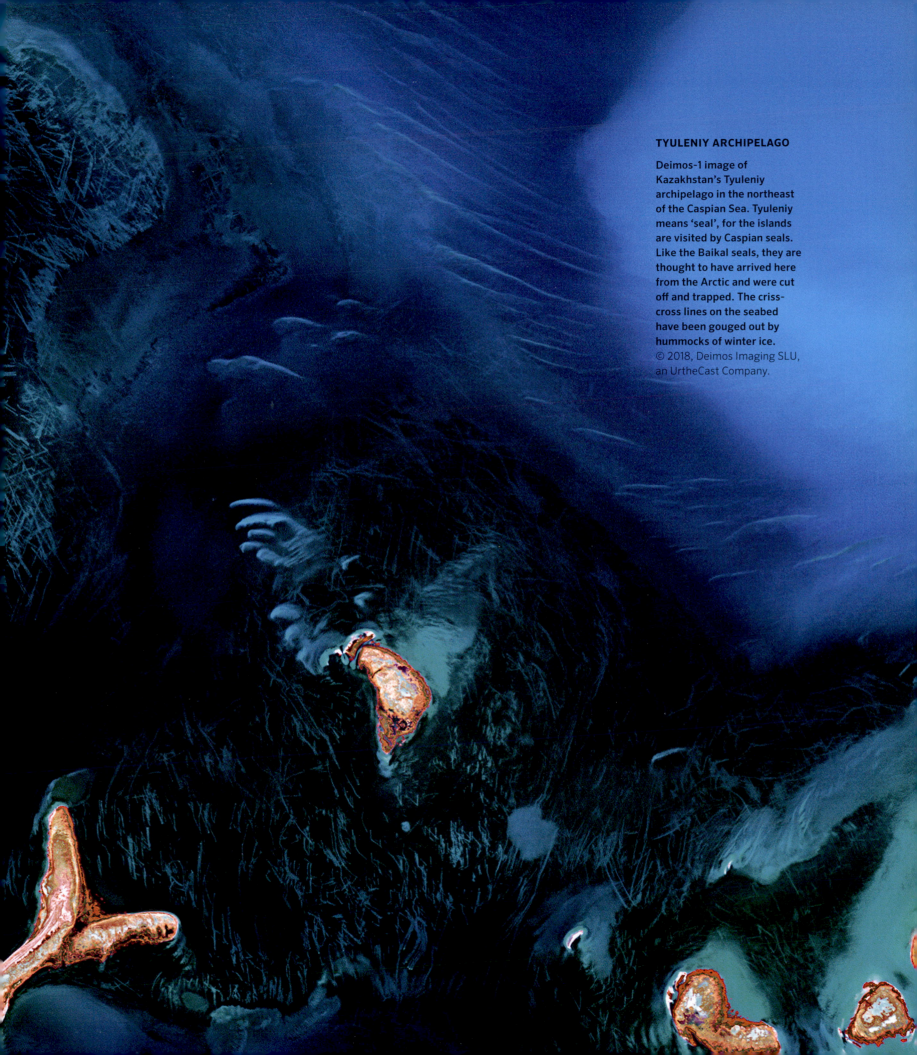

TYULENIY ARCHIPELAGO

Deimos-1 image of Kazakhstan's Tyuleniy archipelago in the northeast of the Caspian Sea. Tyuleniy means 'seal', for the islands are visited by Caspian seals. Like the Baikal seals, they are thought to have arrived here from the Arctic and were cut off and trapped. The criss-cross lines on the seabed have been gouged out by hummocks of winter ice.
© 2018, Deimos Imaging SLU, an UrtheCast Company.

Record-breaking beavers

Canadian ecologist Jean Thie of EcoInformatics International was scanning the boreal landscape of the Birch Mountains plateau in Alberta, Canada, looking for signs of melting permafrost in wetlands. It is a key indicator of global warming that can be monitored with high-resolution satellite images, but during the survey he found something unusual.

'When I took a virtual flight down the slopes of the plateau into the surrounding wetlands using Google Earth,' he recalls, 'I spotted some extraordinary beaver habitat. I had been looking for long beaver dams for several months, and here were an impressive series of dams fed by water running off the Birch Mountains. Where the wooded fen transformed into a bog, one particular large pond and dam stood out.

'Fortunately this area is covered by high-resolution satellite imagery and so, zooming in, I could clearly see beaver lodges and channels. I couldn't see streams or creeks flowing into the pond, but I spotted places where trees had been chewed down or killed by flooding.'

The dam itself turned out to be exceptionally long.

'Using the Google Earth measuring tool, I found that it was 850 metres long, about 200 metres longer than the beaver dam near South Forks, Montana, which, until then had held the title of world's longest beaver dam.'

The Canadian dam was more than twice the length of the Hoover Dam, and at one end Jean found evidence of two smaller dams, about 140 metres long, together with

BELOW **The area around the dam is a remote wilderness of inaccessible swampland and thick forest infested with blood-sucking mosquitoes, so only one person has trekked in to see the dam firsthand.**

OPPOSITE **From space, the beaver lake is in the centre of the picture. The record-breaking dam has been constructed by several generations of beavers in two families, and it could eventually grow to a kilometre long. Dams are long in this area as the land is so flat.** © 2018, Deimos Imaging SLU, an UrtheCast Company.

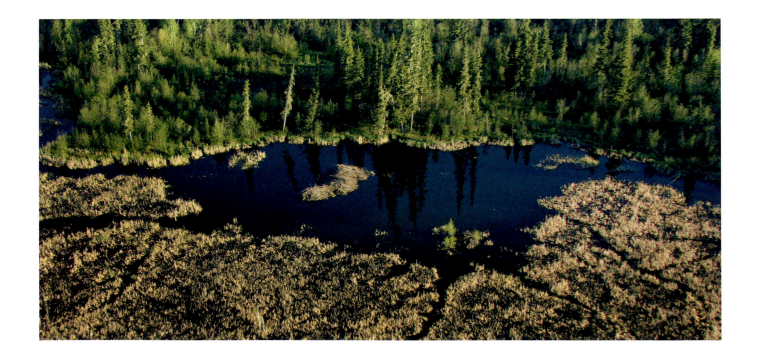

another beaver lodge. It means that, during the next decade or so, the large dam could grow even bigger, maybe as much as another 150 to 200 metres.

Jean checked the coordinates. The dam was located on the southern fringe of Wood Buffalo National Park in northern Alberta, a remote area of bogs and thick forest and scrub to the southwest of Lake Claire. Park rangers confirmed that they had seen large dams on aerial surveys, and this world-record dam had featured in Landsat 7 imagery, so they had an inkling of how long it had been in existence. Previous aerial photographs of the region showed that, although smaller dams had been constructed nearby, one did not exist on this site before 1980, so several generations of beavers might well have spent close to 40 years building the dam we see today.

Such an impressive dam is the work of experienced natural architects, and favoured trees include trembling aspen and white birch, which they fell by gnawing into the base of their trunks. The beavers then haul them into position or float them across the lake to shore up the dam. Once carefully in place, mud, rocks and vegetation help secure the structure.

Unlike beaver dams elsewhere in the world, which tend to be short and high and built across rivers and streams, the dams in this area are long and low. This is because the land here slopes gently and the water from mountain streams is slowed down during the spring melt, so there is a steady flow throughout the year, even during the drier times of the year, resulting in a better habitat. There were also wildfires prior to 1945 that had a major impact on the composition of the vegetation. Regeneration with poplar, aspen and birch may have attracted beavers to settle here, and their dams are often 500 metres long, although any exceeding 600 metres is rare.

The beavers build these dams for security. Once the dam is watertight, they construct a fortified lodge in the lake that forms upstream of the dam. They live on a dry platform of soil and vegetation inside, and enter and leave through underwater tunnels, usually at night. During the summer months, each lodge is like a castle, surrounded by a wide moat that keeps the beavers and their kits relatively safe from prowling bears, lynx and wolves.

The *Earth from Space* team began observing the record-breaking dam from satellites in 2017. At the time, it was still winter in Canada. Snow and ice locked in the dam, the frozen pond offering protection just as the water did during the other half of the year. There were no signs of activity at first, even though beavers choose not to hibernate; instead, they survive on vegetation they have stored in and around the lodge. But, as winter turned to spring, the ice started to melt and the team were keen to see how the beavers would cope with the changing seasons.

Earth from Space cameraman Justin Maguire flew in to see how they were doing, but the location is so remote that, even with a fully fuelled helicopter, he had barely 15 minutes of filming time.

'It's a vast landscape where everything looks the same, and then, suddenly, there's this discernible shape ... and it's huge. I've filmed beaver dams before but this structure was something else, so much bigger than I'd imagined – really impressive.'

A quick survey revealed the dam to be covered by grass, with other plants growing up through the logs, and Justin could see that it looked solid and likely to hold back the spring melt water – important not only for the beavers, but also their neighbours. Ecologically, beavers are a keystone species, which means that although they may be small in numbers, they have a huge impact on their immediate environment, with many types of plants and animals partly or entirely dependent on the beaver-created wetland habitat. The dam slows the general water flow, so floods, droughts and erosion are less likely to occur, making it a more stable place to live. Where beavers have been hunted, biodiversity plummets.

During the 19th century, they were hunted almost to the edge of extinction, but now they are making a comeback, and satellites are essential in monitoring the recovery. In 1945, the area around Pakwaw Lake in Saskatchewan had no signs of beavers, but now it has been nicknamed the 'beaver capital of Canada'. With over 20 dams per square kilometre, it may have the highest density of beavers anywhere on Earth.

'It was my first discovery of exceptional beaver habitat,' says Jean, and it led him to build a computer model that predicted where he might see long dams in the landscape. It was this that helped him to find the longest dam in Canada.

'Even now, almost ten years after my observation, and having surveyed beaver landscapes in North America, Europe, Asia, and the southern part of South America, I have never seen anything like it.'

ABOVE LEFT **Beavers re-engineer the landscape with logs and mud. An old dam has noticeably more vegetation growing amongst the tangle of wood. It helps to stabilise the entire structure.**

ABOVE **The beaver enters and exits its lodge underwater. With its large swimfin-shaped hind feet, its underwater speed is about 5 mph, and it can remain below for up to 15 minutes.**

Village of elephants

From Earth's orbit, the Congo rainforest resembles the surface of broccoli. Millions of square kilometres of unbroken forest canopy stretches across tropical Africa; except, that is, in one spot in the Central African Republic. Here, the *Earth from Space* cameras focussed on an enormous clearing, a special place that hosts one of the forest's big events – an elephant jamboree.

'Cameraman Stuart Trowell and I were led in on foot by guides from the local Bayaka tribe,' explains film director Paul Thompson. 'They insist you make the 30-minute walk in silence, so they can pick up the sounds of any elephants close to the trail. The first sign that you are close to the clearing are blood-chilling roars and screams from the elephants, sounds that awaken something primeval in your brain, telling you to turn around and run the other way. The reward for ignoring that voice is a view that I can only compare to something from *Jurassic Park*, watching 150 elephants in one place.'

The elephants are African forest elephants, smaller in stature and much shyer than their savannah cousins, and they travel in smaller groups. They spend most of their

BELOW **Seen from above, the clearing is a vast patch of brown mud nestling in a thick forest of green. It has been created by generation after generation of forest elephants mining the soil for minerals.**

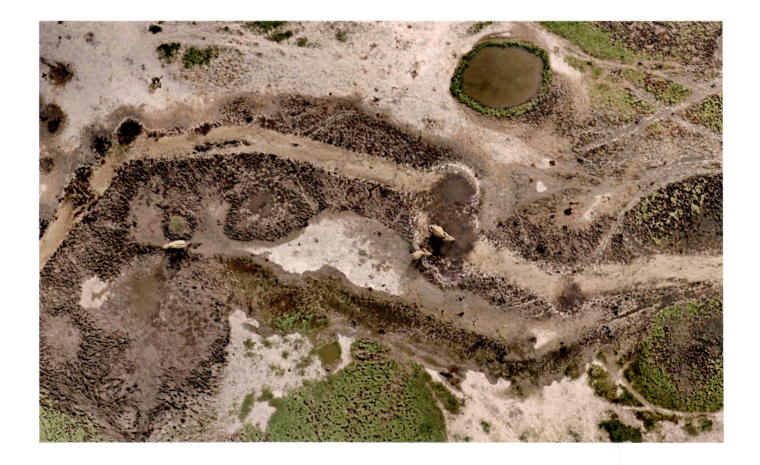

lives hidden amongst the trees, but their regular diet of fruit, leaves and bark needs to be supplemented with minerals found in the volcanic soils. The elephants seek out clearings where these minerals can be accessed more easily. This means stepping out into the open, and meeting others of their own kind.

Elephants arriving are greeted by those already there. The matriarchs of each group seem to renew old friendships, and it is a unique opportunity for younger elephants to meet up and socialise for the very first time. The bulls, which live a lonely bachelor's existence for the rest of the year, have other things on their mind. There are more females in the clearing than a bull may have seen in months. Testosterone levels are high, competition is fierce, and tussles unavoidable. Calves must keep their wits about them. Lifeless bodies have been found in the arena, accidental victims of the clash between rampaging bulls.

Socialising, however violent, is not the main draw of this grand get-together. There are essential minerals beneath their feet, and the families dig to find them, youngsters learning from their mothers how to drink up the mineral-rich water. Bulls uproot trees to clear the ground and churn up the mud, so the clearing gradually gets bigger after every party.

BELOW **Forest elephants socialise in the clearing, although encounters between bulls can be rather violent affairs. Solitary for much of the year, the abundance of females in the clearing seems to trigger fighting amongst males.**

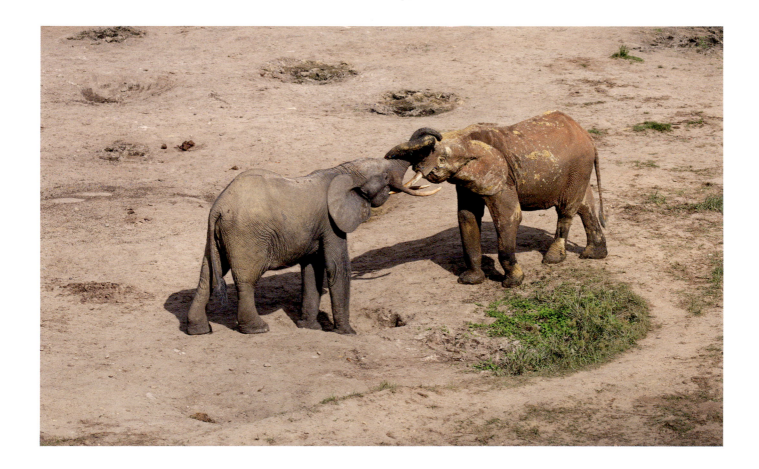

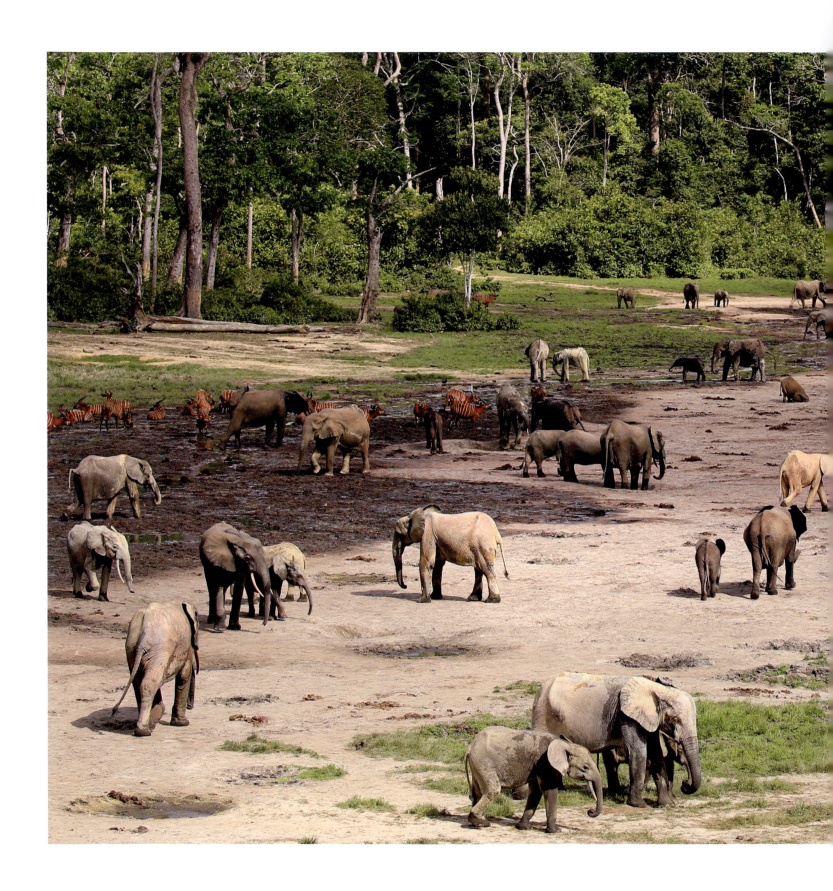

About 3,000 elephants are known to use the clearing, and when the *Earth from Space* team visited there were 173 elephants present on one particular day, along with rare western lowland gorillas, bongos and forest buffalo. The local people call the meeting place *Dzanga Bai*, or 'village of elephants', and it is not the only one. Satellite pictures reveal that elephants have created several clearings in the forests of the Congo Basin. The task now is to protect them. The ivory from forest elephants is harder and of a different colour to that of savannah elephants. It is known as hot or pink ivory, and it is highly prized. Ivory carvers prefer it.

It means the lives of these animals sometimes hang by a thread and, in 2013, tragedy struck at the Bai, when Sudanese poachers killed 26 African forest elephants. Since then, the WWF, ecologists and people living nearby have fought together to protect this special place and its precious inhabitants. It is now a growing centre for ecotourism, with visitors and film crews travelling from around the globe to join the elephant party.

'I could only wonder at how many centuries this gathering has been occurring,' reflects Paul, 'and hope that it continues for many centuries to come.'

OPPOSITE **From space, Dzanga Bai appears as a brown slash in the almost continuous green canopy of the Congo tropical rainforest.** Satellite imagery courtesy of © 2018 DigitalGlobe, a Maxar company.

ABOVE **Western lowland gorillas have been little studied in the wild for they live most of their lives in dense forest. Their appearance at elephant clearings has enabled primatologists to study at least some of their behaviour. They are listed by IUCN as 'critically endangered', threats being human-born diseases, habitat loss and the bush meat trade.**

More dark circles

One eventful day in the *Earth from Space* office, the production team was looking at stunning satellite images of Uluru (Ayres Rock), when their eyes were drawn to a strange pattern. Film director Paul Thompson asked Urthecast to zoom in on South Australia, where they could see that the landscape was covered with small dark spots, spread uniformly across the ground.

'Of course, we wanted to know what on earth they were!'

A closer look revealed them to be holes, but who was the digger? More detailed research revealed it to be a well-known Aussie resident: the southern hairy-nosed wombat. The holes are the openings to underground burrows where wombats hide to avoid the heat of the day. They only emerge when the temperature dips in late afternoon or in the cool of the early morning.

This type of wombat is more sociable than other species. It lives in large family groups with several adults sharing a warren of tunnels, with as many as 30 to 40 entrances. In most other underground species, holes like these would be escape exits, a strategy against predation, but wombats are solidly built. About 30 kilograms of solid muscle is enough to take on, say, a dingo, and the creature is faster and more nimble than it looks, so it is thought that the holes are not primarily escape routes or boltholes.

The truth is that wombats love digging. They can't help themselves. It's a compulsion. One animal can dig through several metres of hard soil in a night, and be responsible for over 100 holes during its lifetime, so the work of an individual and its neighbours becomes part of a larger pattern of spots that can be seen from space.

BELOW The southern hairy-nosed wombat is a marsupial adapted for digging. Stocky and robust, it has flattened claws and a pig-like snout, with the normally naked part sprouting hairs, hence its name. It can survive on the poor quality grass *Stipa nitida*, along with desert shrubs that grow around its burrows, because it has a much lower metabolism than most other marsupial and placental mammals.

OPPOSITE The wombats dig up quite sizable areas. They live in large complex systems of interconnecting burrows, many joining together to form central warrens. Well-worn paths link the warrens, with feeding trails radiating out into the surrounding countryside.

OVERLEAF Seen from space, the wombat burrows appear as thousands of bare patches. The animals destroy large areas of scrub, but this activity enables scientists to monitor their numbers and distribution using satellite images. Satellite imagery courtesy of © 2018 DigitalGlobe, a Maxar company.

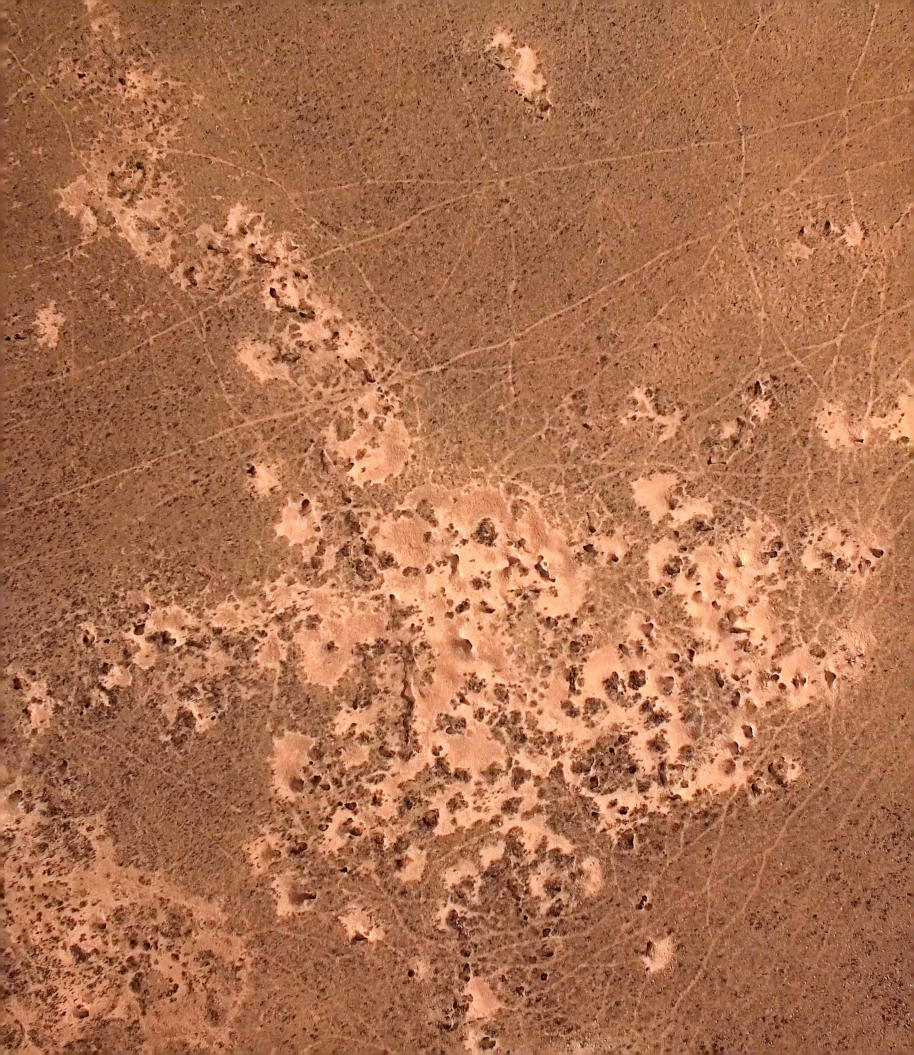

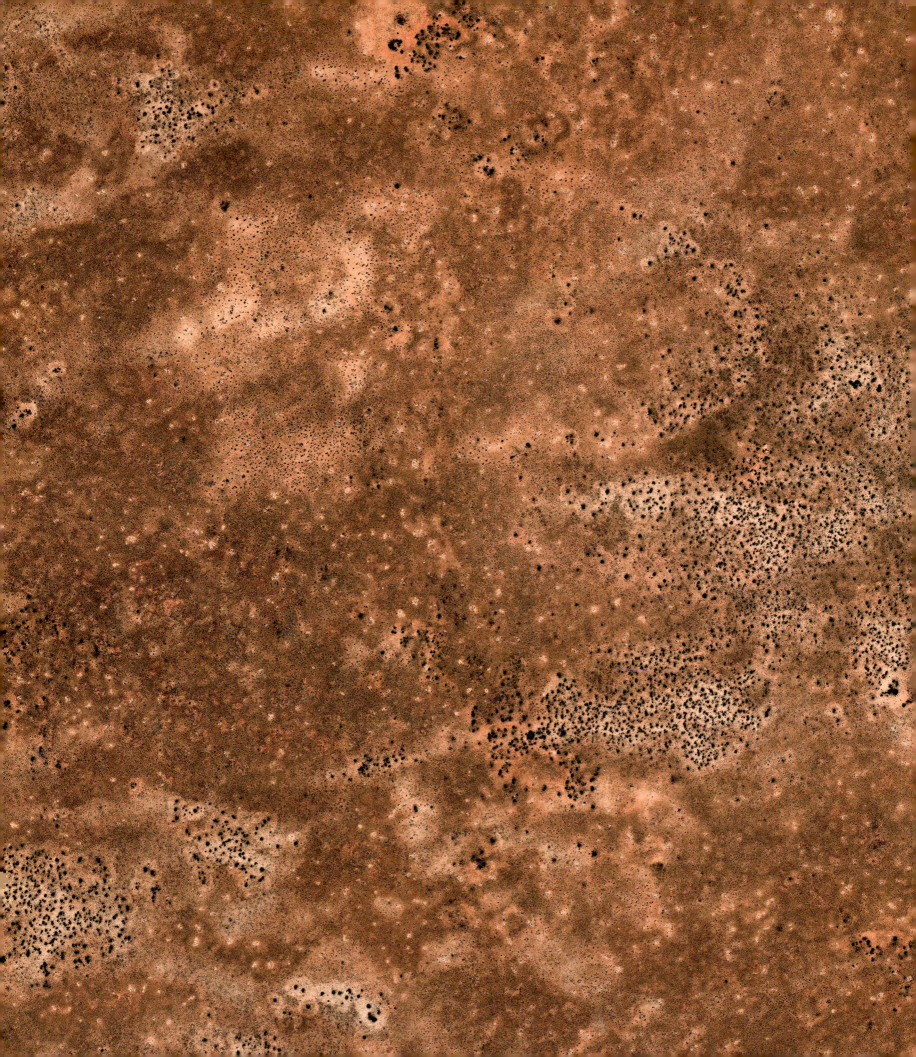

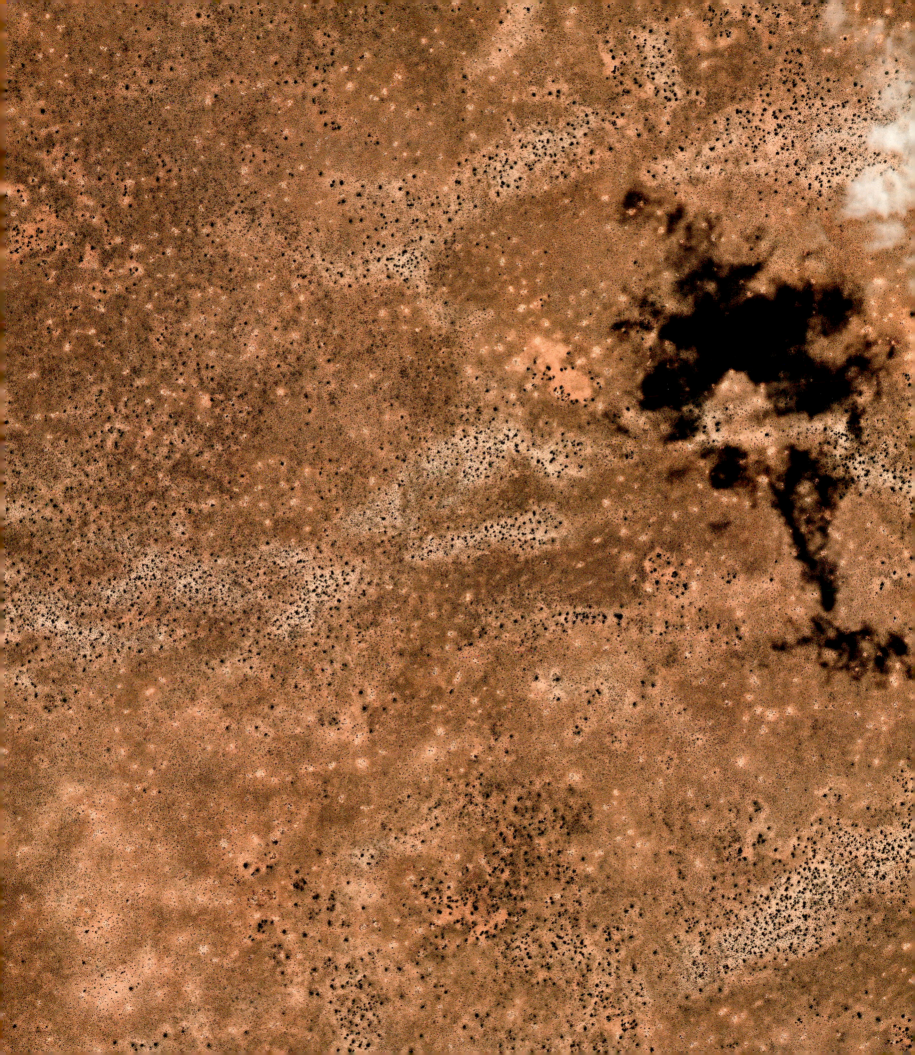

Landscape of fear

Circles are a recurrent theme when looking down on Australia. Repetitive rings of varying sizes can be spotted on Australia's Great Barrier Reef. Each consists of a patch reef surrounded by a submarine meadow of filamentous seaweeds, with a clear gap of bare white sand, called a 'halo', between the reef and the meadow; and, the further away the seaweed is from the reef, the higher it grows.

The barren sand in the halo and the height of the seaweed is the result of fish, sea urchins or other grazers feeding close to the reef. The herbivores shelter on the reef itself, but embark on foraging excursions that radiate outwards from their central refuge. When they leave its safety, they are exposed to predators, such as sharks and groupers, so they do not venture far, generally less than nine metres from the edge of the reef, what scientists have nicknamed 'the landscape of fear'. Their constant munching creates seaweed-free, sandy halos, and observing them is helping scientists to monitor the health of the reef.

If the top predators have been removed, say, by overfishing, the algae-eating fish, such as parrotfish and surgeonfish, make braver excursions. Predation risk is low, and so they feed further from the reef edge, causing the width of the halo of white sand to increase. If the herbivores are absent or low in numbers, the halo disappears as the algae grow back. All this can be seen from space, and so scientists can monitor the health of a tropical coral reef just by watching the size of its grazing halos increase or decrease over time.

Millions of these halo patterns appear on coral reefs all over the world, like the seagrass grazing halos off the Florida coast, and monitoring them is easier from space than on the ground. Scientists can keep watch over the world's tropical coral reefs without ever having to enter the water … and the technique is not confined to coral reefs.

Like the patch reef halos, changes in vegetation cover in terrestrial habitats flag up the health of a ecosystem, especially the relationship between predators and prey. This can all be seen from space. It means that, again, satellites are turning out to be new tools with which we can keep a close eye on animals in the remotest and least accessible parts of the world.

RIGHT **Every patch reef on this stretch of the Great Barrier Reef is surrounded by a pale blue halo. By watching changes in the size and shape of these halos, scientists can monitor from space the indirect effects of predator removals, say, from overfishing, and their impact on the health of the reef.** Satellite imagery courtesy of © 2018 DigitalGlobe, a Maxar company.

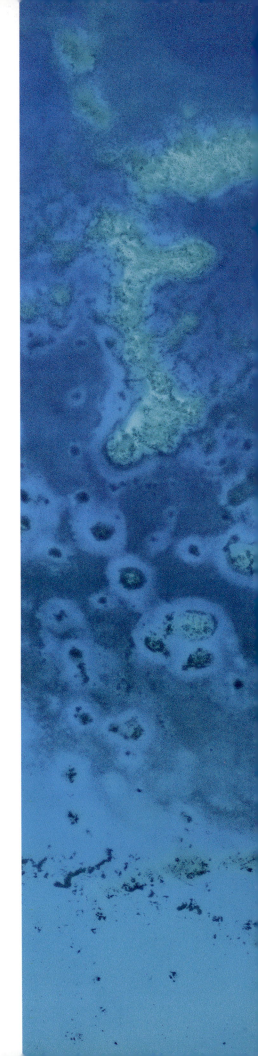

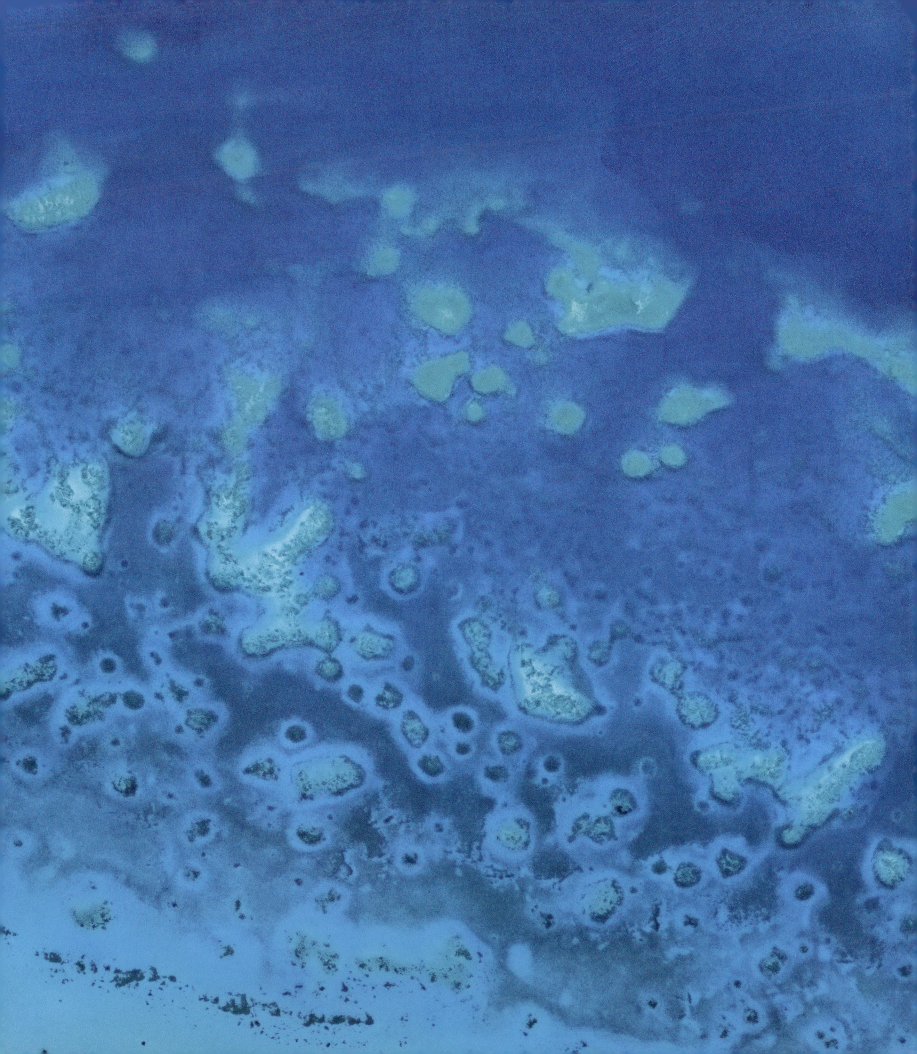

The bluespine unicornfish is a herbivore. As it browses on seaweeds, it becomes one of the species that creates tropical coral reef halos.

Floating ice island

Antarctica was the last continent on Earth to be explored by humans, and even today it is difficult to reach; so much so that it was only with satellite pictures that scientists noticed an unusual pattern in the ice. It was nothing more than a very long line, but it was about to turn into something that would grab the world's attention.

With receding glaciers and rising sea levels, the white continent is never far from the headlines, and in 2016 it was in the spotlight again. That year, scientists noticed that a major change was taking place on the Larsen C ice shelf, a thick platform of floating ice that hangs off the coast of the Antarctic Peninsula bordering the Weddell Sea. They began to take a closer interest in it when the pictures showed a rift in the ice that was over 100 kilometres long and 90 metres wide. The giant crack had the potential to set loose one of the largest icebergs of modern times.

As the weeks went by, the fissure gradually lengthened and widened until this section of the ice shelf was only attached to the mainland by a short, 20-kilometre-long hinge. In July 2017, it broke free, and was named A-68.

Using high-resolution images from Urthecast's Deimos-1 and 2 satellites, the *Earth from Space* production team were able to watch in detail as the crack grew and the iceberg was set loose. Icebergs break away from glaciers and ice shelves regularly, of course, without attracting international interest, but this was something else – an enormous slab of ice twice the size of Luxembourg, which weighed an estimated one trillion tonnes and, if it melts, the water released will have a volume twice that of Lake Erie, one of the Great Lakes.

While the departure of A-68 from the Antarctic will have little immediate impact on global sea levels, it does mean that the glaciers that previously discharged onto the shelf are likely to flow faster. Larsen A and part of Larsen B have broken up and gone, and if the entire Larsen C ice shelf disintegrates, and all the ice it has been holding back enters the sea, then the global sea level *could* rise by about ten centimetres.

Scientists are examining closely the satellite images from this region. Even though the neighbouring Antarctic Peninsula is one of the most rapidly warming parts of our planet, some researchers are at pains to point out that the calving of A-68 was part of the natural cycle of an ice shelf and not influenced, as one might think, by climate change.

Whatever the cause, an event so important in such a remote part of the world could not have been followed without satellite imagery, and, without those early pictures, we might not have known the iceberg was about to calf at all.

RIGHT **The breakaway section of the Larsen C ice shelf is in the centre of the picture. Since it broke from the mainland it has not moved far, about 65 kilometres in a year. It's heading north very slowly, but could survive for decades.** © NASA

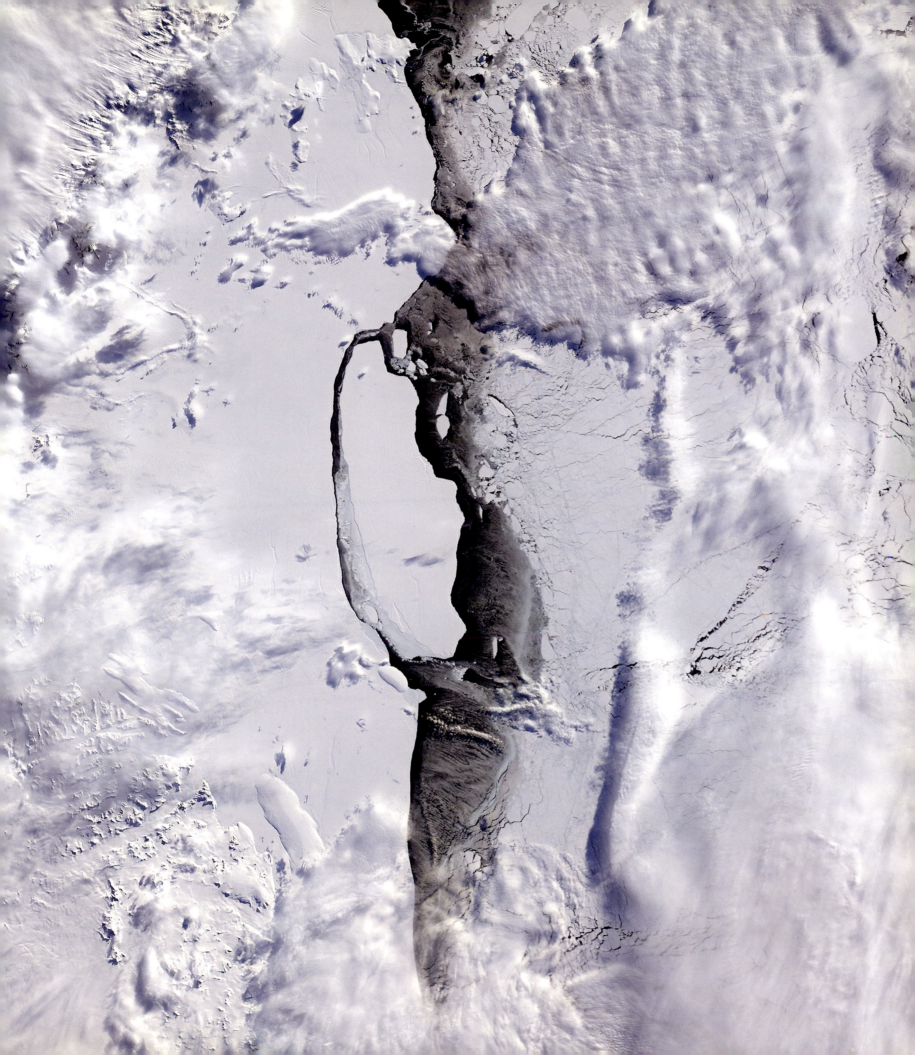

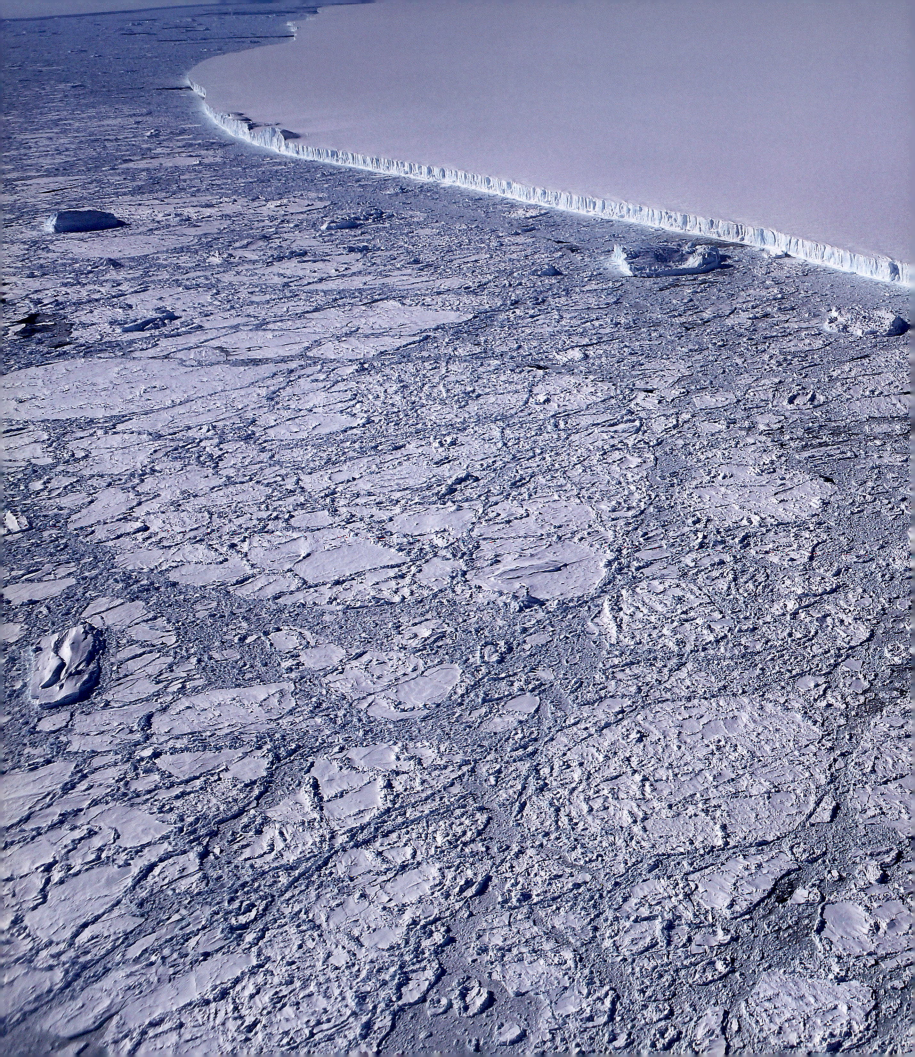

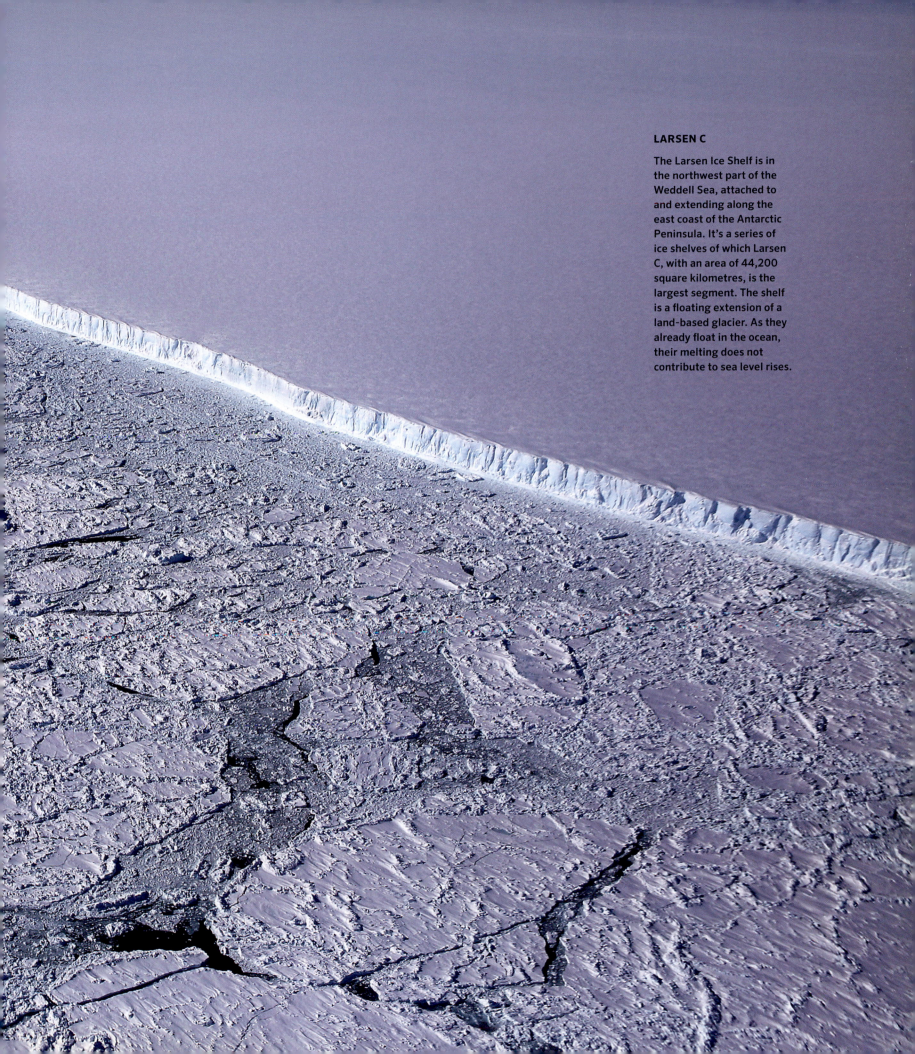

LARSEN C

The Larsen Ice Shelf is in the northwest part of the Weddell Sea, attached to and extending along the east coast of the Antarctic Peninsula. It's a series of ice shelves of which Larsen C, with an area of 44,200 square kilometres, is the largest segment. The shelf is a floating extension of a land-based glacier. As they already float in the ocean, their melting does not contribute to sea level rises.

It's raining rocks ... or maybe not

In some parts of our planet, the Earth wears its violent history on its surface, but it is only when we ventured into space and looked back that we could begin to read the story. Depending on their size, rocky bodies from outer space tend to make an impressive dent in the fabric of the Earth. In the USA, the clearly visible Meteor Crater, east of Flagstaff, Arizona, was created about 50,000 years ago when a nickel-iron meteorite, about 50 metres across, ploughed into the ground. In Canada, two circular Clearwater lakes, near Hudson Bay, are two eroded craters. Lake Manicouagan is a similar impact crater, and is clearly visible from the International Space Station, where astronauts have dubbed it 'the eye of Quebec'. One of the most impressive features, however, must be another eye, the 'Blue Eye of the Sahara' or Richat Structure, as it is more formally known. But, although its shape may be similar to the others, it is probably not a crater.

The structure is hard to spot from ground level, but, when seen from a satellite, it looks like an outsized ammonite, a landmark in the featureless desert for space station crews. It is located near Ouadane in Mauritania, where it is at least 40 kilometres in diameter, and looks to all the world like an asteroid impact crater, but geologists now believe it to be an eroded, layered dome. The concentric rings are made from rocks of different ages, offering an illustrated history of the early Earth. At the centre are rocks laid down when life was getting underway, while on the outside are Ordovician sandstones over 440 million years old.

The dome itself formed about 100 million years ago, when molten rock pushed up towards the surface in an unusually symmetrical way, like a bubble. At first it failed to break through the rocks at the surface but, many years later, the dome erupted and the bubble collapsed. Erosion did the rest.

OPPOSITE **Viewed from the International Space Station, the 'Eye of the Sahara' resembles an impact crater, but it's not. People once thought it looked remarkably like the circular ruins of Plato's Atlantis, but it's not that either. It's an eroded dome.**

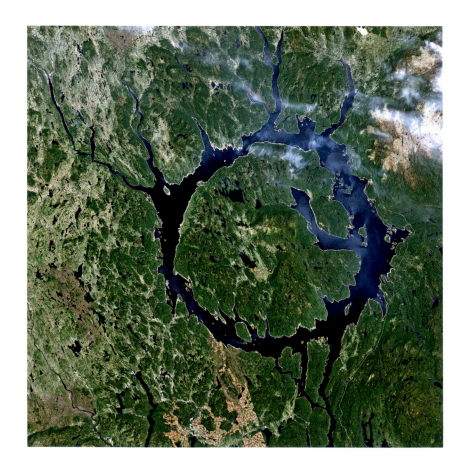

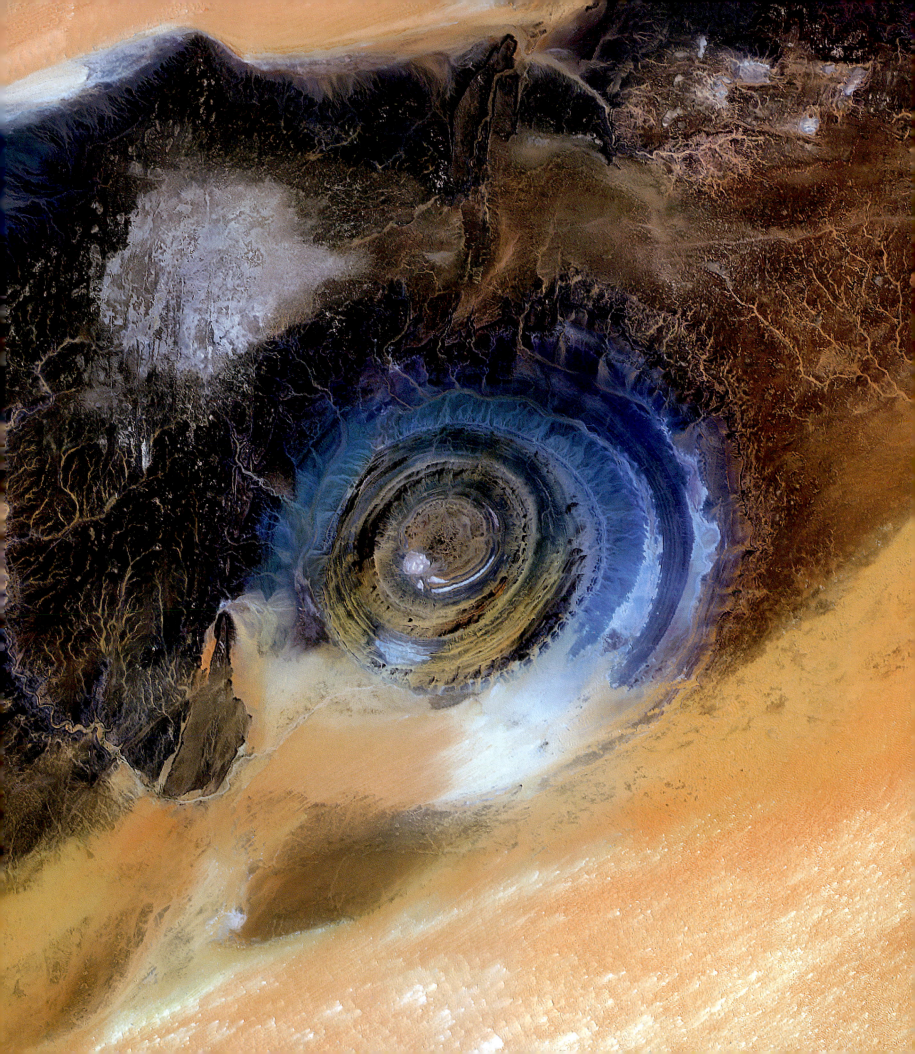

Sand sculptures

Sand dunes are Mother Nature's kinetic art. Without vegetation to bind the sand grains, desert and seaside sands are exposed to the restless whims of the wind. At ground level it might seem chaotic, but from the perspective of space, we can see there is order. The patterns are beguiling – star dunes, crescent dunes and linear dunes – each reflecting and revealing the direction and strength of the wind. In northeast Brazil, this combination of wind, water and rock has sculpted a startling landscape.

From space, the dunes appear as a band of brilliant white that spills in from the blue of the ocean, engulfing the green of the forest. Millions of tonnes of sand have accumulated here, and every tiny grain made a similar journey. It started inland, was then washed downriver to the sea, ground up by the stormy Atlantic Ocean, washed up on the shore, and finally blown by powerful winds back onto the land. The result? About 1,500 square kilometres of brilliant white sand piled into towering dunes – the *Lençóis Maranhenses*, meaning the 'bed sheets of Maranhão'.

It is a beautiful but barren and seemingly lifeless landscape. The Sun beats down from directly overhead, so there is little escape from the burning heat and the blinding sunlight reflected off the glistening white sand. The ground temperature can soar to a blistering 70°C, yet there is life here. When the *Earth from Space* crew on the ground

BELOW **The Maranhão slider turtle is endemic to northeast Brazil, and is considered 'endangered' by IUCN.**

OPPOSITE **Lençóis Maranhenses may look like a desert, but every rainy season 1,195 millimetres of rain transforms the landscape. The water accumulates as clear lagoons in troughs between the dunes.**

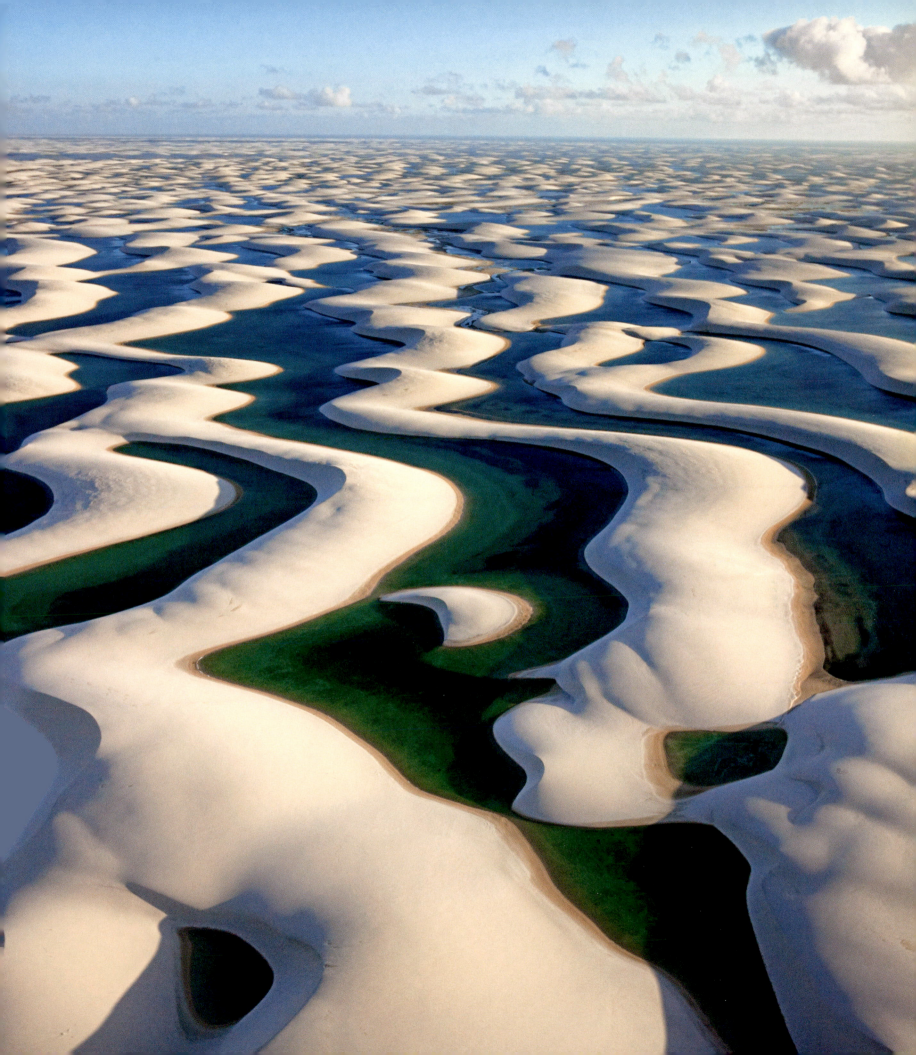

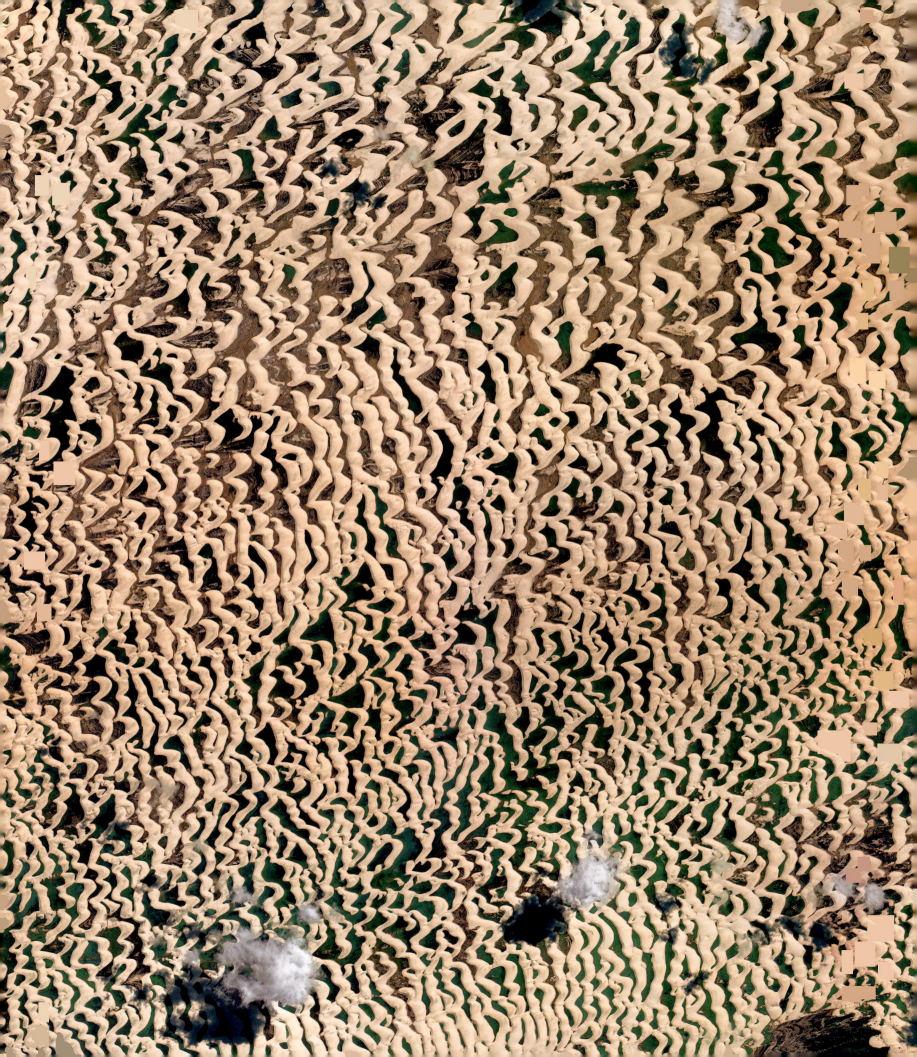

arrived, they were amazed at the diversity of animals that are able to make a living in this unique landscape, and the silhouette of one of them caught their eye.

The brightly coloured, striped face, wrinkled neck and reptilian claws belong to a Maranhão slider turtle, known locally as the 'Pininga'. It is a female and she is on a mission. With precious little water around, she has not fed for several months, but change is in the air. She is going fishing, but where is the water?

These dunes may look like a desert, but it is not one. This *is* Brazil, after all, with a regular rainy season, and the turtle has anticipated the coming transformation. When it rains over the dunes, the water does not drain away. Hard, impervious rock just below the sand causes it to pool in the valleys between dunes, forming hundreds of crystal clear freshwater lagoons, some up to three metres deep. Eggs, which lay dormant for several months, hatch in the pools, filling them with fish almost overnight. One fish, though, remains here all year. The wolfish rides out the dry season in damp mud, emerging at the start of the wet, and it is not the only surprise.

The female turtle heads for a flooded lagoon. While slow on the sand, she turns into a capable assassin under the water, ambushing victims that swim too close, and there are more than enough fish in this one lagoon for her to fatten up and survive another year.

When night falls, the air fills with the sounds of frogs. Members of this night chorus include four-eyed frogs. They were lying in a state of suspended animation for months, but now it is their time to mate, and for this species it is a communal affair. Dozens of males gather in the shallows and sing their hearts out, but not everyone plays by the rules. The old-timers let the youngsters wear themselves out, before letting rip.

The female frogs do not have the yellow skin pigment of the males, so there is no misunderstanding in the pool, and they are attracted to the calls of the males. The older males, who saved their energy, inevitably reach the females first, and each one hangs on tightly to his partner until the female releases her eggs. As soon as they appear, he fertilises them, and the two frogs whip up a mass of protective foam, so the developing eggs are safe from predators and that omnipresent Sun in the sky.

BELOW **The four-eyed frog gets its name from the pair of poison glands in the groin. When lowers its head and raises its body these glands look like eyes, but on a frog with a bigger head.**

Mountain monkeys

Mountainous areas, with their cold winters of icy winds, snow and fog, can be tough places for plants and animals to survive, but in some regions the shape of the land can bring a lifeline. At the far eastern edge of the Himalayas, the Tibetan Plateau acts as a giant heating surface that helps draw up milder air through the valleys of the Hengduan Mountains in southwest China. It enables thick forests to thrive on the high, steep slopes, creating a living space for an extremely rare animal – the black or Yunnan snub-nosed monkey, one of a genus of monkeys that have thick pink lips and an almost comical turned-up nose. It is very rare, fewer than 3,000 are thought to exist, and it is remarkable in that it lives higher than any other non-human primate.

It is a harsh place to bring up a family, but the dominant male of a group, with up to six females and a gang of adolescent youngsters in tow, needs to be savvy about how to survive up here. His group may be part of a large super-troupe or band of up to 400 individuals, and they are often on the move.

Surprisingly, when the weather turns nasty, conditions that would see most mountain animals dropping down to take advantage of more favourable conditions on the lower slopes, the snub-nosed monkeys climb up. They travel up to an altitude of 4,700 metres, sometimes above the tree line, where the solar radiation is at a maximum, their thick black fur absorbing the heat. The upper slopes are also where their main foods are to be found.

These monkeys are unusual in that they eat mainly lichens, supplemented by several other forest foods, such as frost-resistant fruits and even invertebrates. Lichens, though, take decades to regenerate, so, having exhausted one feeding site, the monkeys travel

RIGHT **The snow-covered Hengduan Mountains and their subalpine conifer forests are home to the rare black snub-nosed monkey.** © NASA

extensively to find fresh supplies. Some cover over 1,500 metres in a day, exploring a home range of up to 56 square kilometres of mainly coniferous and oak forest. They move and feed in the early morning and late afternoon, with a four-hour siesta in between.

A respite from winter's hardships comes in spring. The young leaves on trees spice up their monotonous winter diet, and, when rhododendrons bloom, they have been seen to eat the nectar from its flowers. With frost on 280 days of the year and four to six months of snow up to a metre deep in winter, it is not an easy life. However, in this modern world, these monkeys are out of the fray as long as people do not invade their living space, hunt them illegally, and air pollution does not kill off the lichens. The area where they live is relatively inaccessible to people and includes some of the most biologically diverse parts of China. Even so, many large mammals have been wiped out in the area and the black snub-nosed monkey is still one of China's most endangered primate species.

BELOW **Lichens are one of the few food sources available in winter, but in spring, snub-nosed monkeys have a varied diet, including the nectar from rhododendron flowers.**

OPPOSITE **While adult monkeys have dark grey fur on the back and pale fur on the belly, their babies are completely white, with pink sticking-out ears.**

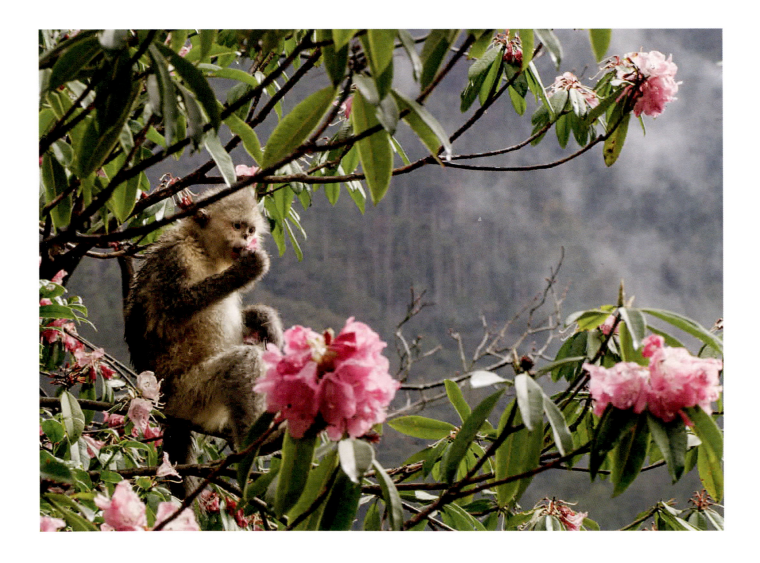

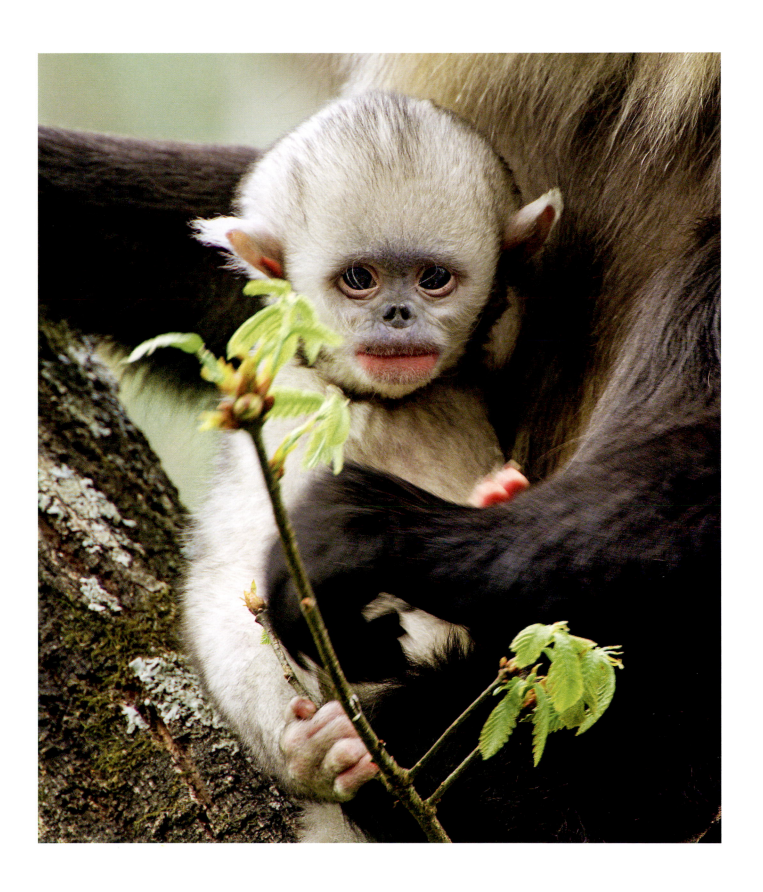

River deep, mountain high

Asia's longest river and the third longest in the world, the Yangtze, passes through deep gorges in Yunnan province. It has its headwaters in the snow-covered Tanggula Mountains on the Tibetan Plateau and, from space, the river looks at first to be a long silver ribbon, then mottled green and brown with silt and sediments, and finally pink with industrial pollution that spews into the turquoise waters of the East China Sea.

As rivers follow their journey from source to mouth, the water rides the unique contours of the landscape and reacts with the rocks and earth beneath, giving each waterway its own personality. The Brahmaputra, for example, has sliced through the rocks of the eastern Himalayas, and, together with an uplifting of the land, forms the Yarlung Tsangpo Canyon. At six kilometres deep, it is the deepest canyon in the

OPPOSITE AND LEFT **These true-colour satellite images show the city of Shanghai and the Yangtze River delta on China's east coast. To the south is the Qiantang River and Hangzhou Bay. The rivers collect silt from inland and dump it, along with industrial pollutants, into the East China Sea.**
© Jacques Descloitres, NASA MODIS Land Science Team.

OVERLEAF **At an altitude of 600 metres, runoff from Iceland's Hofsjökull glacier forms braided rivulets in the river sediments. The adjacent tundra is pocked marked with ponds and palsas, the latter being hollows with permanently frozen ice lenses.**

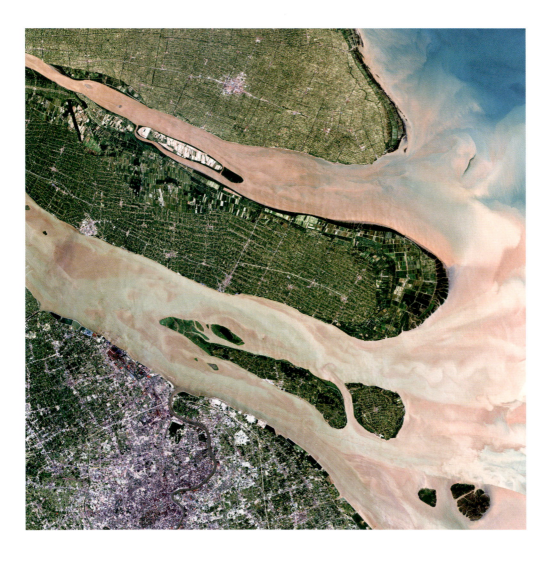

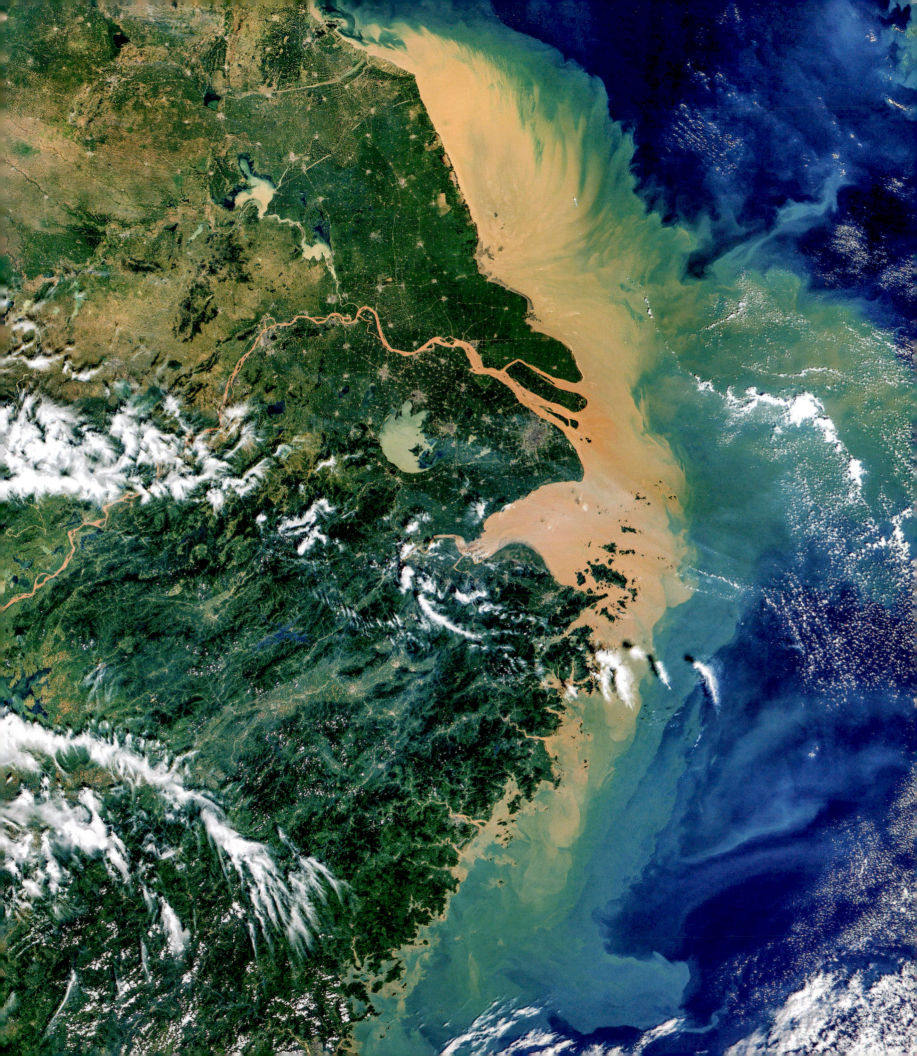

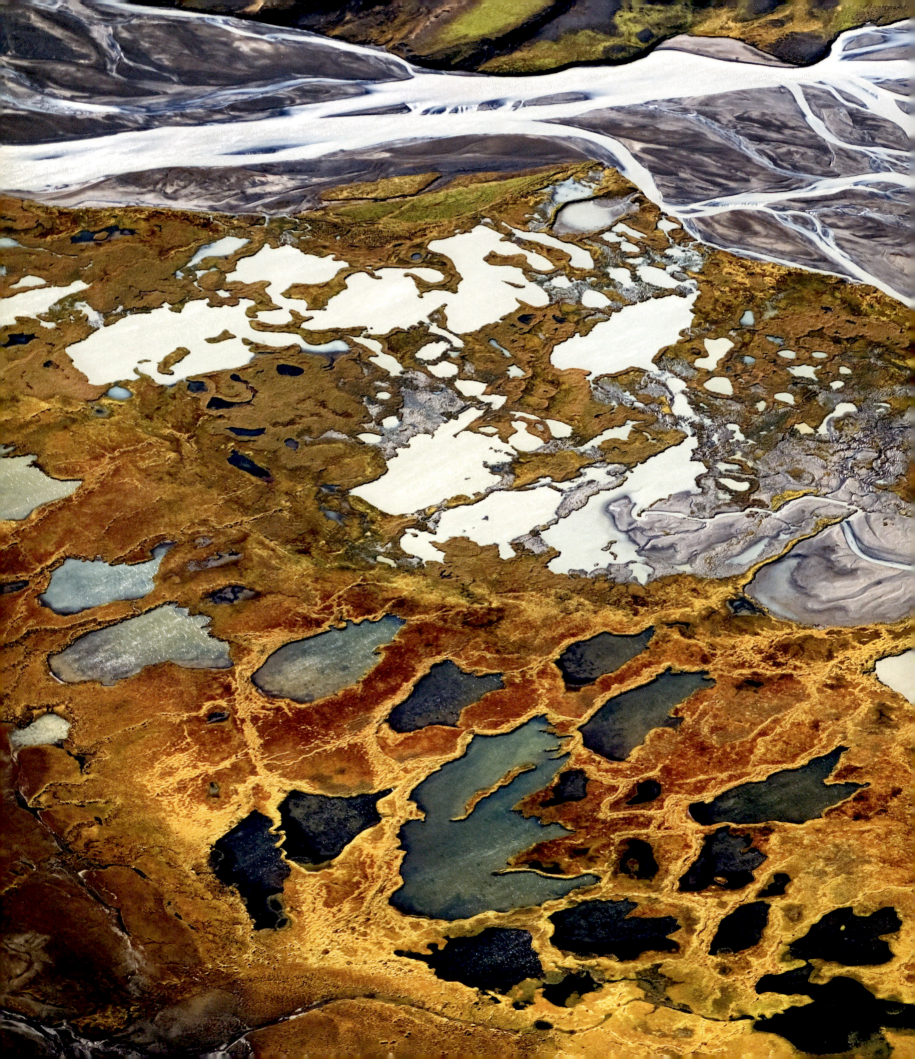

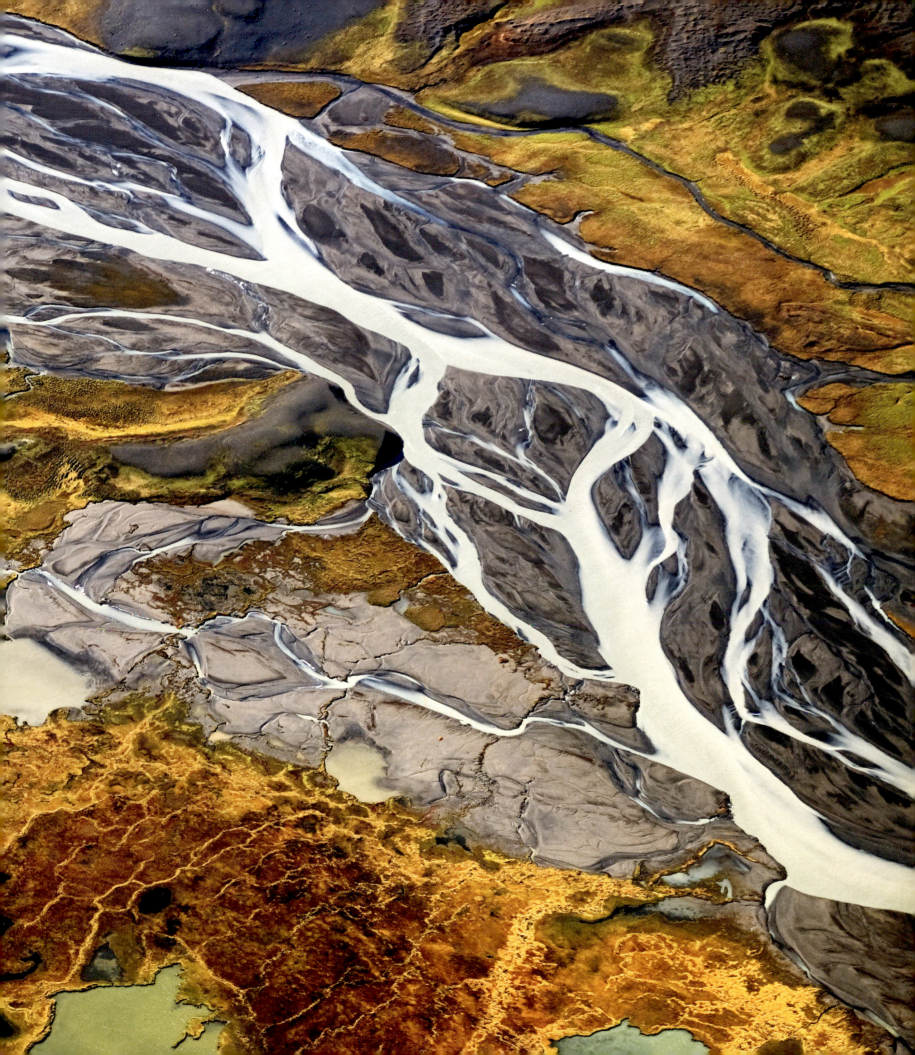

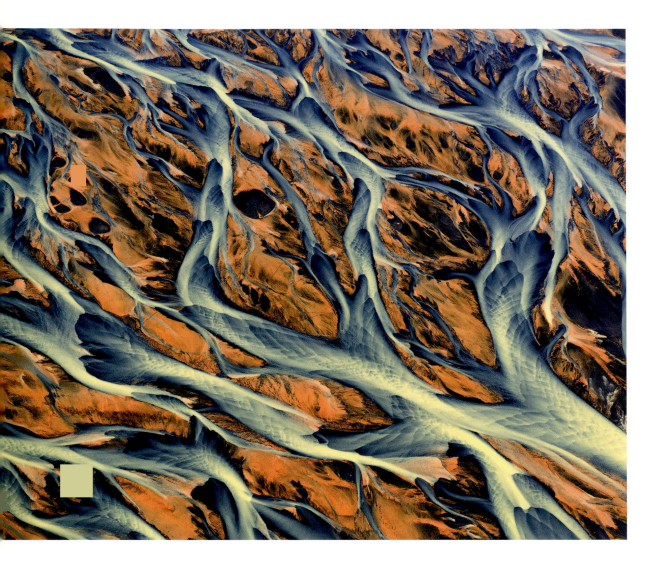

LEFT **An aerial view of a river delta in southwest Iceland shows how the river and sediments have been coloured orange from iron oxide carried down from the volcanic rock interior.**

OPPOSITE **Iceland's Dettifoss carries the greatest volume of water of any waterfall in Europe. It's 45 metres high and 100 metres wide.**

OVERLEAF **This Landsat image shows the 4,500-kilometre-long Lena River forming one of the world's largest deltas. It is 400 kilometres wide and extends 100 kilometres into the Laptev Sea from Siberia, northern Russia. The Lena Delta Wildlife Reserve protects large populations of swans, geese and ducks that arrive each summer from around the world to breed. © NASA USGS.**

world, far deeper than North America's Grand Canyon. Other rivers erode the soft rocks but tumble over hard rocks in spectacular waterfalls, like those at Iguaçu, Niagara or Iceland's Dettifoss – the most powerful waterfall in Europe.

Where the land is flatter, rivers zigzag towards the sea, and, the greater the amount of sediment they carry, the more likely they are to meander. There are also rivers that fan out, forking again and again to create hundreds of shape-shifting ephemeral islands and multiple channels. In Iceland, 'braided rivers' flow over open volcanic plains, picking up enormous loads of ash that builds into networks of river channels separated by temporary islands or braid bars. Wherever these rivers flow and whatever their 'personality', they are sure to bring life; none more so than the world's largest river system – the mighty Amazon.

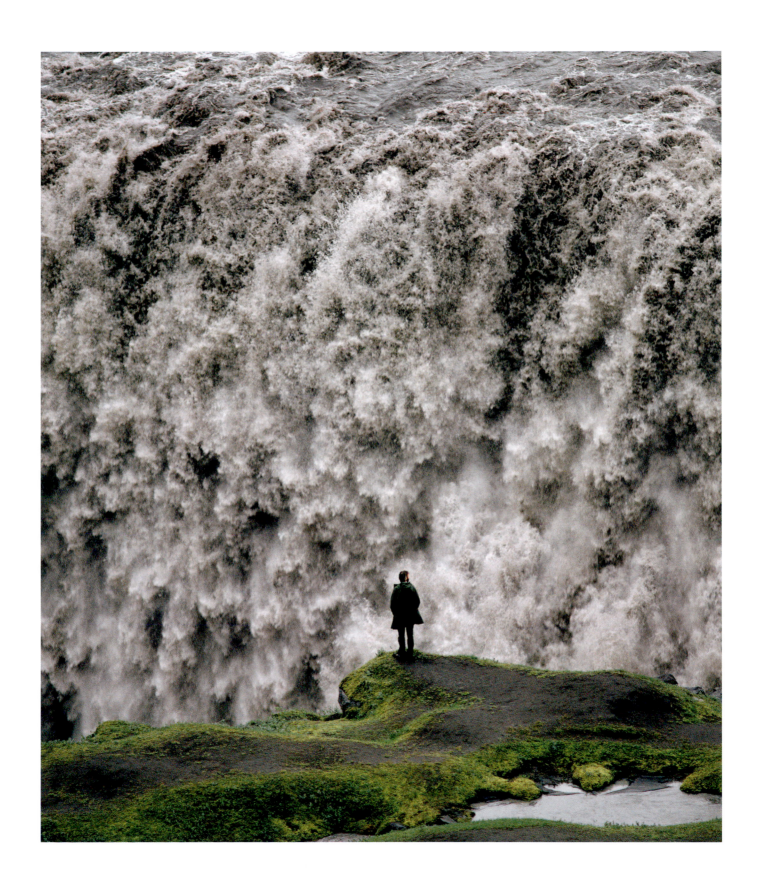

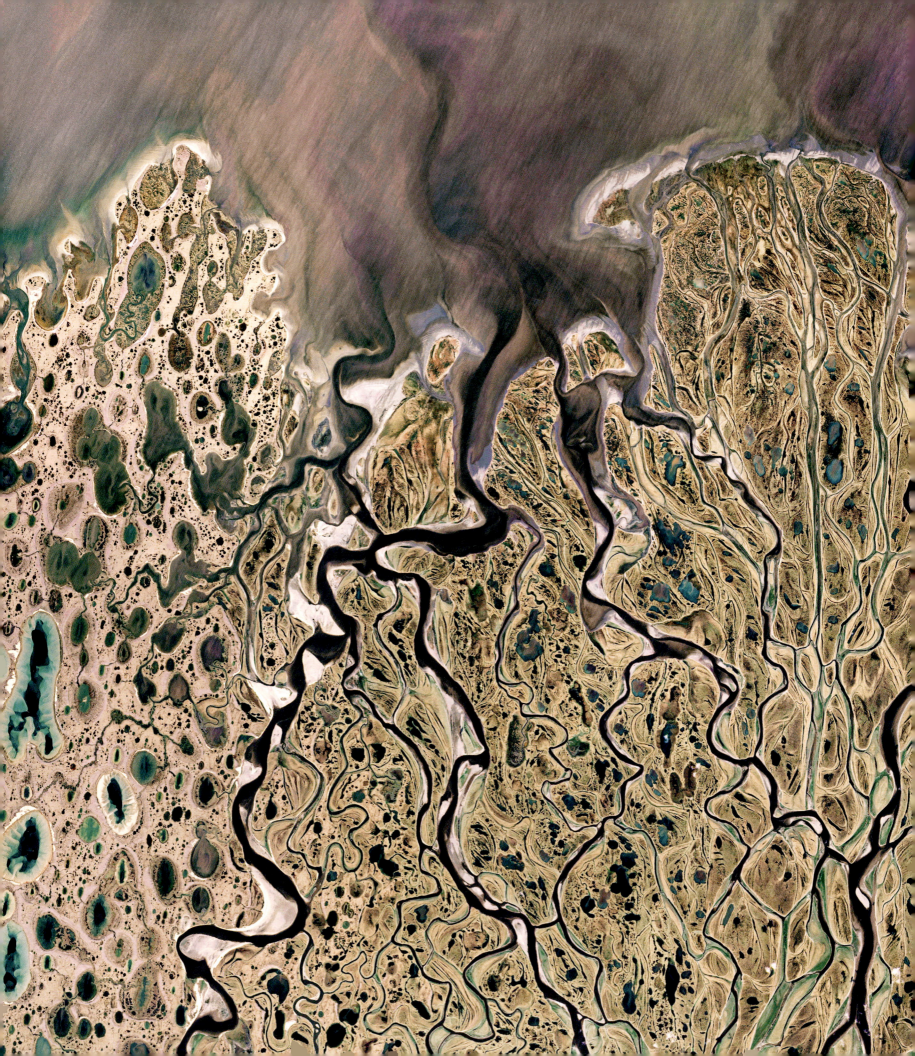

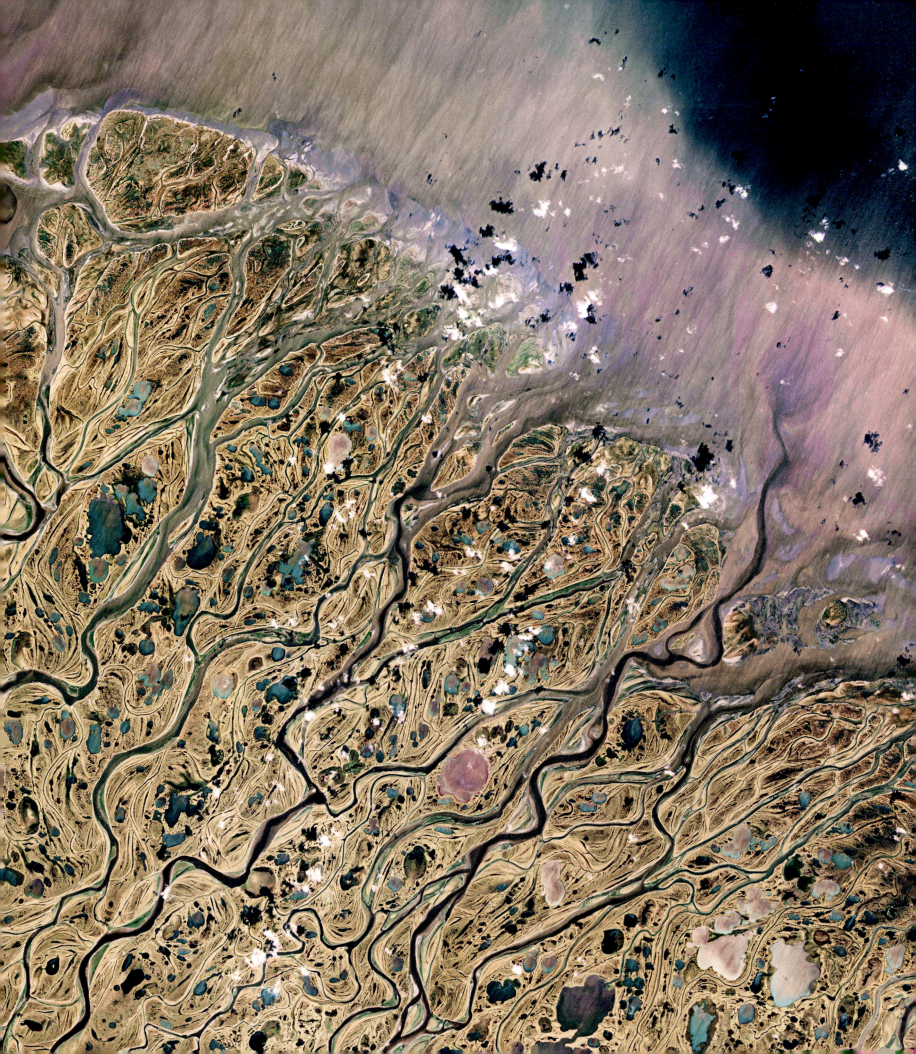

A place for mermaids

One-fifth of all the world's river water flows down the Amazon. From its source in the Peruvian Andes to its mouth over 6,000 kilometres downstream, on average over 200,000 cubic metres of water pour into the Atlantic Ocean every second. It is more than the total discharge of the next six largest rivers combined, and its area of influence is huge. The main river and its tributaries drain 7,000,000 square kilometres of South America, the largest drainage basin on the planet, of which 6,000,000 square kilometres is tropical rainforest.

Seen from space, the network of rivers and streams can be seen winding their way across this vast area but, for much of their journey, they do not rush. At Iquitos in Peru, the Amazon is only 100 metres higher than at its mouth, the gradient being a drop of little more than two centimetres for every kilometre until the confluence with the Rio Negro, and thereafter just one centimetre per kilometre. This allows the Amazon to take its time, meandering through flooded forests and wetlands, following the path of least resistance and creating beautiful sinuous patterns when viewed from above.

Using NASA satellite imagery from 1984 to 2017, the *Earth from Space* team was able to build a timelapse video sequence. It reveals how the route taken by the water is not fixed, but the many tributaries to the main river change their paths as they snake through the Amazon Basin. One result of this ever-changing pattern is that the Amazon forms more of one distinctive shape that any other river on Earth. From space it is as if hundreds of horseshoes appear and disappear, each one an oxbow lake.

An oxbow is a bend in the river that has been cut off from the main flow. It can be small, just a few metres long, or enormous and several kilometres long. Whatever the size, it is a magnet for wildlife, because it has all the benefits of the river without having to constantly fight against the energy-sapping flow. It is the perfect place for giant river otter parents to raise a family, or a pod of Amazon pink river dolphins to feed. It can also be a special place for people.

Elvira is nine years old. She lives in a small community in the Peruvian Amazon. She and her friends like to explore the forest on their doorstep, but her favourite place is a little further into the jungle.

'I always look forward to going there,' she says. 'It's a magical place.'

Known to the local people as El Dorado, this special place is a huge oxbow lake, clearly visible from space.

'The lake is the very best place for seeing lots of different animals,' says Elvira. 'I've seen river dolphins, turtles, fish and many different birds, too many to name.'

While the *Earth from Space* film crew was there, Elvira was about to add another animal to her list.

BELOW **Elvira lives in the Amazon Basin in Peru. Although just nine years old, she is aware of the need to conserve the plants and animals that she lives alongside. One special creature for her is the Amazon manatee.**

OPPOSITE **This true-colour satellite image shows the tangle of waterways in the Amazon River delta in Brazil.**

OVERLEAF **On its tortuous way to the sea, the Amazon River is quite literally 'all over the map'. The greater the amount of sediment carried, the more frequently the river meanders and the more likely oxbow lakes are to be formed.** © ESA

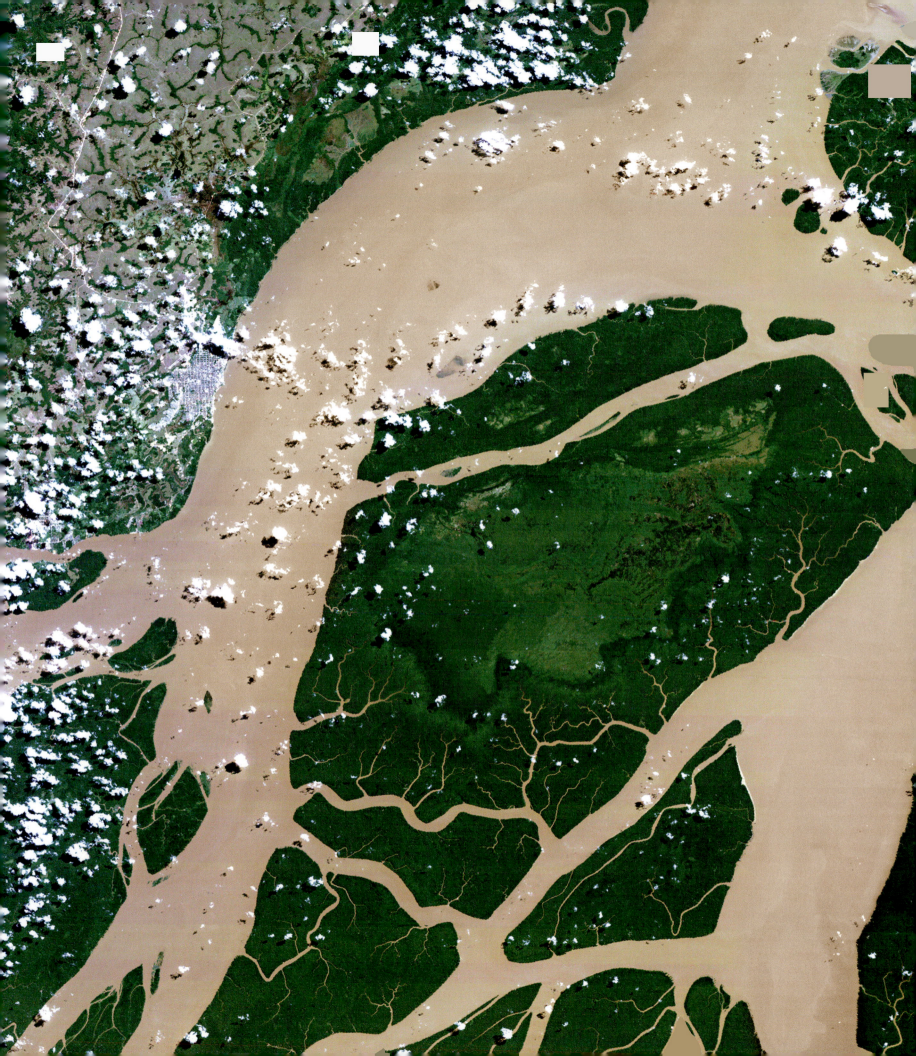

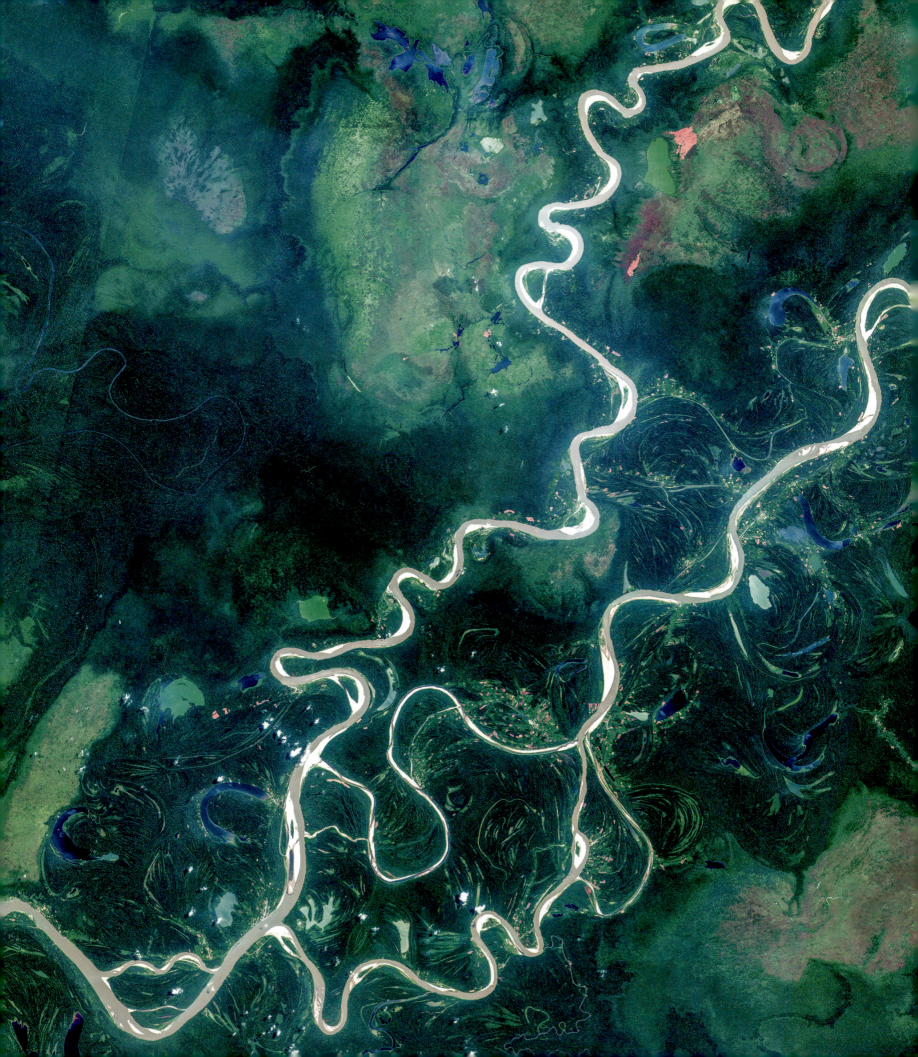

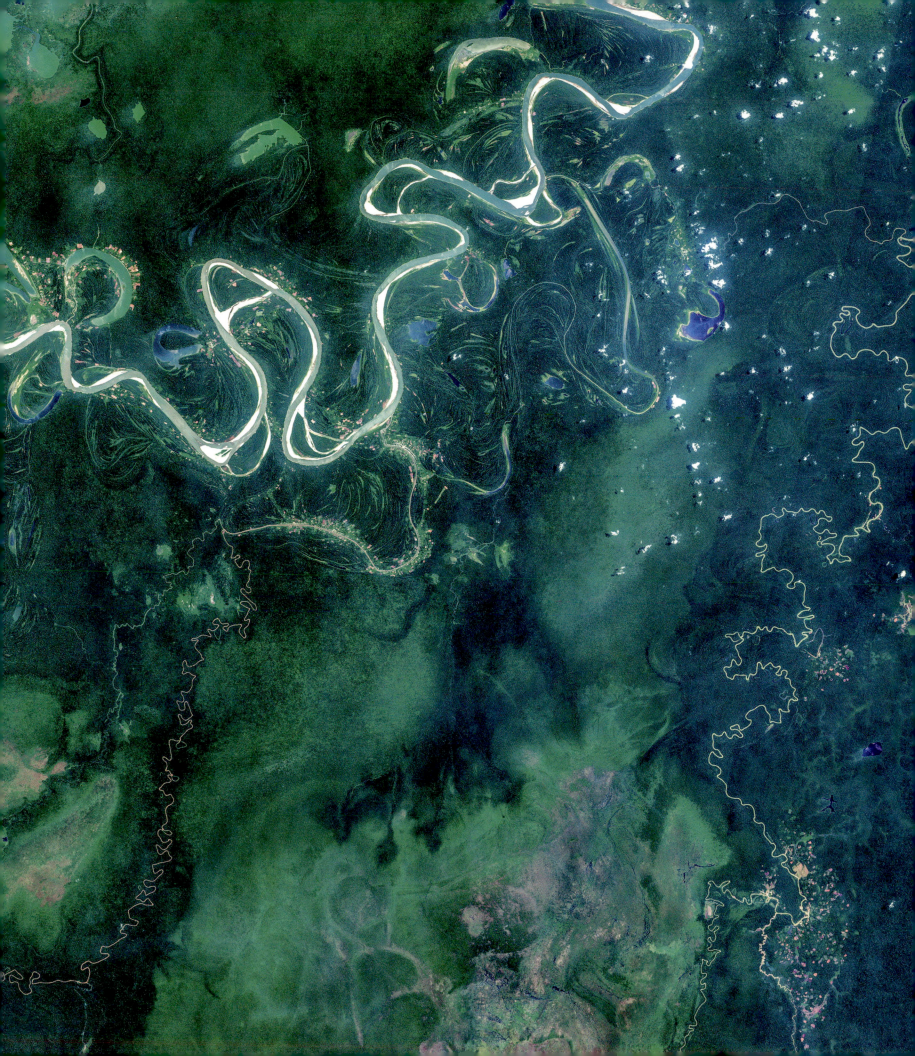

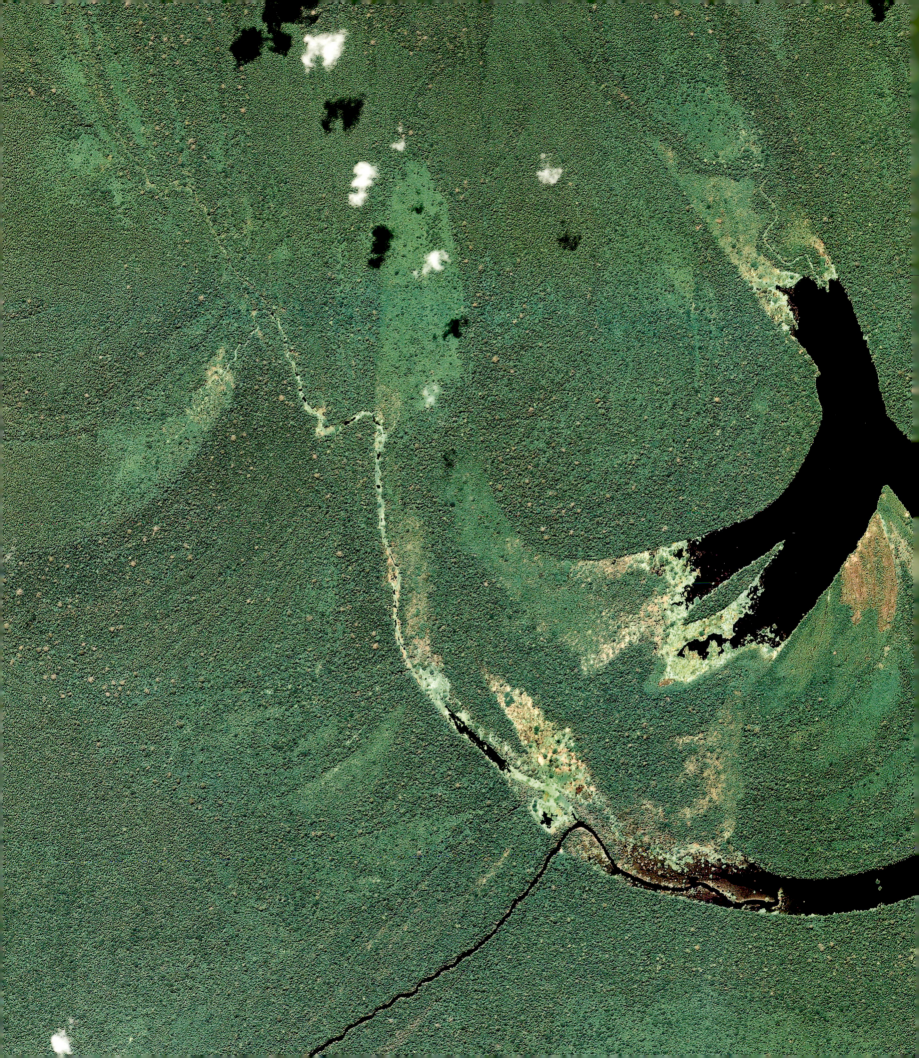

LEFT This satellite picture shows an enormous oxbow lake that has been cut off from the main river in the Peruvian Amazon. Local people call it 'El Dorado', and it is a haven for many of the Amazon's charismatic creatures – manatees, giant river otters, river dolphins, freshwater turtles and all manner of fish and birdlife. © 2018, Deimos Imaging SLU, an UrtheCast Company.

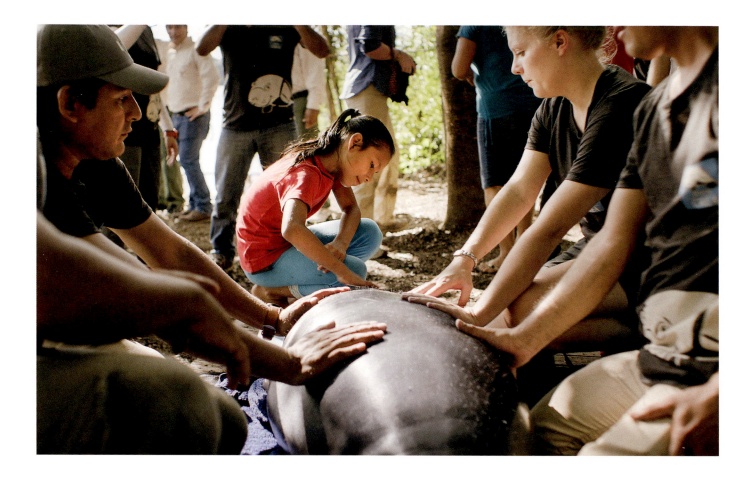

'They're coming from so far away,' she exclaims. 'I hope they are safe, and get here OK.' And, to spot the new arrival, she listens carefully.

'I can hear it,' she cries. 'There it is!'

An aircraft comes into view, its precious cargo closely guarded. It is a floatplane and it lands on the river, its cargo is unloaded.

'Let's go, let's see.'

Elvira pushes to the front of the crowd.

'I want a closer look.'

It's an Amazonian manatee, a close relative of the gentle animals that ancient mariners once mistook for mermaids. This is one of five brought here to start a new life in the safety of the oxbow lake. They are the largest mammals in the Amazon but, despite their size, they are rarely seen. They feed on aquatic vegetation, only surfacing to breathe once every five minutes or so. They are easy targets for hunters, who kill them for their meat, but these are the lucky few that have been rescued and rehabilitated. For Elvira, it is a chance to get a really good look at a creature that is usually hidden.

ABOVE AND OPPOSITE **The Amazon manatee is the smallest of the manatees and the only species to live exclusively in freshwater. It feeds on aquatic plants, which is crunches with molar teeth that are continuously replaced throughout its life. Its closest living relatives, apart from other manatees and dugongs, are the hyrax and the elephant. It is considered 'vulnerable' by IUCN, but many are killed for their meat.**

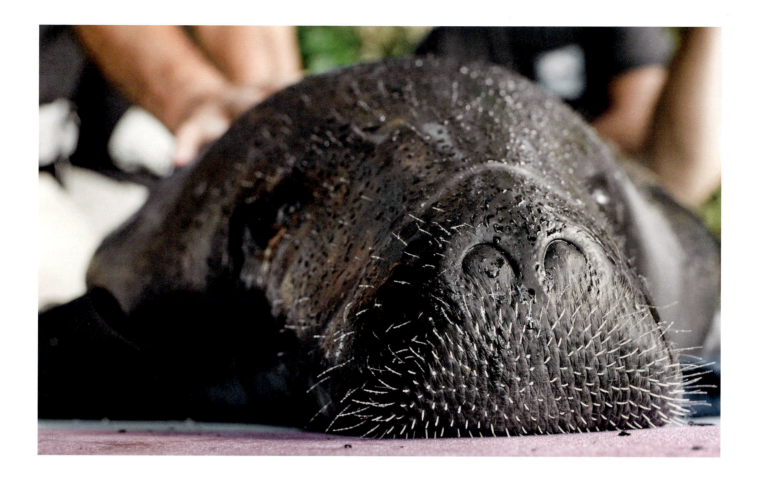

'You might live your whole life here and never see one, so it's amazing to be able to be so close.'

One of the manatees was found at a village nearby, but now it is to be released back into the wild, and Elvira is about to play a leading role.

'On the count of three,' a voice shouts. 'One, two, three.'

And Elvira helps ease the manatee into the water.

'Hopefully they'll be safe and happy here at El Dorado. I'll try and visit them, and maybe there will be more manatees here in the future.'

Elvira's optimism is welcome. There are thought to be no more than 30,000 of these animals in the entire Amazon river system, according to IUCN, but nobody is certain because the river water is so murky and the animals so difficult to spot. The trend, however, appears to be downwards. Faced with increased boat traffic, drowning in fishing nets, oil spills, habitat loss, climate change, reduction of vegetation in waterways, and illegal hunting, Elvira's manatee is an important individual in the fight to save this shy and secretive species.

OVERLEAF **Of all the patterns on the Earth's surface, many of the most striking and revealing are satellite images of farmland. Here, the terraces of Spanish vineyards follow the contours of the hills.**

Crop circles

When our ancient ancestors first abandoned a nomadic lifestyle, stopped relying on hunting and gathering, and put down roots to farm domesticated animals and grow crops, those first farmers inevitably settled close to a waterway. It caught on. Even today, most of our major cities – London, Paris, New York – are beside rivers. Water, after all, is vital to keep us healthy. It's also essential to quench the thirst of all those animals and to grow all those crops; at least as long as you could get the water to them. If you could not rely on sufficient rain, a bucket was probably the first solution, but the scale was wrong. Then one enterprising soul had a brilliant idea. You can't bring crops to the river, they thought, but you can bring the river to the crops, and irrigation was born. Now, irrigation, along with different methods of farming, is responsible for some of the most striking man-made patterns on the face of the Earth.

In Brittany, an irregular patchwork of small fields harks back to land use in the Middle Ages. In Minnesota, large square fields reflect the way early 19ᵗʰ-century farmers made best use of their new farm machinery. In Bolivia, fields have a radial pattern. Each has a small community at its centre, which is surrounded by fields set out like the spokes of a

BELOW **In rainforest areas, Bolivian farms are like the spokes of a wheel, with a settlement at the centre and fields radiating outwards. A small buffer of forest separates each farming community.** Satellite imagery courtesy of © 2018 DigitalGlobe, a Maxar company.

OPPOSITE **In Brittany, this November landscape is a vestige of medieval times when farms were an irregular patchwork of small fields. Green fields are mostly pastures, while crops have already been harvested in the brown ones. The dark brown patches are forest. The silver area is the town of Châteaubriant.** © NASA

OVERLEAF **Rice terraces on mountain slopes in China's Yunnan Province form exquisite patterns when seen from above. Some observers consider them to be the most beautiful rice terraces in the world.** © 2009 DigitalGlobe, Inc.

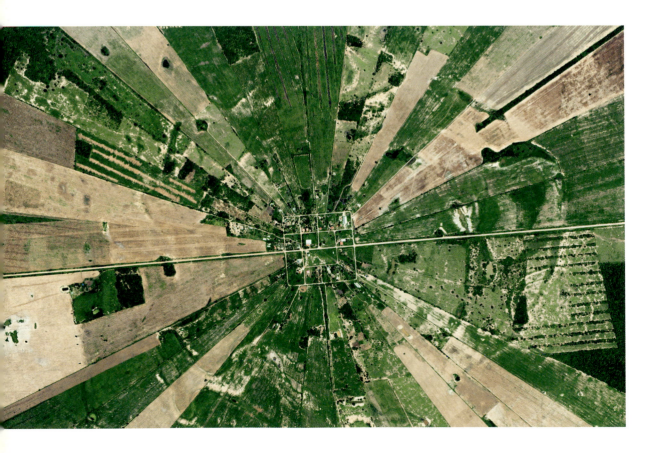

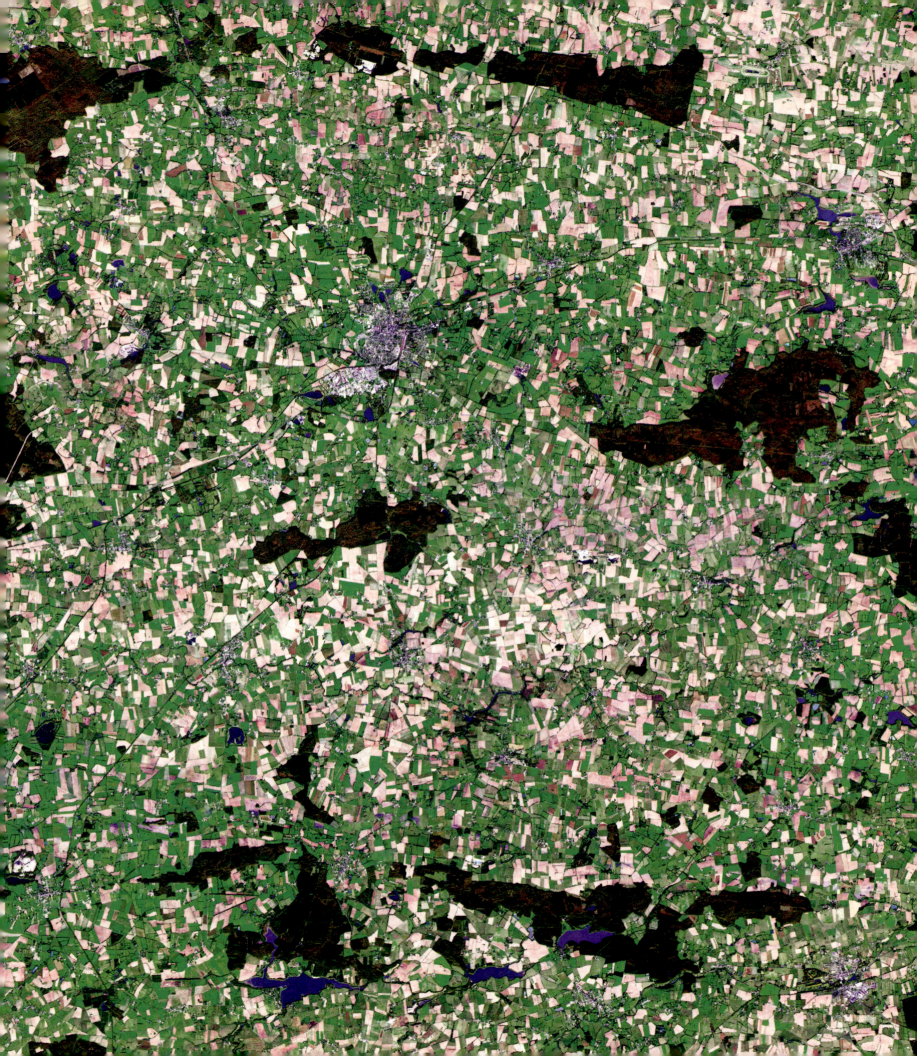

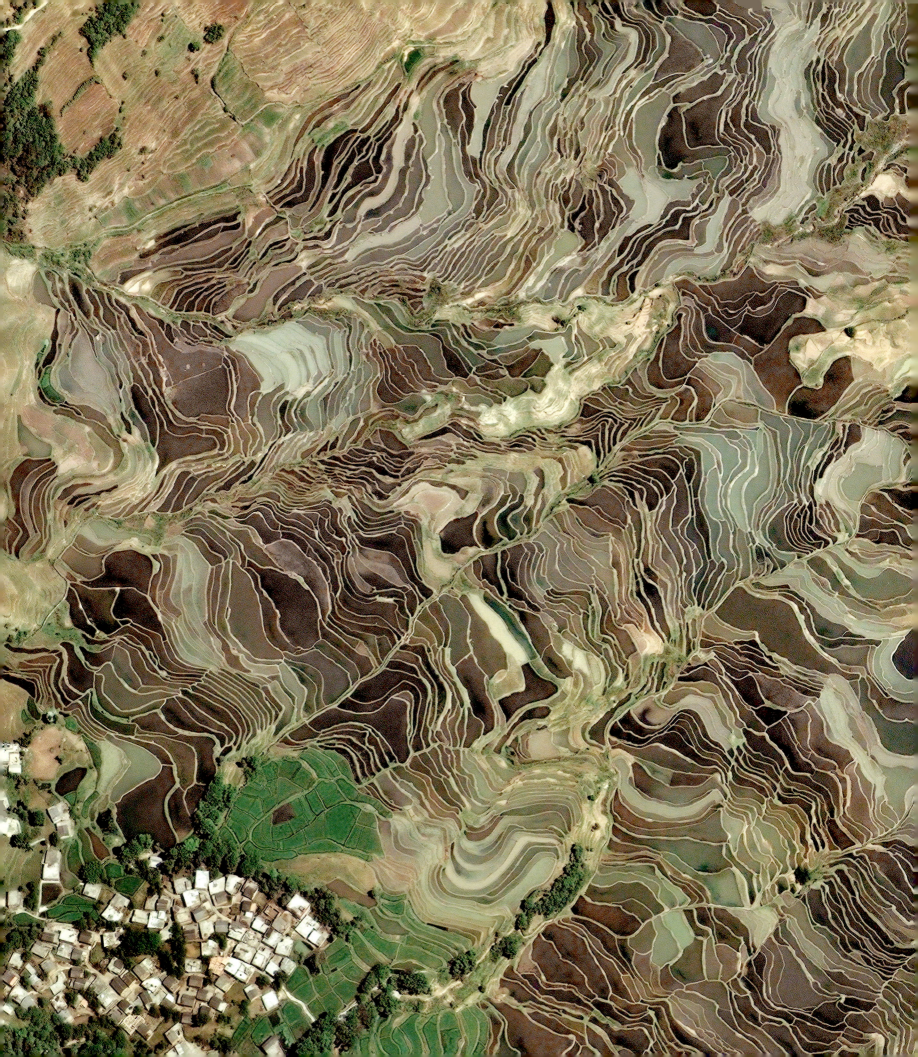

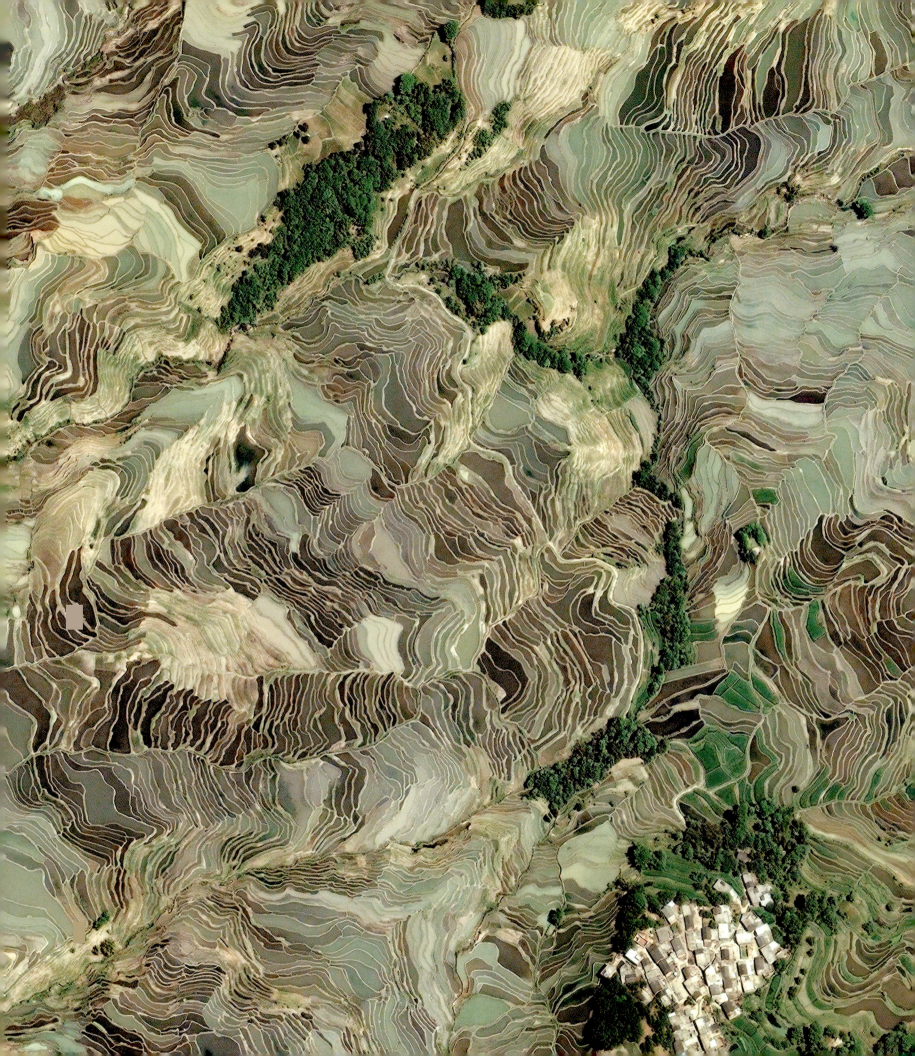

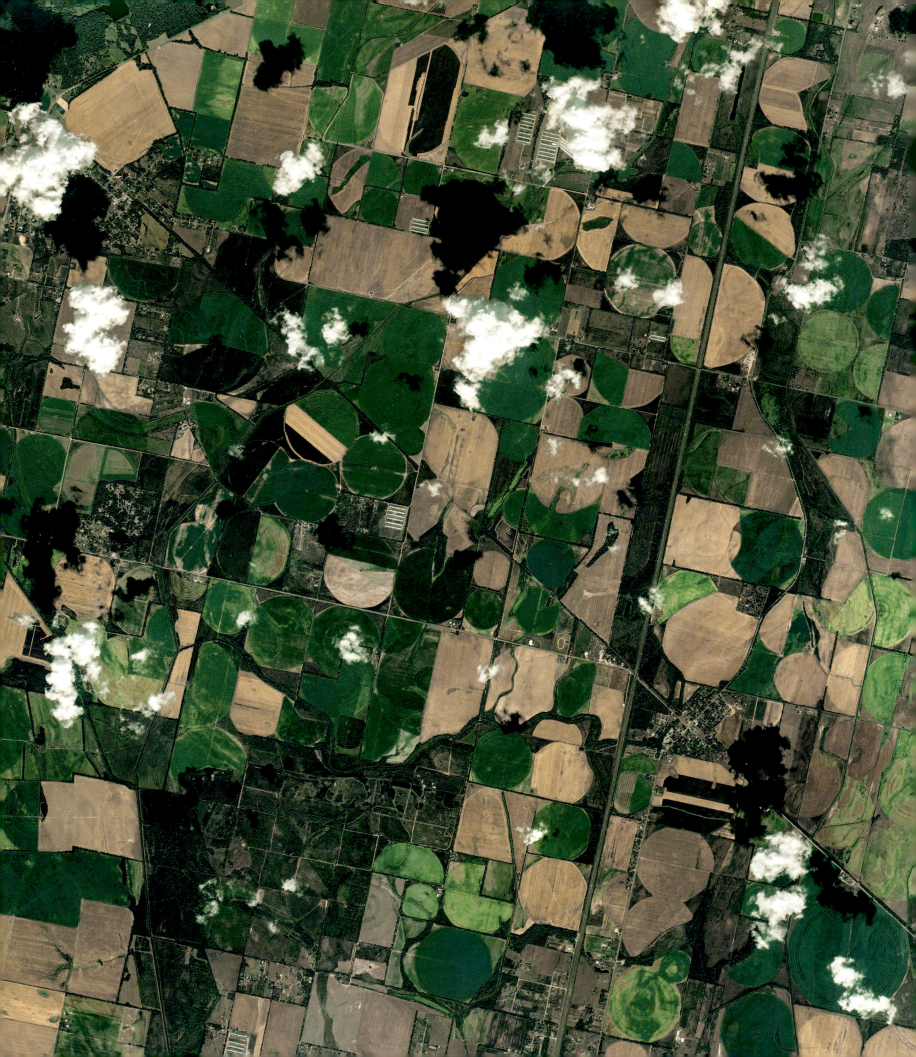

LEFT **The bobwhite quail mother hides her chicks from the dangers of the prairie, such as American kestrels. The family takes cover in the natural vegetation growing between the circular irrigated fields.**

wheel. In Thailand and China, thin strips of rice terraces are fed by irrigation canals and follow the contours of the hills and, similarly, the tightly packed slender fields in Sudan are separated by man-made channels. Look from space at the USA, however, and you will see the most impressive pattern of all: thousands of circles covering the Mid-West like a patchwork quilt.

Variegated green and yellow circles appear where a single moving and rotating arm of water sprinklers irrigates circular patches of crops. The different colours are due to crops being at different stages of growth. However, no matter how tightly they are packed, there are always gaps in between, and the bigger the circles, the bigger the gaps. Conservationists are putting them to good use.

The bobwhite quail is one of the New World quails, only distantly related to the more familiar Old World quails, and, all across North America, populations have been thinning due to disappearing habitat, down by as much as 80 percent in some places. To help reverse the trend, the National Bobwhite Conservation Initiative has been encouraging farmers to plant native grasses and forbs in the triangles between irrigated crop circles as a habitat for quail. Already, quail populations are beginning to bounce back. America's farmers really are making a difference.

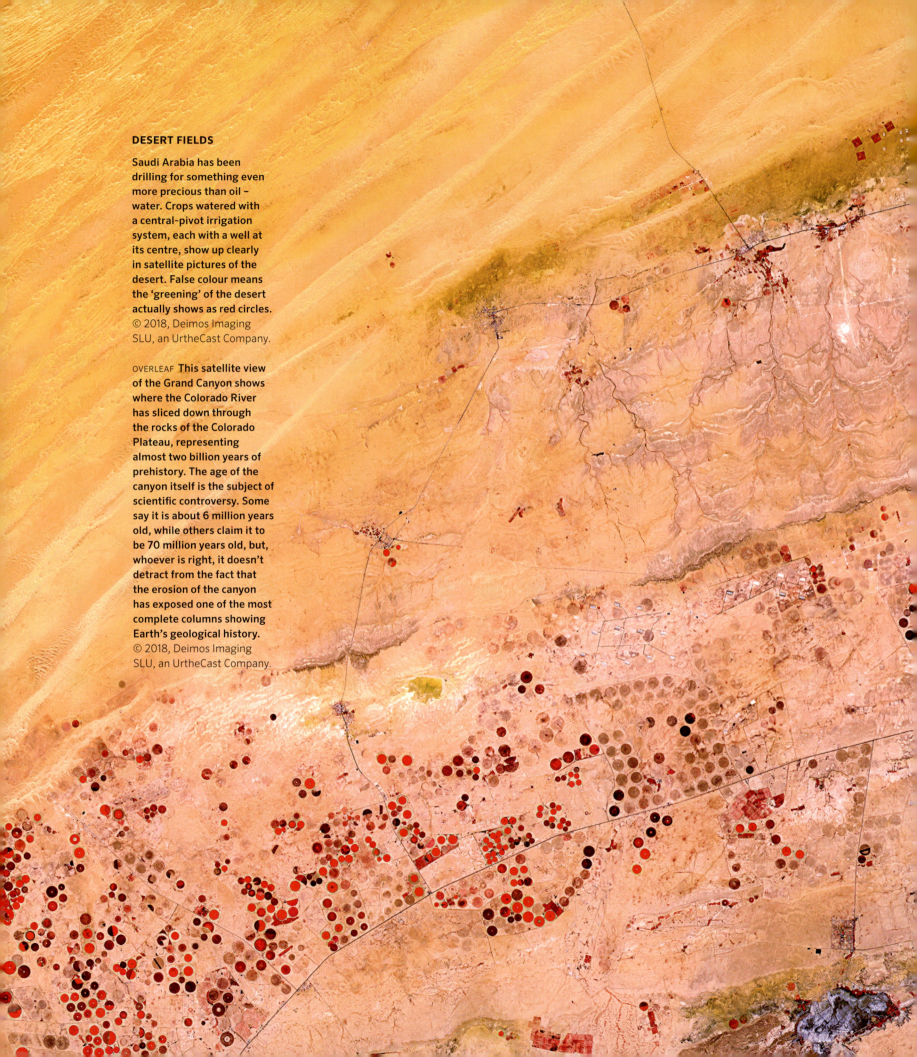

DESERT FIELDS

Saudi Arabia has been
drilling for something even
more precious than oil –
water. Crops watered with
a central-pivot irrigation
system, each with a well at
its centre, show up clearly
in satellite pictures of the
desert. False colour means
the 'greening' of the desert
actually shows as red circles.
© 2018, Deimos Imaging
SLU, an UrtheCast Company.

OVERLEAF **This satellite view
of the Grand Canyon shows
where the Colorado River
has sliced down through
the rocks of the Colorado
Plateau, representing
almost two billion years of
prehistory. The age of the
canyon itself is the subject of
scientific controversy. Some
say it is about 6 million years
old, while others claim it to
be 70 million years old, but,
whoever is right, it doesn't
detract from the fact that
the erosion of the canyon
has exposed one of the most
complete columns showing
Earth's geological history.**
© 2018, Deimos Imaging
SLU, an UrtheCast Company.

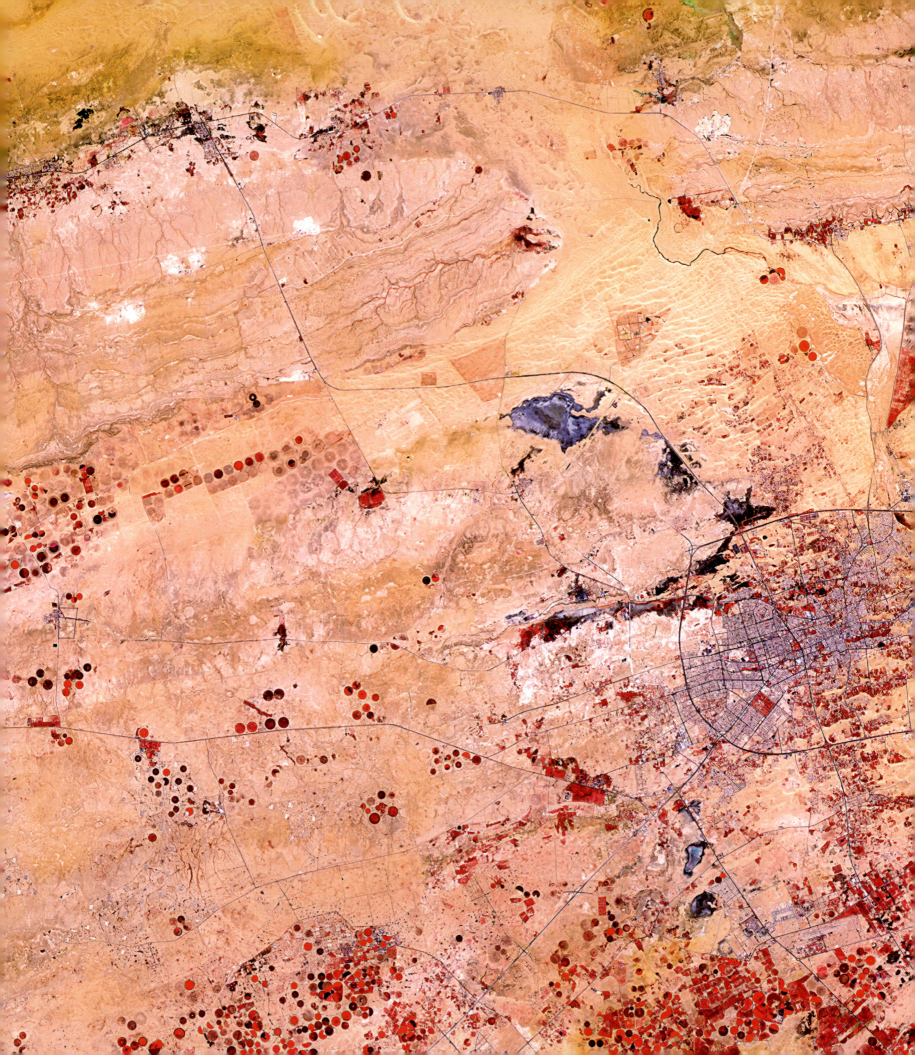

WORLD OF
CHANGE

You might think that the world around you is solid and immoveable, but this could not be further from the truth. The Earth is continually changing: it always has and it always will. Colliding tectonic plates push up mountain ranges and cause islands to form in the middle of the ocean. Earthquakes demolish homes, molten lava destroys farmland, volcanic ash closes down airports, tsunamis flood cities and sinkholes swallow entire neighbourhoods. Powerful forces, over which we have little control, shape our planet. They can be destructive, often with a tragic loss of life, but those same forces can give birth to new land, new life and new opportunities; and this is all the more evident when our restless Earth is viewed from space.

RIGHT **Sarychev Peak dominates Matua Island, one of Russia's Kuril Islands in the northwest Pacific Ocean. It has erupted at least 17 times since 1760, and a violent eruption in 2009 disrupted air traffic between East Asia and North America. From the International Space Station, astronauts were able to photograph the early stages of the blast. Pyroclastic flows of searingly hot gas and dust can be seen barrelling down the side of the mountain towards the sea, and a rapidly growing bubble-like pileus cloud, formed from strong updrafts, is at the top of a brown ash and white steam plume that rose 18 kilometres into the air and drifted 200 kilometres downwind of the volcano.**
© Image courtesy of the Earth Science and Remote Sensing Unit, NASA Johnson Space Center.

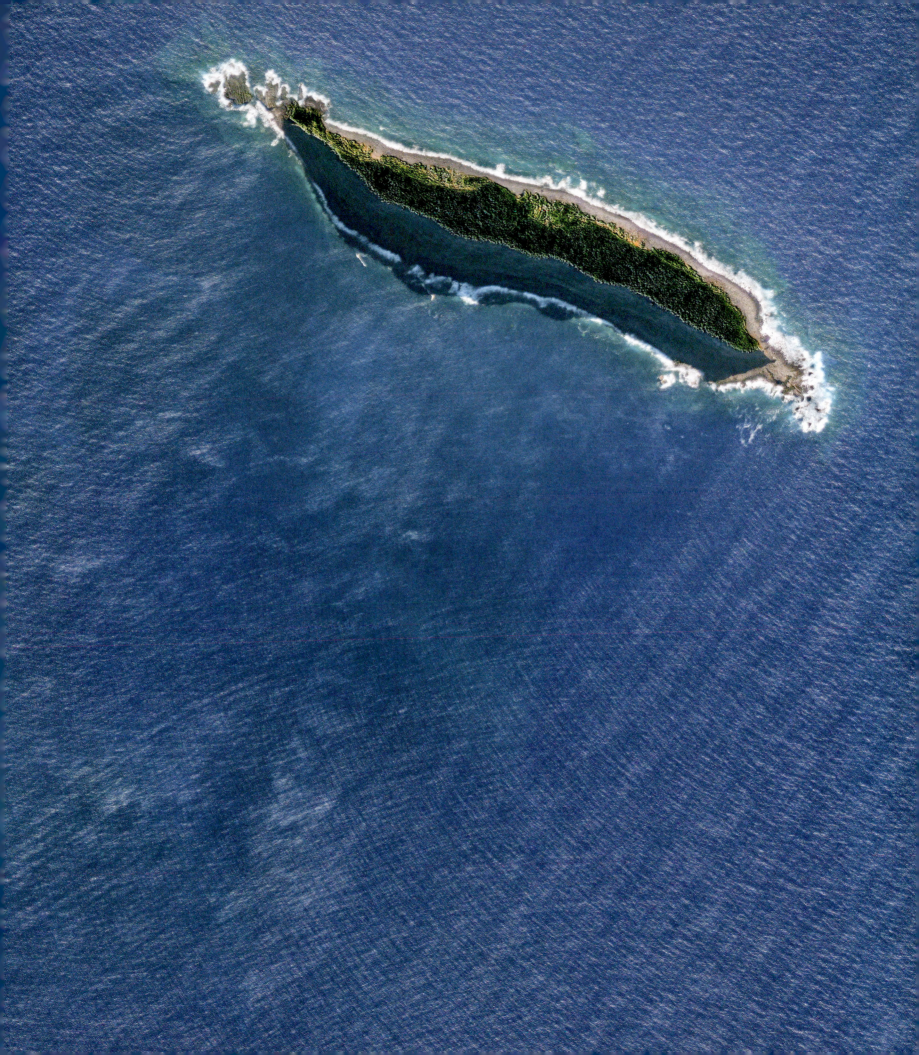

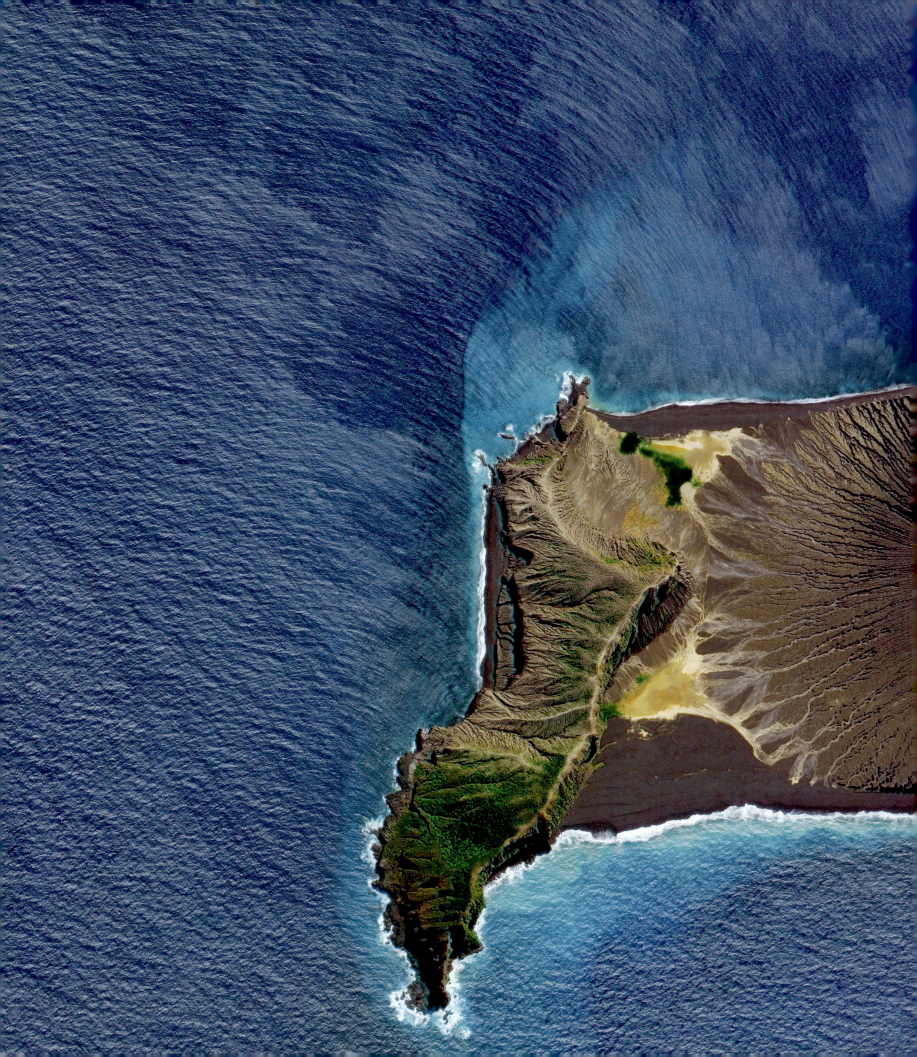

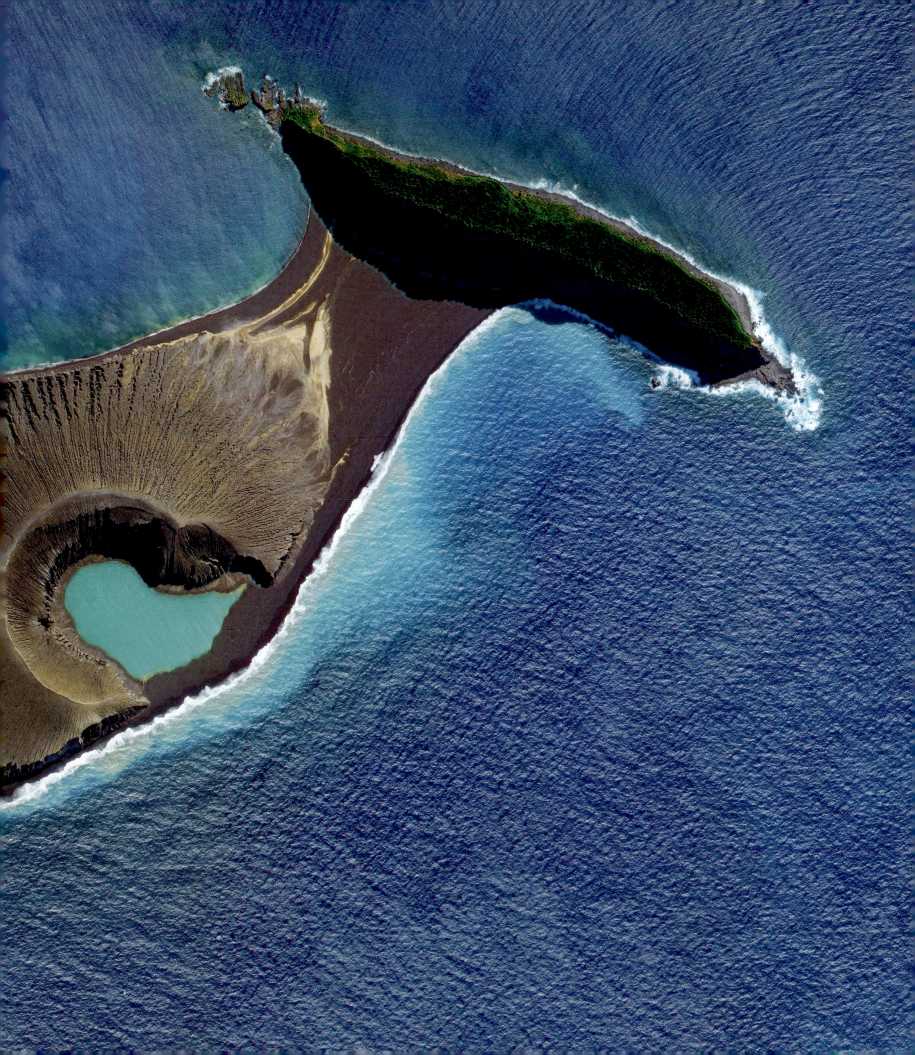

Frogs in danger

Living in the shadow of an active volcano can be unnerving at the best of times, but for one tiny creature the behaviour of its local mountain could mean the difference between life and death, not only for the individual, but also an entire species.

The little creature causing such concern is the Quito or chocolate-striped rocket frog. It lives in Ecuador, where it is found along the snow-and-ice-fed Río Pita. Here, fewer than 100 adults and an unknown number of juveniles and tadpoles represent the entire world population. They are already critically endangered according to IUCN, and now their existence hangs by a thread thanks to their next-door neighbour.

Cotopaxi, Ecuador's second highest mountain and a potentially explosive stratovolcano, towers above their home. It had been relatively quiet since the early 1940s, but in 2015 it began to splutter with a number of minor eruptions. More violent activity is predicted for the near future. An eruption would put at least 300,000 people living in the surrounding countryside at risk, and could mark the end for the tiny rocket frog.

BELOW **In the shadow of Ecuador's Cotopaxi volcano, Dr Santiago Ron searches for the critically endangered Quito rocket frog.**

Ash would blanket the land, while lava and incandescent balls of gas would melt the snow and ice on the volcano's summit, creating massive mudflows and flash floods that would sweep down the Pita valley. This destructive scenario has played out once before in recent history. In 1877, water, mud and ice travelled 100 kilometres into the Pacific Ocean in one direction and into the Amazon Basin in the other, causing great swathes of destruction. For the rocket frogs, it would mean complete annihilation.

The frogs, unaware of the danger, go about their everyday business. At mating time, the males call and the females come looking, but one female is in for a shock. Following the direction from which the call is coming, she looks behind a rock to find not a potential mate but a sound speaker, and then her world goes black.

She has been duped. Dr Santiago Ron and his team from Pontificia Universidad Católica del Ecuador in Quito are collecting frogs in order to raise a breeding population in captivity. If Cotopaxi does blow, they hope that these captive frogs can be reintroduced into the wild, saving the species from extinction.

And it is not only the rocket frog that needs the team's help. Ecuador is one of the most amphibian-diverse countries on Earth. Of the more than 500 known species living here, over 40 percent are found nowhere else, and about a third are threatened by something – habitat destruction, fungal diseases, climate change. There is room for them all at the univerity's *Balsa de los Sapos*, meaning 'Life Raft for Frogs', conservation initiative, but it is a race against time.

On the dark side

A natural phenomenon that has engaged crews living on the International Space Station is lightning. As the station passes over the night side of the world, the flashes are frequent. Of the several different types of lightning, 'sheet lightning' is the most common. It occurs within a cloud, whereas the more damaging 'forked lightning' travels between the cloud and ground, hitting anything in its path. All over the world about 44 lightning flashes occur every second, but nowhere has more lightning strikes than Venezuela's Lake Maracaibo, the lightning capital of the world. It has thunderstorms on 297 days a year on average, with over 8,000 lightning strikes in a single night.

Lightning works in a series of steps. First, the negatively charged 'stepped leader' hurtles out of the cloud at more than 200,000 mph and heads down towards the ground. When it is within about 50 metres, a positively charged 'streamer' travels up through a tree, church steeple or even a person, and when the two meet there is a blinding flash. It is very narrow, just the width of your thumb, and extremely hot. A single bolt can heat the air around it to 50,000°C, three to five times hotter than the surface of the Sun. This hot air expands rapidly and vibrates, producing the thunder that is heard directly after a flash, and when the flash and thunder are at roughly the same time, beware: the storm is directly overhead, and it is extremely dangerous.

Satellite imagery and observations from spacecraft and the International Space Station have also identified more unusual forms of lightning. A phenomenon that produces bursts of radio and gamma waves at the same moment as the electrical discharge, for example, has been dubbed 'dark lightning'.

In 1989, experimental physicist John Winckler first photographed 'red sprites' – jellyfish-shaped, red or crimson flashes above highly active storm clouds. They are rarely seen from the ground because they are so high up – up to 50 kilometres above the Earth's surface – and last for only milliseconds, but they are huge, up to 10 kilometres across. Although the lightning is generally created by negative electrical charges, sprites are positive lightning, which is ten times stronger than conventional negative lightning and shoots upwards into space rather than down to the ground. It is thought that the red colour is produced when the sprite interacts with gases in the atmosphere, much like an aurora.

RIGHT **From the International Space Station lightning can be seen over Kuwait. The lights of Kuwait City are at the bottom of the image, and those of Hafar Al-Batin in Saudi Arabia are above the lightning flash.** © NASA / ISS Expedition 38 crew.

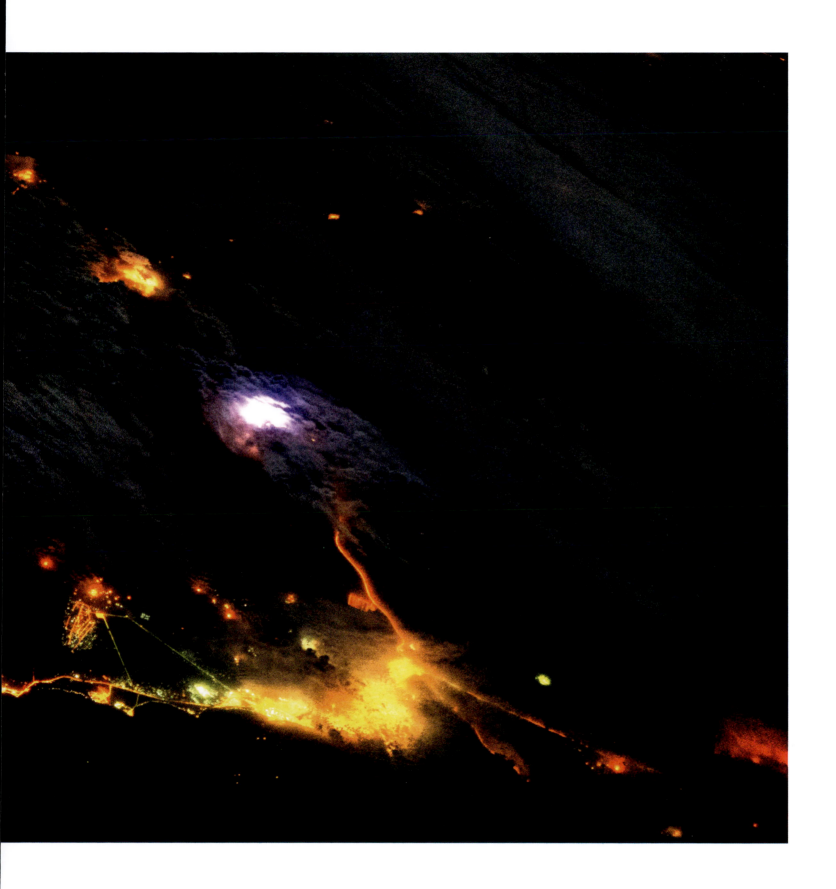

Fire spotting

With such high temperatures involved, lightning is frequently responsible for igniting wildfires, and the consequences of a wildfire burning out of control can be fully appreciated when seen from space. The speed and direction of travel, the threat to homesteads and towns, and the extent of scarred forest or orchards, can be monitored via satellite. Following a long, hot summer, the risk of wildfires burning in the remote forests of the USA is high. A short response time is crucial for effective fire-fighting. From the very first plume of smoke, a fire can be raging within minutes, and so there is still a need for observers on the ground.

At 86 years old, Billy Ellis is a veteran spotter who has manned the Devil's Head Lookout in Colorado's Pike and San Isabel National Forests for almost 35 years.

'It's still important that we have a lookout up here, and I hope that when I'm gone, they'll put another up here,' says Billy. 'Just as long as I can climb the mountain and my eyes hold up, I think I'll have about another five years. When I'm 90 years old, I'll think about retiring.'

The forest sits on the edge of the Southern Rocky Mountains, and the view from the lookout, which is perched on the top of a huge granite outcrop, is nothing short of spectacular. Pikes Peak and Mount Evans are in the distance, but it is the thousands of square kilometres of forest that Billy scans diligently every 15 minutes throughout the day. He's usually there five days a week, but if lightning storms are forecast or there are red flag warnings of impending wildfires, he mans the lookout at weekends too. When the *Earth from Space* crew visited, the fire season was well underway.

'The most exciting part of the job is when I first spot a smoke. You can look for days and never see anything and, all of a sudden, there it is.

'It's scary, and if it's a bad storm, and I'm right in the middle of it, I'm saying, "I'm never going to do this again. When this year's over, that's it." But the winter goes and spring comes back, and you think, "Well, I'll do it one more time."'

From his lofty lookout, Billy can spot smoke hundreds of kilometres away, and reaching such remote and inaccessible blazes by road can be impossible. By the time the fire-fighters arrived on foot, the blaze would be out of control. These situations need specialists – the smoke jumpers. They parachute

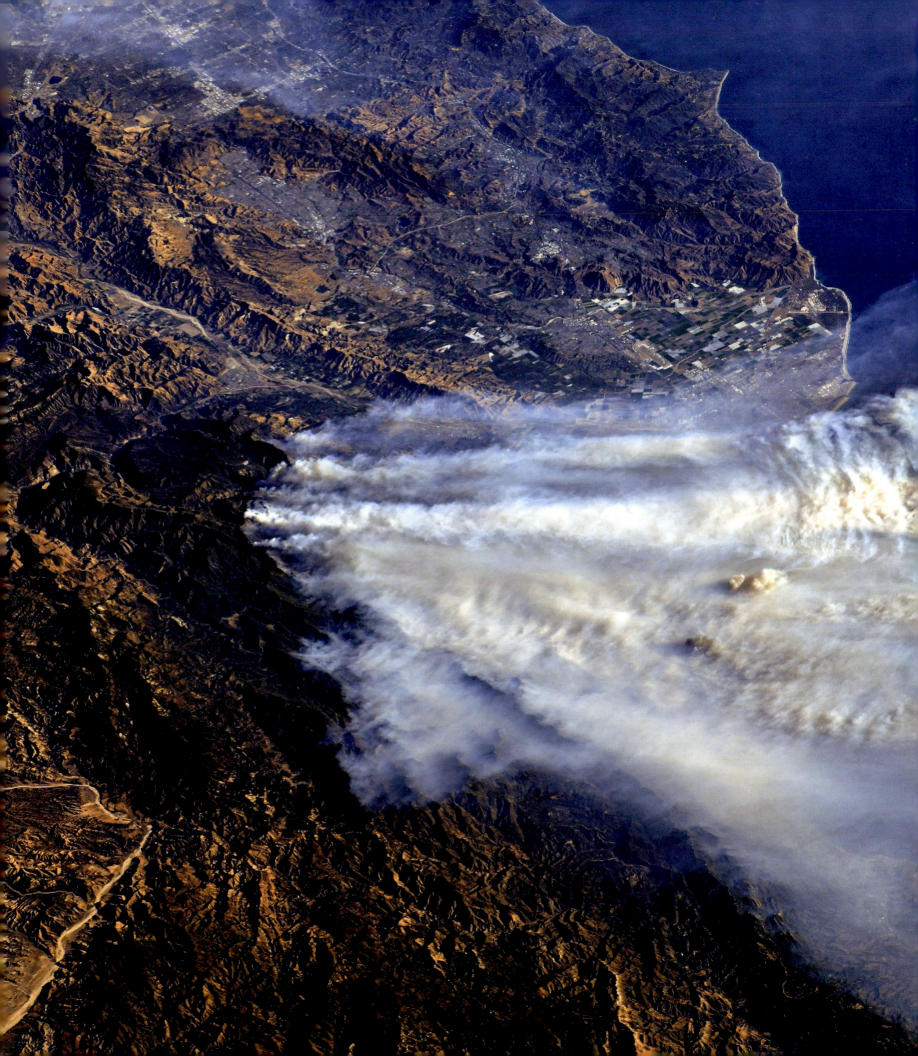

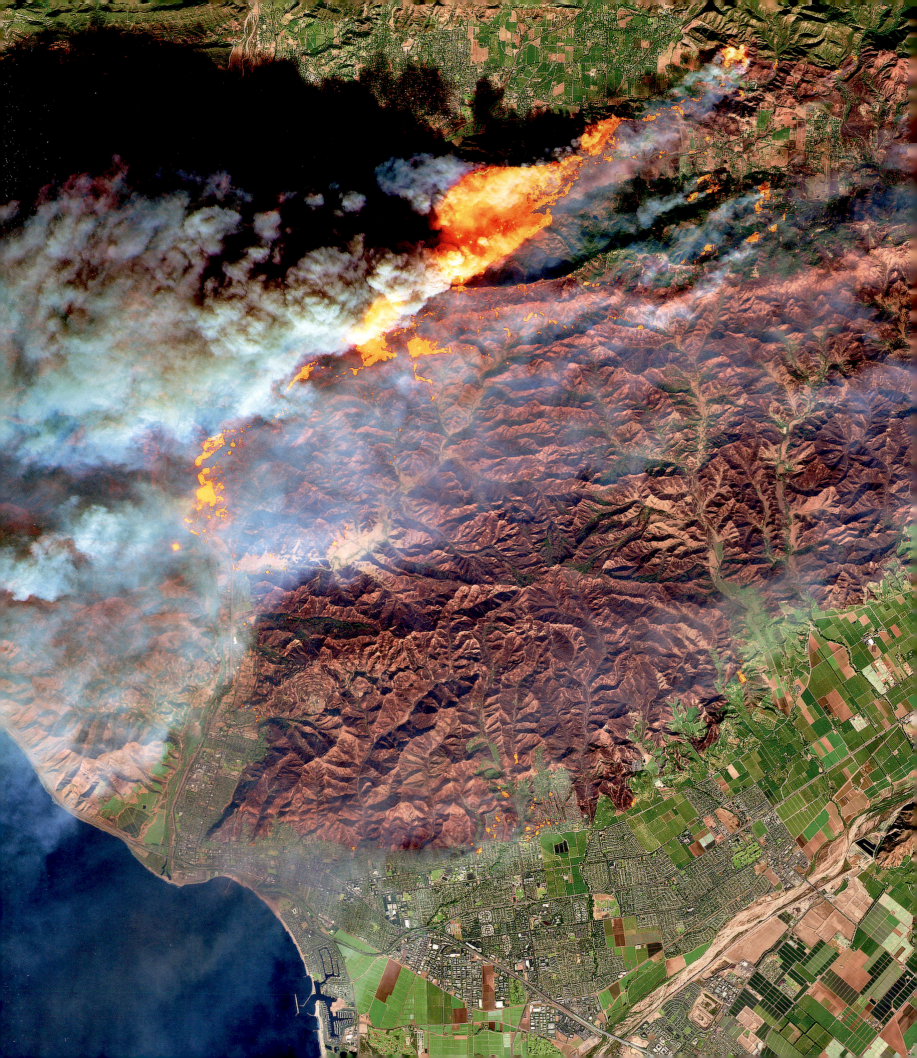

to 120 square kilometres of gleaming salt. It is perfect for one particular sport. In August, Bonneville is host to a motor sports event that sees drivers, mechanics and fans arriving from all over the world.

Many of the competitors have been driving on the flat for years, but the *Earth from Space* team met with Maddie. She was out there for the very first time … and it was not the only first!

'I've never even driven a car by myself before,' she announced, 'and now I'm going to be driving a car on Bonneville Salt Flats at over 100 mph!'

Maddie was hoping to get her first rookie licence, and she was not going to let her limited driving experience hold her back. She had simply outrageous ambitions for her very first time trial.

'I want to get to 150 mph, if I can.'

Well, racing at Bonneville is certainly not for the fainthearted, as series director Barny Revill can testify.

'It's hot at that time of the year, but the real challenge is the salt itself. The white reflects the Sun and the heat straight back at you.'

Undaunted, Maddie walked to her car. She was about to drive a solid American roadster that her father had built, and as Maddie's car was on the starting line for her very first time trial, the *Earth from Space* team had coordinated satellites to take photographs from space of the Bonneville speedsters. The result? They were watching as Maddie pushed her car towards 150 mph.

'That was pretty crazy! I can still feel the adrenaline pumping. All you can hear is the engine. Everything else just zones out, and you're focussed on the track. I definitely have salt fever for the rest of my life now.'

And, even as she stepped of the car, Maddie was already thinking about her next goal.

'Now I've gained my rookie licence, I can get onto the main course … and reach 200 mph!'

Whether Maddie can achieve her dream is somewhat dependent on the weather. Bonneville's 'Speed Week' was cancelled two years in a row because a combination of unseasonal torrential rains and commercial salt extraction is thought to have caused the salt layer to thin. Normally the salt dissolves in winter rains and hardens in the summer heat, as it's been doing since the end of the last Ice Age, but now change is in the air. It is something that is being repeated in other parts of the world.

OPPOSITE **The European Space Agency's Copernicus Sentinel-2B satellite captures an image of a lithium extraction works at Salar de Uyuni. Upper left are the rectangular evaporation ponds where lithium bicarbonate is isolated from brine, to be used especially in the manufacture of electric car batteries.** © ESA

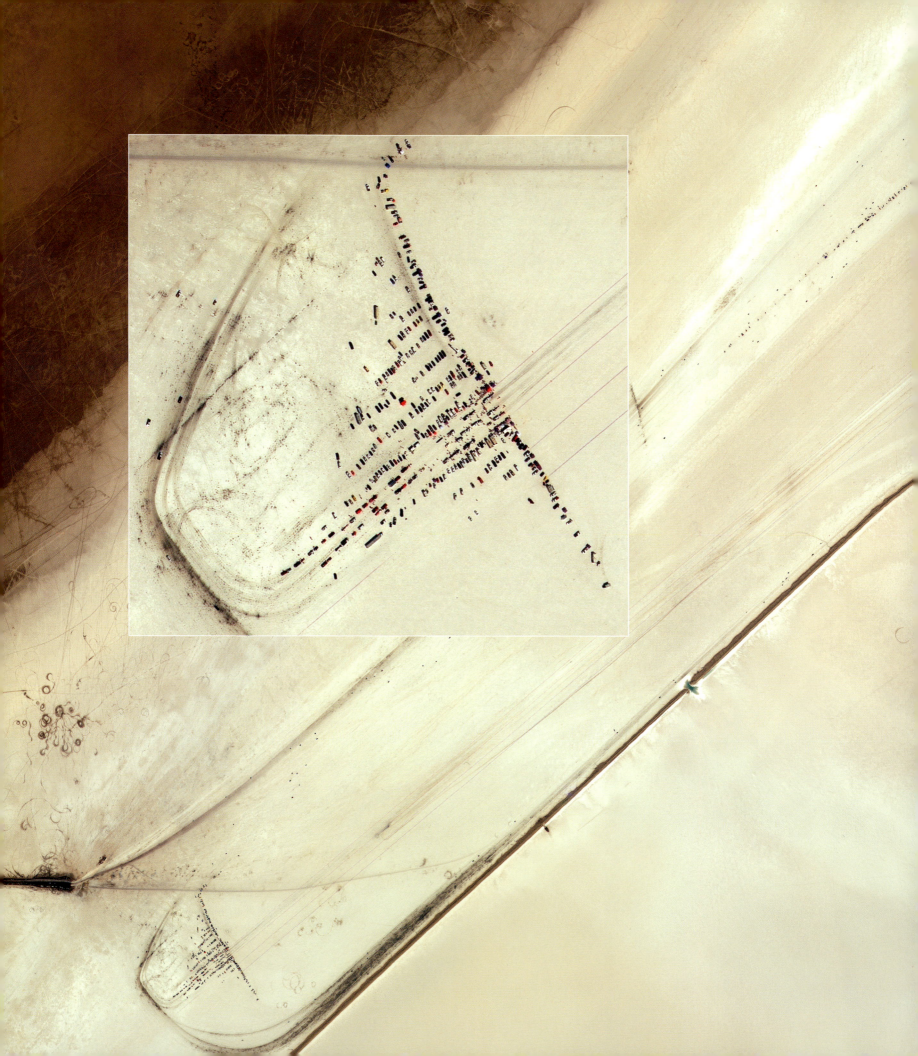

SALT PAN SPEED TRACK

The densely packed salt at Bonneville Salt Flats in northwest Utah has spawned the famous 'Bonneville Speedway', in existence since 1914. Five land speed events take place each year, including 'Speed Week' in mid-August. In August 2018, the world's fastest piston-driven car, Challenger 2 driven by Danny Thompson, set a new record of 448.757 mph at Bonneville. Satellite imagery courtesy of © 2018 DigitalGlobe, a Maxar company.

Disappearing lake

While the ancient forces of change on our planet assert their power over millennia, satellites are also able to monitor change that occurs on a more regular basis – change brought about by the seasons. A dramatic example of this can be seen when the cameras focus on China's Poyang Lake. From space, this vast expanse of water undergoes a startling transformation. One season it is all there, and the next it has almost gone.

Poyang Lake is in Jiangxi Province, where water levels fluctuate dramatically between wet and dry seasons. Between April and September, the lake covers an area of about 4,000 square kilometres, but come October the water starts to disappear. Ships are left high and dry, cattle graze on the lakebed, flowers suddenly bloom, island temples are no longer on islands, and the body of water almost disappears completely. However, the lake is so vast that this transformation can only be truly appreciated from space.

Coinciding with low water is an influx of 500,000 migratory birds. In the vanguard are critically endangered Siberian cranes, and they come here to overwinter. A 2012 survey revealed there were about 3,000 Siberian cranes living in the wild, and 98 percent of

BELOW **A temple that was built on an island in Poyang Lake is no longer isolated by water at times of drought. Local people can reach it on foot or by bicycle across the dry lakebed.**

OPPOSITE **Siberian cranes have arrived from Siberia to spend the winter at Poyang Lake in the Lower Yangtze River basin. The birds are critically endangered, but those that survive appear to live to a grand old age. One individual named Wolf died at 83 years old.**

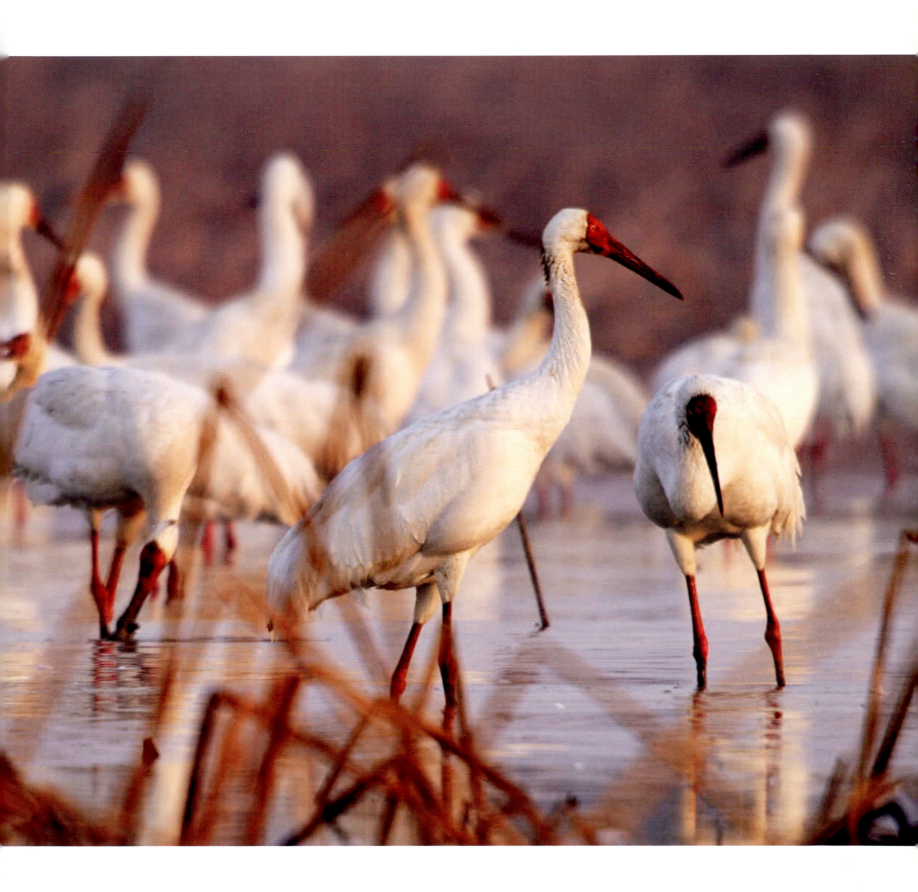

them make the 5,000-kilometre-journey from their summer breeding sites across northern Yakutia in northeast Siberia to Poyang Lake. They come for the nutritious tubers of eelgrass, and they are very pernickety about where they feed. They are big birds, standing up to 1.4 metres tall, but if the water is more than half a metre deep, they go elsewhere, no matter how good the eelgrass beds. And if the water is too low and the mud too dry, they cannot pull out the tubers.

Despite their size, finding the birds is sometimes difficult. Thick fog often blankets the lake in winter, but the *Earth from Space* film crew found a family of three – the parents and their five-month-old offspring. These birds are very territorial so any other bird encroaching on their piece of the lake gets short shrift. A rival male, which had designs on their vegetable patch, was challenged. The two males squared up, checking out strengths and weaknesses, for neither was willing to back down. The fight, when it came, was vicious. Feathers and mud flew. With a long bill and sharp claws, they could have done each other serious damage, but the altercation stopped short of causing real injury. The challenger backed down and conceded defeat, pulling up weeds and walking backwards away from the family as an act of submission. The dominant male turned and the female showed her appreciation with a dance and loud trumpeting calls.

Meanwhile, their youngster made itself scarce. It was learning what and what not to eat. The young birds need to grow strong enough to make the return flight to Siberia, where, on landing, they will be left to fend for themselves. Knowing how to feed independently is crucial, not only for the young crane, but also the species. Ornithologists have noticed a marked decline in the number of juvenile birds at Poyang and they are not sure why, so every youngster counts.

In the spring, water fills the lake, and the cranes start their long flight home. The question is whether they have eaten sufficient food during the winter for egg laying in the summer. These birds have evolved this long-distance lifestyle to take full advantage of seasonal change, but now the habitat at one end of their journey, at least, is changing too rapidly for them to adapt.

In recent years, like many other lakes in the world, Poyang Lake's average size has been decreasing due partly to droughts, partly to the storage of water at the nearby Three Gorges Dam, and partly because dredging boats are extracting hundreds of millions of tonnes of sand and changing the hydrology of the lake. With the natural cycle being thrown out of kilter by human intervention, the future for its influx of winter visitors hangs in the balance.

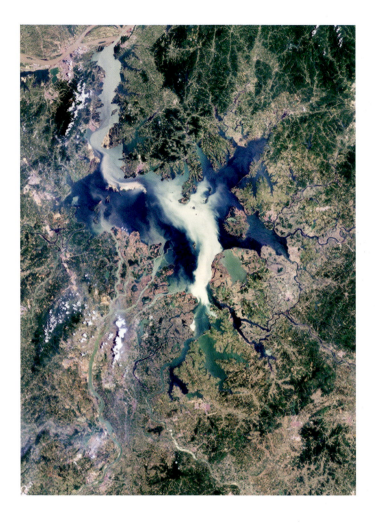

ABOVE AND OPPOSITE **Satellite pictures show how Poyang Lake fills with water during the spring (above), but it is very depleted by the winter (opposite). Drought and the seasonal diversion of water to fill the reservoir of the Three Gorges Dam caused the lake to almost dry up completely in 2016.**
© NASA USGS.

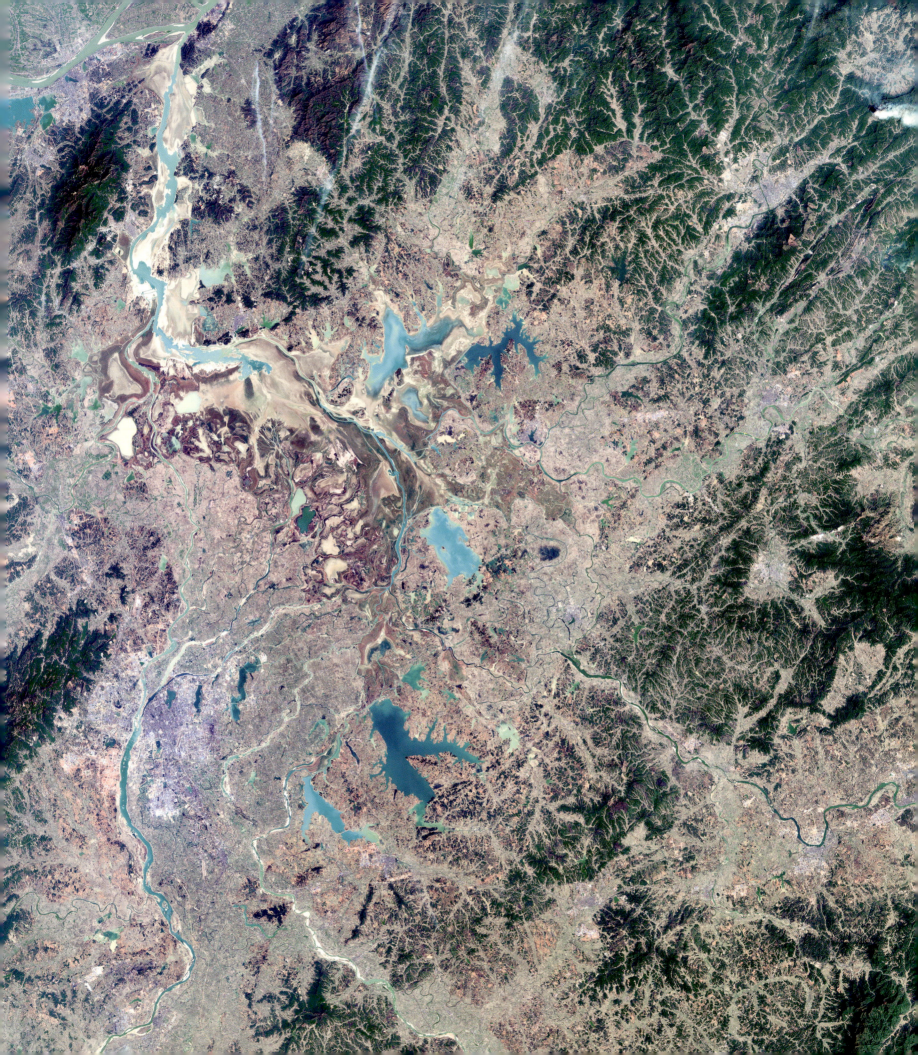

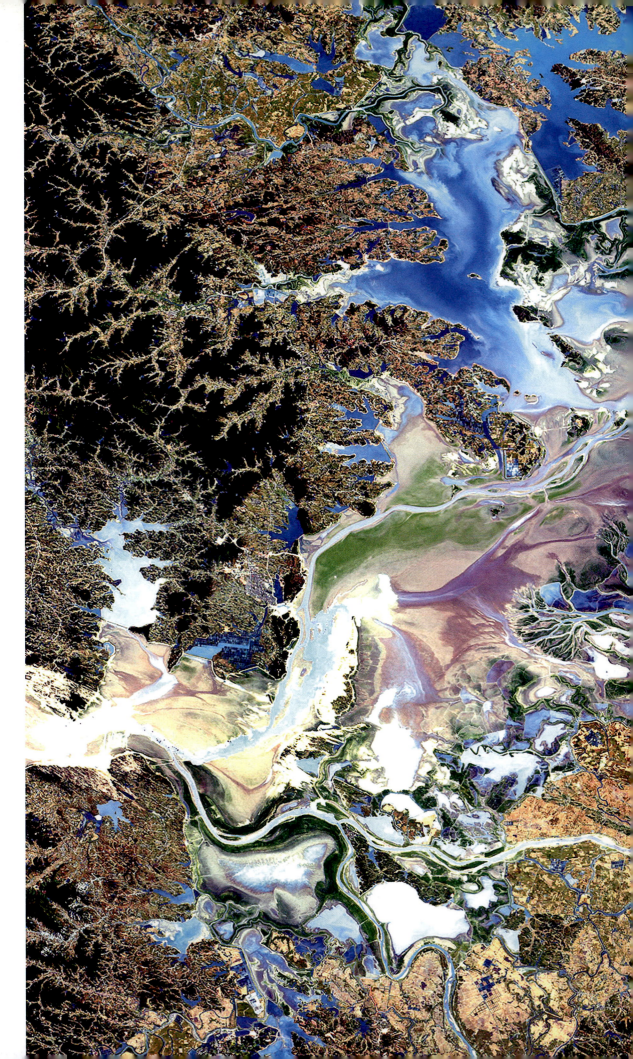

RIGHT An image from the Deimos-1 satellite shows how Poyang Lake is a complex environment. During the past few years, the lake has been emptying increasingly earlier before reaching full capacity after the monsoon. Climate change, sand dredging and the disruption to the flow of the Yangtze River are possible causes.

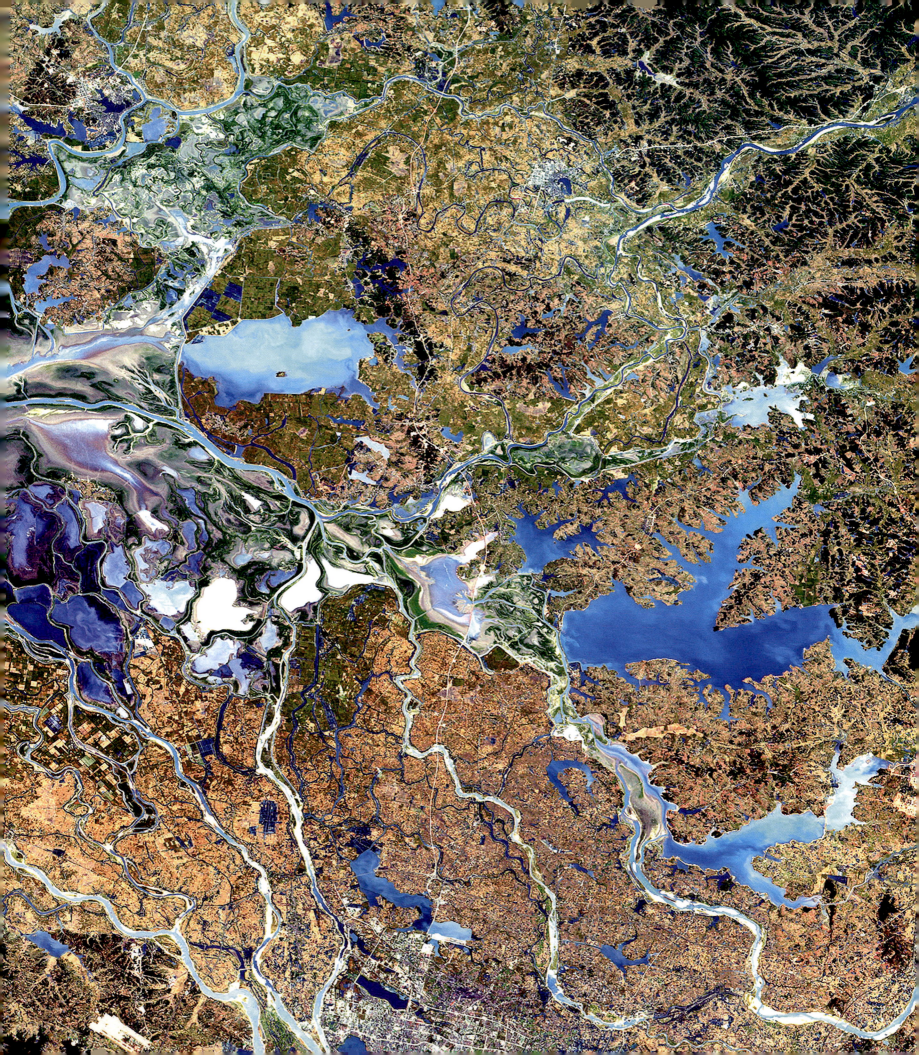

Adapting to change

Japanese forests experience an astonishing change from summer to winter. For half the year, satellite pictures show the island to be a temperate haven, but look again in the winter and it is transformed into one of the snowiest places on Earth. This is because the islands are in the direct path of icy-cold Siberian winds that blow southeastwards across the relatively warm waters of the Sea of Japan before slamming into the mountains in northwest Japan. Here, the air rises and the clouds let loose their snow. The snowfall statistics are staggering: up to 38 metres in a year has been recorded in some parts of Japan. Forests are completely buried, freezing fog transforms trees into 'ghosts', and roads have canyons cut into the snow with walls 15 metres high. In the city of Sapporo, the capital of Hokkaido, the average annual accumulation is close to six metres, making it one of a handful of cities worldwide that receives so much snow.

People here have had to adapt. In some villages, residents enter their homes by the second floor as their main entrances are inaccessible, and, in the past, they buried vegetables under mounds of snow. It was one way to preserve them through the long, harsh winter, when roads were impassable and farms and villages cut off for weeks. Nowadays, these frozen vegetables are seen as a delicacy. The natural refrigerator and steady humidity make apples and root vegetables taste sweeter and less earthy. It is a tradition that has its origin in the eighth century CE, and now they are sold all over Japan.

As well as a fondness for these delicacies, Japanese people also have a thing about anything that is cute. They even have a name for it: *kawaii*, which comes from the word describing blushing in the face, but the most obvious sign of cuteness is big eyes, and, if there is one creature living in the mountain forests that embodies kawaii, it is a big-eyed fur-ball: the Siberian flying squirrel.

The squirrel's large eyes are an adaptation that enables it to be active at night. The forest floor is a dangerous place. Predatory weasels would make light work of a small squirrel. Travelling through the treetops during the hours of darkness helps keep it safe, but makes moving from tree to tree a challenge. The squirrel's answer is to take to the air. It has flaps of skin between wrists and ankles on each side of the body. It uses them like a wingsuit, gliding more than 100 metres in a single flight.

As winter approaches, food is less easy to collect and after a mega-snowfall getting about is sometimes impossible, but this squirrel doesn't hibernate. Instead, it switches its behaviour. It is a few degrees warmer during the day, so it resets its body clock and becomes diurnal. Even so, bitterly cold winter nights present another problem.

Flying squirrels are not social animals. They tend to keep themselves to themselves, but with temperatures plummeting and food scarce, they are forced to make friends. The squirrels gather together in little huddles, swapping personal space for body heat. Being really friendly with the neighbours is one way to survive the bleak midwinter.

OPPOSITE **So much snow falls on the mountains on the Japanese island of Honshu that high-sided 'canyons' must be cut in the thick blanket. It is a springtime tourist attraction.**

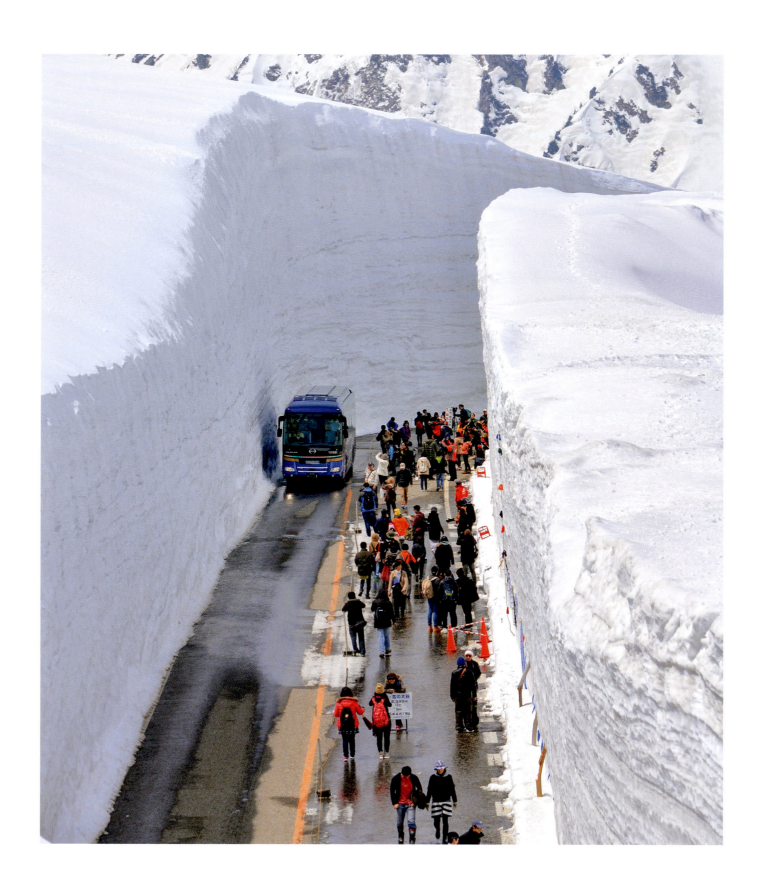

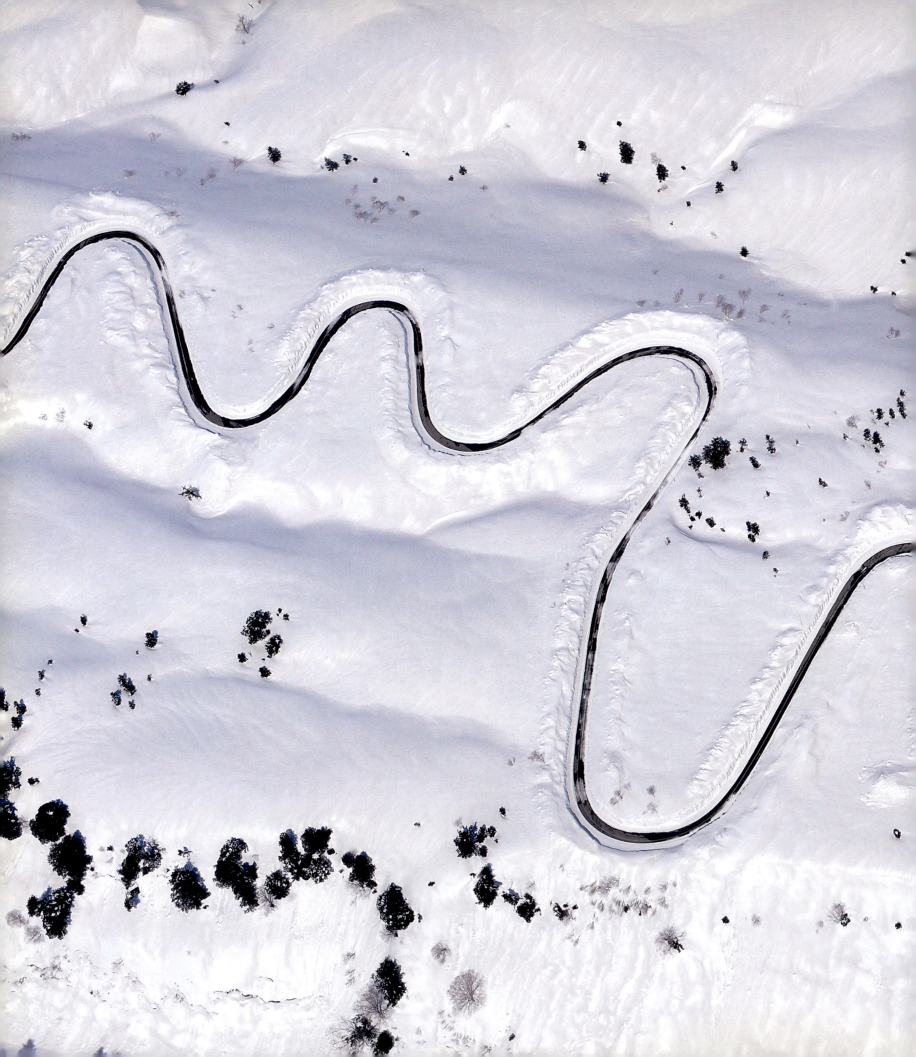

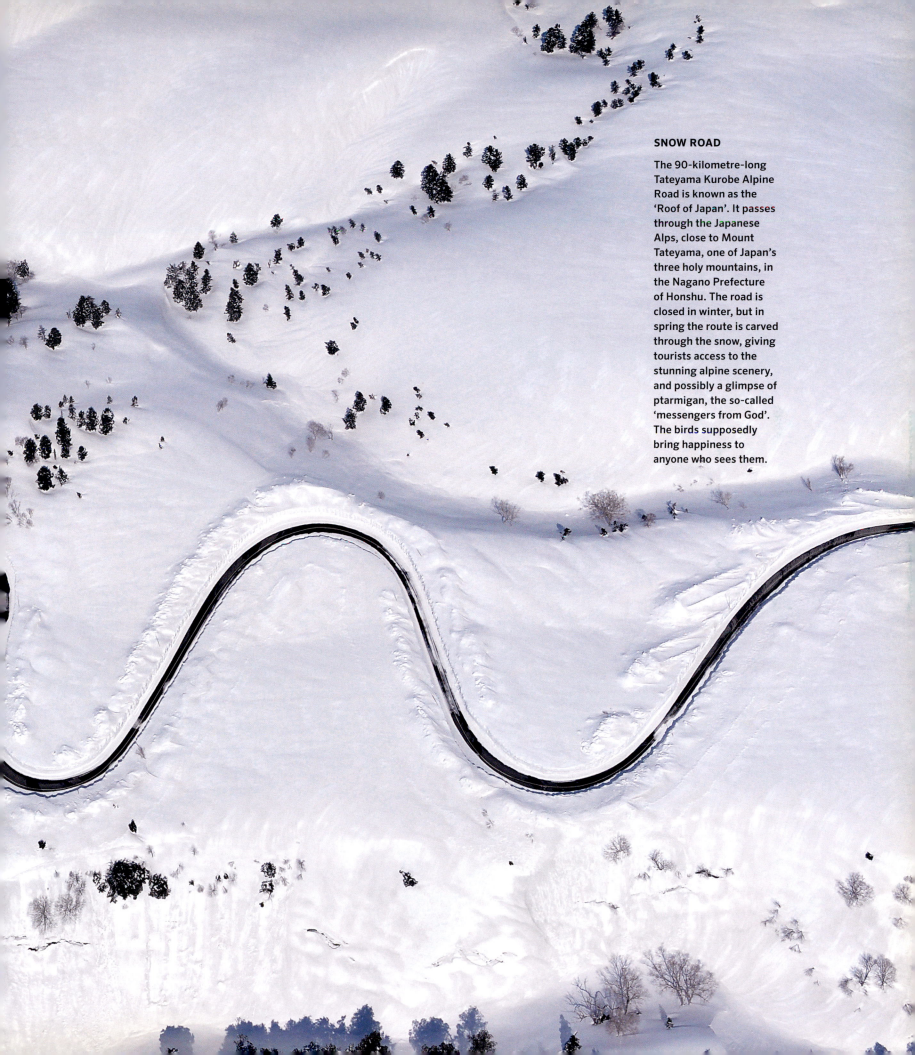

SNOW ROAD

The 90-kilometre-long Tateyama Kurobe Alpine Road is known as the 'Roof of Japan'. It passes through the Japanese Alps, close to Mount Tateyama, one of Japan's three holy mountains, in the Nagano Prefecture of Honshu. The road is closed in winter, but in spring the route is carved through the snow, giving tourists access to the stunning alpine scenery, and possibly a glimpse of ptarmigan, the so-called 'messengers from God'. The birds supposedly bring happiness to anyone who sees them.

RIGHT A seriously cute Siberian flying squirrel. Membranes connecting its wrists to its ankles enable it to glide from tree to tree. It is more usually active at night, but will appear during the day.

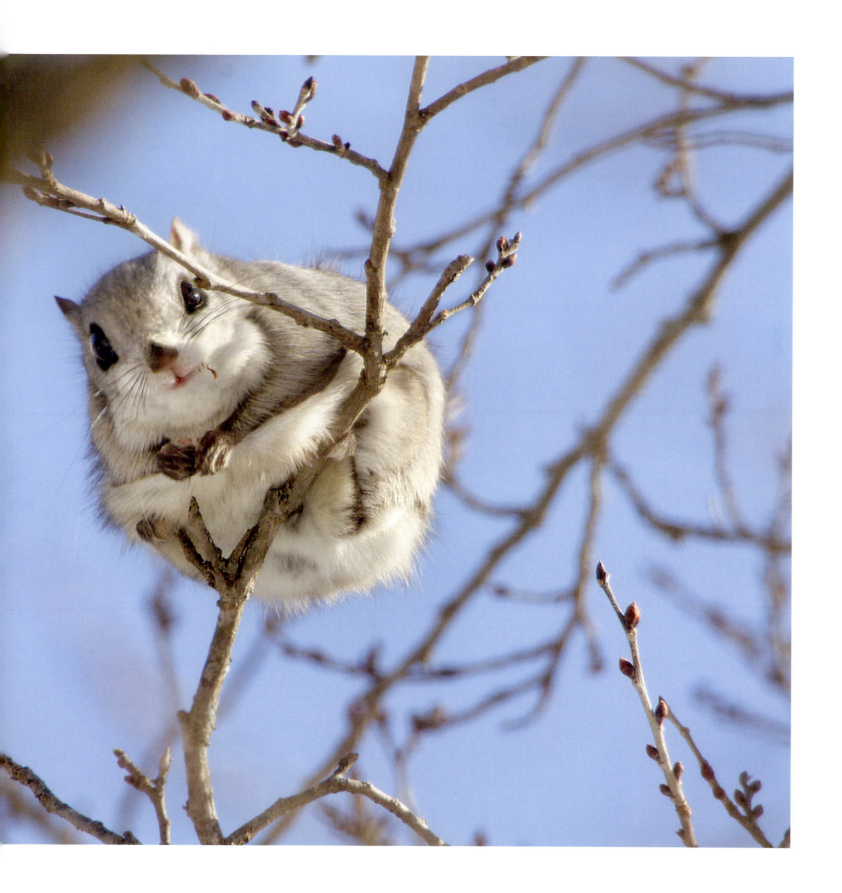

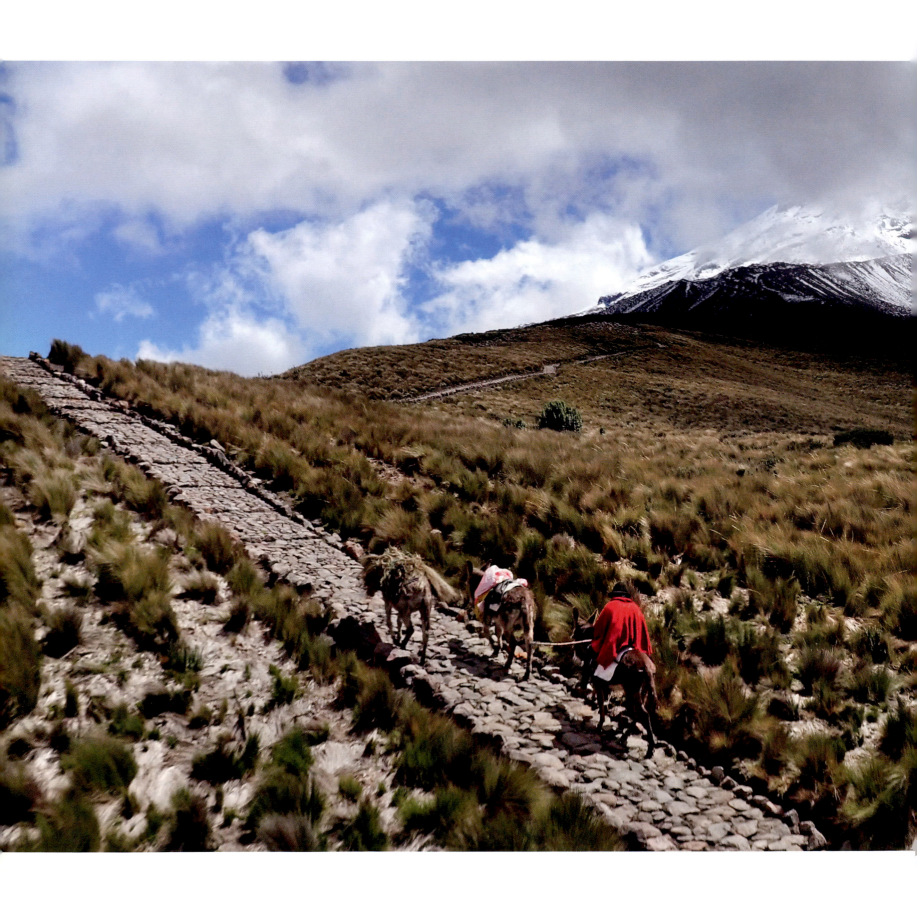

Last of the icemen

Not everyone can adapt to change so easily. Once each week, usually on a Thursday or Friday, 75-year-old Baltazar Ushca sets out from his home and climbs the steep, energy-sapping slopes of Ecuador's highest mountain – Chimborazo. If he reached the very top at midday, he would become the closest person on Earth to the Sun, even closer than a mountaineer on Mount Everest. This is because our planet is not a perfect sphere. His mountain is near the Equator, where the Earth bulges out by about 21 kilometres, so, although Chimborazo is not the world's highest mountain, when measured from sea level, its summit is the furthest point from the centre of the Earth, about 6,384 kilometres, compared to Mount Everest's 6,382 kilometres.

Baltazar's very special mountain is an inactive stratovolcano that last erupted about 1,400 years ago. Now its once-fiery upper slopes are covered by glacial ice, and it is for this that Baltazar makes his weekly ascent. In this part of Ecuador, Chimborazo's ice is valued as the purest to make juices and ice creams, and the locals even believe it to have healing properties. The old man has been harvesting it since he was 15 years old, a way of making a living handed down from one generation to the next. In the recent past, up to 40 of his compatriots made the ten-hour round trip, but now he's

LEFT Ecuador's last iceman and his donkey climb the steep pathway up Mt. Chimborazo. Lashed by winds and snow in winter and enduring intense sunshine in summer, 75-years old Baltazar leaves his home at seven in the morning and will not return until the early evening.

OVERLEAF Volcán Chimborazo is clearly visible as an ice-capped mountain in pictures from space. It has four major summits, the highest being 6,268 metres above sea level, and they shine bright white with snow and ice. The inhabitants of nearby towns and villages rely partly on Chimborazo's glacial melt water for drinking water and to irrigate crops, but a noticeable reduction in precipitation falling on the region in recent years, coupled with receding glaciers, means that these people are very much in the frontline when it comes to climate change. © 2018, Deimos Imaging SLU, an UrtheCast Company.

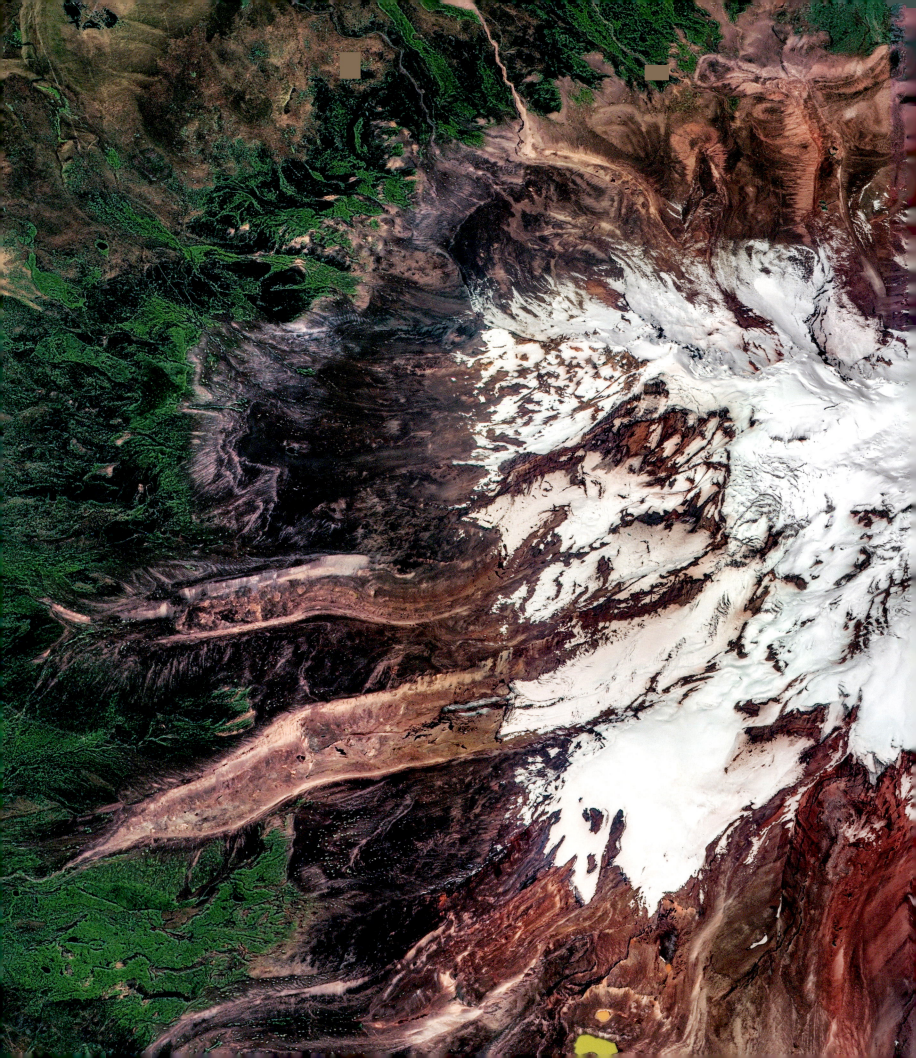

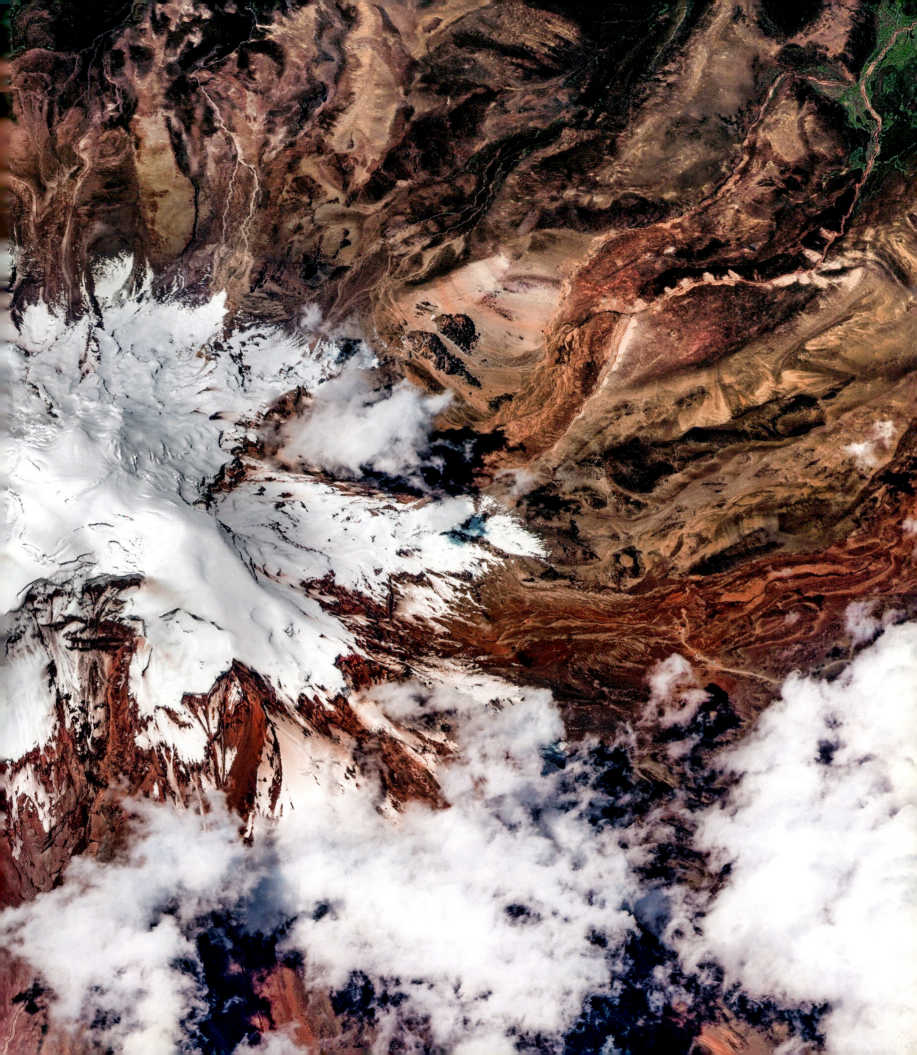

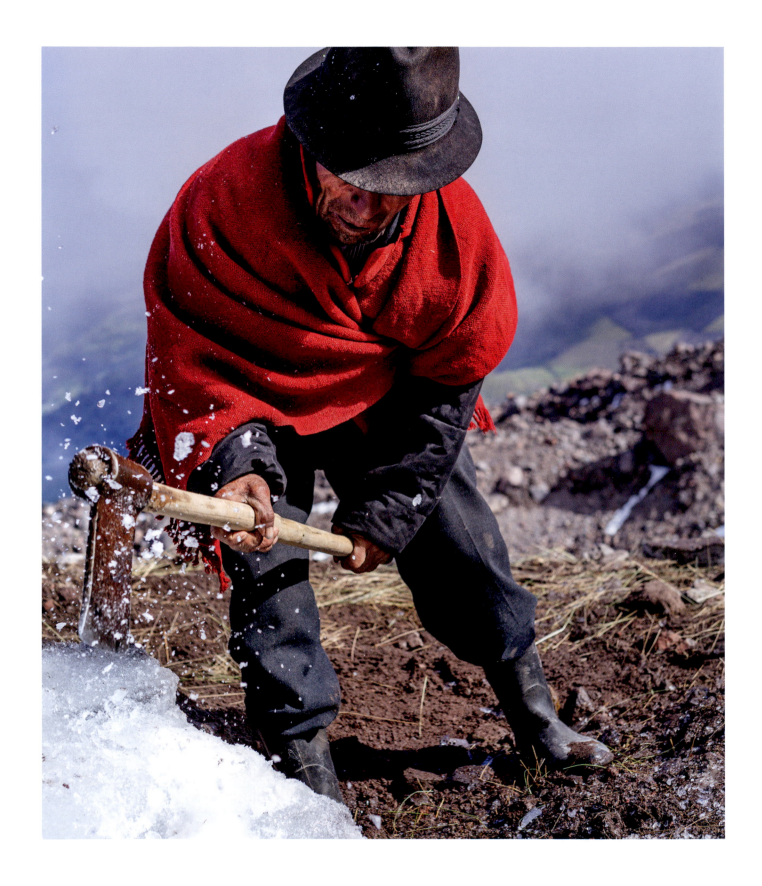

the last *hielero* or 'ice merchant'. On each visit, he chips away a couple of 30-kilogram blocks by hand, packs them in straw, and carries them down by donkey to the Riobamba market, ten kilometres away. But for how much longer he can do this will depend on our changing climate.

Cameras on satellites many kilometres above Baltazar's head show that Chimborazo's glaciers are receding. Dr Jeff La Frenierre, professor of geography at Gustavus Adolphus College, Minnesota, is monitoring the decline using images obtained from satellites and a small research drone. He has already found that, between 1986 and 2013, there has been a 21 percent reduction in the surface of ice on the mountain. While global climate change – both warming temperatures and changing precipitation patterns – is the primary culprit, ash from nearby Volcán and other active volcanoes has blackened some of the ice so it absorbs more heat. If the rate of ice loss, which is similar to that measured throughout the tropical Andes, continues, in the not too distant future, Baltazar might find that there is no ice for him to collect.

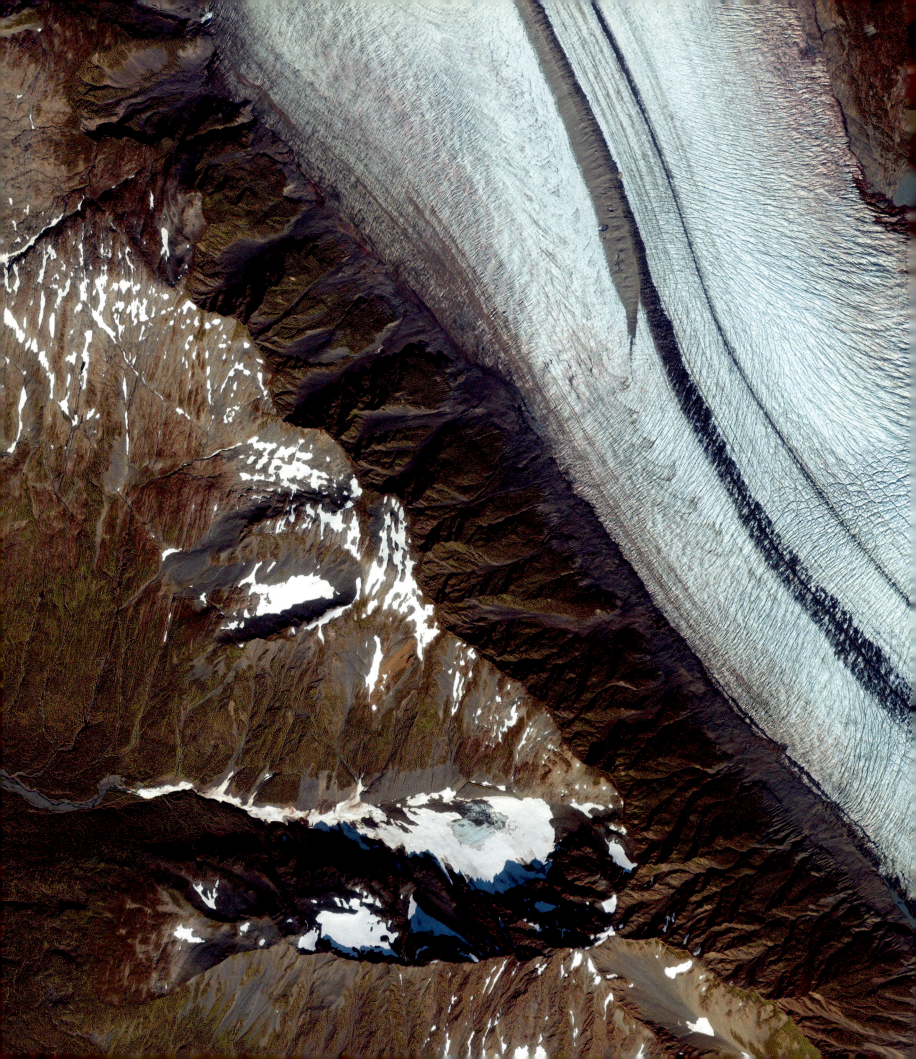

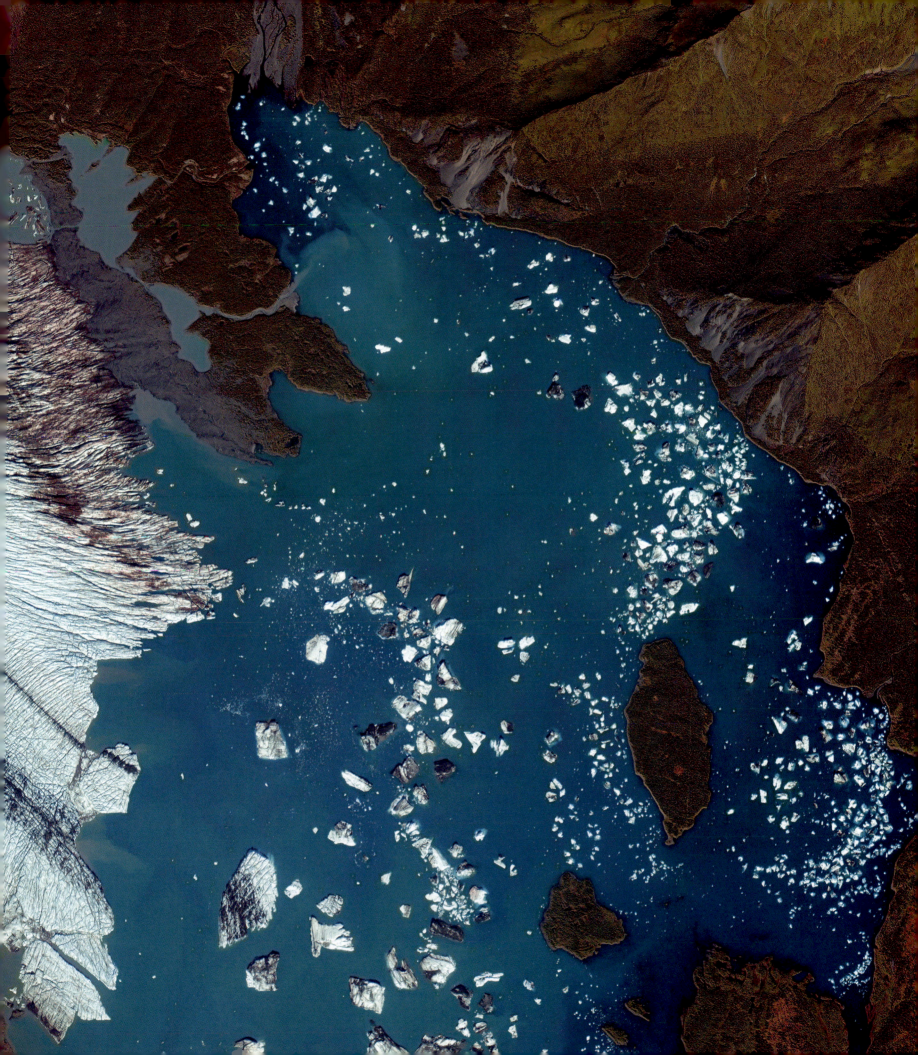

Disappearing forests, disappearing apes

A receding glacier is one of many telltale signs of environmental stress, but one of the more disturbing, whether viewed from space or on the ground, is the destruction of the world's forests. The views of Madagascar, for example, are heartbreaking. The crew on the International Space Station saw how the forest had degraded and how streams and rivers washed out the thin red soil, carrying it to sea. The island really looked as if it was bleeding.

They could also see how the island of Borneo has lost much of its natural forests in favour of commercial palm oil plantations, leaving the critically endangered orangutan population with fewer places to live. Figures from the IUCN reveal that the island lost nearly 65 percent of its orangutans between 1973 and 2012, and the number continues to decline. Destruction of their habitat has affected them seriously, but many have also been killed due to illegal hunting for bushmeat, or parents have been killed so babies can be captured for the pet trade. The latest population figures, though, do not reflect what is really going on. Even though there are estimated to be 105,000 individuals surviving today, the way the red apes are distributed means that far fewer are in a viable breeding population than one might think.

BELOW **This Borneo orangutan lives in the relative safety of a national park. More than 180,000 of its kind have been killed by poachers or have died through habitat loss during a period of about 40 years.**

OPPOSITE **Dirt roads intersect rows of palm oil and acacia plantations. Very little of the native forest survives. The largest percentage of orangutan losses in Borneo has been where the forest has been cut down in favour of plantations.** © CNES 2014 - Distribution Airbus DS.

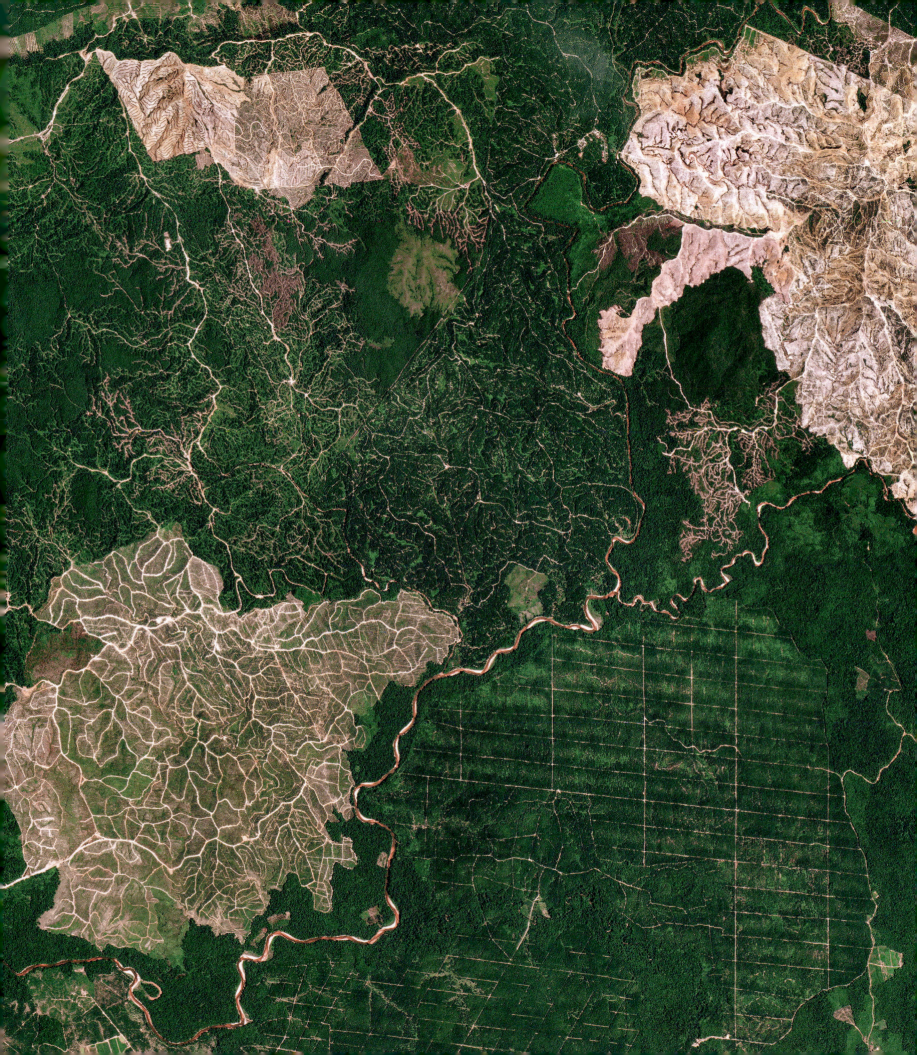

Scientists have found that Borneo's orangutans can be broken up into 64 'metapopulations', which means the island's total population is fragmented, with one or two sub-populations in each metapopulation. These metapopulations are separated from each other by rivers that they cannot cross, wide roads that are dangerous, and areas without trees where they are reluctant to go. Out of the 64, only 38 have more than 100 animals, and so are thought to be viable, but there is a hope.

Orangutans appear to tolerate human disruption to some extent, and, as long there is forest within and around plantations in which to forage and nest, they can exist, and even thrive. So, if commercial loggers were persuaded to keep enough habitat intact, the species might have a chance. Even so, it would only solve a local problem for Borneo, for forests are disappearing rapidly in the rest of the world.

Currently about 30 percent of the land on Earth is still covered by forests, and an estimated 1.6 billion people rely on them for food, fresh water, clothing, traditional medicines and shelter. The rest of us depend on them for some of the oxygen we breathe, and new medicines with which we can fight diseases.

Forests are destroyed for many reasons: accidental or deliberate fires, and clear-cutting for plantations, ranches and urban development. The losses are staggering. The World Wildlife Fund (WWF) estimates that we are losing the equivalent of 30 soccer fields of forest every minute ... a sobering statistic. So, it is impossible to look down at our planet and ignore the damage that we, as a species, have done and are still doing. Viewed from space, it is only too clear that the truly wild places on Earth are shrinking, but when we harness the information that this unique perspective gives us and use it for positive change, we can make a noticeable difference.

RIGHT **The Betsiboka River pours silt-laden water into Bombetoke Bay on Madagascar's northwest coast. It looks as if the island is bleeding. The heavy load, which is silting up a port, is due to deforestation inland. With the trees gone, the soil is washed away, and the land becomes barren.** © 2018, Deimos Imaging SLU, an UrtheCast Company.

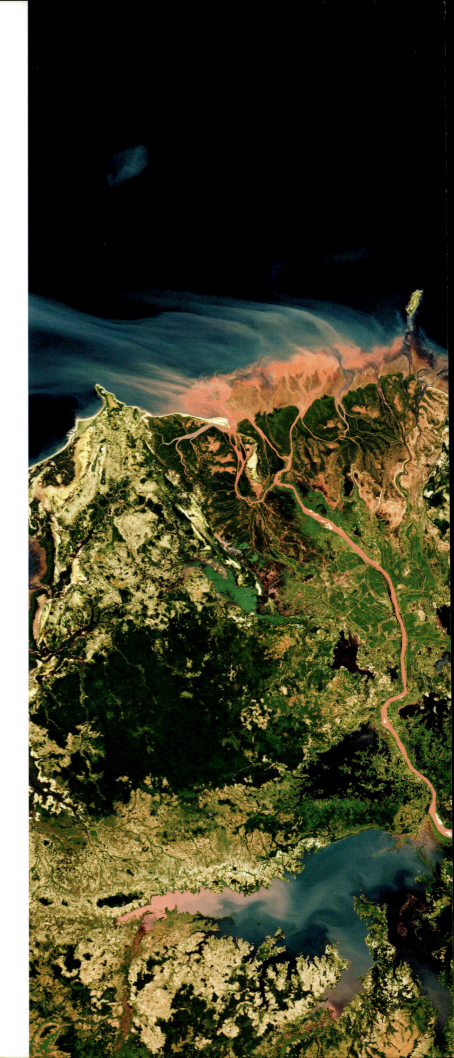

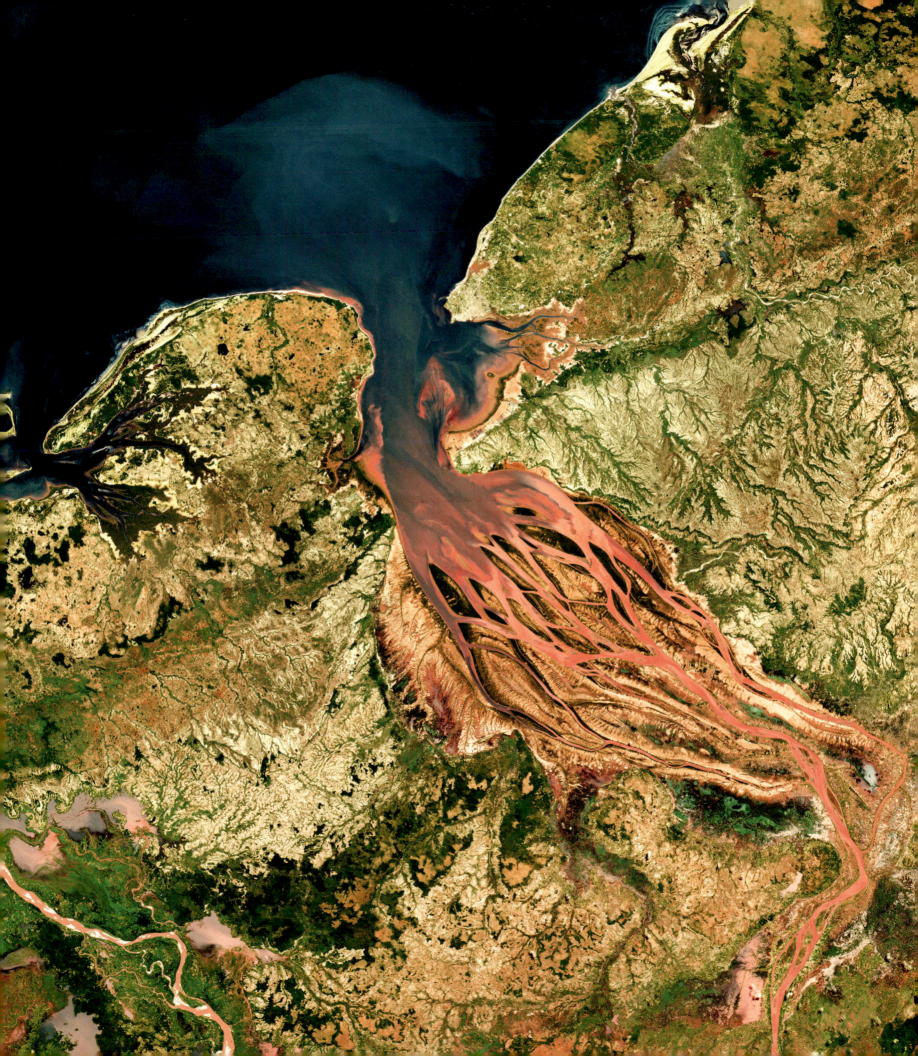

Reappearing forests, reappearing apes

One of the most successful reforestation programmes has been in Tanzania, at the Gombe Stream Research Centre, where Jane Goodall carried out her pioneering work on the behaviour of chimpanzees. Here, up-to-the-minute satellite technology is being used to monitor how the forests have changed, in a bid to protect and restore them. It set out initially to safeguard chimpanzee habitat in and around Gombe, and, since then, it has spread.

The work began with the Lake Tanganyika Catchment Reforestation and Education Project (TACARE), a pilot programme designed to address poverty, support sustainable livelihoods, and arrest the degradation of natural resources. Many trees were lost, especially after 1993, when ethnic fighting in Burundi caused refugees to seek sanctuary in Tanzania. They had nothing, so were forced to cut down trees for firewood and to create farmland. The Jane Goodall Institute found that this was having a big impact, not only on the chimpanzees, but on the livelihoods of local people, both in the study area and beyond, so the institute enlisted the help of neighbouring villages. By showing before-and-after pictures of their woodlands, villagers and local farmers were inspired to change the way they used their land. Now they are actively conserving any surviving forests and planting new.

Modern satellite technology is also playing a role. A recent development is for local computer-savvy 'forest monitors' to use tablets and smartphones to record information about their forests, such as the whereabouts of wildlife and any illegal activity, all with GPS coordinates, and then upload it to Google Cloud. The data is analysed at the Jane Goodall Institute, and conservationists on the ground are able to keep track of how the project is progressing.

Global Forest Watch, which monitors forests using photographs taken from space, is able to alert people living in forested areas about changes in their immediate environment and pre-empt anything that might threaten their homes, their lives and their livelihoods.

Already, large swathes of forest have been regenerated around Gombe, meaning that local people have ample wood, slopes prone to mudslides are stabilised, more carbon dioxide has been sequestered, and the chimpanzees have a more secure home. Connecting to adjacent forests has seen chimpanzees from outside the protected area joining Gombe troops, which is hugely significant in maintaining the population's genetic diversity and avoiding inbreeding.

Now the race is on to link up with other chimpanzee hotspots, such as the Mahale Mountains National Park, the only place in Africa where chimpanzees share their living space with lions; Burundi's Vyanda Forest Reserve and Kibira National Park, along with reserves in Rwanda and the Democratic Republic of Congo. It is an attempt to create a lush, contiguous, chimpanzee-friendly forest, and all with the help and support of local communities. In this part of Africa, at least, this kind of change is benefitting people and wildlife – a model for forest communities in other parts of the world.

OPPOSITE **Gombe in Tanzania is home to the most studied group of wild chimpanzees in the world. Their environment is preserved by community-centred conservation, and it works!**

OVERLEAF **Gombe is located on the eastern shores of Lake Victoria. Back in 2005, hillsides were brown and mudslides common due to deforestation (left). By 2016, following a community-centred reforestation programme, the hillsides are green once again (right), not only increasing the habitat for chimpanzees, but also revitalising a resource for local human communities.** Satellite imagery courtesy of © 2018 DigitalGlobe, a Maxar company.

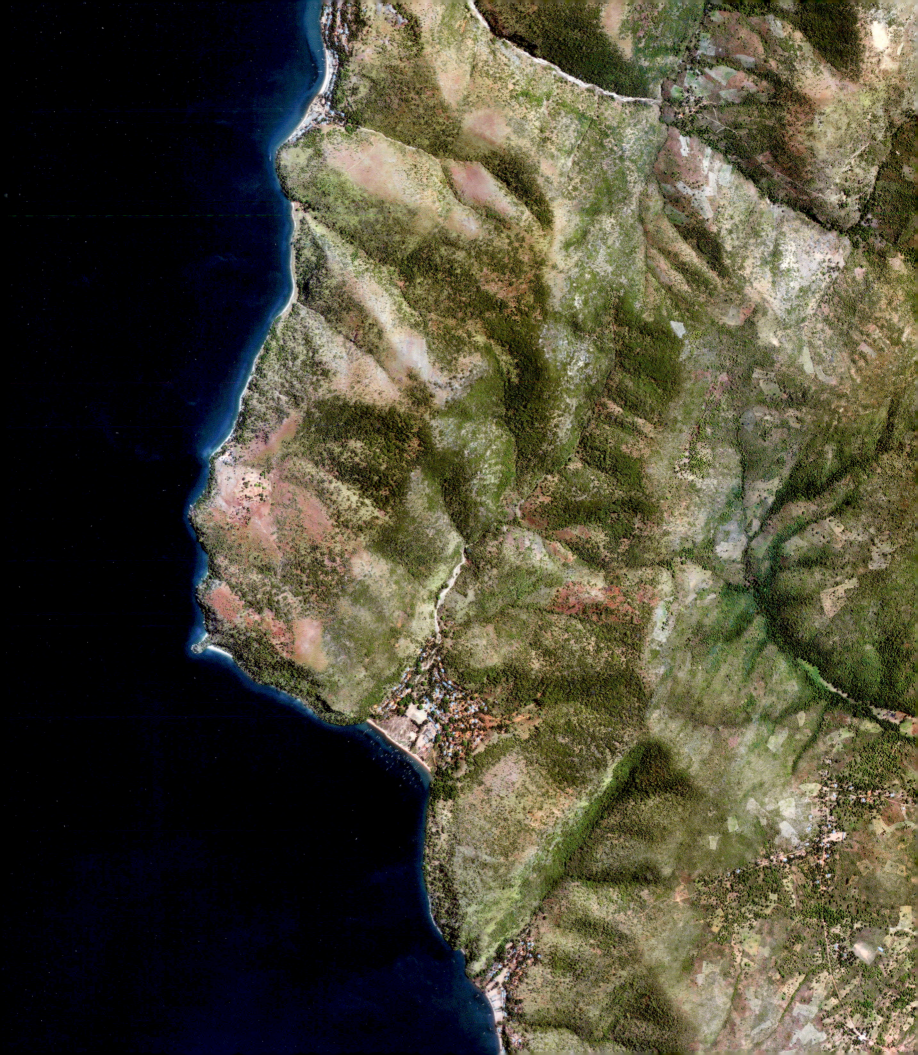

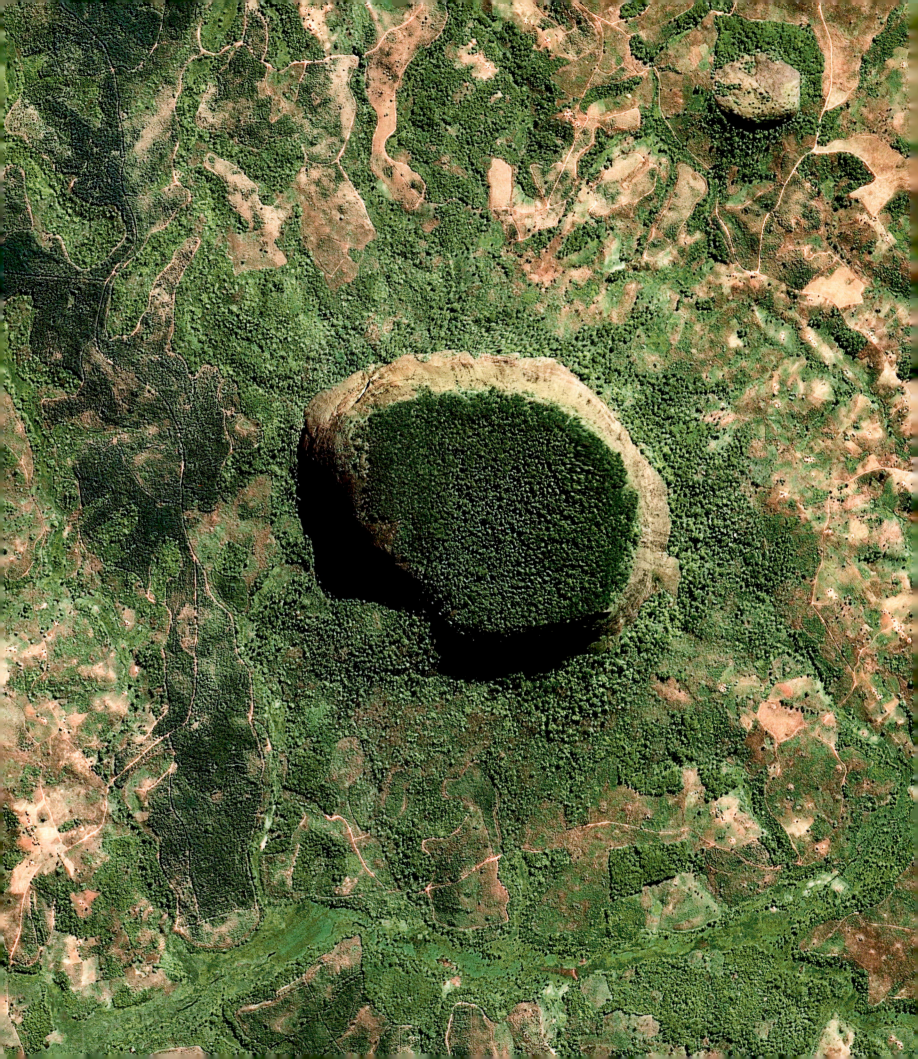

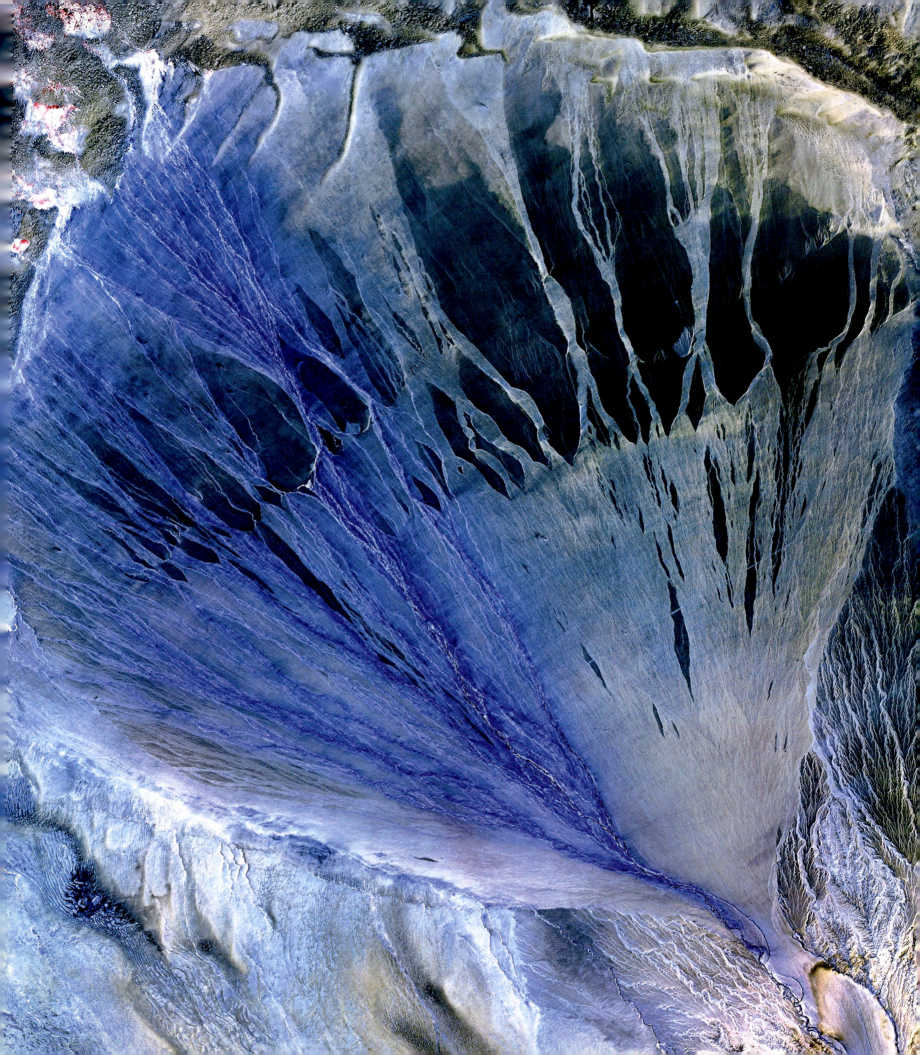

Our beautiful Earth

We have come a long way since the 'blue marble' and 'pale-blue dot' pictures were published several decades ago. The detailed imagery that satellites deliver presents us with an extraordinary new perspective on our planet. We can now access up-to-date pictures of the remotest parts of our globe without ever leaving home. With them, we can make brand-new discoveries that could not have been made from the ground, and we can monitor changes, giving ourselves fair warning not only of a storm that is moving in, but also of the more lasting effects that humans especially are having on our fragile planet. This view from space gives us a unique opportunity to health-check our home, to see where we are making positive change, but also crucially where we are doing harm.

These eyes in the sky can take in large-scale natural or man-made events, which previously would have taken an army of ground-based observers to record. In a single image we can see the spread of pollution across a continent, through an entire river system and across the oceans. We can monitor precisely the damage inflicted on a region by an earthquake, volcanic eruption, forest fire or tsunami, and we can observe the entire span of a hurricane system from its tranquil eye to its roiling spiral.

As satellites remain in place for many years, they can record slow changes over long periods of time. We can see from day to day, month to month and from year to year, the fate of the world's forests and how agriculture or urban development have come to dominate a landscape. Onboard instruments can measure land and sea height with an accuracy of a few centimetres, and so keep tabs on rising sea levels. They monitor the depletion of the ozone layer and the amount of water vapour in the atmosphere. They record land and sea temperatures, register cloud patterns, and record how much of the Sun's energy is absorbed by the Earth and how much is reflected away. These eyes in the sky aid weather forecasting, map ocean productivity, monitor land use, track migrating animals across the world, and even count them.

As the technology improves, we will be able to look down at our planet in ever more detail, these satellite images giving us the opportunity to marvel in the beauty and diversity of our planet. All political boundaries disappear and we can see one, incredibly special Earth, full of movement, colour and pattern, a planet so unlike any other in our solar system, so unique in its ability to house life, that we are inspired to look after it.

'As we got farther and farther away, it [the Earth] diminished in size. Finally, it shrank to the size of a marble, the most beautiful you can imagine. That beautiful, warm, living object looked so fragile, so delicate, that, if you touched it with a finger, it would crumble and fall apart. Seeing this has to change a man ...'

James B. Irwin (1930–1991)
Apollo 15 astronaut.

PREVIOUS PAGES
Mozambique's Mount Lico (left) rises vertically from the surrounding land and harbours a secret rainforest at its summit that has been left undisturbed by humans. 2018, Deimos Imaging SLU, an UrtheCast Company. **This spectacular alluvial fan (right) is a triangle-shaped deposit of silt, sand and gravel formed by streams at the southern border of the Taklimakan Desert in China's autonomous region of Xinjiang.**

OPPOSITE **Earthrise from the Moon, photographed by US astronauts on the Apollo 11 mission in 1969.** © NASA

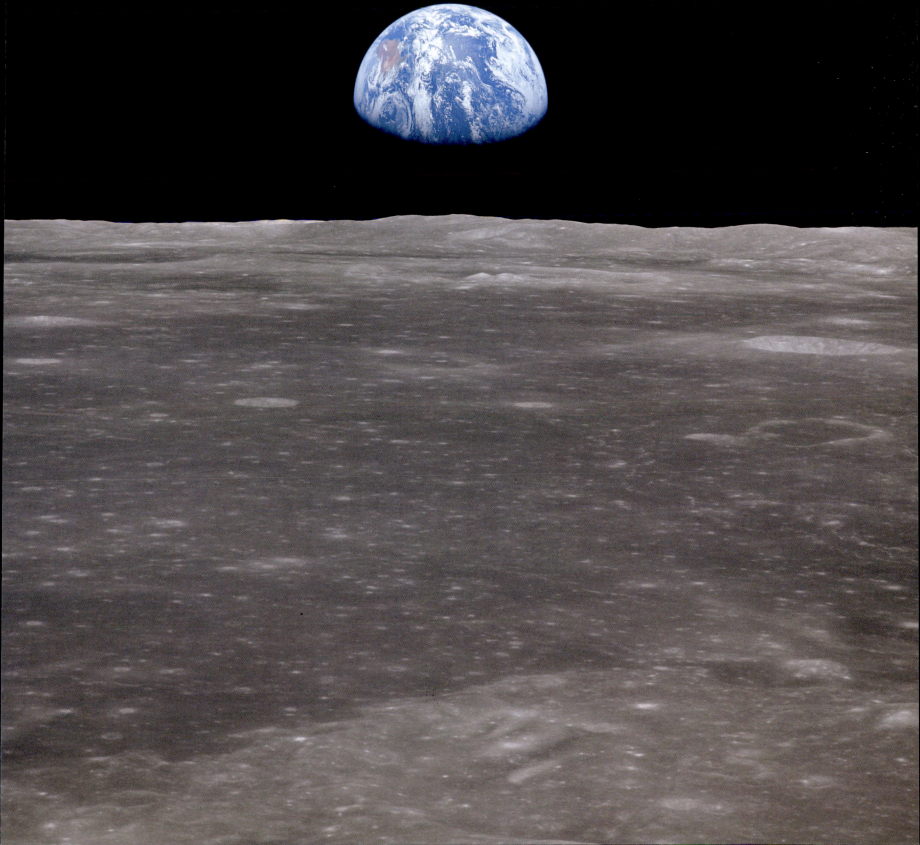

Index

Acknowledgements

10 9 8 7 6 5 4 3 2 1

BBC Books, an imprint of Ebury Publishing
20 Vauxhall Bridge Road, London SW1V 2SA

BBC Books is part of the Penguin Random House group of companies whose addresses can be found at global.penguinrandomhouse.com

Copyright © BBC Books 2019

This book is published to accompany the television series entitled *Earth from Space*, first broadcast on BBC One in 2019.

Commissioning Editor: **Craig Hunter**
Executive Producer: **Jo Shinner**
Series Producer: **Chloë Sarosh**
Series Director: **Barny Revill**
Producer/Director: **Justin Anderson**
Producer/Director: **Paul Thompson**
Edit Producer: **Hannah Gibson**
Additional directing: **Katie Parsons, Patrick Evans, Natasha Filer and Bertie Allison**

First published by BBC Books in 2019

www.penguin.co.uk

A CIP catalogue record for this book is available from the British Library

978-1-785-94353-9

Commissioning Editor: **Albert DePetrillo**
Project Editor: **Bethany Wright**
Picture Research: **Laura Barwick**
Image grading: **Stephen Johnson, www.copyrightimage.co.uk**
Design: **Bobby Birchall, Bobby&Co**

Printed and bound in Italy by Printer Trento

Penguin Random House is committed to a sustainable future for our business, our readers and our planet. This book is made from Forest Stewardship Council® certified paper.

It would have been impossible to make *Earth from Space* without the extraordinary satellite images we have been given access to. We have worked closely with the team at Deimos and Urthecast, who have advised and supported the production team throughout the process. Your patience in teaching us (in layman's terms) the intricacies of acquiring imagery from satellite has been invaluable. We would also like to thank Digital Globe and Airbus as well as NASA, ESA, USGS and NOAA, who have allowed us to feature a good deal of their beautiful imagery.

We are hugely grateful to the cinematographers, aerial photographers, time-lapse specialists and stills photographers who have complimented the satellites with stunning imagery on the ground.

As ever, a natural history series cannot be made without the support and guidance of scientists and experts. We are ever grateful to you for sharing your knowledge and expertise.

Lastly, each and every one of the production team must be thanked for their tireless hard work and creativity, with a particular nod to Rory May who has wrestled these images into a book-friendly shape.

PRODUCTION TEAM
Craig Hunter
Jo Shinner

Adam Evans
Amirah Daley
Ashley Farkas
Barny Revill
Bertie Allison
Chloë Sarosh
Claire Efergan
Douglas Mackay-Hope
Emily Fellowes
Emma Fry
George Ireland
George Roden
Hannah Gibson
Harry James
Isabelle Corr
Jack Hulme
Jessica Chen
Jessica Hayes
Justin Anderson
Kate Gorst
Katie Parsons
Matt Cooper
Natasha Filer
Nick Smith-Baker
Nicola Melton
Patrick Evans
Paul Thompson
Rory May
Thomas Fulcher
Tim Jeffree
Zoë Beresford

CAMERA AND SOUND TEAM
Aaron Colussi
Andrew Thompson
Barny Trevelyan-Jones
Benjamin Cunningham
Brad Bestelink
Charlie Yang
Chenghao Zhang
David Broad
Dean Miller
Duncan Parker
Freddie Claire
Graham Macfarlane
Guillermo Armero
Hossam Aboul Magd
Isaac Chen
Ivan Insausti
Jacky Poon
John Shier
Jonathan Jones
Justin Maguire
Kevin Flay
Kevin Pinto
Leo Chang
Lindsay Mccrae
Mark Macewen
Mark Sharman
Matt Norman
Maurício Copetti
Michael Male
Neil Harvey
Oli Haukur Myrdal
Parker Brown
Rory Mcguiness

Santiago Cabral
Simon De Glanville
Simon Lewis
Simon Reay
Stuart Trowell
Warren Samuels
William Luo
Zubin Sarosh

POST PRODUCTION
Arun Hall
Ben Lyons
Ben Peace
Blair Wallace
Evolutions Television
James Beynon
Jonny Crew
Katelin Rice
Tim Owens

MUSIC
David Poore
Neil Davidge

FILM EDITORS
Alex Boyle
Amy Fathers
Jacob Parrish
Mike Denny
Nico Bee
Rob Davies
Tim Lasseter
Will Ennals

VISUAL EFFECTS
Graham Stott
Jon Grafton
Moonraker
Scott Metcalfe

SATELLITE IMAGERY
Airbus
Aster
Copyright © 2018, Deimos
 Imaging Slu,
 an Urthecast Company
Copyright © 2018,
 Digitalglobe, a Maxar
 Company
ESA
EUMETSAT 2018
Google
JAXA Imagery
JSC Earth Science &
 Remote Sensing Unit
KOMPSAT
MODIS
NASA
NOAA
Suomi National Polar-
 Orbiting Partnership
US Geological Survey

ACADEMIC CONSULTANTS FOR THE OPEN UNIVERSITY
Dr Clare Warren
Dr Julia Cooke
Dr Kadmiel Maseyk
Prof. Mark Brandon

WITH THANKS TO
53d Weather
 Reconnaissance
 Squadron
Abigail Michels
Adarsh Nc.
Alexei Kouraev
Amy Tam
Andika Putraditama
Anthony Collins
Athena Dinar
Baima Snow Mountain
 National Nature
 Reserve
Balsa de los Sapos,
 Pontificia Universidad
 Católica del Ecuador
Baltazar Uscha and family
BBC High Risk teams
Bernarda Cornejo
Bertram Ostendorf
Betsy Didrickson,
Billy and Margaret Ellis
Bindu Menon
Bob Baer, Saluki Stadium
Bob Nansen
Brandon Li
Brett Lewis
British Antarctic Survey

Buffalo Springs National
 Reserve
Bureau of Land
 Management
Captain Carlos Apablaza
Casey Decker
Chad Hanson
Chaolong Chen
Chenghao Zhang
Chris Herwig and the
 Google team
Chris Kemp
Claire Mirande
Coli Whewell
CREA Animal Rescue
 Centre
Dallas World Aquarium
David Dabellan
David Taggart
Department of Earth and
 Marine Science
Department of Geography,
 Gustavus Adolphus
 College
Director Feng
Douglas Beggs
Dr Andres Merino
Dr Anne Pusey
Dr David L A Gaveau
Dr Deus Mjungu
Dr Elizabeth Madin
Dr Fengshan Li
Dr Frank Marks, NOAA
Dr George Archibald
Dr Jeff La Frenierre
Dr Jiefeng Jin
Dr Jivanildo Miranda
Dr John Hedley
Dr Kara Walker
Dr Katrin Linse
Dr Lesley Daspit
Dr Michael Bravo
Dr Neil Arnold
Dr Phil Trathan
Dr Poul Christoffersen
Dr Richard Beilfuss
Dr Santiago Ron
Dr Stef Lhermittte
Dr Tatsuo Oshida,
Dr Zoltan Szantoi
Dzanga Area Protection
Dzanga-Sangha Protected
 Areas
El Parque Nacional
 Cotopaxi
Elis Nurhayati
Eyes on the Forest
Florida Fish and Wildlife
 Conservation
 Commission
Frank Pope
Freddy Almeida
Global Forest Watch
Grand Targhee Resort
Grand Teton National Park
Great Barrier Reef Legacy

Great Basin Smokejumpers
Guanming Wang
HAkA (Forest, Nature and
 Environment of Aceh)
Harbour City
Henan Province Foreign
 Affair Bureau
Hidayah Hamzah
Hong Kong Tourism Board
Huayan Zeng
International Crane
 Foundation
Irwan Gunawan
Isaac Chen
Jackson Hole Mountain
 Resort
Jane Wynyard
Janice Beatty, African
 Environments
JD Miners
Jeff Gore
Jennifer Fowler
Jeremy Close
Jiangxi Province Foreign
 Affair Bureau
Jivanildo Miranda
Johannes Kirchgatter,
 WWF Germany
John and Linda Rumney
Kara Walker
 Anne Pusey
Kari Cobb, NIFC External
 Affairs Public Affairs
 Specialist
Kasper Trojlsgaard
Kathy and Arnold Tollefson
Katie Fletcher
La Reserva de Producción
 Chimborazo
Laurel Surtherlin
Lawrence Lujan
Leonardo Pumina
Leslie Finstein
Lilian Pintea
 Emmanuel Mtiti
Luis Arranz
Mai Nishiyama
Major Kendall Dunn
Marco Cruz
Mark Fletcher
Masato Yamada
Matthew G Nowak
Michael Male
Michael Swinbourne
Michael Wilson
Montana Nasa Epscor
 Program, University of
 Montana
Mr Dai and family
Mr Natsuo Ohsawa
Ms Misaki Koguro
Nagdlunguak-48
Nakuprat Goto
 Conservancy
Nathan Tse
Nelson Mwangi

Nikki Standing
Northern Rangelands Trust
Nottingham Natural
 History Museum
Obihiro University of
 Agriculture and
 Veterinary Medicine
Pavel Ageychenko
Peter Fretwell
Peter Matthew
Prefectura Naval Argentina
Prineville Hotshots
Prof. Adrian Luckman,
 Swansea University
Prof. Alun Hubbard,
 Aberystwyth University
Prof. Julian Bayliss,
 Mt Lico
Prof. Michael Wilson
Prof. Paul Garber,
 University of Illinois
Prof. Serge Wich
Prof. Terry Hughes
Qian Li
Queensland University of
 Technology
Rachel Mclaughlin
Rainforest Action Network
Redding Hotshots
Reserva de Producción de
 Fauna Chimborazo
Richard D Anderson
Richard Kimber
Richard Stacey
Rodrigo Donoso and family
Roger Munns
Sajid Darr
Samburu National Reserve
Sara Gavney Moore
Save the Elephants
Scott Polar Research
 Institute
Secretary General Carlos
 Barrios Cardozo
Sent into Space
Sequoia National Forest
Shane Cronin
Shaolin Tagou Martial Arts
 School
Sharon Jordan
Shawn Sweeney
Spike Millington
Stanislaus National Forest
Suhandri Suhandri
Sumatran Orangutan
 Conservation
 Programme
Takuji Yoshihara
Tambo Films
TANAPA (Tanzania
 National Parks)
Tanzania Civil Aviation
 Authority
The Chinese Association
 of Radio, Film and
 Television Exchanges

The crew of Prefecto
 Derbes
The High Commission of
 India, London
The Jane Goodall Institute
The Lam family
The United Republic of
 Tanzania Ministry of
 Defense and National
 Service
The United Republic of
 Tanzania Ministry of
 Information Youth
 Culture and Sport
The Yeung family
Thomas Barano
Tim Coey
Tim Kavan
Tim Kavan
Tim Moffat
Up! Studios
US Department of Defense
US Fish and Wildlife
 Service
US Forest Service
US Forest Service
Viewfinders
Weiyi Feng
Wild Vision Aventures
Will Lawson
Wilson Mao
Wonders of Yunnan Travel
Wong Tai Sin Temple
Wood Buffalo National
 Park
World Resources Institute
 Indonesia
WWF
WWF Indonesia
Wyoming Department of
 State Parks
Xingyu Song
Yosemite National Park
Yunling Honey
Yunnan Province Foreign
 Affair Bureau
Yury Burykin
Yushin Asari Ph.D

Picture Credits

1 NASA image by Norman Kuring, NASA's Ocean Biology Processing Group; **2** Horizon International Images Limited/Alamy; **4tl** NASA USGS; **4tr** ESA; **4bl** © 2018, Deimos Imaging SLU, an UrtheCast Company; **4br**, **5** Science History Images/Alamy

INTRODUCTION
6-7 image courtesy of NASA Johnson Space Center; **8** Wikimedia Commons; **9l** Nadar/Getty; **9r** age fotostock/Alamy; **10** Chronicle/Alamy; **11** Wikimedia Commons; **12l** H.Lee Wells, NG Creative; **12r** nsf/Alamy; **13** Johns Hopkins Applied Physics Laboratory; **14** NASA/ATS-3 satellite; **15** NASA/JPL; **16-17** Satellite imagery courtesy of © 2018 DigitalGlobe, a Maxar company

1 WORLD OF MOVEMENT
18-19 © 2018, Deimos Imaging SLU, an UrtheCast Company; **20-1** NASA/Jesse Allen/LANCE Suomi National Polar-orbiting Partnership; **22** BBC; **23-5** Satellite imagery courtesy of © 2018 DigitalGlobe, a Maxar company; **26-7** Barny Revill; **28-9** DigitalGlobe/ScapeWare3d/Getty; **30** NASA/MODIS Rapid Response Team at NASA GSFC; **31-3** Carlton Ward Jr; **35** robertharding/Alamy; **36-7** Jacques Descloitres, MODIS Rapid Response Team, NASA/GSFC; **38** Andrew Thompson; **39** NOAA; **40-1** BBC; **42-3** NASA/NOAA Suomi National Polar-orbiting Partnership; **44** Geoff Kirby/Alamy; **45** Satellite imagery courtesy of © 2018 DigitalGlobe, a Maxar company; **46** dpa picture alliance archive/Alamy; **47** Nottingham City Museums; **48-9** CNES 2012 – Distribution Airbus DS; **50** Freddie Claire; **51** © 2018, Deimos Imaging SLU, an UrtheCast Company; **52-3** Freddie Claire; **54-5** NASA Earth Observatory images by Jesse Allen, using data from LAADS and LANCE; **56-7** NASA/NOAA Suomi National Polar-orbiting Partnership; **58-9** AFP Contributor/Getty; **60** Juan-Carlos Munoz/Getty; **61** image courtesy of the Earth Science and Remote Sensing Unit, NASA Johnson Space Center; **62-3** CNES 2016 – Distribution Airbus DS; **64** Michael Poliza; **65** Eric Baccega/naturepl.com; **66-7** Satellite imagery courtesy of © 2018 DigitalGlobe, a Maxar company; **68** Jean Tresfon; **69** Satellite imagery courtesy of © 2018 DigitalGlobe, a Maxar company; **70-1** NASA image by Norman Kuring, NASA's Ocean Color web; **72-3** CNES 2018 – Distribution Airbus DS; **74-7** Freddie Claire; **78** Barcroft Media/Getty; **79** Satellite imagery courtesy of © 2018 DigitalGlobe, a Maxar company; **80** Andrew Thompson; **81** BBC; **82** Natalie Behring/Getty; **83** Scott Olson/Getty

2 WORLD OF COLOUR
84-5 NASA / ISS Expedition 44 crew; **86-7** by Daily Overview, satellite imagery (c) DigitalGlobe; **88** Freddie Claire; **89** BBC; **90-1** Freddie Claire; **92-3** image courtesy of the Earth Science and Remote Sensing Unit, NASA Johnson Space Center; **94-5** BBC; **96** Lonely Planet Images/Getty; **97** ESA; **98** Bertie Gregory/naturepl.com; **99** Mitsuaki Iwago/Minden/FLPA; **100-1** NASA image by Norman Kuring, NASA's Ocean Color web; **102** Anup Shah/naturepl.com; **103** © 2018, Deimos Imaging SLU, an UrtheCast Company; **104-5** Tim Fitzharris/Minden/FLPA; **107** Phillip Colla; **108-9** Frans Lanting/Mint/Getty; **110-1** NASA Earth Observatory image by Joshua Stevens, using MODIS data from LANCE/EOSDIS Rapid Response; **112** DigitalGlobe/ScapeWare3d/Getty; **113** NASA Earth Observatory image by Jesse Allen and Robert Simmon, using Landsat data from the U.S. Geological Survey; **114-5** Satellite imagery courtesy of © 2018 DigitalGlobe, a Maxar company; **116** Pete Turner/Getty; **117** © 2018, Deimos Imaging SLU, an UrtheCast Company; **118** Freddie Claire; **119** BBC; **120-1** Satellite imagery courtesy of © 2018 DigitalGlobe, a Maxar company; **122-3** Freddie Claire; **124** Fred Olivier/naturepl.com; **125** Satellite imagery courtesy of © 2018 DigitalGlobe, a Maxar company; **126-7** Fred Olivier/naturepl.com; **128** Michel Roggo/naturepl.com; **129** NASA USGS; **131** Peter Scoones/naturepl.com; **132-3** © 2018, Deimos Imaging SLU, an UrtheCast Company; **134-5** BBC; **136** Justin Anderson; **137** Satellite imagery courtesy of © 2018 DigitalGlobe, a Maxar company; **138-9** Justin Anderson; **140-1** NASA USGS; **142-3** NASA Earth Observatory images by Jesse Allen and Adam Voiland, using Landsat data from the U.S. Geological Survey; **145tl** NASA / ISS Expedition 16 crew; **145tr** image courtesy of the Earth Science and Remote Sensing Unit, NASA Johnson Space Center; **145b** NASA / ISS Expedition 45 crew; **146-7** Science History Images/Alamy; **149** NASA/NOAA Suomi National Polar-orbiting Partnership; **150-1** Justin Anderson

3 WORLD OF PATTERNS
152-3 PlanetObserver; **154-5** Satellite imagery courtesy of © 2018 DigitalGlobe, a Maxar company; **156** Bertie Allison; **157** NASA; **158-9** NASA USGS; **160-1** Bertie Allison; **162-3** © 2018, Deimos Imaging SLU, an UrtheCast Company; **164** BBC; **165** © 2018, Deimos Imaging SLU, an UrtheCast Company; **167l** Robert McGouey/Wildlife/Alamy; **167r** Michel Roggo/naturepl.com; **68** BBC; **169-171** Paul Thompson; **172** Satellite imagery courtesy of © 2018 DigitalGlobe, a Maxar company; **173** Anup Shah/naturepl.com; **174** Dave Watts/naturepl.com; **175** BBC; **176-9** Satellite imagery courtesy of © 2018 DigitalGlobe, a Maxar company; **180-1** Jeff Rotman/naturepl.com; **182-3** NASA Earth Observatory image by Jesse Allen, using data from LANCE; **184-5** Mario Tama/Getty; **186** NASA GSFC Landsat/LDCM EPO Team; **187** PlanetObserver; **188** Bertie Allison; **189** George Steinmetz/National Geographic Creative; **190** © 2018, Deimos Imaging SLU, an UrtheCast Company; **191** BBC; **192-3** NASA Landsat; **194-5** BBC; **196** Universal Images Group North America LLC/Alamy; **197** Jacques Descloitres, NASA MODIS Land Science Team; **198-9** Erlend Haarberg/naturepl.com; **200** Pal Hermansen/naturepl.com; **201** Bryan and Cherry Alexander/naturepl.com; **202-3** NASA USGS; **204** Bertie Allison; **205** UniversalImagesGroup/Getty; **206-7** ESA; **208-9** © 2018, Deimos Imaging SLU, an UrtheCast Company; **210-1** BBC; **212-3** DigitalGlobe/ScapeWare3d/Getty; **214** Satellite imagery courtesy of © 2018 DigitalGlobe, a Maxar company; **215** NASA Earth Observatory image created by Jesse Allen, using data provided courtesy of the NASA/GSFC/METI/ERSDAC//JAROS and the U.S./Japan ASTER Science Team; **216-7** © 2009 DigitalGlobe, Inc; **218** © 2018, Deimos Imaging SLU, an UrtheCast Company; **219** BBC; **220-3** © 2018, Deimos Imaging SLU, an UrtheCast Company

4 WORLD OF CHANGE
224-5 Francisco Negroni; **226-7** image courtesy of the Earth Science and Remote Sensing Unit, NASA Johnson Space Center; **228-9** Mary Lyn Fonua/Getty; **230-3** Satellite imagery courtesy of © 2018 DigitalGlobe, a Maxar company; **234-5** BBC; **236-7** CNES 2015 – Distribution Airbus DS; **238-9** NASA / ISS Expedition 38 crew; **240** Andrew Thompson; **241** image courtesy of the Earth Science and Remote Sensing Unit, NASA Johnson Space Center; **242** ESA; **244** Barney Revill; **45** Mark Taylor/naturepl.com; **246** ESA; **248-9** Satellite imagery courtesy of © 2018 DigitalGlobe, a Maxar company; **250-1** BBC; **252-3** NASA USGS; **254-5** CNES, 2010 Distribution Spot Image/SPL; **257-9** The Asahi Shimbun/Getty; **260-3** BBC; **264-5** © 2018, Deimos Imaging SLU, an UrtheCast Company; **266-7** Zubin Sarosh; **268-9** Satellite imagery courtesy of © 2018 DigitalGlobe, a Maxar company; **270** Anup Shah/naturepl.com; **271** CNES 2014 – Distribution Airbus DS; **272-3** © 2018, Deimos Imaging SLU, an UrtheCast Company; **275** Freddie Claire; **276-7** Satellite imagery courtesy of © 2018 DigitalGlobe, a Maxar company; **278** © 2018, Deimos Imaging SLU, an UrtheCast Company; **279** World History Archive/Alamy; **281** NASA

inside cover © Science History Images/Alamy Stock Photo; **endpaper** *front* © 2018, Deimos Imaging SLU, an UrtheCast Company; **endpaper** *back* ESA

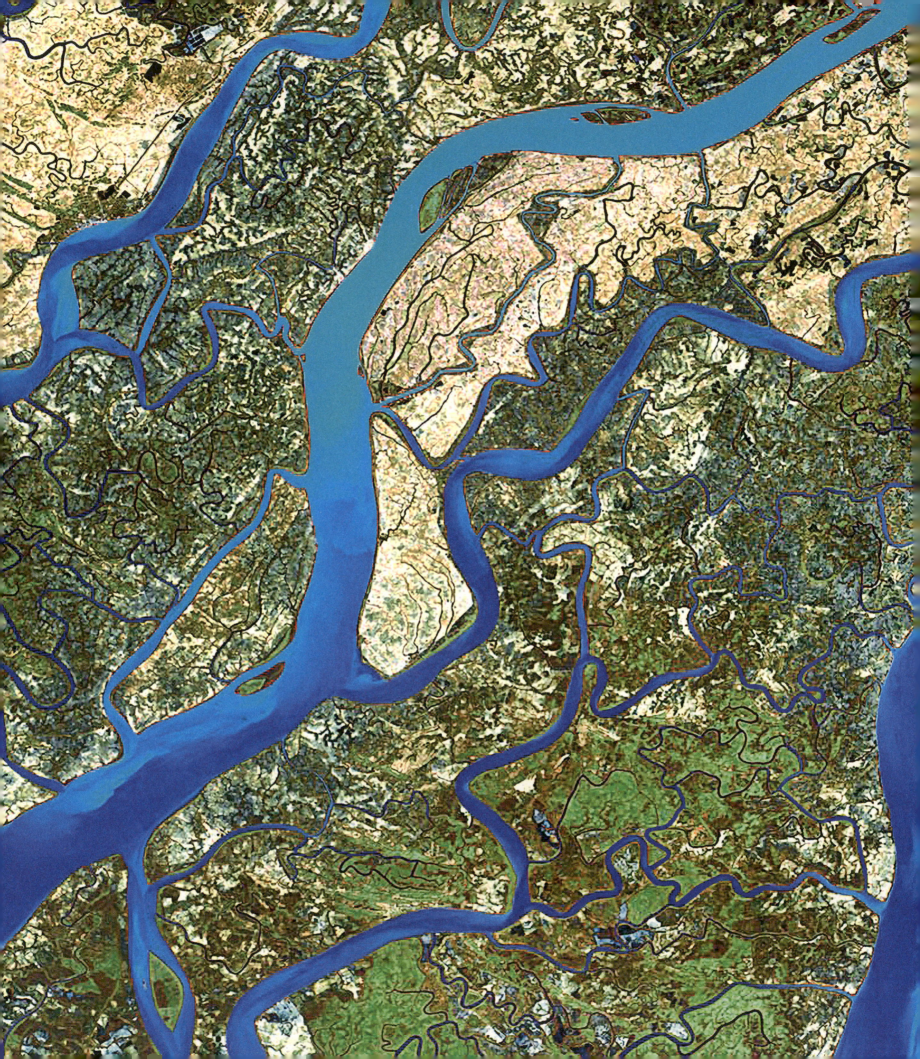